Representing
SLAVERY

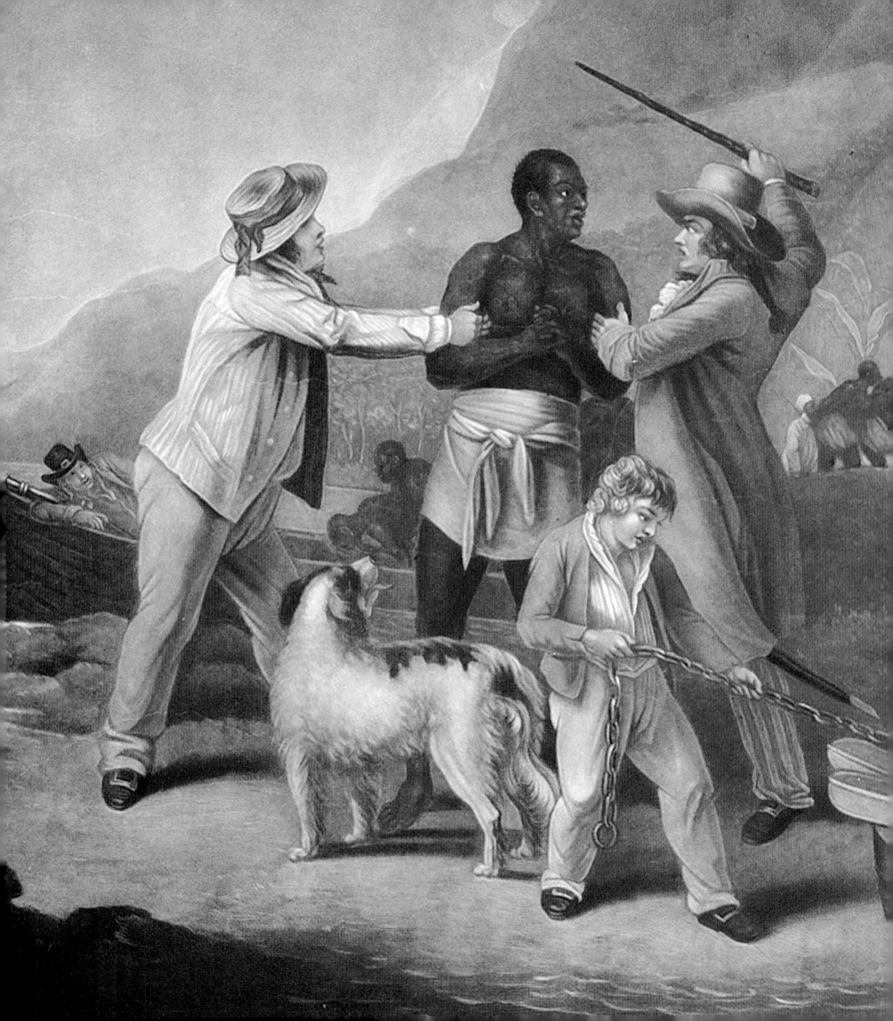

LUND HUMPHRIES

Representing SLAVERY

Art, Artefacts and Archives in the Collections of the National Maritime Museum

EDITED BY DOUGLAS HAMILTON AND ROBERT J. BLYTH

First published in 2007 by

Lund Humphries
Gower House
Croft Road
Aldershot
Hampshire GU11 3HR

and

Lund Humphries
Suite 420
101 Cherry Street
Burlington
VT 05401-4405
USA

in association with the

National Maritime Museum
Greenwich
London
SE10 9NF

Lund Humphries is part of Ashgate Publishing

www.lundhumphries.com

British Library Cataloguing-in-Publication Data
A catalogue record for this book is available from the British Library

ISBN (hardback) 978-0-85331-966-5
ISBN (paperback) 978-0-85331-967-2

Library of Congress Control Number is 2007926964

Representing Slavery: Art, Artefacts and Archives
in the Collections of the National Maritime Museum
Copyright © 2007 National Maritime Museum, London
Essays Copyright © 2007 The Authors

Project managed by Sarah Thorowgood
Picture research by Sara Ayad
Designed by Michael Keates
Printed in Singapore under the supervision of MRM Graphics

CONTENTS

Acknowledgements

Producing this catalogue has been a collaborative effort with contributions from across the National Maritime Museum and beyond. The editors acknowledge the assistance of the Photo Studio and the Publications and Inventory teams at the National Maritime Museum. We would like to thank especially our former colleagues Andrew Davis, Jenny Gaschke, Sue McMahon, Jean Patrick, Rina Prentice, Nigel Rigby, Karen Scadeng, Barbara Tomlinson, Liza Verity and Jelmer Voss for sharing their expertise and time, Roger Quarm for his invaluable assistance with queries regarding the prints and drawings, and Pieter van der Merwe who read and commented on the entire manuscript. Particular thanks are due to Kathryn Pickles, who helped collate the catalogue from the diverse collections at the National Maritime Museum. It is also our pleasure to thank Michael Graham-Stewart, whose dedicated research forms an important part of this catalogue.

Contributors

Dr Hakim Adi is Reader in the History of Africa and the African Diaspora at Middlesex University. He is a founder member of, and currently chairs, the Black and Asian Studies Association and is a member of the Mayor of London's Commission on African and Asian Heritage. Hakim is the author of *West Africans in Britain 1900–60: Nationalism, Pan-Africanism and Communism* (1998) and (with M. Sherwood) *The 1945 Manchester Pan-African Congress Revisited* (1995) and *Pan-African History: Political Figures from Africa and the Diaspora since 1787* (2003). He has appeared in several television documentaries and radio programmes, and has written widely on the history of the African diaspora and Africans in Britain, including three history books for children.

Dr Robert J. Blyth is a Lecturer in History at Queen's University, Belfast and Visiting Fellow at the Centre for Imperial and Maritime Studies at the National Maritime Museum, where he spent six years as Curator of Imperial and Maritime history. He is the author of *The Empire of the Raj: India, Eastern Africa and the Middle East, 1858–1947* (2003), and has written articles on Britain, India and the western Indian Ocean. His current research focuses on the political impact of the South Asian diaspora across the British Empire in the first half of the twentieth century, and on the Malcolms of Burnfoot and Scottish imperial connections in the early nineteenth century.

Dr Douglas Hamilton is Lecturer in History in the Wilberforce Institute for the study of Slavery and Emancipation (WISE) at the University of Hull. He is a Fellow of the Royal Historical Society and Visiting Fellow at the Centre for Imperial and Maritime

Studies at the National Maritime Museum, where he was Curator of Eighteenth-Century Maritime and Imperial History. He has written several articles on the history of the eighteenth-century Caribbean, and is the author of *Scotland, the Caribbean and the Atlantic World, 1750–1820* (2005).

Professor Paul E. Lovejoy FRSC, Distinguished Research Professor, Department of History, York University, holds the Canada Research Chair in African Diaspora History and is Director, Harriet Tubman Resource Centre on the African Diaspora and Research Professor, Wilberforce Institute for the study of Slavery and Emancipation (WISE), University of Hull. His recent publications include *Transformations in Slavery* (2nd edn, 2000) and many edited volumes on slavery and the African diaspora including: (with Robin Law) *The Biography of Mahommah Gardo Baquaqua* (2001); (with Toyin Falola) *Pawnship, Slavery and Colonialism in Africa* (2003); (with David Trotman) *Trans-Atlantic Dimensions of Ethnicity in the African Diaspora* (2004) and *Slavery on the Frontiers of Islam* (2004). His essays have been revised and republished in *Slavery, Commerce and Production in West Africa* (2005) and *Ecology and Ethnography of Muslim Trade in West Africa* (2005). He is a member of the International Scientific Committee of the UNESCO Slave Route Project, and is co-editor of *African Economic History and Studies in the History of the African Diaspora – Documents*.

Dr John Oldfield is Senior Lecturer in Modern History at the University of Southampton. He is the author of *Popular Politics and British Anti-Slavery: The Mobilisation of Public Opinion Against the Slave Trade, 1787–1807* (1995) and has written numerous articles on slavery and abolition in the Atlantic world. His most recent book is *Chords of Freedom: Commemoration, Ritual and British Transatlantic Slavery* (2007).

Dr Geoff Quilley is Curator of Fine Art at the National Maritime Museum. His research focuses on British art, empire and the maritime nation in the long eighteenth century, on which he has published widely, including the edited books *An Economy of Colour: Visual Culture and the Atlantic World, 1660–1830* (with Dian Kriz, 2003) and *Conflicting Visions: War and Visual Culture in Britain and France c.1700–1830* (with John Bonehill, 2005). He is curator of the exhibitions *William Hodges 1744–1797: The Art of Exploration* (2004) and *Art for the Nation: The Oil Paintings Collections of the National Maritime Museum* (2006). He is currently completing a monograph *From Empire to Nation: Art and the Visualization of Maritime Britain 1768–1829*.

Professor David Richardson is Professor of Economic History and Director of the Wilberforce Institute for the study of Slavery and Emancipation (WISE) at the University of Hull. He has published extensively on the history of transatlantic slavery, especially the slave trade from Africa to the Americas, and is co-author of *The Trans-Atlantic Slave Trade: A Database on CD-ROM* (1999). A revised and online version of this database is currently in preparation. He has been and remains an advisor to various

British museums, notably on exhibits relating to slavery and, through WISE, is co-leader on the Venture Smith Documentation Project (with the University of Connecticut and the Beecher House Society) which seeks to reconstruct the life of an enslaved African who freed himself. He currently serves on the Scientific Committee of the UNESCO Slave Route Project.

Professor James Walvin taught for many years at the University of York. His books have been mainly on slavery and the slave trade, most prominently *Black Ivory: Slavery in the British Empire* (2nd edn, 2001) and *Atlas of Slavery* (2005). His book *Black and White: The Negro and English Society, 1555–1945* (1973) won the Martin Luther King Memorial Prize. His recent books include *A Short History of Slavery* (2007) and *The Trader, the Owner, the Slave* (2007).

Dr Jane Webster is Lecturer in Historical Archaeology in the School of Historical Studies at Newcastle University, where she teaches and researches on colonial material culture and slavery in both the Roman and early modern periods. She is a former Caird Senior Research Fellow at the National Maritime Museum, and is currently completing a book on *The Material Culture of British Slave Shipping from 1680–1807*.

Professor Marcus Wood is Professor of English at the University of Sussex, and he also has an alternative career as a painter and performance artist. His recent publications include *Blind Memory: Visual Representations of Slavery in England and America, 1780–1865* (2000), *Slavery, Empathy and Pornography* (2002) and *The Poetry of Slavery: An Anglo-American Anthology, 1764–1865* (2003). He is currently working on a book entitled *The Horrible Gift of Freedom*, and on a film concerning the National Great Blacks in Wax Museum, Baltimore.

FOREWORD

In 2002, with generous assistance from the Heritage Lottery Fund, the National Maritime Museum acquired the Michael Graham-Stewart Slavery Collection of over 450 artefacts, documents, paintings, photographs, and prints and drawings. This is one of our most important additions in recent years. The Museum's previous holdings on slavery and abolition, although significant, were largely documentary and did not match, in display and public interpretation terms, the pre-eminent strengths of its collections on many other aspects of Britain's maritime history.

Taking old and new together we can now reasonably claim to have the United Kingdom's most significant slavery collection and one that opens many windows into a terrible history. Above all, its breadth and depth movingly demonstrate the inexcusable human cost of an abhorrent trade, showing the extent, brutality and centrality of slavery in the Atlantic world. However, it also shows the underrated extent of African resistance, the widespread efforts to achieve abolition and emancipation and the zeal with which the Royal Navy pursued anti-slavery operations after British abolition in 1807. The Museum's collections further reveal that slavery and the fight against it were by no means confined to the Atlantic but were important features of the Indian Ocean as well, aspects frequently obscured by debates centred on the notorious 'triangular trade' between Europe, Africa and the Americas.

Most importantly, the overall collection forces us to engage with complex issues and uncomfortable legacies, all now brought into particular focus by events in 2007 marking the bicentenary of Parliament's abolition of the British slave trade. Slavery did not, of course, end in 1807 or in the nineteenth century: indeed, it is still with us in various forms around the world, with occurrences even sometimes exposed in Britain. While the bicentenary therefore commemorates a remarkable early victory, it is also an occasion for reflection on an enduring evil that remains to be fully eradicated.

The Museum is at the forefront of activities designed to promote such engagement. It is a lead partner in Britain's Understanding Slavery Initiative and has long participated in the annual Black History Month programme as a means to sustain thoughtful interpretations of key issues. Two new permanent galleries, opening in 2007 and 2009, will explore slavery and abolition within the broader context of Britain's imperial expansion into the Atlantic and Indian Oceans from the early seventeenth century. We also hope that this catalogue will make a meaningful contribution to ongoing historical debate and help deepen understanding of a subject that continues to touch all our lives. The informative and accessible essays offered here by leading historians provide contexts within which to assess the Museum's subject as a whole, in addition to individual collections, and I am grateful to them for contributing their expertise.

I would also like to thank the editors. Until recently Dr Robert Blyth and Dr Douglas Hamilton were curators at the Museum and worked closely with the collection. Thanks are also due to their many colleagues here who assisted with this book's production and who will be responsible for the programme of displays, online provision and wide public engagement in 2007 and beyond.

ROY CLARE, DIRECTOR, NATIONAL MARITIME MUSEUM

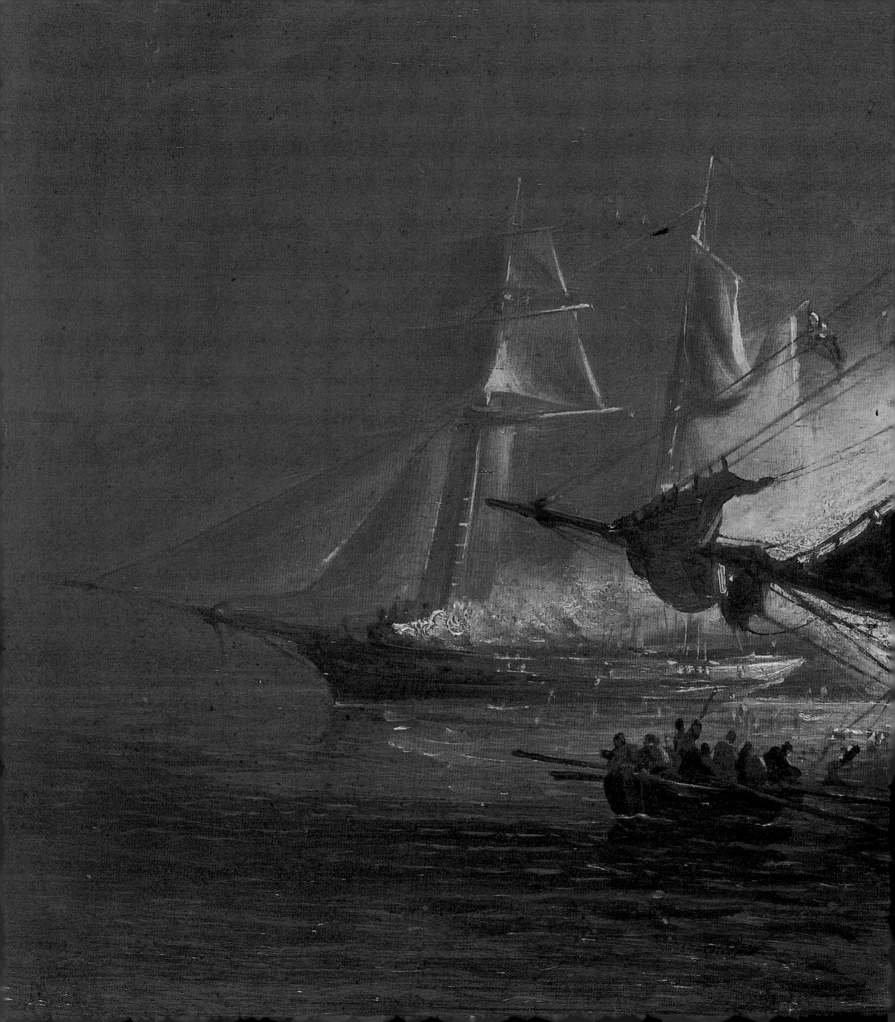

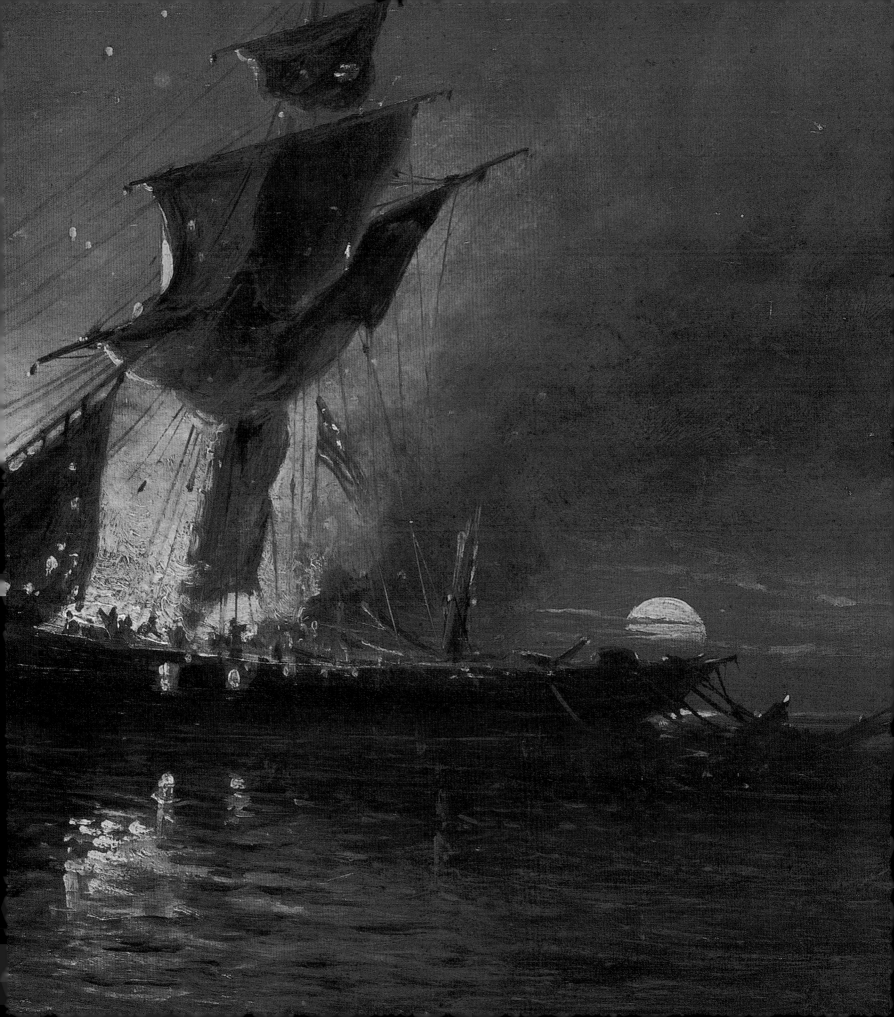

INTRODUCTION

Douglas Hamilton
and Robert J. Blyth

THE CAPTURE AND BRUTAL SHIPMENT of millions of Africans to the plantations and towns of the Americas between the sixteenth and nineteenth centuries helped shape the modern world, and has consequences that still resonate today. Yet despite the immense impact of transatlantic slavery on Africa, the Americas and Europe, the nature of the system of enslavement and the appalling dynamics of the trade itself are still not widely understood. In Britain, centuries of active involvement in slavery and the slave trade have been readily forgotten. On the one hand it has perhaps too easily been masked by self-congratulation on the pioneering achievement of abolition and emancipation in the years after 1807; on the other, by a national sense of superiority deriving from the Royal Navy's imperial suppression of the 'foreign' and 'colonial' aspects of slavery in the nineteenth century. The result has been a tendency to diminish the importance of this shameful passage in British history and, in some cases, to deny its role in the nation's past. This collective amnesia and wilful neglect is beginning to end.

In recent years, the study of slavery as a cruel but multifaceted phenomenon has developed into a major field of serious academic research, producing some of the most significant and thought-provoking historical scholarship. It has taken time for this scholarly interest to translate into broader public awareness. In about the last fifteen years, however, cultural institutions, schools and colleges, historians, and members of the public have collaborated to encourage a much wider engagement with the histories and legacies of slavery and the slave trade. The opening of the Transatlantic Slavery Gallery at the Merseyside

Maritime Museum, Liverpool in 1994 was an early and important manifestation of this process, which has been pushed forward by other vital initiatives, including the 'Understanding Slavery' and 'Moving Here' websites and many aspects of Black History Month. In 2007, the bicentenary of the British abolition of the slave trade has provided a focus for a series of commemorations in Europe, Africa and the Americas which aim to foster, as never before, a greater public understanding of the slave trade and slavery. These commemorations have taken many forms: from new exhibitions to community projects; from the creation of new research institutes to the development of web-based resources.

Issues relating to slavery, the slave trade and their abolition form a significant component of the National Maritime Museum's display and interpretation work, its community, education and research programmes, and its collecting policies. Indeed, it was the Museum's growing commitment to the subject from the late 1990s that led it to purchase, with help from the Heritage Lottery Fund, a major collection of slavery-related material in 2002. The Michael Graham-Stewart Collection consists of more than 450 items covering a range of subjects connected to the histories of slavery, the slave trade and the abolition campaigns; it forms the core of the material presented in this catalogue. The acquisition allowed the Museum to explore the complex histories of slavery more fully than was possible with its existing collections. Furthermore, it brought different perspectives to bear on these collections and helped to integrate objects and manuscripts into new contexts and interpretations. This catalogue therefore forms part of the wider process of broadening public engagement with this crucial subject and represents the results of some of the myriad activities undertaken by the Museum.

In many ways, the catalogue marks a new approach as it moves beyond the usual focus on a particular exhibition, or artist, or individual collection. It draws together 623 objects and images from the 2.5 million items which comprise the diverse collections of the National Maritime Museum. Understandably, the process of selection raised a number of issues about its scope, emphasis and, ultimately, its purpose. Should it contain only items directly connected with slavery and abolition, or should it seek to recognise their wider impact through the inclusion of contextual material? For both practical reasons of space and intellectual balance, we have primarily concentrated on the Michael Graham-

Stewart Collection and other items specifically connected to slavery, the Atlantic and Indian Ocean slave trades and their abolition and suppression, omitting, for example, material relating to European conflict in the Caribbean. This required some hard decisions but we believe it more useful to have a fuller analysis of the core material.

The slavery collection, as selected and examined here, comprises items from a range of media covering the period from the sixteenth century to the early twentieth century. Artefacts and material culture, ethnography, coins and medals, manuscripts, rare books, maps and charts, newspapers, oil paintings, photographs and a substantial number of prints and drawings are all represented. The collection has particular strengths. The voluminous output produced by the abolition campaigns of the late eighteenth and early nineteenth centuries forms one area of concentration. The wealth of visual representations in prints and drawings forms another central component of the Museum's collection. Nonetheless, the collection also promotes an understanding of African agency in, and opposition to, slavery through African artefacts and representations of resistance. The collection further encourages a broader understanding of slavery itself. Although 1807 marked the abolition of the slave trade in British ships, it did not end all slave trades or slavery itself. By including important material relating to slavery in the Indian Ocean, and exploring the role of the Royal Navy in suppressing slave trades after 1807, the collection thus helps to widen the geographical scope of the study, and offers opportunities for comparative analyses.

The essays in this volume have been specially commissioned. They highlight the major themes and debates in the history of the slave trade and slavery and, collectively, provide an introduction both to the subject and to the multifarious contexts within which the images and artefacts in the catalogue can be understood and interpreted.

James Walvin's opening essay places the enslavement and abuse of Africans within a global context, and he shows the many ways in which the demands of European economies and consumption patterns required slavery's continuation. Yet it is clear, as Paul Lovejoy points out, Africans were not just victims. Slavery was widespread in Africa and some Africans were active participants in the trade; others, notably those who were enslaved, rejected and resisted their condition. This notion of African participation forms a central theme in this book and it is their

rejection of, and opposition to, slavery that emerges most powerfully. In Chapter 3, David Richardson explores the transatlantic voyage (the 'Middle Passage') through the eyes of Olaudah Equiano, who left one of the very rare descriptions of slavery by someone of African descent. As Richardson demonstrates, Africans actively resisted their enslavement during the Middle Passage in a variety of ways. This is developed in Douglas Hamilton's essay on enslaved life and resistance in the Caribbean, in which he argues that despite the appalling conditions in which they found themselves, the enslaved were able to create lives of their own. Ultimately, after centuries of horrors, first the slave trade and then slavery itself were abolished. Yet the reasons why they were abolished continue to spark intense debate among historians. John Oldfield unravels the competing interpretations to explain the complex and often contradictory forces at work within the process of abolition. Having abolished its slave trade, Britain then acted as a kind of international policeman in its attempts to suppress the slave trades of other countries in the Atlantic and Indian Oceans. The anti-slavery patrols carried out by the Royal Navy in the nineteenth century are examined by Robert Blyth.

It can be easy for historians or curators to regard slavery and the slave trade purely as a historical problem. But, as Hakim Adi makes clear in his essay on the role of black people in Britain over many centuries, racism and discrimination are far from being issues of the past and the history of slavery retains a powerful contemporary relevance.

The three remaining essays in the volume turn their attention more closely to the collection itself and suggest some of the ways in which the study of material, artistic and print cultures provides a more sophisticated and nuanced understanding of slavery. Jane Webster's essay uses the Museum's artefacts – the material culture of slave shipping – to provide insights into the terrible conditions of the Middle Passage. Geoff Quilley examines the rich collections of eighteenth-century art to show that the ways in which artists represented Africa and the Caribbean were profoundly affected by their relationships to slavery. Finally, Marcus Wood analyses a diverse range of nineteenth-century graphic images of slavery, and discusses how they shed light on wider European attitudes to, and anxieties about, race and black people.

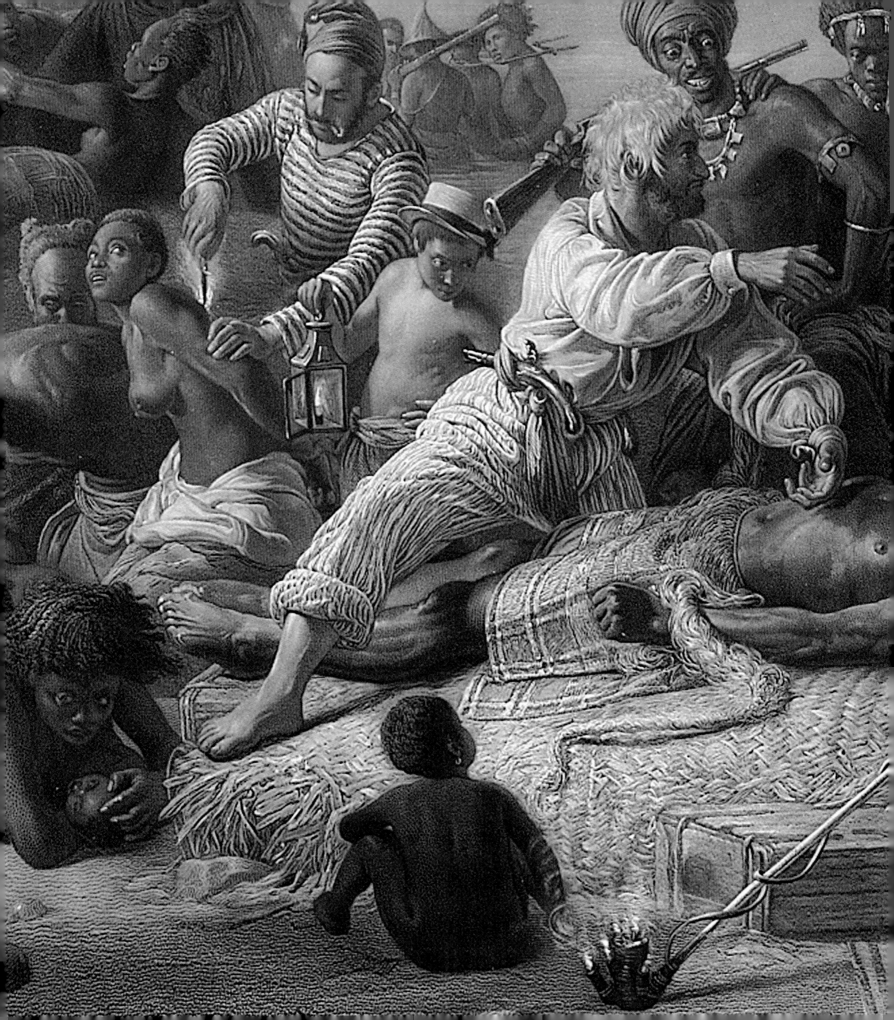

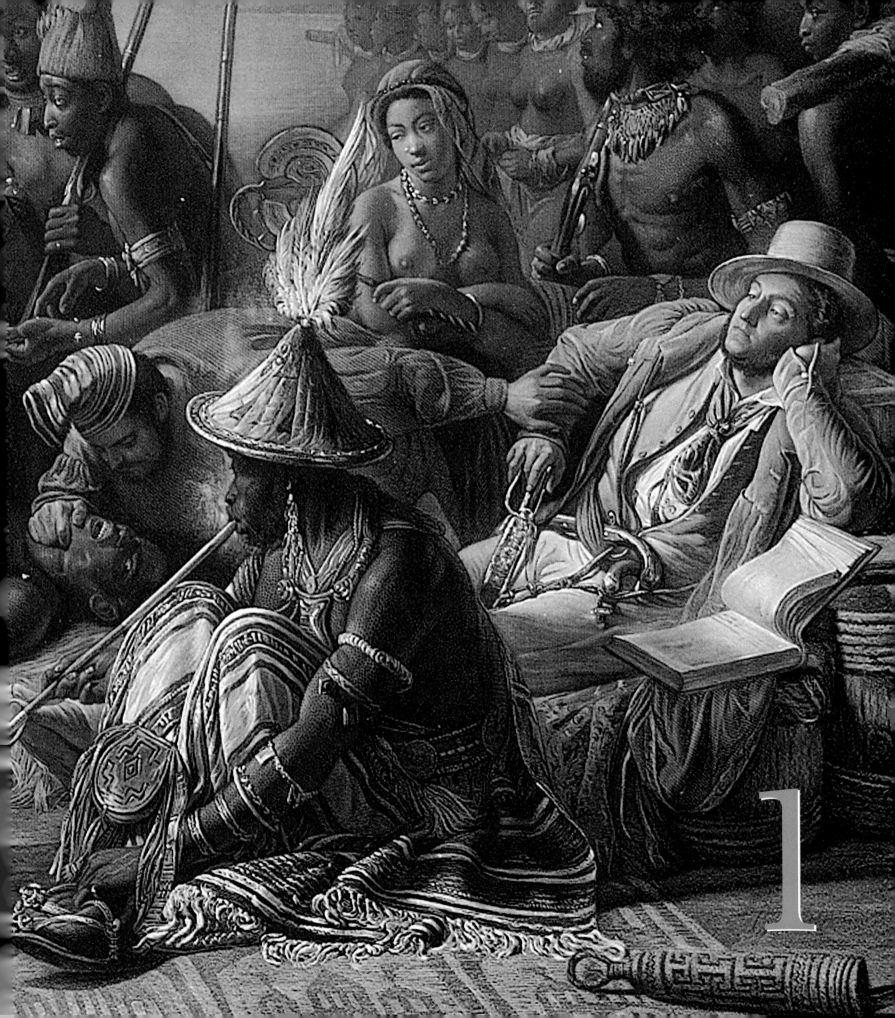

1

Slavery, mass consumption and the dynamics of the Atlantic world: an overview

James Walvin

DURING THE LONG HISTORY of Atlantic slavery, over 11 million Africans were landed in the Americas as slaves, not counting those who perished crossing the Atlantic, or on the long, brutal trek from the point of enslavement to the African coast. By any standards, these are shocking figures: massive movements of population that far outstrip any other enforced diaspora. Even more striking is the fact that many more Africans than Europeans migrated to the Americas in the years before the 1820s. By then, some 2.5 million Europeans had crossed the Atlantic to settle in the Americas. But in the same period, about 8 million Africans had been transported as slaves.[1]

In the first half of the seventeenth century, the Portuguese – still dominant in the Atlantic trade – transported nearly 440,000 Africans to the burgeoning markets of the Americas.[2] As demand increased in the sugar islands, the Atlantic slave traders came into their own. Soon, all the major European maritime powers, led by the Dutch and later the British, wanted their share of the slave trade. The Atlantic system that emerged linked together the varied economies of Europe, the trading posts on the West African coast, the slave colonies in the Americas, and the dangerous and uncertain Atlantic sea lanes. The elements of this vast complex also became arenas for disputes and competition between European nations. Each sought an advantage over their rivals with the dominance of one giving way to another in a succession of imperial and commercial ascendancies and declines. In the early seventeenth century, just as they made their first tentative settlements in North America, the British also began to emerge as a major slaving nation in the Atlantic. They moved into the Caribbean and developed a slave-trading presence on the African coast, despite resistance from their many rivals. Though the British did not initiate Atlantic slavery or the slave trade, from this period onwards they began to exploit, and later perfect, a system pioneered by other Europeans. In their small eastern Caribbean islands, they turned to sugar, using Africans as slaves. Beginning in Barbados and then in Jamaica, the British revolutionised the economies of their flourishing West Indian possessions to become the leading exponents of slave-grown sugar.

This essay explores the ways in which the growth of the slave trade, and the slave system, were driven by demand in Europe for colonial products. Africans, and only Africans, seemed able to produce the tropical commodities craved by the clamouring

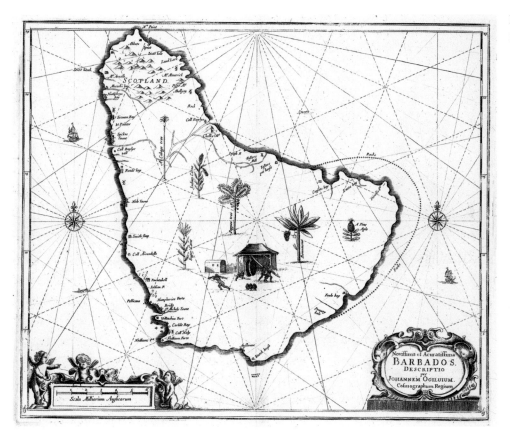

Fig.1: John Ogilby, *Map of Barbados,* 1671
(Cat.168) G.245:15/44.

markets of the western world. This raises an obvious question: why and how did tropical commodities, like sugar and tobacco, become so great and growing a popular taste, where very little demand had existed before? In every single case, the major slave-grown commodities began life as costly and relatively scarce luxuries. Very quickly, however, they became the cheap and easily available daily necessities of ordinary people. The rise of popular material consumption throughout the western world was made possible by the labour of enslaved Africans.

From Africa to the Americas: transportation and enslavement

We know the details of some 34,000 slave-trading voyages – almost half of which were British or British-colonial. Of those, some 6000 originated from Liverpool alone.[3] Ships on these voyages rarely followed the familiar triangular trade route from Europe to West Africa and on to the Americas before returning home. Instead, they traversed the Atlantic along many and varied routes: from Europe to Africa and thence to the Americas; direct from Brazil to Africa and back; from North America to Africa and back; and north and south, to and from the North American colonies and the Caribbean. It was a sailing system that formed not so much a triangle but an intricate and shifting web of trading routes and shipping lanes. The end result was simple

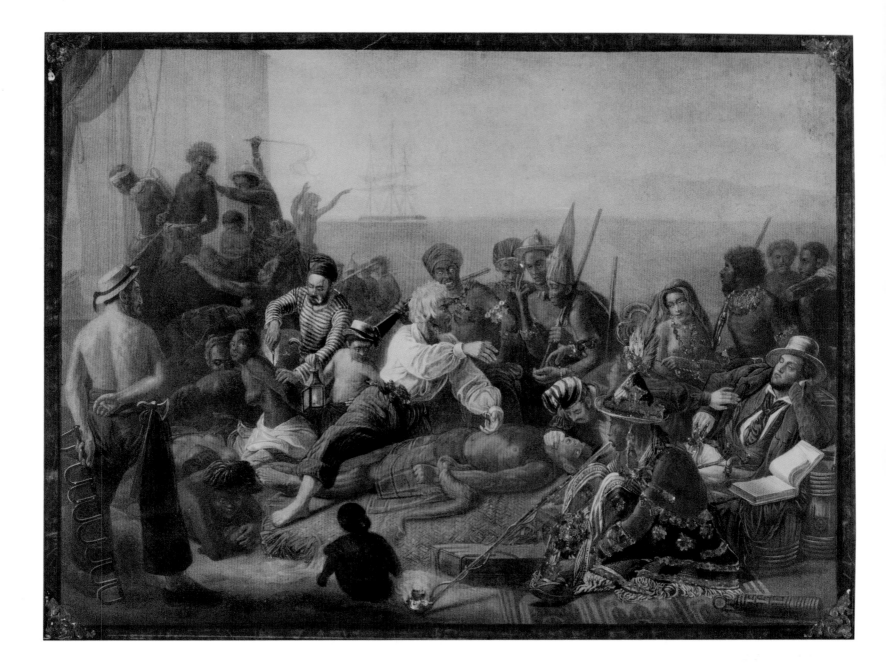

Fig.2: after François-Auguste Biard, *Scene on the coast of Africa*, c.1844 (Cat.336) PZ2626.

enough: to maintain the supply of Africans to the Americas, and to ship the produce of their labours to distant (mainly European) markets. However, it involved extraordinary economic and human complexities. Africans were bought and bargained for on the African coast in return for a vast range of imported goods: British metal wares, firearms, French wines and brandy, textiles from India and later Lancashire, and cowrie shells from the Maldives. The process of exchange was normally a slow, interminable business of acquiring a handful of Africans here, and another group elsewhere. The slave ships cruised up and down the coast, following hard news and rumour about where best they could fill their holds with human cargo. For the Africans, the terrifying squalor of the slave ships was only the latest passage in a long, protracted nightmare from their initial enslavement in the interior, often months before. What followed, however, was uniquely horrible.

The agony of the crowded slave ships and the terrible Middle Passage across the Atlantic stand out in the popular imagination of the slave trade.[4] But little of what has been said, either in print or in popular culture, can truly capture the stinking, unhinging terror of life in the slave holds. As the ships made their way westwards to the Americas (the voyage time was dependent on the weather but, in any case, it took many weeks), Africans slid around the decks in their own communal filth – the living, the dying and the dead chained to each other. Most survivors were sick at landfall in the Americas and had to be revived and revitalised (washed, cleaned up and rubbed with palm oil to look healthier). Then began yet another terrifying round of purchasing: new masters, time spent in holding pens, and long marches to plantations in the islands, in North America and throughout much of South America. All this happened, of course, before they were forced into a lifetime – often short – of unremitting hard labour.

We can measure the levels of sickness and death on the slave ships and afterwards, in the Americas. But we will never know what mental demons were summoned by this oceanic trauma, and the upheavals preceding it, between enslavement and the Atlantic coast of Africa, and what came afterwards on the trek to the final destination on the plantations. Not surprisingly, the slave ships, and recollections of transportation from Africa to the plantations, have become a haunting theme in the folk memory of Africans and their descendants, from the days of slavery down to the present.

For the first few years after they were landed in the Americas, Africans suffered a period known as 'seasoning', during which they were forcibly introduced to the punishing horrors of plantation discipline. This was inevitably severe, especially in sugar production where Africans were drafted into gangs, according to age, strength and aptitude. The working regimes of slaves varied greatly from crop to crop. The physical demands of tobacco production were less harsh than sugar, and rice cultivation was organised by task- rather than gang-work. But everywhere, whatever the local system, each slave regime set out – through a mixture of punishment and rewards – to create a workforce that was finely tuned to the particular crop and its natural agricultural rhythms. A distinct social structure emerged among the slaves, with labouring groups at the bottom and skilled slaves (mainly men) at the top. This world of slavery was

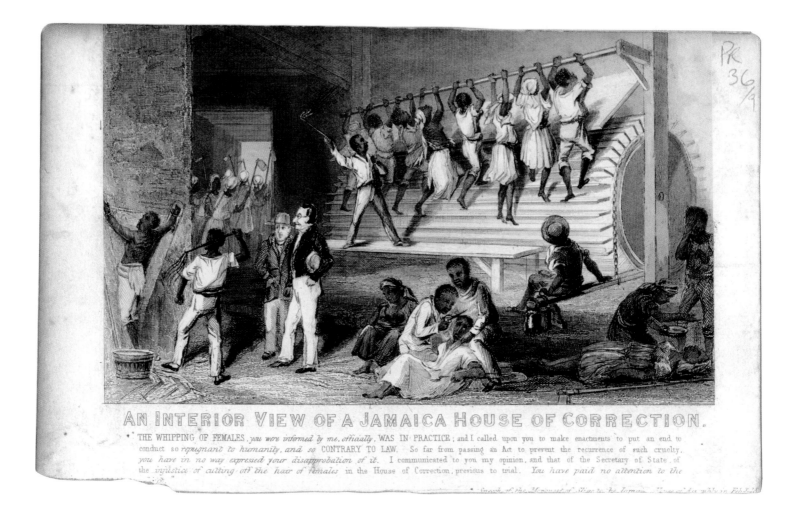

AN INTERIOR VIEW OF A JAMAICA HOUSE OF CORRECTION.

* THE WHIPPING OF FEMALES, *you were informed by me, officially,* WAS IN PRACTICE; and I called upon you to make enactments to put an end to conduct *so repugnant to humanity,* and *so* CONTRARY TO LAW. So far from passing an Act to prevent the recurrence of such cruelty, *you have in no way expressed your disapprobation of it.* I communicated to you my opinion, and that of the Secretary of State, of the *injustice of cutting off the hair of females* in the House of Correction, previous to trial. You have paid no attention to the

Fig.3: *An interior view of a Jamaica house of correction, c.*1834 (Cat.409) ZBA2546.

much more complex and varied than we might imagine at first glance, developing into an unusually effective means of delivering massive volumes of produce for the consumers of Europe and America.[5] Slavery quickly moved out from the plantations to take up residence in towns and cities, becoming a ubiquitous institution across the Americas and beyond. Africans worked as slaves in Britain and we even find slaves employed on slave ships, where they were especially useful as interpreters. Not surprisingly, slaves and freed slaves were found in port communities throughout the Americas and Europe.

Mass consumption and the rise of the plantation economy

If a single commodity was responsible for this enforced migration of millions of Africans to the Americas it was sugar. Sugar cane was not indigenous to the Americas but, like so many forms of flora and fauna, it was imported in the wake of the European invasions. Sugar cane, a tropical plant originally native to South and East Asia, had long been grown in the Mediterranean, to satisfy the sweet taste of Europe's elites. The expansion of the Ottoman Empire severely restricted the supply of Mediterranean

sugar to Northern Europe; instead as Europe expanded westward, from the fifteenth century onwards, new lands were conquered where sugar could be cultivated. First in the Atlantic islands of Madeira and the Canaries, then in the small islands off the coast of West Africa, Europeans began to grow cane, using the plantation system already employed so effectively in the Mediterranean.

The real breakthrough came with the opening of the first Brazilian cane fields at the beginning of the sixteenth century. Even in their crude, early form, sugar plantations were labour-intensive and the indigenous and European settler workforce was never numerous enough to satisfy the voracious needs of expansion. Gradually, Europeans turned to Africa for labour and imported Africans as slaves, repeating the pattern established in the Atlantic islands and Portugal. What rapidly fell into place was a formula soon to be replicated across the Americas: land was seized from indigenous populations, turned over to plantation agriculture and worked exhaustively by African slaves. By the late sixteenth century, Portuguese Brazil began to prosper. In 1600, perhaps 15,000 Africans toiled in the country, producing some 16,000 tons of sugar from the hundreds of plantations and mills that were located throughout its many rural settlements. Over the next 50 years, another 200,000 Africans arrived, their efforts yielding more and more sugar for European markets.[6]

Sugar, this once rare, costly and inaccessible product became a vital ingredient of daily life for millions of people on both sides of the Atlantic by the late seventeenth century. Europeans and Americans had acquired an irresistible taste for sweet things. Indeed, all the major hot drinks discovered in the age of European expansion (tea from China, coffee from Arabia, and chocolate from Mexico) were naturally bitter and were never sweetened in their places of origin. Europeans added sugar to all of them. This was only made possible by the sweat of African slaves, first in Brazil, later in the West Indian islands. The first crops of Brazilian sugar were easily shipped back to Portuguese markets thanks to direct and relatively fast sea routes, aided by currents and winds. Quickly established as a fashionable taste among Europe's elites, sugar consumption spilled out from the world of privilege to become a daily item of consumption among humble people everywhere. In the first instance, it was adopted by the socially ambitious, the rising middle classes, who were keen to confirm their status by adopting the habits of the elite. Thereafter, it spread down the social scale, adopted first by servants, who saw their employers enjoying tea and coffee with sugar, tried it for themselves, and then quickly passed on the habit to families, neighbours and friends. In addition, sugar – along with tobacco – was also propelled to popularity by being adopted as a medicine. Both sugar and tobacco were basic items on the shelves of all good apothecaries by the mid-seventeenth century.

The rise of tea-drinking was a major factor in the irresistible growth in sugar consumption. China tea, imported by the East India Company and liberally sweetened with sugar from the West Indies, had become a hugely popular beverage in Britain and America by the late 1600s. With a booming demand for sugar and an expanding supply from the plantations, its cost fell by a half during the seventeenth century and fell by another third in the next 50 years. The cheaper it became, the more each person

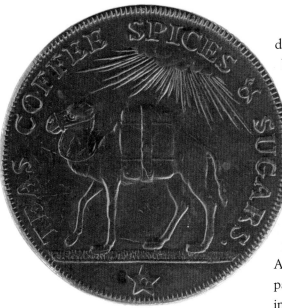

Fig.4: Grocer's token – penny, 1794
(Cat.64) ZBA2804.

devoured. In 1650, the English consumed about two pounds of sugar a year per head; by 1700 that had risen to five pounds; and by the 1790s it stood at a staggering 20 pounds. This explosive growth paralleled the equally massive expansion in the consumption of tea: the East India Company imported 9 million pounds of tea to Britain in the 1720s and by the 1750s it had increased to 37 million pounds.

Raw sugar poured into British and American ports in amazing volumes. By 1700, 23,000 tons landed in Britain. A century later, sugar imports had increased more than tenfold to 245,000 tons. Port facilities everywhere expanded to cope with the sugar-based West India trade. Sugar refineries were a common feature on the skyline of major ports (there were 80 in London alone by 1750), helping to process the hogsheads (casks) of wet sugar that had pitched their way across the Atlantic from Barbados, Jamaica and the smaller Caribbean islands. From there it passed through the hands of peddlers and hawkers, to market stalls and, most important of all, to the rapidly expanding number of shops whose prime purpose was to sell tropical produce to the consuming public.[7]

The story of tobacco followed a similar trajectory. By the eighteenth century, Americans were consuming over five pounds of tobacco per head. Who could have dreamt that this strange weed, discovered among the Native American peoples, would within a century become the addiction of millions? Once again, it did so thanks to African slaves. Soon after the first Spanish encounters in the Americas, tobacco travelled to Europe with Spanish sailors. But pipe-smoking soon broke free from dockside communities, spreading like other exotic habits, first to Europe's wealthy elites. It was, again, driven forward by medical advice; like sugar, it became a favourite medicine of doctors and apothecaries for tackling a host of ailments. The smoking habit took hold, especially among the Dutch in their great Golden Age of commercial and cultural splendour. Tobacco was both medicine and addiction but it was also increasingly regarded by the upper and middling sorts as a masculine habit. By the early eighteenth century, society frowned upon women smokers, of whom there were many among the lower orders. In contrast, men of all social classes were won over by tobacco. They smoked it everywhere: in taverns and coffee shops, at work and at rest. Tobacco was used to pacify shackled Africans aboard the Atlantic slave ships, and it was (as it still is) the lubricant of social life among the military. Throughout much of the era of slavery however, smoking was widespread, among men, black and white, rich and poor. It had passed from the simple (often religious) ritual of Native American peoples to the daily habit of men in all corners of the world; from the taverns of Philadelphia and London, to the bivouacs of the American frontier, to the seaborne squalor of the slave ships.

The end of slavery in the Anglo-American world

Although demand for African labour grew strongly, some plantations became self-sufficient in slaves. By the mid-eighteenth century, for example, the local slave population in North America began to increase of its own accord. It no longer needed

imports of Africans and henceforth slave owners could acquire new slaves by turning to American slave traders who bought their human commerce from existing American slave communities. But the overall appetite for imported Africans across the enslaved Americas seemed insatiable and continued until the 1860s, despite the Anglo-American abolition of their slave trades in 1807–8.

The British, the greatest slave traders of the eighteenth century, became the most zealous abolitionists of the nineteenth, taking every opportunity to proclaim their national virtue. They did so with scarcely a hint of the irony that Britain had previously been responsible for delivering more Africans into the Americas than any other nation. The United States perpetuated an even greater irony, joining the nineteenth-century anti-slave-trade patrols at sea, while slavery still thrived in the American South. The revolution in American cotton cultivation and in British spinning and weaving technology saw the proliferation of new plantations across the South. It was a form of plantation slavery that differed from the systems employed in sugar, tobacco and rice but, like the others, it was rooted in a denial of freedom and secured by brutality. After 1800, however, American slavery did not need the Atlantic slave trade. The human traffic feeding the cotton plantations in the South was internal, and African-American peoples found themselves forcibly displaced and separated from established families and communities in America rather than from places of origin in Africa. Even without the Atlantic slave trade there was a massive increase in the number of slaves in the United States, from 697,897 in 1790 to almost 4 million on the eve of the Civil War.[8]

At the heart of North American society was an obvious paradox, which troubled Americans for years. The men of the American Enlightenment, who directed both the struggle for independence and shaped the republic, were acutely aware of the contradiction of tolerating slavery at the heart of the world's first major democracy. Many of the Founding Fathers were slave holders and although there had been expressions of ethical and religious scruples about African slavery from the early years of European settlement in the Americas, they were simply rendered inaudible by the clink of money. At every point in the development and spread of slavery across the face of the settled Americas, a similar pattern emerged, as moral doubts were stifled by economic self-interest.

The culture of slavery in the American South served to distance the slave states from the North, creating a political and cultural divide that ultimately produced the catastrophe of the Civil War. The British, for their part, ended their massive slave system peacefully in 1834–8, although not without earlier slave uprisings and at great profit to the compensated planters. The British took enormous pride in the way they brought about and managed black freedom. Yet it is now clear that they no longer needed slavery. They had turned to new systems of labour and production that were inspired by a freer trade in commodities, produce and labour. But the British also shared the American contradiction of the years 1800 to 1860, because the cotton flooding through Liverpool was slave-grown. So too was other imported tropical produce, notably sugar and tobacco from Brazil and Cuba. And in any case the British had devised a new kind of unfree workforce for their colonies, indentured labour from

LAND AND NEGROES
FOR SALE!!

Jno. Ingram, adm'r. vs. Lydia Ingram and others.

IN pursuance to an order made in the above cause, at the March Term, 1855, of the Chancery Court at Jackson, I shall on

MONDAY THE 18TH OF JUNE NEXT,

in the town of Denmark, before the door of Merriwether's Tavern, offer for sale the following tracts of land and negroes, to-wit:

$100 \frac{114}{160}$ acres, conveyed to Jno. Ingram by Mrs. Mary Smith, lying in Madison county——on Big Black Creek.

113 acres, conveyed to Jno. Ingram by Jno. Cook, lying in Haywood county——Range 4, Sec. 6.

The remainder of the $23 \frac{24}{100}$ acre tract, after dower taken off——conveyed to Jno. Ingram by A. G. Welcher, lying in Denmark.

$2 \frac{15}{160}$ acre lot in Denmark, conveyed to Jno. Ingram by A. Skillon. + one lot in Mistinaula

Frederick, aged about	50	years,		
Susan,	"	"	25	"
Wesley,	"	"	10	"
Elijah,	"	"	16	"

TERMS OF SALE.

On a credit of 12 months, with bond and good security required and a lien retained.

Sale to commence between 10 and 11 o'clock, A. M.

THOS. CLARK, C. & M.

May 16, 1855.

India, which gave the appearance of freedom while providing all the economic benefits of slavery. Throughout the nineteenth century and into the twentieth (Indian indentured labour was not officially ended until 1920), the British continued to display to the world their characteristic blend of high moral principle and low economic cunning.

Opposite: Fig.5: Land and Negroes for sale!!, 1855 (Cat.231) ZBA2707.

* * * * *

Slavery brought prosperity; except, of course, to the slaves. Look at those who prospered and how they demonstrated their wealth: the planters' great houses scattered across the islands of the Caribbean; the mansions of cotton traders and planters on the bluffs at Natchez; those elegant town houses in New Orleans and Mobile; and the many 'stately homes' in rural Britain, or the merchants' town houses in London, Bristol or Liverpool. But by the twentieth century, few in the West would stand up publicly and argue the case for slavery. The West had changed: it now regarded slavery as the most inhumane of institutions. It was universally denounced and was viewed, by the late nineteenth century, as a reminder of a wicked past, or an indication of what more 'primitive' peoples continued to practise, notably in Arabia and Africa. Yet Atlantic slavery had been devised and perfected by Europeans – at the cost of millions of blighted African lives, to say nothing of the consequent damage to Africa itself – and all for the economic betterment of settlers in the Americas and for their European homelands.

NOTES

1 For a fuller discussion, see Philip D. Morgan 'The black experience in the British empire, 1680–1810', in P.J. Marshall (ed.), *The Oxford History of the British Empire, Volume II: The Eighteenth Century* (Oxford, 1998), pp 465–86.

2 David Eltis, 'The volume and structure of the transatlantic slave trade: a reassessment', *William and Mary Quarterly*, 58, 1 (2001), p.43, table 1.

3 David Eltis, Stephen D. Behrendt, David Richardson, and Herbert S. Klein (eds), *The Trans-Atlantic Slave Trade: A Database on CD-ROM* (Cambridge, 1999). This data is currently being updated for re-publication.

4 See also Chapter 3, pp 42–7.

5 See also Chapter 4, pp 52–5.

6 For sugar production, see James Walvin, *Atlas of Slavery* (Harlow, 2005), pp 31–5.

7 For details of the import/export data, see Andrew N. Porter (ed.), *Atlas of British Overseas Expansion* (London, 1991), sections 44–50.

8 Peter Kolchin, *American Slavery, 1619–1877* (New York, 1993), p.242.

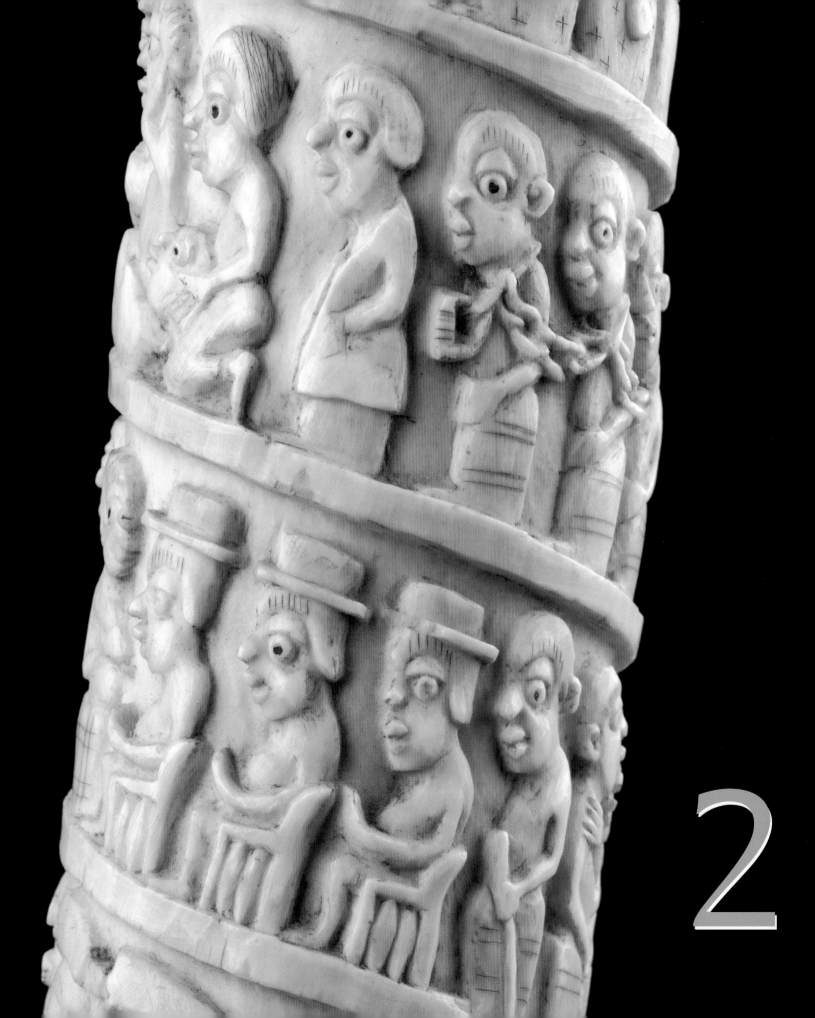

2

SLAVERY, THE SLAVE TRADE AND AFRICAN SOCIETY

PAUL E. LOVEJOY

THE HISTORY OF SLAVERY IN AFRICA is as complex as the history of Africa itself. Slavery and Africa are usually associated with the enforced migration of enslaved Africans to the Americas via the notorious Middle Passage and their life in bondage, typically on sugar plantations in the Caribbean. Of the estimated 12 million Africans sent to the Americas from the sixteenth to the nineteenth century, the largest number of slaves was taken in the eighteenth and first half of the nineteenth centuries.[1] Yet slavery was a historical reality of the African past and its longevity in Africa also reflects its omnipresence around the world. The purpose of this essay is to examine the impact of this enforced migration of the enslaved on the African societies from which they were taken and on those territories through which they passed on the way to the coastal ports from which they were shipped to the Americas. In addition, this overview aims to demonstrate that slavery was common in many parts of Africa, with most slaves remaining there rather than being exported either to the Americas, or elsewhere, such as across the Sahara and the Indian Ocean to other parts of the world.

The trade throughout Africa was continuous from the sixteenth to the nineteenth centuries, based on historic patterns that were well established. In the nineteenth century, however, there was a great expansion in the numbers of enslaved people sent to North Africa, the Middle East and the Indian Ocean. Thus at the time when the transatlantic slave trade was being undermined, the trade in slaves elsewhere continued, probably on unprecedented levels. It is important to recognise that slavery and society were closely associated in many parts of Africa even before the era of the transatlantic slave trade, for reasons that were indigenous and had little if any connection with the Atlantic world.[2] Without such a widespread system it would have been impossible to secure the millions of Africans who were deported. The European transatlantic trade exploited this system, but European and American abolition merely refocused rather than ended it.

The Islamic slave trade

Slavery was ubiquitous in areas where Islam was to be found. It was sanctioned under Islamic law and slaves were common in Muslim countries and societies everywhere, from sub-Saharan Africa to south-east Asia, as well as in Morocco and the Ottoman domains of North Africa and the Middle East. Islamic slavery therefore not only

survived the termination of the transatlantic trade but lasted in many parts of Africa well into the twentieth century: indeed it still exists today in some places.

One fundamental distinction separates those parts of Africa where Islam has been important and those isolated from Muslim influence. This difference is significant in terms of understanding both the historical role of slavery in African societies and the contemporary significance of the political and social legacies of slavery. According to Islamic law, and reflected in practice in areas where Muslims were to be found, it was illegal to sell Muslims to non-Muslims, especially to Christians. While such prohibitions were difficult to enforce, it is also clear that in places where Muslim merchants were active, these restrictions interfered with the sale of slaves but not their purchase by Muslims. How slaves were supposed to be treated was enshrined in Islamic law and was associated with conversion and acculturation. In areas where Muslims were not found, however, or where their role was minimal, there were no such restrictions on the sale of slaves. Consequently the overwhelming majority of enslaved Africans who were sent to the Americas came from coastal West Africa and especially from the region of modern Angola and Congo.

The areas where Islam was a factor in government and society included the savanna and Sahel (desert) region that stretches from Senegal to the Red Sea, as well as along the East African coast. Areas that were isolated from the Muslim presence included the region along the Atlantic coast south of Sierra Leone and the vast interior of the Congo River basin. These areas had little, if any, contact with Muslims at the time Europeans first sailed down the African coast in the fifteenth century, although by the nineteenth century Muslims were common at most of the coastal towns west of the Niger Delta. Portuguese, English, Dutch, French, and indeed Danish and Norwegian intrusion provided access to an alternate world system that derived from Europe and the Americas, and which developed on the periphery of the regions under Islamic influence.

The European slave trade

European influence was particularly strong in the Kingdom of Kongo (to use the original spelling), which became Christian in the sixteenth century, while African states founded in the seventeenth and eighteenth centuries (such as Oyo, Dahomey, Akwamu and Asante) dominated a stretch of coast west of the Niger Delta as far as Cape Lahou in modern Côte d'Ivoire. Similarly, the Guinea coast south of the Gambia had links around the Atlantic, not across the Sahara, Red Sea or the Indian Ocean, and in this region a coastal mulatto (mixed race) population was important in trade and society. Because of the Atlantic orientation of the towns, states, and peoples along the Guinea coast, the relationship between slavery and society in these places was different from that in Muslim areas, although in both cases slavery was important.

There were many states along the West African littoral and numerous trade routes connected the towns and ports on the coast to the interior. Around the Bight of

Fig.6: Gabriel Bray, *The Kroomen of Sierra Leone*, 1775 (Cat.327) PAJ2038.

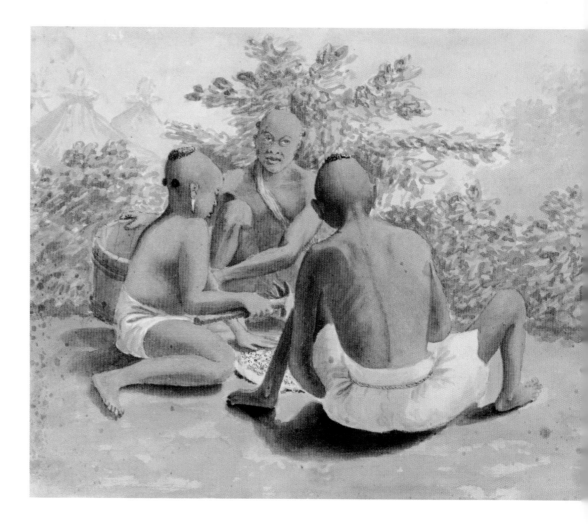

Opposite: Fig.7: Loango Tusk, 19th century (Cat.91) ZBA2430.

Benin, from the mouth of the Volta River as far as the Niger Delta, a series of lagoons and lakes allowed transportation by boat on these calm waters rather than along the coast itself. Kru mariners worked the coast of modern Liberia, first in their own small fishing craft and then as sailors on European ships, so that the shore of West Africa as far south as Angola specialised in trade and servicing trade.[3]

Coastal towns and villages sent fish and salt into the interior as part of regional patterns of trade and provisioning. As already suggested, there were significant differences in the cultural and political landscape of Africa in the period of transatlantic slavery and the dichotomy between Muslim and non-Muslim regions was pronounced. Beyond this distinction between the Muslim interior of West Africa and the coastal zone, however, there was a division between West Africa and the region of west-central Africa, which was divided between the Kingdom of Kongo and the Portuguese colony of Angola (and includes modern Congo and Angola). Historically, moreover, the Kingdom of Kongo and Angola were the source of almost half of all Africans sent to the Americas as slaves, because slaves either came from these places or passed through their ports from the interior. Because of the sheer numbers involved in this forced migration, a brief history of Kongo and Angola is necessary.

Kongo and Angola

The Kingdom of Kongo predated the arrival of Europeans. The Portuguese first established diplomatic relations and then commercial links with it in the early sixteenth century, and from this time, Kongo undertook an aggressive programme of Christianisation. At the end of the sixteenth century, the Portuguese established a permanent settlement at Luanda, to the south of Kongo, and this formed the basis of colonial expansion and the emergence of Angola as the principal source of slaves for Brazil. Indeed, the Portuguese link across the south Atlantic between Angola and Brazil was very strong from the end of the sixteenth century until the end of their slave trade in the 1860s. The Portuguese established forts at Benguela in southern Angola and elsewhere along the coast and at strategic points in the interior. Portuguese colonial troops and merchants (many of whom were mulatto and included adventurers from Brazil and Portugal) formed alliances with the small, independent states to the south and east of Kongo.[4] Slaves were gathered for export to the Americas through raiding and the payment of enforced tribute. Brazil received about 45 per cent of all Africans who were sent to the Americas as slaves, and a very large proportion came from Kongo, Angola and the interior. This region was such an important source of slaves that the Dutch seized the Portuguese possessions for a period in the seventeenth century, and thereafter Dutch, British and French slavers operated on the coast north of the Congo River, but to some extent drawing on the same interior regions.

The impact of the slave trade and slavery on the region of west central Africa that includes Angola, Congo, and the areas of Gabon and Cabinda to the north of the Congo River was severe and long lasting. Demographically, large parts of this region may have experienced a net loss of population as a result of slavery and the destruction and famines associated with slave raiding, war and the enforced collection of tribute. Culturally, the region had strong internal similarities: the Bantu cluster of African languages were closely related, so that it was easy to learn other languages, the similarities being analogous to those among French, Italian, Spanish and Portuguese. As is evident in the sculpture and ivory carvings from this area, craft specialisation and artistic traditions were well developed, and often associated with religious practices that were transferred and translated to the African societies that developed under slavery in the Americas. The tradition of Capoeira – a martial art and associated music and rituals that became popular in Brazil and then spread elsewhere – derives from antecedents identified with Angola.[5] In Kongo and in the Portuguese enclaves, Christianity became well established and priests from Italy, Portugal and Spain were common in the countryside. Nonetheless, the dominant religious traditions in the interior were associated with kinship-based shrines and rituals.

The impact of slavery and the slave trade on this region was particularly severe in several distinct periods, first in the early seventeenth century when Imbangala bands of warriors raided the region south of Kongo, forming alliances with the Portuguese at Luanda and subjecting the region to a reign of terror associated with slavery and fears of cannibalism. Second, the Kingdom of Kongo experienced decades of internal strife

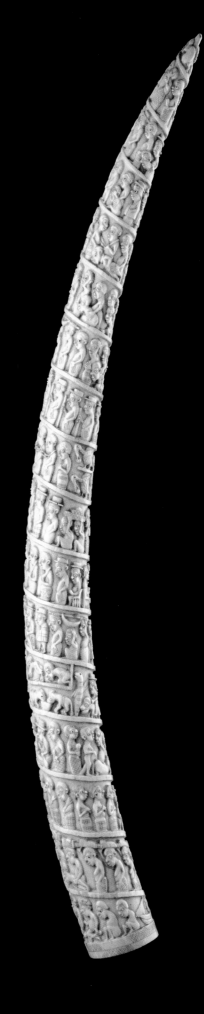

after 1660, sometimes referred to as the era of the civil wars; and while the kingdom survived, its population declined as captives were deported. One martyr was a young woman, Beatrice, who attempted to impose a peaceful solution on the wars, with the tragic consequences that she and her followers were killed or enslaved, many sent to the Americas.[6]

The Lower Guinea Coast

Along the West African coast, the transatlantic trade was closely associated with the political history of the region. Several states became the principal sources of slaves, including Oyo, Asante and Dahomey, to mention only the three most prominent. Oyo emerged as an expansive state in the seventeenth century and in the course of establishing its hegemony over the northern Yoruba and neighbouring parts of Nupe and Borgu (in present-day south-western Nigeria) began to supply slaves to the coastal ports on the lagoons of the Bight of Benin. Initially, the trade was through the state of Allada, located in the southern part of the Republic of Benin, and the port of Ouidah (Whydah), which became one of the two or three most important embarkation points on the African coast for slaves sent to the Americas.[7] The emergence of Dahomey as a militarised state after 1700 challenged the dominance of Oyo, leading to the Dahomian conquest of Allada in 1724 and Ouidah in 1727, and the Oyo invasion and subjugation of Dahomey in the 1730s. These wars and political consolidation in turn produced large numbers of slaves who were sent to the Americas, and resulted in the deaths of many people and the migration of many others. Dahomey paid tribute to Oyo but otherwise remained an autonomous state that relied on slave exports for revenue.[8]

These states emerged among peoples whose cultures were ancient and complex, as reflected in religious practices, myths, music and art. Ethnographically, the indigenous populations of Dahomey, Allada and Ouidah spoke related Gbe languages. They comprised a cluster that includes Fon, Ewe, Ga and Allada people who were sometimes identified as 'Mina' or 'Gege' in different parts of the Americas where they became concentrated. Oyo was a Yoruba state, and while it was the largest and most powerful from the second half of the seventeenth century until the 1820s, it was not the only one, others including Ijebu, Ife and Ketu. Culturally and religiously, however, the Yoruba states focused on the rituals and beliefs associated with different deities, or *orisa*, which were like the various *voodun* of the Gbe cluster of peoples. Ceremonies, masquerades, musical performance, and complex and interlocking myths were the modes of expression, in which dance and ritualised performance were fused with spirit possession.[9] Moreover, particular deities were associated with specific states, Sango, the god of thunder and fire, being the official deity of Oyo.

The music and religious traditions that underlay the political power of states and guaranteed community solidarity were transformed by the enforced migration of transatlantic slavery. Whereas the *orisa* and *voodun* were associated with political power and dominance in West Africa, the deities and the cults that survived around them

were the basis of resistance to slavery and a means of assuring cultural survival in the Americas. Visiting European slavers occasionally commented on the outer symbols and trappings of this complex religious and cultural tradition in Africa. However, in the Americas, because of the preoccupation with the fear of slave revolts, these religious and cultural practices were more visible, and became identified with Candomblé in Brazil, Santeria in Cuba and Voodoo in Haiti.[10]

The states along the Gold Coast and its hinterland were also drawn into the transatlantic slave trade. The region centred on modern Ghana was a focal point of trade because of its deposits of gold, from which the coast derives its name, and from agricultural products, especially caffeine-rich kola nuts. They were sold into the interior where there was strong demand for them, especially in Muslim areas where alcohol was prohibited. Asante emerged as the most important state in this region in the eighteenth century and in the course of its wars of expansion generated large numbers of slaves.[11] The rivalries among the various Akan states, of which Asante emerged pre-eminent, included wars fought among Denkyira, Akyem, Akwamu and Asante, and then extended to the north into Gonja, Dagomba and beyond. On the Gold Coast itself, the different European slave-trading nations established stone fortresses, often within sight of each other. The most important were at Elmina, Cape Coast and Anomabu. In all these places, African political office was reserved for those related to the royal families of the different states and towns, and was symbolised using stools. In the case of Asante, the stool of the king, the Asantehene, was made of gold.[12]

The Bight of Biafra became a major source of enslaved Africans in the eighteenth century. British merchants, and especially those of Liverpool and Bristol, dominated this trade, which was centred at Bonny in the Niger Delta and Old Calabar on the Cross River.[13] In the century before British abolition of the slave trade in 1807, these two ports exported almost one million people, many of whom were ethnically Igbo or Ibibio. Both ports connected with the interior through a network of trade. Unlike areas to the west and north, where cowries were used as currency, copper and brass rings in the form of bracelets (known as manillas) were used, and these were imported from Britain.

Besides the use of manillas as money, the metal was melted down for use in sculpture and jewellery for internal trade. This region was governed by secret societies of individuals who had been able to acquire titles and positions that derived from success in trade, craft production or agriculture. The Ekpe society, which was devoted to the leopard, was particularly powerful, and its colourful masquerades were associated with the maintenance of public order.[14]

The internal African slave trade

Most of the enslaved Africans who were destined for the Americas came from the regions along the Atlantic coast or from the immediate interior in areas beyond Muslim influence, although Muslim traders were active in many parts of West Africa. Slaves in

Muslim regions tended to be kept locally or sold across the Sahara rather than being sent to the Atlantic coast. This created the dichotomy between areas that were pulled into an Atlantic orbit tied to transatlantic slavery, and the regions in the interior that tended to be associated with the Islamic world. In Senegambia, however, the two regions overlapped. Moreover, slaves were also common in many parts of Africa that were not exposed to Muslim influence.[15]

Slavery in Africa was linked to the history of the expansion and decline of states, and the consolidation of political and religious institutions that regulated trade and society. Enslavement, or the threat of enslavement, was common: political prisoners, alleged criminals and social deviants were all subjected to slavery as a mechanism of punishment, social control and economic profit. Because of the insecurity arising from the dangers of enslavement, people relied on kinship structures that were reinforced to provide protection and, potentially, to secure freedom for anyone seized or otherwise held in captivity. The investment in kinship structures was achieved in a variety of ways: from the use of facial and body scarification, devotion to religious shrines, the use of protective devices such as amulets, and the contracts associated with marital arrangements. The transatlantic demand for enslaved Africans exacerbated tensions within Africa, straining kinship structures and encouraging political aggression, which in turn influenced the forms and extent of enslavement for religious, judicial and other reasons. Where political and judicial structures were weak or corrupt, people were not protected with the result that kidnapping, 'panyarring' and 'illegal' forms of enslavement increased. These expanded the numbers of individuals reduced to the

condition of slavery, which meant that they could be sold and would not be redeemed or ransomed.

The trade in slaves within Africa was closely integrated with long-distance trade in general. The Muslim states in the interior and the states near the coast appointed officials to oversee trade, conduct marketing on behalf of the state, and otherwise intervene in the export of slaves through collection of taxes, duties, payments for specific services, and bribes. The aim of merchants who provided the African agency in the slave trade to the Americas was the same as that of their European counterparts – the quest for profits. An effort to benefit from slavery is not surprising. Logically, where slavery exists, there is a concomitant trade in slaves – as commodities – and this is clearly demonstrated in the historical record as far as Africa is concerned. The question was not whether people would sell their 'brothers' and 'sisters' but how slavery was legitimised in the context of the times.

People sold into slavery were often enemies in war or criminals within the accepted social order and slavery, in a sense, was a justified form of punishment or banishment. From this perspective, it was easy to sell enslaved people to anyone who wanted to buy them. If those willing to buy suddenly included Portuguese and then other European merchants coming in ships to the West African coast, it made little difference. The reality of history is that the transatlantic slave trade was prompted by demand for cheap and exploitable labour, in immoral conditions of bondage. This market in human beings transformed Africa, as it did the Americas and western Europe.

Because slavery is based on coercion, it is not surprising that individuals attempted to resist when they could, or otherwise tried to reach some kind of accommodation that minimised the brutality that could be inflicted on them. Hence, in Africa, slaves ran away if they had the opportunity and were not willing to accept abuse. In some places, slaves could attach themselves to religious shrines as a means of protection, although devotion to a deity often resulted in isolation from the surrounding community, and hence this form of resistance did not lead to amelioration and integration into society, except as a religious dependant. In non-Muslim areas, slaves might be sacrificed at funerals or religious ceremonies. Victims were usually purchased specifically with this purpose in mind and war captives were also sometimes executed at public occasions. As these examples demonstrate, shipment to the Americas was only one possible fate for slaves and those who were deported often understood that they might well have been sold for sacrifice instead.

It was also possible for slaves and potential slaves to redeem their liberty. Consider Muslim areas, where individuals were protected from enslavement if they were identified as Muslims. This was easy enough; all that was required was the fluency to recite prayers in Arabic. A willingness to work with the enslavers could lead to assimilation and success, as in the case of the Agalawa and Tokarawa, descendents of Tuareg slaves, who became successful Hausa merchants, operating especially from the city of Kano, and still dominate its commerce and banking today. Similarly, in the Bight of Biafra, individuals of servile background could become major businessmen and officials, as in the cases of Eyo Honesty at Calabar and Jaja at Bonny. Indeed, as the

Ghanaian historian, John Fynn, has noted, it is sometimes difficult to ascertain whether a specific individual is descended from slaves or officials, because everyone faced the possibility of enslavement during the wars that resulted in the consolidation of Asante, and ultimately led to British conquest.[16]

* * * * *

How the legacy of slavery has affected African societies is a complicated issue. It has undoubtedly had an impact on how history is understood and reinterpreted in contemporary political contexts. This applies both in the countries of the diaspora, where enslaved Africans were sent, and in the continental homelands which were transformed by the enforced migration of people across the Atlantic, the Sahara and the Indian Ocean. How the internal use of slaves within Africa altered the course of history has also altered perspectives. The moral, legal and social issues reverberate to the present, and ultimately relate to the impact of religion, economics and kinship.

Fig.9: Carved stool, *c.*1902 (Cat.95) AAA3751.

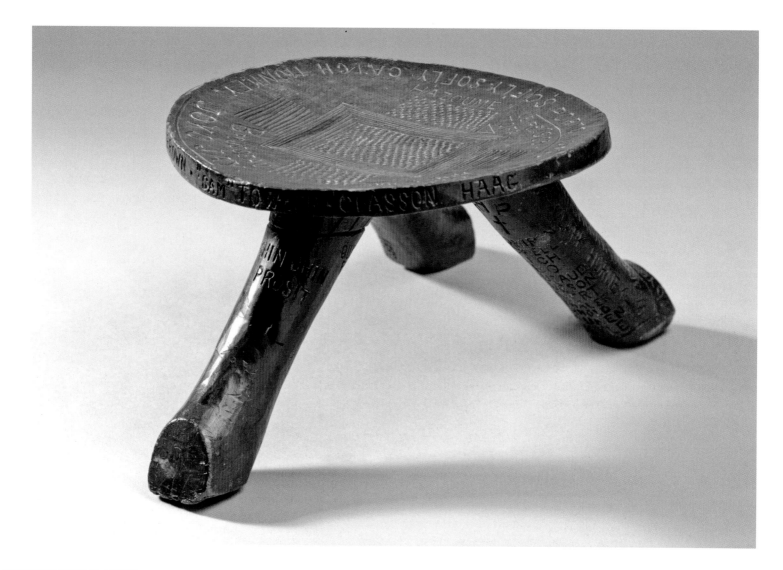

What is seen in museum exhibits and represented in this catalogue helps us to understand the complex history of slavery and its impact on African societies. Objects that were brought back to the ports of the slave trade in Britain and elsewhere were of two sorts: items of trade, such as things used as money in Africa, including cowrie shells and the manillas of copper and brass; and items of prestige and power, whether the carved three- and four-legged stools that were a symbol of political office and title, or ivory tusks, wood, or sculpture. Such objects reveal aspects of African societies, the extent of craft specialisation, the degree of aesthetic appreciation, and artistic development. What is not apparent is the close connection between these aesthetic forms and religion, especially in non-Muslim areas where shrines were widespread, and deities numerous.

NOTES

1 David Eltis, Stephen D. Behrendt, David Richardson and Herbert S. Klein (eds), *The Trans-Atlantic Slave Trade: A Database on CD-ROM* (Cambridge, 1999).

2 For an overview, see Paul E. Lovejoy, *Transformations in Slavery: A History of Slavery in Africa* (Cambridge, 2nd edn, 2000).

3 George E. Brooks, Jr., *The Kru Mariner in the Nineteenth Century: An Historical Compendium* (Newark, Delaware, 1972).

4 Joseph C. Miller, *Way of Death: Merchant Capitalism and the Angolan Slave Trade, 1730–1830* (Madison, Wisconsin, 1988); and John Thornton, *The Kingdom of Kongo: Civil War and Transition, 1641–1718* (Madison, Wisconsin, 1983).

5 Carlos Eugênio Líbano Soares, *A capoeira escrava e outras tradições rebeldes no Rio de Janeiro (1808–1850)* (Campinas, 2001).

6 Thornton, *Kingdom of Kongo*; and John Thornton, *The Kongolese Saint Anthony: Dona Beatriz Kimpa Vita and the Antonian Movement, 1684–1706* (Cambridge, 1998).

7 Robin Law, *The Slave Coast of West Africa 1550–1750* (Oxford, 1991).

8 For the Bight of Benin and its interior, see especially Law, *The Slave Coast of West Africa* and Toyin Falola and Matt D. Childs (eds), *The Yoruba Diaspora in the Atlantic World* (Bloomington, Indiana, 2004).

9 Andrew Apter, 'The historiography of Yoruba myth and ritual', *History in Africa*, 14 (1987), pp 1–25.

10 Falola and Childs (eds), *The Yoruba Diaspora*.

11 Edmund Abaka, *'Kola is God's Gift': Agricultural Production, Export Initiatives and the Kola Industry in Asante and the Gold Coast* (Athens, Ohio, 2005).

12 Ivor Wilks, *Forests of Gold: Essays on the Akan and the Kingdom of Asante* (Athens, Ohio, 1993).

13 Paul E. Lovejoy and David Richardson, 'Trust, pawnship and Atlantic history: the institutional foundations of the Old Calabar slave trade', *American Historical Review*, 104, 2 (1999), pp 332–55; and Lovejoy and Richardson, '"This horrid hole": royal authority, commerce and credit at Bonny, 1690–1840', *Journal of African History*, 45, 3 (2003), pp 363–92.

14 E.J. Alagoa, *A History of the Niger Delta* (Ibadan, 1972); and Carolyn Brown, Paul E. Lovejoy and Renée Soulodre-La France (eds), *Repercussions of the Atlantic Slave Trade: The Interior of the Bight of Biafra and the African Diaspora* (Trenton, New Jersey, n.d.)

15 Paul E. Lovejoy, 'Internal markets or an Atlantic-Sahara divide? How women fit into the slave trade of West Africa', in Gwyn Campbell, Suzanne Miers and Joseph C. Miller (eds), *Women and Slavery* (Athens, Ohio, 2007).

16 John Fynn in 'The African Trade', *Timewatch*, BBC Productions, 1997.

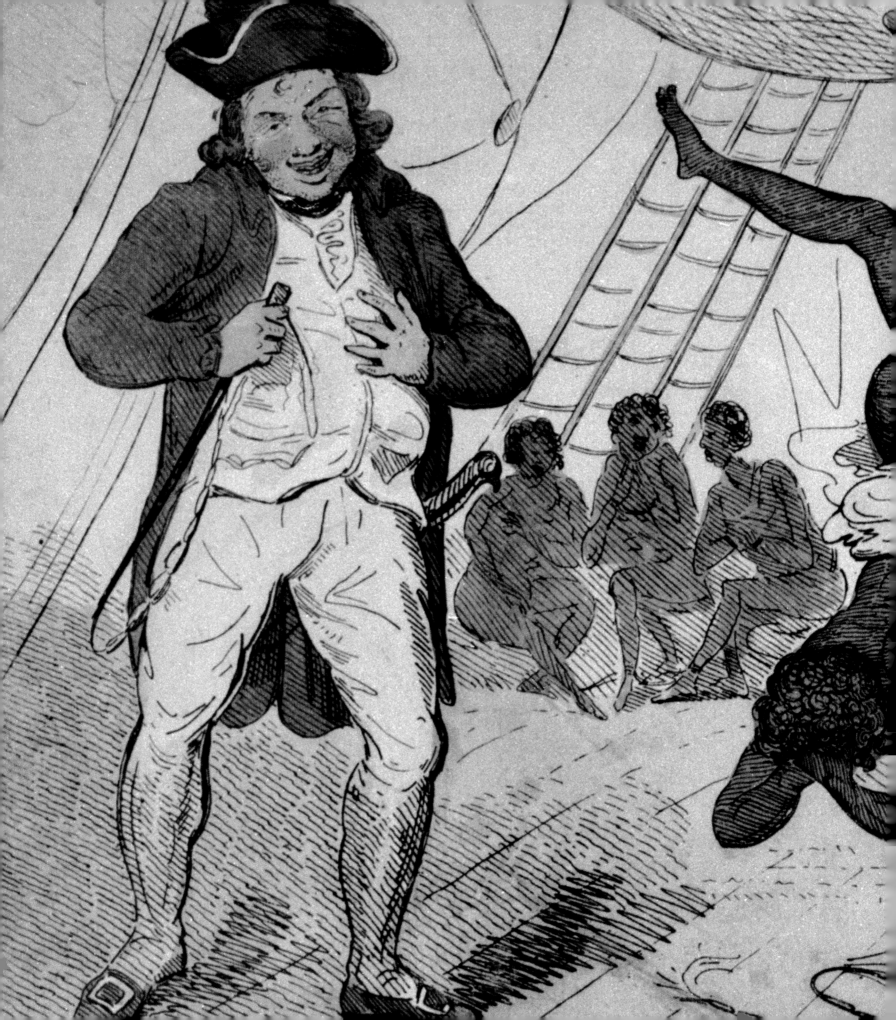

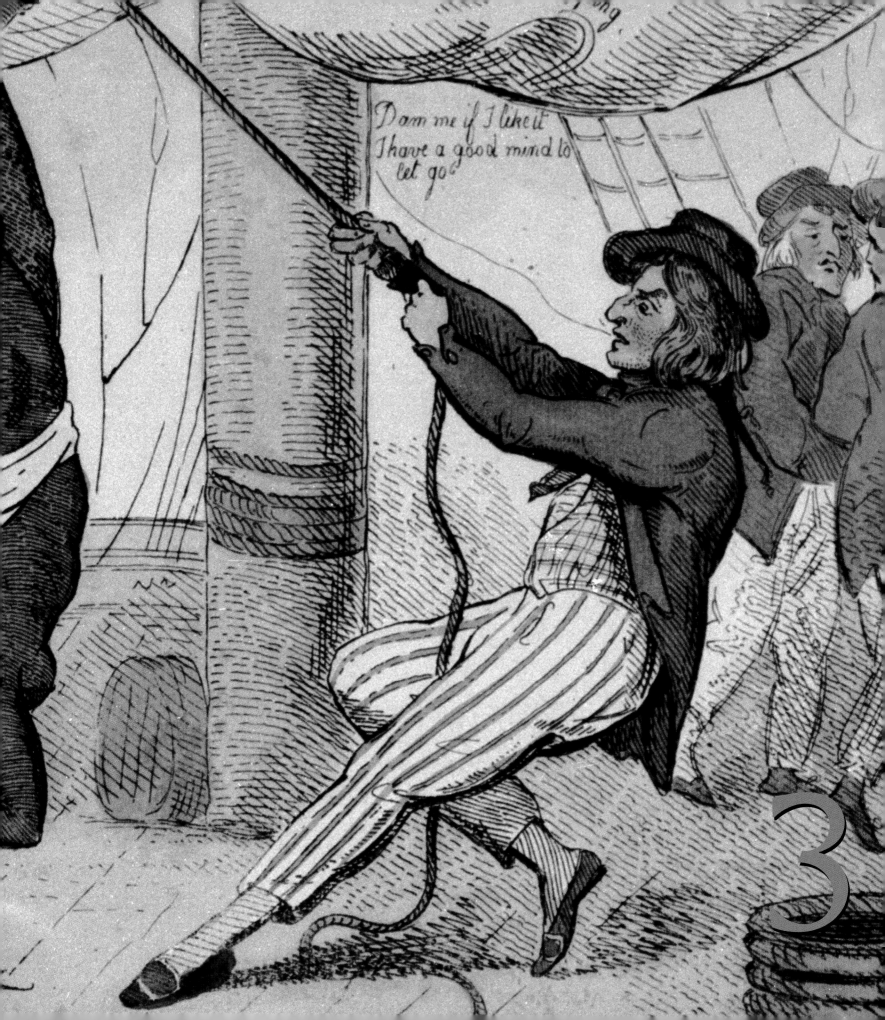

Through African Eyes: the Middle Passage and the British Slave Trade

David Richardson

EVER SINCE ABOLITIONISTS in the 1780s alerted contemporaries to the intensity with which enslaved Africans were packed on board ship and the levels of their mortality in transit, the Atlantic crossing or 'Middle Passage' has served as a metaphor for the horrors of the slave trade. Although some merchants testifying to Parliamentary inquiries into the slave trade in 1788–90 calculated how restrictions on loading rates of slaves on board ship might affect voyage profits, other witnesses, including several ships' surgeons, focused on shipboard conditions and the treatment of slaves. In this they remind us, as one historian has remarked, that the Middle Passage is properly 'considered in terms other than economic'.[1]

Unfortunately, none of the witnesses to Parliament was African. Sadly, too, many of the narratives of the slave trade left by its victims are largely silent on the Atlantic crossing.[2] There is, however, one narrative – that of Olaudah Equiano or Gustavus Vassa, 'the African', published in 1789 – which reports in detail the alleged experiences of the Middle Passage by one of the enslaved.[3] Some caution is needed in using Equiano's narrative. For one thing, his claim to have been born in Africa, and specifically Igboland in the interior of the Bight of Biafra, has been openly challenged; and while it remains disputed, it questions the suggestion that his story of the crossing was one based on personal experience.[4] Furthermore, even if it was a reflection of personal experience, Equiano's commitment to the abolitionist cause makes his comments on the Middle Passage open to charges of exaggeration. His commentary on his alleged crossing is, moreover, unspecific about the number of slaves on board ship, their foodstuffs, health and mortality, and the length of the crossing, all issues that have dominated historical research in this area. Even with these qualifications, Equiano's *Narrative* remains almost alone among contemporary writings in providing a perspective on the Middle Passage from someone of African descent. His observations on it also provide a platform for quantitative investigation of some aspects of the trauma experienced by Africans in the ocean voyage to America. Many aspects of that experience remain, of course, beyond quantification and can barely be imagined over two centuries later.

Opposite: Fig.10: Daniel Orme after William Denton, *Olaudah Equiano, or Gustavus Vassa, the African*, 1789 (Cat.565) ZBA2657.

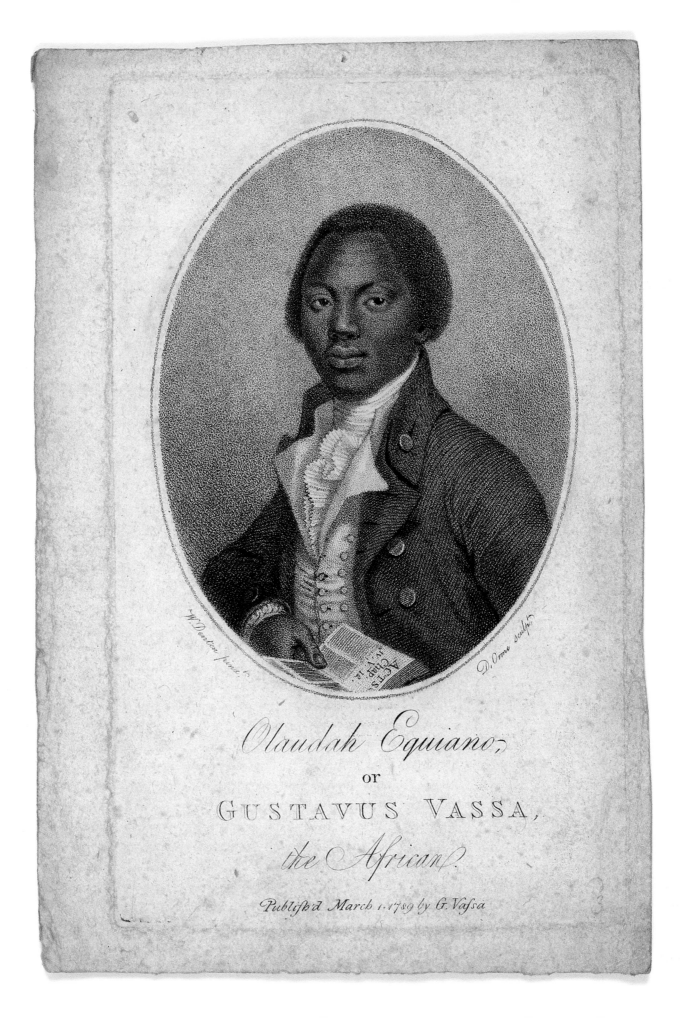

Olaudah Equiano,

or

GUSTAVUS VASSA,

the African.

Publish'd March 1.1789 by G. Vassa

British slave ships

Ranging in size from 50 to 200 tons, most British slave ships carried probably three or more slaves per ton when they departed from Africa. Excluding those dying before ships left, the number of enslaved Africans on board at the start of the Middle Passage therefore typically varied between 150 and 600, with most ships carrying some 200 to 400 victims.[5] Compared to other contemporary or later oceanic voyages involving the movement of people, these represented exceptionally high rates of 'packing', a finding that casts doubt on the value of arguments about the impact of slave-per-ton ratios or 'tight packing' on slave mortality. It also raises questions about the efficacy of such measures as the Dolben Act of 1788, one of the first results of the abolitionist movement, which was intended to restrict the carrying capacities of ships and reduce slave mortality. Be this as it may, the shipboard transport of such concentrations of enslaved Africans demanded organisation, aspects of which were revealed by both Equiano's and other evidence, and helped to turn slave ships into what one former shipmaster called 'floating prisons'.[6] Equiano, for instance, describes how, on leaving the coast, 'we were all put under deck, so that we could not see how they managed the ship'; how slaves, notably men, were often chained; and how men tended to be held in apartments separate from the women and children.[7] Other evidence corroborates Equiano's observations but also reveals that preparations for the incarceration and management of slaves on board were well advanced long before ships reached Africa. The number of crew enlisted in Britain was specifically linked to the anticipated number of slaves to be loaded, a ratio of one crew to ten slaves being the norm. The crew normally included a surgeon, and sometimes an assistant, armed with medical supplies. Ships sailed from Britain with 'Negro provisions', principally beans and peas, as well as 'recreational' items such as tobacco and pipes. They were also usually expected to buy water and supplementary stocks of foods such as rice and yams in Africa, thus becoming 'floating' larders and reservoirs, often before loading slaves.[8] Carpenters, coopers and their assistants were normally employed en route to the coast in building slave accommodations and in preparing casks for water and latrines, or 'necessary tubs'. Routines for handling, controlling, and ultimately dehumanising enslaved Africans (described by one ship captain as 'black cattle'), while simultaneously trying to ensure their survival, had been well rehearsed on British slave ships by the time that Equiano was allegedly deported from Africa in 1750s.[9]

Mortality rates

The most quantifiable experience of enslaved Africans on board British ships – their mortality rate – has been the subject of much investigation.[10] One recently published calculation suggests that, of the 3.4 million enslaved Africans deported in British Empire ships after 1662, over 450,000, or more than one in eight, died in the Atlantic crossing.[11] Because those enslaved were predominantly aged below 30 and because the

ocean crossing normally lasted no more than three months, such losses represented an extraordinary age-specific mortality rate for such a population. It was more than equal to those experienced in mortality crises in Africa and Europe before 1800. It can thus be seen as testimony to Equiano's observation about the impact of the 'improvident avarice' of British traders on the health and mortality of the enslaved.[12] The alleged effects of such avarice, whether true or not, seem to have been tempered by various developments in medical and health practices, ship design, and other factors that contributed to a halving or more of slave mortality levels on British ships in the eighteenth century.[13] Even with these falls in mortality, however, the spectre of death continued to hang heavily over the enslaved on British ships in the late eighteenth century, most ship owners or regulators of British ships assuming some loss of slaves in transit as being inevitable. The Dolben Act, for example, allowed the payment of bonuses to shipmasters and surgeons where losses of slaves were less than three per cent of those shipped. Only a tiny minority of ships seems to have reached the Americas without any loss of life, while 20 per cent or more of the enslaved on perhaps one in ten of British ships died during the Atlantic crossing in the period 1751–1800. Disproportionately represented among the latter were ships that, like the one carrying Equiano, traded to the Bight of Biafra. Though the pattern varied from one Biafran port to another, British ships leaving this region tended to lose, on average, some 15 to 20 per cent of their human cargo in the late eighteenth century, or twice as many as those leaving other parts of Africa. The reasons for this are still unclear but in observing that 'sickness among the slaves, of which many died' occurred on the ship that carried him away, Equiano was reflecting a common African experience on British ships leaving the Bight of Biafra.[14] Sadly, he was also reflecting an only moderately less common experience of enslaved Africans on British ships generally, especially before 1750.

The enslaved who died in the Atlantic crossing were largely victims of respiratory, intestinal or epidemic diseases. Some of these were the product of conditions experienced by the enslaved before boarding ship, but shipboard conditions undoubtedly exacerbated such disorders and proved a breeding ground for additional ones. While disease was the principal killer of slaves, a small but perhaps growing proportion of shipboard deaths were caused by white action. Some slaves fell victim to international conflicts that resulted in attacks on British slave ships by enemy vessels or pirates. Though many ships were taken without slaves on board, a proportion was seized in the Atlantic crossing, with slaves sometimes being killed in the process. Other slaves were victims of behaviour by the crew of ships. Some – such as those thrown overboard by Luke Collingwood, master of the Liverpool ship, *Zong*, in 1781–2 – were victims of a mistaken assumption that insurance would compensate ship owners for slaves jettisoned during a food crisis (Cat.119).[15] Collingwood's heartless action was matched by other crew who physically abused slaves on board ship, notwithstanding instructions by ship owners banning such behaviour. Typically motivated by sex and overwhelmingly directed against female slaves, such abuse sometimes resulted in the premature death of those who sought to resist the unwanted advances of ruthless and

sadistic masters or other crew.[16] One local Bristol newspaper, for example, reported that on some ships 'the common sailors are allowed to have intercourse with such of the black women whose consent they can procure...[and] the officers are permitted to indulge their passions among them at pleasure'.[17] In 1793, during the first wave of abolitionism, John Kimber, the master of a Bristol ship, was tried for assaulting and killing a 15-year-old girl on board his ship the previous year. He was acquitted (Cat.483, Fig.11). For women, therefore, to the risk of death from disease was added rape and murder, features of female slave existence that were to continue beyond the ocean crossing.

Fig.11: Isaac Cruikshank, *The abolition of the slave trade*, 1792 (Cat.483) PAF3932.

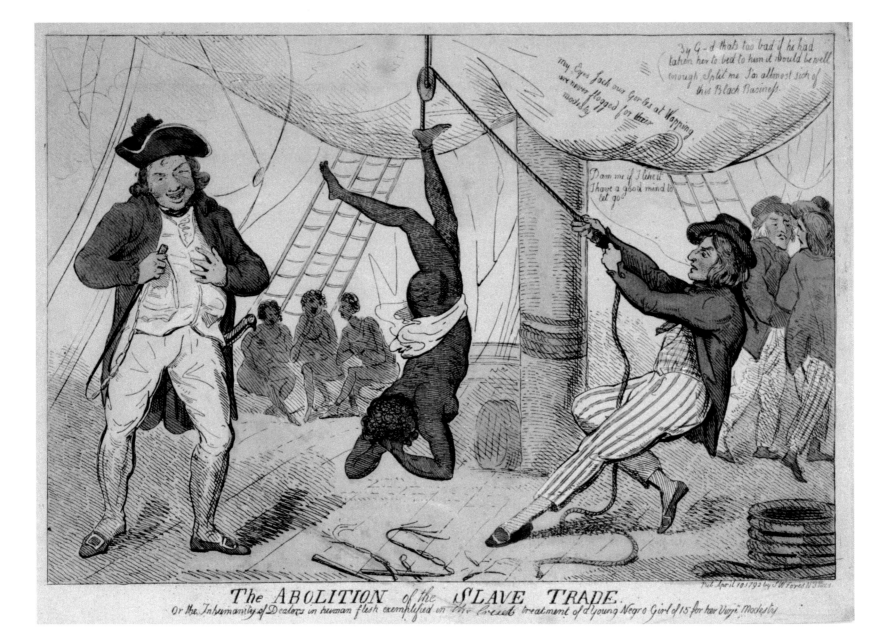

The ABOLITION of the SLAVE TRADE.
Or the Inhumanity of Dealers in human flesh exemplified in the cruel treatment of a young Negro Girl of 15 for her Virgin Modesty

Shipboard resistance

Female resistance to white abuse was one element in a spectrum of forms of opposition by enslaved Africans on board ship that, in some cases, resulted in death. Some slaves chose passive resistance, refusing, for example, food or water, a form of defiance met by force-feeding. Others resisted their enslavement by more violent and destructive means, thereby threatening the security of the voyage. Some chose suicide, a form of escape from slavery particularly identified by some contemporaries with Igbos, and therefore a not uncommon occurrence on British ships. Consistent with this belief, Equiano noted in his *Narrative* the suicide at sea of two of his 'wearied countrymen', who jumped overboard and drowned. A third failed in a similar attempt and, Equiano reports, was flogged 'unmercifully' for 'attempting to prefer death to slavery'.[18]

Suicide as a form of resistance, however, was not confined to Igbos. Nor was it the only, or even preponderant, form of resistance through violence by enslaved Africans, Igbos or otherwise, on British ships. More common, and more dangerous in terms of ship security, was armed rebellion by groups of enslaved Africans.[19] Africans united to rise up against their captors in perhaps one in ten British slaving voyages. On voyages to Senegambia and Upper Guinea, to which British traders resorted in greater numbers after 1750 than earlier, the incidence of rebellion was much higher than elsewhere. Various factors conspired to encourage slaves to rebel. Some historians suggest that the propensity for such action was greatest while ships were on the African coast and while the chance of an uprising allowing the enslaved to return to their homeland remained conceivable.[20] Such claims are, however, contradicted by evidence showing that slaves seized the opportunity to rebel wherever and whenever they were held on board ship.[21] Like the acts of suicide described by Equiano, therefore, revolts on British ships by enslaved Africans seem to have been driven, more than anything else, by an unqualified ambition for freedom from slavery or at least from enslavement by white captors. As acts of self-liberation, shipboard revolts by enslaved Africans were rarely completely successful. Most revolts were repressed, often with heavy bloodshed among both the slaves and their captors, and the ships involved went on to complete their voyages to America. Nevertheless, the fear of slave uprising remained constant among the owners and crews of British slave ships, helping to drive up the cost and thus lower the number of enslaved Africans carried to America.

* * * * *

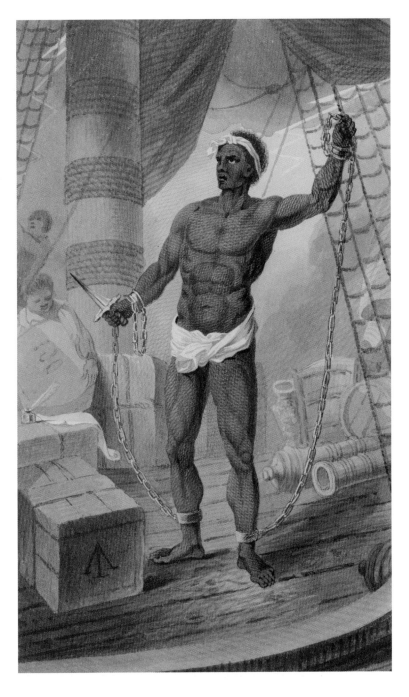

Fig.12: George Cooke, *Slave on deck*, 1801 (Cat.489) ZBA2660.

The anxiety of enslaved Africans boarding ships bound for America was frequently ascribed by contemporaries to a belief that they were to be eaten by their white captors, a sentiment bolstered by the failure of any enslaved to return home. The reality, of course, was otherwise, but methods of shipboard confinement, high mortality, unchallenged abuse, and the unceremonious way in which the deceased where thrown overboard fostered the impression that the enslaved were being consumed. This impression was further reinforced by the natural decline of slave populations in the British Caribbean in the years preceding its abolition there in 1833, a decline linked to the harshness of slave life on sugar plantations.[22] Resistance and rebellion, however, demonstrated that the spirit and humanity of enslaved Africans were not crushed by their experience of the Middle Passage or their endurance of life in the Americas. On the contrary, it is possible that erstwhile strangers among the enslaved formed bonds and new identities during the Atlantic crossing, sometimes drawing on recollections of their African homeland. Equiano, for example, claims that amongst 'the poor chained men' on board ship, he 'found some of my own nation, which in a small degree gave ease to my mind'. He also highlights the comfort he derived from the women slaves 'who used to wash and take care of me'.[23] He notes too, however, how on reaching America friends and relatives among the enslaved 'were sold in different lots' and were thus denied the solace of companionship to relieve 'the gloom of slavery'.[24] The spirit of resistance evident among the enslaved on board ship transcended the movement of Africans from ship to shore in the Americas. Whether the bonds between enslaved Africans, nurtured by memories of homeland and by the shared brutality of the Atlantic crossing, were as easily dissipated at the point of sale as Equiano's account implies, remains a more open and still highly contested question.

NOTES

1 Kenneth G. Davies, *The Royal African Company* (London, 1957), p.292.

2 Venture Smith, who was taken from Africa as a child in the 1730s, simply notes in his narrative that the ship carrying him had 'an ordinary passage, except great mortality by the small pox, which broke out on board'. *A narrative of the life and adventures of Venture, a native of Africa but resident above sixty years in the United States of America* [1798] (Middletown, Connecticut, 1897), ch.2.

3 *The interesting narrative of the life of Olaudah Equiano or Gustavus Vassa, the African, written by himself* [1789], reprinted in Vincent Carretta (ed.), *Olaudah Equiano: The Interesting Narrative and Other Writings* (London, 1995). The version included in Carretta's volume is the ninth edition, published in 1794.

4 Carretta notes, for example, that Equiano's name (or, more accurately, his adopted one of 'Gust. Vasa') appeared on the muster roll of a British ship on 1 January 1756, a year before he recounted arriving in England in the *Narrative* (Equiano, *Interesting narrative*, pp ix, 67). On doubts about Equiano's African birth, see Vincent Carretta, 'Olaudah Equiano or Gustavus Vassa? New light on an eighteenth-century question of identity', *Slavery and Abolition*, 20, 3 (1999), pp 96–105; and idem. *Equiano the African: Biography of a Self-Made Man* (Athens, Georgia, 2005). Carretta's doubts about Equiano's African birth have been contested. See Paul E. Lovejoy, 'Autobiography and memory: Gustavus Vassa, alias Olaudah Equiano, the African', *Slavery and Abolition*, 27, 3 (2006), pp 317–47.

5 The most comprehensive data on numbers of slaves per ship are to be found in David Eltis, Stephen D. Behrendt, David Richardson and Herbert S. Klein (eds), *The Trans-Atlantic Slave Trade: A Database on CD-ROM* (Cambridge, 1999). These include data on non-British as well as British ships.

6 John Adams, *Remarks on the country extending from Cape Palmas to the River Congo* [1823] (London, 1966), p.133.

7 Equiano, *Interesting narrative*, pp 58–61.

8 Data on the quantities of foods and water carried on British slave ships in the 1780s are given in David Richardson, 'The costs of survival: the transport of slaves in the Middle Passage and the profitability of the eighteenth-century British slave trade', *Explorations in Economic History*, 24 (1987), p.185.

9 For the reference to 'black cattle', see Suzanne Schwarz (ed.), *Slave Captain: The Career of James Irving in the Liverpool Slave Trade* (Wrexham, 1995), p.113.

10 For one recent discussion, with other references, see Herbert S. Klein, *The Atlantic Slave Trade* (Cambridge, 1998), pp 130–61.

11 For data on the scale of the British Empire slave trade and imputed mortality rates between 1662 and 1807, see David Richardson, 'The British Empire slave trade, 1660–1807', in P.J. Marshall (ed.), *The Oxford History of the British Empire, Volume II: The Eighteenth Century* (Oxford, 1998), p.442.

12 Equiano, *Interesting narrative*, p.58.

13 Robin Haines and Ralph Shlomowitz, 'Explaining the mortality decline in the eighteenth-century British slave trade', *Economic History Review*, 53, 2 (2000), pp 262–83.

14 Equiano, *Interesting narrative*, p.58.

15 For discussions of the case of the *Zong*, see James Walvin, *Black Ivory: A History of British Slavery* (London, 1992), pp 16–21; Emma Christopher, *Slave Ship Sailors and Their Captive Cargoes, 1730–1807* (Cambridge, 2006), pp 178–80.

16 For examples on Bristol ships in the late eighteenth century, see Madge Dresser, *Slavery Obscured: The Social History of the Slave Trade in an English Provincial Port* (London, 2001), pp 152–3; Christopher, *Slave Ship Sailors*, pp 181–2.

17 Cited in Dresser, *Slavery Obscured*, p.163.

18 Equiano, *Interesting narrative*, p.59.

19 What follows draws on Stephen D. Behrendt, David Eltis and David Richardson, 'The costs of coercion: African agency in the pre-modern Atlantic world', *Economic History Review*, 54, 3 (2001), pp 454–76.

20 Daniel P. Mannix and Malcolm Cowley, *Black Cargoes: A History of the Atlantic Slave Trade* (New York, 1962), p.111; Darold D. Wax, 'Negro resistance to the early American slave trade', *Journal of Negro History*, 51 (1966), p.9.

21 David Richardson, 'Shipboard revolts, African authority, and the Atlantic slave trade', *William and Mary Quarterly*, 58, 1 (2001), p.75.

22 On the demographic 'deficit' of slaves in British America, especially the West Indies, see B.W. Higman, 'The economic and social development of the British West Indies, from settlement to *c*.1850', in Stanley L. Engerman and Robert E. Gallman (eds), *The Cambridge Economic History of the United States, Volume 1: The Colonial Era* (Cambridge, 1996), pp 307–9; J.R. Ward, 'The British West Indies in the age of abolition, 1748–1815', in Marshall (ed.), *British Empire*, p.431.

23 Equiano, *Interesting narrative*, p.62.

24 Ibid. p.61.

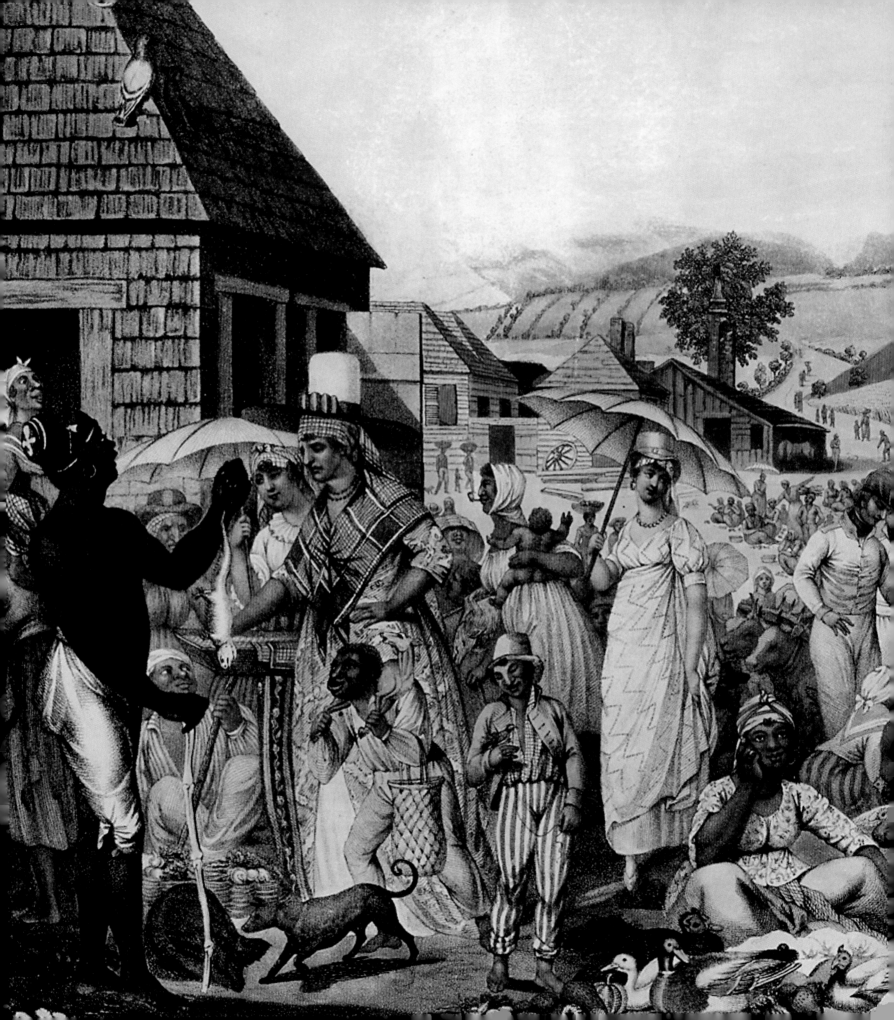

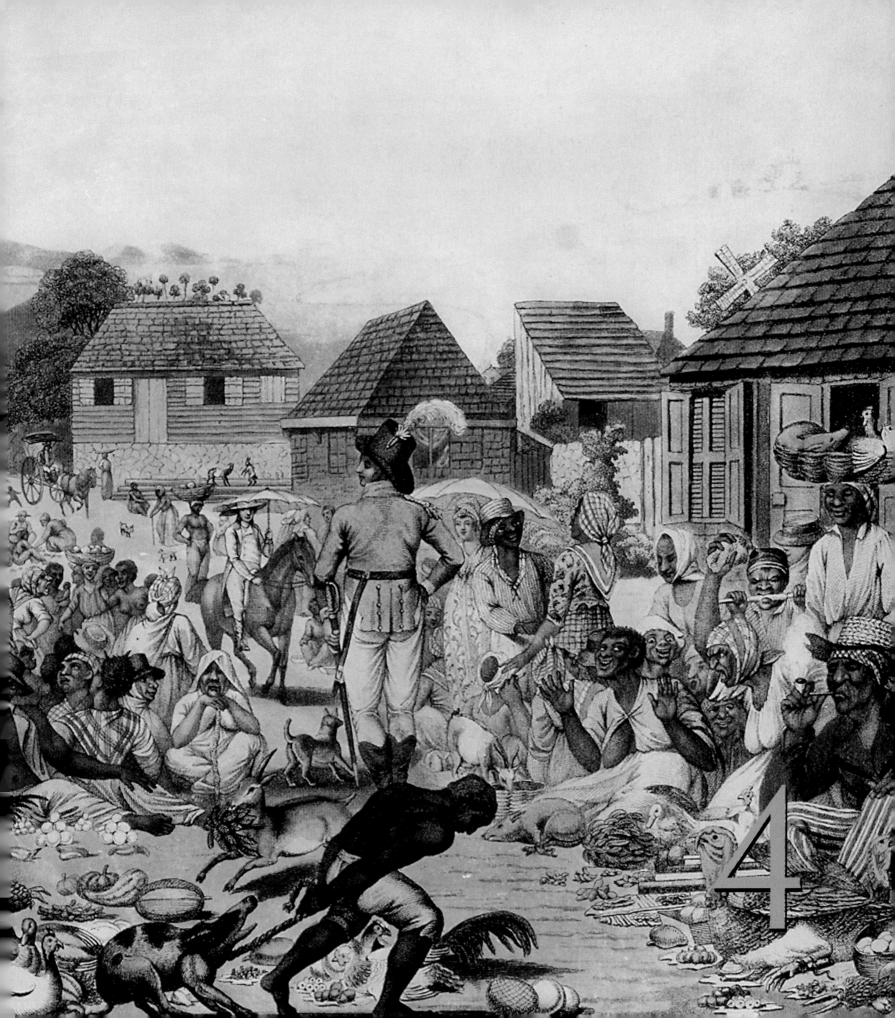

SLAVE LIFE IN THE CARIBBEAN

DOUGLAS HAMILTON

FOR THOSE MILLIONS OF ENSLAVED AFRICANS who survived the Middle Passage across the Atlantic, landfall in the Americas signalled little improvement in their desperate condition. Their horrendous captivity in ships' holds was over, but they quickly discovered that a new cycle of cruel indignity and maltreatment was about to begin. The wealthy plantation owners of the Caribbean, Latin America and the American South all used African labour to produce the colonial commodities demanded in huge quantities by European markets. Tobacco, cotton, indigo and rice from North America, and sugar, cotton and coffee (among others) from the Caribbean all were purchased in Europe after being grown by the enforced labour of African slaves in the fields of the Americas. Despite the oppressive nature of the system, however, the enslaved found ways to deal with slavery and to react against it.

Sugar was the main crop of the Caribbean islands. It was grown and harvested on plantations, but was also processed and packaged in the sugar 'works' before being shipped to Britain for refining. Sugar plantations were, therefore, more than just large farms; in some respects they more closely resembled industrial rather than agricultural units. The production of sugar cane was extraordinarily labour-intensive and planters soon recognised the need for a large and constant labour supply. In seventeenth-century Barbados it was not unusual to see white indentured servants, often from Ireland, working beside Africans in the cane fields. But by the eighteenth century – as sugar became the dominant crop on increasingly industrialised plantations and as Africans became particularly associated with slavery in European minds – the sight of mixed-race field gangs became unthinkable. The demand for relatively cheap and easily replenished labour allied itself with powerful and pervasive racial assumptions about who could be enslaved.

The plantations of the Caribbean were certainly not as benign as many of their contemporary visual representations suggest. For those who were enslaved, the plantations were not tropical idylls but places of unremitting toil and violence. The Belle Estate in Barbados (shown in Figure 13) had not been the peaceable recreation ground that this image of 1838 purports it to be. Philip Bell, then governor of Barbados, acquired the Belle Estate in 1641. Its ownership passed through a number of hands before Daniel Lascelles bought it in 1780. It remained in the Lascelles family (later the Earls of Harewood) until 1970. Many hundreds of Africans worked on the 537-acre estate and by the time the abolition of slavery came into force in 1834 there were still 291 slaves working in the fields.[1] This insatiable need for labour resulted in a black population that was very much larger than the white. In Jamaica, black people outnumbered white people by about 11:1, while in Grenada in the 1770s it was nearer

22:1. This essay examines the world inhabited by this vast majority – that is, the enslaved. It begins by reviewing the work patterns and structures imposed on them by the planter class, before considering the lives they carved out for themselves, distinct from, and sometimes in opposition to, the demands of the white elite.

Enslavement, society and economy: patterns of plantation life

Although their principal role was to produce sugar, the enslaved were engaged in a wide variety of occupations on the plantations. The most common, and the one most associated with Caribbean slavery, was field work, which was organised into gangs.

The first gang was made up of the strongest and fittest workers, regardless of gender. Indeed, because many of the skilled occupations were reserved for men, most slave women worked in the fields where they often constituted the majority of the field gang. The workers in this group toiled the hardest. They prepared the soil, dug the holes, planted the cane, spread manure on the fields, cut the cane (which, by harvest time, had grown up to 15 feet high) and carried it to the sugar works. Throughout the year, they worked from dawn to dusk in the sweltering Caribbean heat. But when the cane was harvested, their hours were lengthened. Once the cane had been cut, it had to be processed quickly to catch the fleets sailing to Europe. The sugar works operated through the night and field hands were often required to carry on working after a gruelling and exhausting day in the fields.

Fig.13: *Belle Estate, Barbados,* 1838 (Cat.446) ZBA2735.

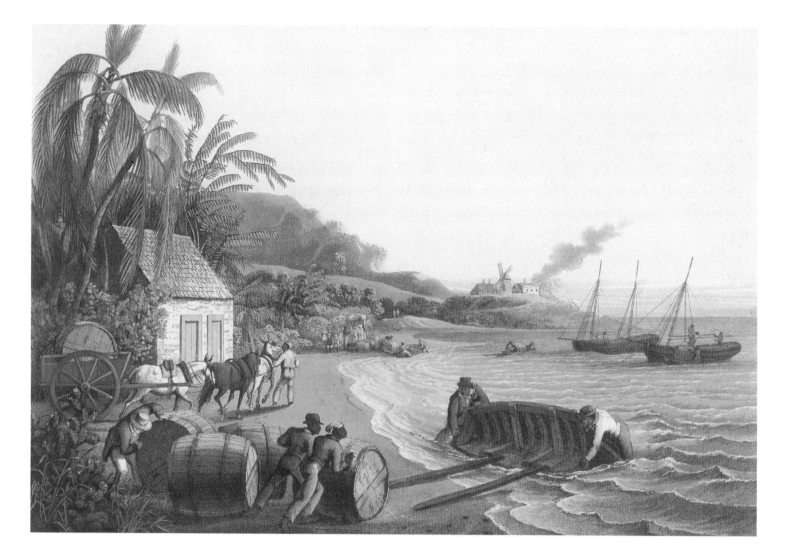

Fig.14: William Clark, *Shipping sugar*, 1823 (Cat.401) PAH3019.

The second gang generally comprised those unable to work in the first: heavily pregnant women, mothers with babies, adolescents who were not yet strong enough, and the elderly and infirm. There was a brutally managed movement from the second gang to the first, and back again as the enslaved grew up and then weakened. The second gang kept the cane fields weed-free, cleared them after the canes were cut and swept the trash from the factory. Drivers, who were themselves often enslaved, oversaw the field labourers. These men (and drivers were always men) were at the summit of the hierarchy of labour among the enslaved and used the whip on fellow slaves to maintain discipline and set the pace of work.

Other male workers were engaged in more skilled occupations. Running a plantation required a number of artisans. Buildings and walls had to be kept in good repair, for example, and therefore some chattel slaves became masons and carpenters. There were also stockmen who looked after the plantation's livestock. Others had to work in the factory. Sugar production involved first crushing the canes and then extracting the juice, which was then boiled and crystallised. Knowing the precise point at which the boiling sugar was ready was the result of long experience and a prized

skill. Rum was distilled from the molasses produced during the making of the raw sugar. As well as the boilers and distillers, there were also coopers to make the barrels in which the sugar and rum were exported (Fig.14).

The enslaved were managed by occupation and had clearly defined roles. The skilled jobs were regarded as less demanding and indicative of a higher standing in the enslaved community. Many skilled workers enjoyed a greater degree of mobility. The skilled tasks tended to be reserved for men and for creole slaves, those who were born in the Caribbean, who had known nothing but enslavement and who were regarded as more 'reliable' than newly arrived Africans. In the eyes of the planters, their jobs also reflected the cash value of the enslaved. A 'List of negroes' from Antigua in 1782 makes it clear that chattel slaves with additional responsibilities were valued more highly, in nakedly monetary terms, than those who worked in the field. Prince, a 'boiler' (of sugar), was worth £150 compared to Toby, a carter and field worker, who was valued at £130. Toby's additional responsibility as a carter, however, marked him as worth more than Robin (£90) or Stepney (£85), who are likely to have been field hands. The list also suggests how their perceived worth fell as they were worn down and aged: Jacob, who was 'ruptured', was 'worth' £25 while Jupiter, described in 1782 as 'superannuated' and valued at only £6, had certainly been much more highly valued in his younger days. In all there were 56 people on the estate who were valued collectively at £3590, or about £360,000 today.[2]

The deliberate management of labour extended to Caribbean-born children. From a young age – sometimes as young as five, and certainly by the age of seven – enslaved children were assigned tasks. Often these jobs were designed to lead to their adult occupation. Boys and girls who gathered up grass could expect to progress to the field gangs; those who looked after the hogs or the goats were more likely to become stock-keepers. Other workers served in the plantation house as cooks, cleaners, maids and nannies. Women largely filled these roles, though boys also found employment in domestic service. This, of course, does not mean they had an easier life: Mary Prince described in graphic detail the abuses she and others suffered in domestic service at the hands of their owners in Bermuda. Mary was born a slave on the island and later sold to one 'Captain I'. She was put to work in his house, under the guidance of his wife, from whom Mary came 'to know the exact difference between the smart of the rope, the cart-whip and the cow-skin, when applied to my naked body by her own cruel hand... She was a fearful woman, and a savage mistress to her slaves'.[3]

The production of large amounts of good-quality sugar was critical for the planters, and because this was dependent on the enslaved, the planters were determined to work their labourers as hard as possible. Not only was this work backbreaking, it was also often dangerous. Cutting cane involved wielding heavy machetes and lacerations were frequent. In the factory burns were commonplace during the hazardous process of boiling the cane juice. In 1789, one Scottish doctor on the island of Dominica encountered a slave whose legs were so horribly scalded that they were 'as white as any European'.[4]

The enslaved worked extraordinarily long hours doing exceptionally demanding

work, but for many planters that was not enough. They strove constantly to increase the work rate. Many held racist assumptions that Africans were inherently lazy and had to be forced to work. One Jamaica planter believed 'The Negro is so averse to labour, that <u>without force</u> we have hardly been able to obtain it'.[5] 'Force' meant use of the lash and so the brutality that characterised the Middle Passage was carried over into plantation life. As a result of their long hours of desperately arduous labour and the unremittingly inhumane treatment meted out by the planters, life expectancy for the enslaved was drastically reduced. But despite the suffering they endured, they were able to find ways of retaining their dignity and humanity while ensnared in a system that tried to deny these basic rights.

One of the main ways they did so was through the medium of the family. While the precise nature of 'the family' among the enslaved is the matter of debate, it is clear that family and kinship groups, whether nuclear or extended, were central to the creation of slave communities. Even the records left by the planters show that they acknowledged the presence of slave families. It is remarkable that family life was able to survive the ravages of slavery and the physical and violent sexual abuses to which the enslaved (and especially slave women) were routinely exposed.[6] As well as highlighting occupations and perceived values, the 1782 list of slaves from Antigua also indicates the presence of families among the enslaved. The purpose of the list was not to signify families but family groups are nevertheless discernible among the 56 slaves listed. Ten children were directly connected with their mothers and it is reasonable to assume that, as elsewhere, family groups of different types existed across more than one generation.[7] For those people, such connections were essential elements providing stability and support within an oppressive system. Families did not necessarily cohabit. Patterns of slave accommodation varied from plantation to plantation, and the size of buildings (as well as the nature of relationships) would determine living arrangements. Often, however, slave houses were arranged together around a yard. The yard was the arena for community life. The houses provided sleeping quarters and some privacy but much of the slaves' day-to-day life took place in the yards.

In this wider community environment, culture and religions flourished. Families provided the means by which cultures from Africa – of music, dance and storytelling – were transmitted across the Caribbean. African religions were widely practised, although Europeans disparaged them as pagan witchcraft. The planters also had serious concerns about slave culture (and especially religions) because they represented a world beyond their control. In many ways, the enslaved also had grave reservations about European religions that looked so different from their own. The rise of evangelical religion during the eighteenth century, however, produced faiths that were more appealing to the enslaved. At one level groups such as the Baptists were active campaigners for improvements in slave conditions and for abolition; at another their form of worship was more sympathetic to African religious practice, and so attracted huge numbers of the enslaved in the early nineteenth century (see Cat.415).[8]

In another key respect, slave families were significant. They provided the networks of labour and merchandising that facilitated the emergence of internal

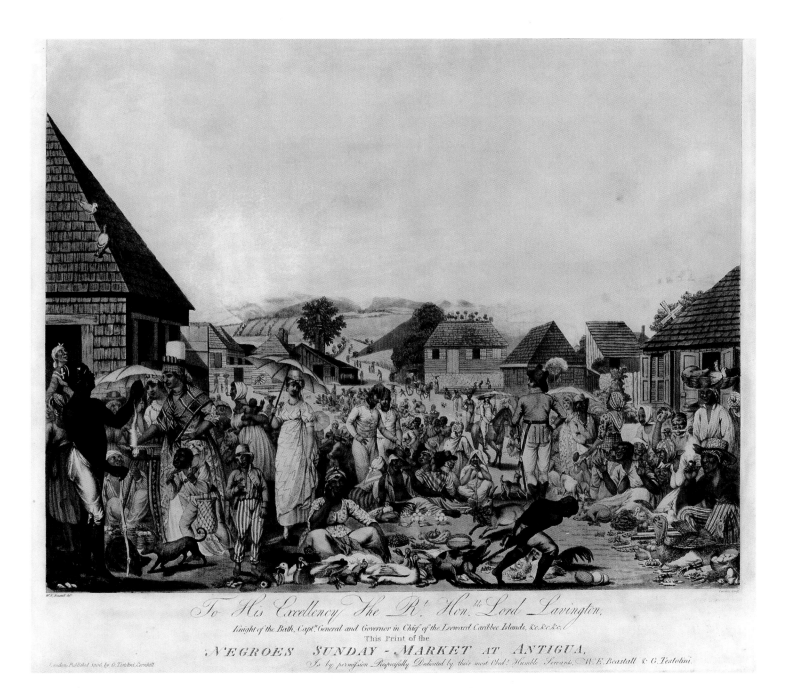

economies based on provision grounds, which consisted of land given over to the enslaved by the planters. This was hardly driven by great altruism: the provision grounds were those bits of marginal land deemed unsuitable for growing cash crops such as sugar. The planters realised that they would not have to supply food if the enslaved could produce their own. But what began as a shrewd calculation on the part of the planters, came to be a vital part of the lives of the enslaved and, indeed, highly important for the colonies as a whole. There was no restriction on how much the enslaved could grow, beyond the limitations of the soil and the available space. What they did not eat, they could sell. In colonies where the plantations were geared up for

Fig.15: Cordon after W.E. Beastall, *Negroes Sunday-market at Antigua*, 1806 (Cat.397) ZBA2594.

exports, producing food became a crucial sector of the local economies. At the end of the eighteenth century as many as 10,000 slaves participated in markets in Kingston, Jamaica. Figure 15 shows a Sunday market in Antigua in 1806: here the produce of the provision grounds was sold. What is especially important is that the market supplied not only other chattel slaves, but wealthy Europeans as well. The enslaved who sold goods did not make vast fortunes, but many were able to save money. Sometimes this was enough to buy their freedom and to leave legacies, in some cases of up to £200 (about £20,000 at today's prices).

Of course, these opportunities to make money were not open to all chattel slaves. Taken collectively, however, the market traders may have held up to 20 per cent of an island's currency, playing a vital economic role.[9] The markets were also places where the enslaved could legitimately meet, interact and exchange information and so provided a potential arena in which to foment rebellion. For as well as finding strategies to cope with the system that bound them, the enslaved actively and sometimes openly and violently opposed it.

Resistance and rebellion: countering colonial slavery

The enslaved developed a wide variety of tactics to resist slavery and the relentless demands of the planters. At various times the enslaved took it upon themselves to work slowly, to break tools, to damage crops or to feign injury or illness. These measures inevitably brought with them the threat of vicious reprisals and merely added to the planters' view that the enslaved were lazy, rather than resistant. At other times, slaves made bids for freedom by running away. In the Caribbean islands, especially in those where there were communities of Maroons, the prospect of hiding out in the mountains was highly attractive. Maroons were largely independent communities of runaway slaves, which became established in a number of Caribbean islands. In Jamaica there were two groups in the Blue Mountains, one to the west and one to the east. Sometimes whites distrusted them as 'an enemy within', but at other times (as we will see) they appeared to be allies.

Running away was a persistent problem for slave owners, and they often used adverts in the press to appeal for the return of runaways. Figure 16 shows one for Jack, an African boy from the Congo, who had been on the run for five weeks when this advert was placed. The fact that he was 'well acquainted' in the neighbouring parish of Clarendon is significant. There is no way of knowing exactly with whom Jack was acquainted, but it is possible to speculate that they were friends or family from Africa, or people he met during the Atlantic crossing. In any

Fig.16: Advertisement from *The Jamaica Mercury & Kingston Weekly Advertiser,* December 1779 (Cat.214) MGS/45.

event, it reminds us that the enslaved maintained relationships beyond the confines of their particular plantation. These links were made possible by running away, or through 'legitimate' meetings at markets, or with the (sometimes unwitting) permission of the planters.

Jack the runaway had no brand mark to signify the plantation to which he belonged – but he was not meant to be absent from it. It was often necessary, however, to allow slaves off the plantation. Trusted slaves were given the tasks of delivering letters, herding cattle or transporting sugar around the islands. In order that slaves without brands could be identified away from the plantation, planters would lock identification bands onto their wrists. These bore the names of the plantation and the owner, not the name of the slave. Should the slave be apprehended, he could prove he was there with permission, or could be returned if he had strayed. In this sense identification wristbands, by stripping away identities and asserting ownership, appear to be a further reinforcement of the oppression of the slave system. But they also facilitated mobility among the enslaved, which was key to their maintaining connections across plantations, and to the spread of news between enslaved communities. While the planter may have imparted specific instructions to the wearer of the band, he had no control over other information being carried. This mobility was of particular importance for organised revolts.

The enslaved did not opt only for relatively passive opposition to their condition. They often fought it with violence. The vast differences in numbers between the ruling white elite and the enslaved population meant that the planters were in constant fear of slave revolts – and they were right to be worried. All the Caribbean islands

Fig.17: Identification band, 1746 (Cat.1) ZBA2474.

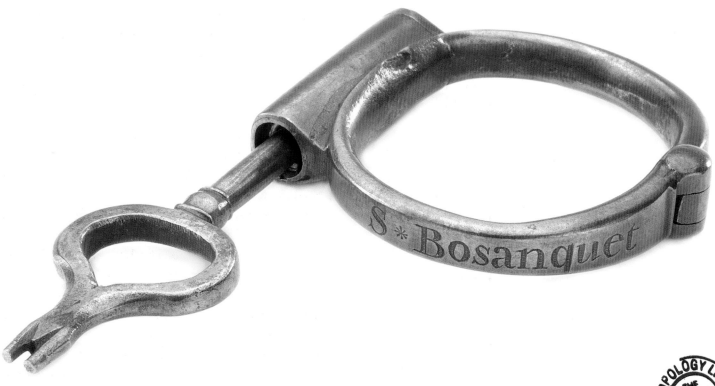

experienced slave rebellions. The most successful was the 1791 rising in the French colony of Saint-Domingue (also known as the Haitian Revolution) that in 1804 resulted in the first independent black republic in the Americas. On the British islands, revolts were scarcely less bloody or less frequent, although the enslaved were never able fully to seize control. But they did come close.

In May 1760, while Britain was embroiled in the Seven Years War against France, a well-orchestrated revolt broke out in St Mary's parish in western Jamaica. Led by Tacky, an Akan slave from the Gold Coast, it spread quickly through a well organised Akan network to the parishes of Clarendon, Westmoreland, St Elizabeth and St James. This was no piecemeal protest but a deliberate effort to create a West African state in the Caribbean, along with the 'entire extirpation of the white inhabitants'.[10] It was genuinely an attempt at revolution rather than resistance of the colonial regime. Thousands of slaves rose in revolt, resulting in tremendous damage to life and property. The revolt drew a ruthless reaction from British authorities. The response of planters and British forces, allied to the inability of the rebels to rouse wider support among the enslaved population, crushed the revolt. Its chances of success were also dealt a severe blow by the reaction of the Maroons who, in return for guarantees for their security, worked with the British. Although ultimately unsuccessful in its aims, Tacky's Revolt deeply shocked the plantocracy and confirmed to them the precariousness of their situation. It also heightened their distrust of Akan peoples (or 'Coromantees') who had been central to risings in Jamaica for decades.

The planters were quite unable to prevent slave risings and many broke out across the Caribbean in the years that followed. Not until more than three decades later, however, did a rebellion in a British island come close to emulating Tacky's Revolt. In the 1790s, during the French Revolutionary War and in the wake of the initial rising in Saint-Domingue, the leaders of the French Revolution in the Caribbean began to encourage slave insurrections in British islands. Consequently, in 1795, a revolt broke out in Grenada led by Julien Fedon, a French 'man of colour'. Its aim was to create an independent black republic, and for many months from the spring of 1795, Fedon's forces controlled most of the island. They had captured, and later killed, many members of the white elite, including the lieutenant-governor, Ninian Home. Although the rebels were never able to seize the capital, St George, it took until July 1796 for reinforcements of 5000 regular British troops gradually to push them back and finally to end their revolution. Like Tacky's Revolt in Jamaica, Fedon's Rebellion was a major armed struggle that seriously threatened a key part of the British Empire. In total, Fedon's Rebellion caused the destruction of 100 plantations, resulted in the loss of some 7000 slaves killed or deported, and caused an estimated £2.5 million worth of damage – which equates to about £250 million today. These revolts showed just how vulnerable British colonies could be when large and alienated groups of the enslaved decided to take on their British overlords.[11]

What is particularly striking about these major revolts is how they coincided with periods of crisis for the colonial power: in the British case, Tacky's and Fedon's rebellions both occurred during major wars, while the Haitian Revolution was sparked

in the particular circumstances of the French Revolution. This is surely not just a coincidence, and it points to the extent of knowledge and the means of communication among the enslaved communities.

* * * * *

The lives of the enslaved were to a great extent dictated by the terrible conditions in which they existed. The harsh regime of work and punishment exacted an appalling toll on the bodies of the enslaved. But they were not simply passive in the face of this oppression. They carved out family and economic lives in a way that is all the more remarkable for the pressures placed upon them. They also retained and developed cultural forms. In short, enslaved communities were highly complex and played important roles in shaping the Caribbean colonies. As well as finding ways to reconcile themselves with their condition, they found ways to oppose their enslavers. Minor day-to-day acts of resistance were accompanied by very serious uprisings. These insurrections had profound impacts on the islands but they also began to play into wider debates in Britain about the morality of slavery. The revolts at the end of the eighteenth century inspired more in the early nineteenth century. European reprisals for these risings in Barbados, Demerara and Jamaica had important effects for the coming of abolition.

NOTES

1 The National Archives, Kew, T71/553 (320–321), Barbados slave returns.

2 National Maritime Museum (hereafter NMM), MGS/30, List of Negroes when the estate was rented to Mr Thibou (see Cat.132).

3 Sara Salih (ed.), *The history of Mary Prince, a West Indian slave* [1831] (London, 2000), p.14.

4 Douglas J. Hamilton, *Scotland, the Caribbean and the Atlantic World, 1750–1820* (Manchester, 2005), p.122.

5 Richard S. Dunn, '"Dreadful idlers" in the cane fields: the slave labor pattern on a Jamaica sugar estate, 1762–1831', *Journal of Interdisciplinary History*, 17, 4 (1987), p.800.

6 See, for example, Trevor Burnard, *Mastery, Tyranny, and Desire: Thomas Thistlewood and his Slaves in the Anglo-Jamaican World* (Chapel Hill, 2004), pp 156–62.

7 NMM, MGS/30, List of Negroes (Cat.132).

8 James Walvin, *Black Ivory: A History of British Slavery* (London, 1992), pp 157–97.

9 Gad Heuman, *The Caribbean* (London, 2006), pp 31–2.

10 Monica Schuler, 'Akan slave rebellions in the British Caribbean', in Hilary Beckles and Verene Shepherd (eds), *Caribbean Slave Society and Economy* (New York, 1991), pp 377–8; Burnard, *Mastery, Tyranny, and Desire*, pp 170–4 (the quote is from p.171).

11 Edward L. Cox, 'Fedon's Rebellion 1795–96: causes and consequences', *Journal of Negro History*, 67, 1 (1982), pp 7–19.

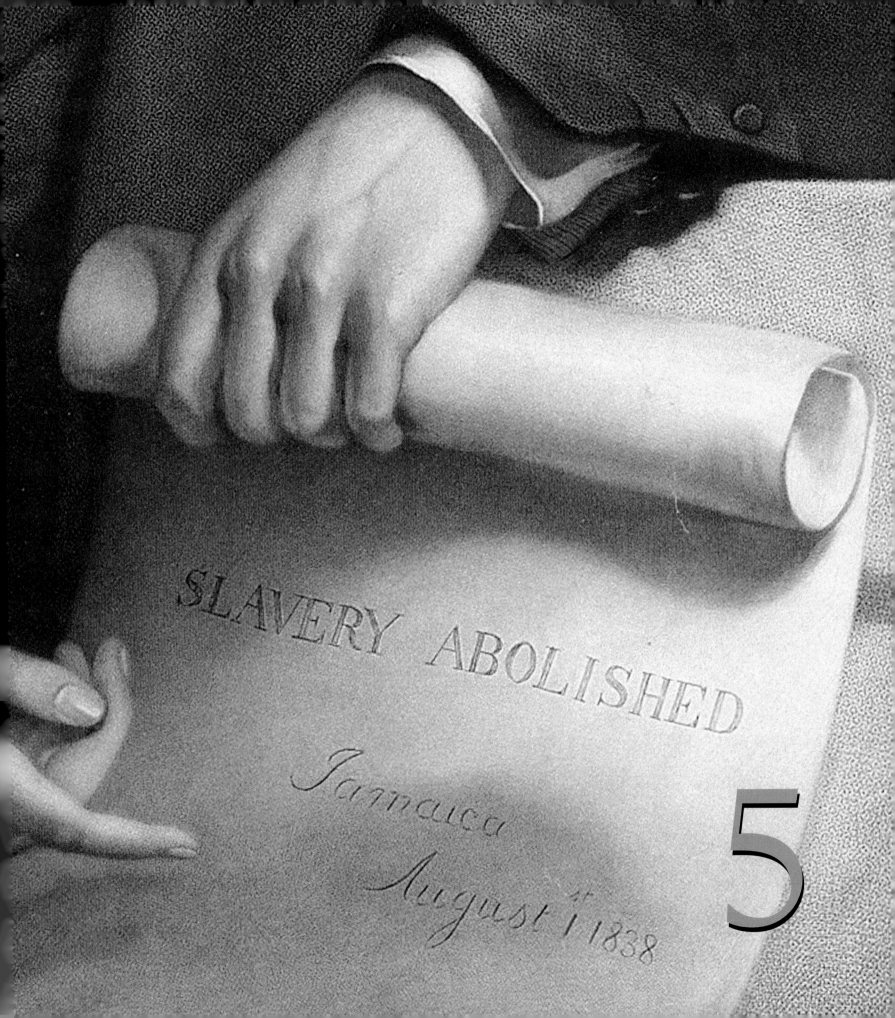

ABOLITION AND EMANCIPATION

JOHN OLDFIELD

SLAVERY WAS AN UNAVOIDABLE and, some might have deemed, necessary adjunct of empire in the seventeenth and eighteenth centuries. All of the major European powers at one time or another entered the Atlantic slave trade, just as most of them possessed slave colonies. Yet it was the British who came to dominate the trade. At its height, British Empire ships carried more slaves than any other nation, British slave colonies produced vast quantities of tropical goods and the country as a whole grew rich on the profits of African slavery. All the more remarkable, then, that the British were the first to dismantle the Atlantic slave system: in 1807 they acted decisively to end British involvement in the transatlantic slave trade, and then in 1833 to abolish slavery in the British West Indies. In fact, 'abolition' was to emerge as one of the most popular reform movements of the eighteenth and nineteenth centuries.

How and why this came about are questions that continue to puzzle historians. Early accounts, produced in the nineteenth and early twentieth centuries, tended to explain the abolition of slavery and the slave trade in terms of a moral crusade that pitted abolitionists (the 'Saints') against evil planters and slave merchants. The first serious challenge to this moral interpretation of abolitionism came from Eric Williams in his controversial book, *Capitalism and Slavery* (1944). There is not space here to go into all of Williams' arguments. Suffice it to say that he believed that 'abolition' was primarily the result of economic forces: he had very little time for the abolitionists as a group or, indeed, for arguments that placed emphasis on moral as opposed to economic change. It was 'mercantilism' that created the slave system, Williams argued, and 'mature capitalism' that destroyed it. Abolition, in other words, was motivated purely by economic self-interest: 'When British capitalism depended on the West Indies, [capitalists] ignored slavery or defended it. When British capitalism found the West Indian monopoly a nuisance they destroyed West Indian slavery as the first step in the destruction of West Indian monopoly.'[1]

For obvious reasons, *Capitalism and Slavery* unleashed a bitter historical controversy that still continues unabated. But while most historians today would not dissent from Williams' view that 'abolition' was in some way bound up with economic interests that had no direct stake in the Atlantic slave system, few would accept that Britain's economic development in the nineteenth century actually required the destruction of slavery. More to the point, Williams' decline thesis – arguing that calls to end British slavery coincided with periods of general economic decline in the British Caribbean – is open to criticism. Indeed, historians such as Seymour Drescher have argued that abolition (meaning in this case the abolition of the transatlantic slave trade) took place at a time of favourable economic trends for the British Caribbean economy.

Similar doubts surround Williams' assertion that 'overproduction in 1833 demanded emancipation'.[2] But if economic decline did not cause abolition, what did?

Since the 1970s historians have placed renewed emphasis on the 'moral' elements in abolitionism, tracing its origins in the growth of compassionate humanitarianism and the rise of evangelical religion, within both the established church and the main Dissenting sects.[3] Others have stressed the importance of industrialisation and the emergence of an increasingly leisured middle class. The population of Britain's four largest manufacturing towns almost quadrupled between 1760 and 1800, a rate of increase that overturned the traditional urban hierarchy. Under-represented in Parliament, eighteenth- and nineteenth-century towns would become the focus of middle-class aspirations, of philanthropy, 'Reform' and liberal politics.[4]

The abolition of the slave trade

Properly speaking, the abolitionist movement in Britain dates from the 1780s, but clearly there were attacks on slavery and the slave trade before this date. Aphra Behn and the Quaker, George Fox, both expressed their disapproval of the Atlantic slave system, as did Rousseau and Montesquieu. For the most part, these early critics focused on the inhumanity, cruelty, and immorality of the slave trade – themes that would be picked up by abolitionists in the 1780s. But the case against colonial slavery was greatly strengthened by political economists such as Adam Smith, who argued that slave labour was also costly and inefficient. Others went further, condemning slavery on the grounds that it was inimical to personal industry, profitable economy and family life. Slavery, in other words, was increasingly viewed as part of a 'system' that appeared outmoded and in urgent need of repair.[5]

These divergent trends made organised anti-slavery possible. Of far greater moment, however, at least in the short term, was the American Revolution. At an ideological level, the fate of Britain's North American colonies unleashed a heated debate about political representation that was quite often framed in terms of slavery (disenfranchisement) and freedom (the vote).[6] In this way, slavery began to take on a more immediate significance that was related to the political condition of thousands of native-born Britons. The American Revolution, in other words, gave slavery political meaning. But it also had a more far-reaching effect. As Linda Colley has argued, defeat in the American war (1775–83) brought with it a searching and sometimes painful re-evaluation of Britain's standing as a once-victorious Protestant nation. One result of the loss of the American colonies was a move to tighten the reins of empire elsewhere, notably in Canada, Ireland, and, more slowly, in the British Caribbean. Another was 'a rise in enthusiasm for Parliamentary reform . . . for religious liberalisation, for the reform of gaols and lunatic asylums; for virtually anything, in fact, that might prevent a similar national humiliation in the future'.[7]

The American Revolution also had a vital impact on abolitionism because it effectively divided British America, at the same time halving the numbers of slaves in

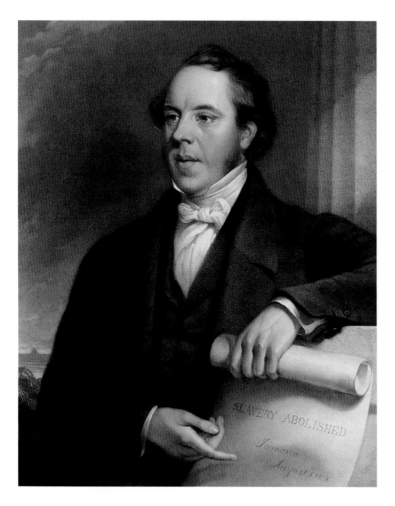

Fig.18: G. Lobel after Henry Room,
*Thomas Clarkson, c.*1840 (Cat.563) ZBA2504.

Opposite: Fig.19: James Heath,
William Wilberforce, 1807
(Cat.584) ZBA2499.

the British Empire.[8] In other words, war – or, to be more precise, defeat – created a climate in which abolitionism could take root. Abolitionists, in turn, exploited this opening and turned it to their advantage. With some justification, the Society for Effecting the Abolition of the Slave Trade (SEAST), established in May 1787, has been described as the prototype of the nineteenth-century reform organisation. Its self-appointed task was to create a constituency for abolition through the distribution of circular letters, books, and pamphlets. Abolitionists were also quick to exploit the influence of the press and, in the case of Wedgwood's famous cameo of the kneeling slave (Cats 178–9), visual images and material culture. Moreover, in Thomas Clarkson they possessed the movement's only full-time, professional reformer. An indefatigable and obsessive man, Clarkson not only popularised abolition through his various letters and pamphlets, but as the SEAST's travelling agent (he made three tours of England and Scotland between 1788 and 1791) he provided a vital link between London and the provinces. It was a demanding role – indeed, it finally broke Clarkson's health – but one that was crucial to the society's success in mobilising public opinion against the slave trade and, later, British colonial slavery.[9]

A key role was also played by a small group of black abolitionists, among them Olaudah Equiano (Cat.565), whose *Interesting narrative* (1789) remains probably the most complete account we have of slave life in the eighteenth century.[10] Equally important, there was always an international dimension to the early abolitionist movement; indeed, foreign support and intervention were deemed vital to the success of the movement at home. In pursuit of these aims, British abolitionists made contact with the *Société des Amis des Noirs* in France, following its organisation in 1788, and distributed books and pamphlets through the British ambassador in Madrid. More significant, certainly in the long term, were the links that British abolitionists established with their American counterparts, and, principally, with the Pennsylvania Abolition Society and the New York Manumission Society. Through these channels, which stretched from London to Paris, Philadelphia and New York, abolitionists exchanged ideas and information, in the process creating an 'imagined community' of reformers who offered each other support, advice and encouragement. America also provided British abolitionists with an example to follow, at least insofar as local (state) action was concerned: by 1788 no fewer than six states had legislated for the immediate abolition of the slave trade and two more, South Carolina and Delaware, had suspended it temporarily. Despite this, one can detect a subtle shift in the relationship between British and American abolitionists, certainly after 1790 when the United States Congress refused to interfere directly with the slave trade (that is, until 1808, when the Constitution stipulated that a ban would come into effect).[11]

The SEAST's long-term objective was to stimulate enough interest to encourage

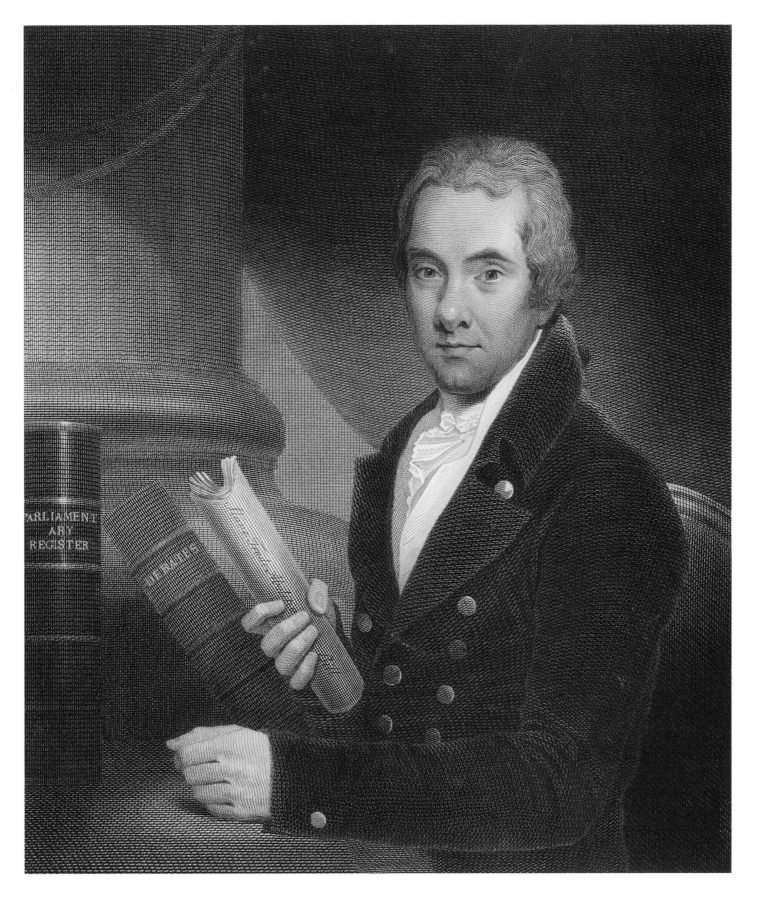

mass petitioning. In fact, the history of the early abolitionist movement can be told in terms of two major petition campaigns. The first of these took place in 1788, when over 100 petitions dealing with the slave trade were presented to the House of Commons.[12] It was against this background that on 11 February a committee of the Privy Council was appointed to look into the state of the slave trade. Some months later, in May, William Wilberforce, working in close co-operation with the London committee of the SEAST, introduced a motion in the House of Commons calling for an early abolition of the trade. But so far from being willing to discuss Wilberforce's motion, the Commons resolved to hear its own evidence, a compromise measure that left abolitionists playing a dangerous waiting game. Wilberforce and his supporters did win one concession, however. Late in the same session both Houses passed Sir William Dolben's Slave Limitation (or Middle Passage) Bill, which reduced the number of slaves that British ships could carry.[13]

In the event, the Commons' hearings dragged on for nearly two years, until February 1791. Undaunted, the SEAST went on collecting evidence, distributing tracts and lobbying MPs. Despite these efforts, Wilberforce's motion was again defeated, this time by 163 votes to 88.[14] The size of this defeat prompted Wilberforce to propose launching another petition campaign. Everything indicated that public support for abolition was still strong. Help also came from an unexpected quarter in the shape of William Fox's *Address to the people of Great Britain, on the utility of refraining from West India sugar and rum* (1791). Fox's pamphlet, which went through 14 or 15 editions, inspired a nationwide boycott of West Indian sugar and rum that at its peak involved some 300,000 families. Thomas Clarkson later reported that on his tour of the north of England in 1791 he had encountered widespread support for the boycott: 'in smaller towns there were from ten to fifty by estimation, and in the larger from two to five hundred, who had made this sacrifice to virtue. These were of all ranks and parties. Rich and poor, churchmen and dissenters, had adopted the measure . . . and even children, who were capable of understanding the history of the sufferings of the Africans, excluded, with the most virtuous resolution, the sweets, to which they had been accustomed, from their lips.'[15]

Abolitionists were quick to exploit this opening, seizing the opportunity to distribute yet more tracts and circular letters. Not to be outdone, in 1792 the powerful Society of West India Planters and Merchants set up its own publications committee, whose activities exactly mirrored those of the SEAST.[16] The propaganda war was further intensified by debates over the meaning and significance of the slave insurrection in Saint-Domingue in 1791. Understandably, the SEAST was eager to refute the charge that abolition of the slave trade, or even abolitionist activity, might in any way lead to the destruction of West Indian property. The rebellion in Saint-Domingue, abolitionists countered, had not been caused by 'the friends of the blacks in France', but by 'the pride and obstinacy of the whites who drove them to their fate, by an impolitic and foolish dissention with the mulattoes, and with each other'. Yet, for many, Saint-Domingue would remain a potent symbol of violence, instability and unrest, conjuring up images that made explicit the linkage between abolition, 'liberty'

and the rising tide of revolutionary violence in France.[17] Despite these obstacles, the petition campaign of 1792 was a huge success. In all, 519 petitions were presented to the House of Commons, 'the largest number ever submitted to the House on a single subject or in a single session'.[18] Moreover, the tactic worked, or so it seemed. In the ensuing debate the Commons resolved by 230 votes to 85 that the slave trade ought to be gradually abolished. After lengthy discussion, 1 January 1796 was fixed for the abolition of the trade. The Lords, however, rejected the Commons' resolution and on 5 June 1792 voted to postpone the business until the following session, when they would proceed by calling evidence to their own bar. Abolitionists then suffered humiliation in 1793 when the House of Commons refused to revive the subject of the slave trade, thus effectively reversing the resolution of the previous year. The abolitionist moment had passed. As the hearings in the Lords spluttered to a halt, even the gathering of fresh evidence began to lose its significance, and slowly the movement started to disintegrate.[19]

In retrospect, it is easy to see that the petition campaigns of 1788 and 1792 took place during a period of anxiety for many Britons, wedged as they were between the American Revolution and the mounting conflict with Revolutionary and Napoleonic France. Thereafter, the movement foundered. It was not until 1804 that it sprang back into life at the instigation of Wilberforce.[20] This time the campaign was successful. Nevertheless, to understand why Parliament acted decisively in 1807, as opposed to the 1790s, raises another set of issues. For one thing, most of the Cabinet was in favour of the measure. Furthermore, the entry into Parliament of a batch of new liberal Irish MPs, following the Act of Union of 1801, subtly altered the disposition of pro- and anti-slavery forces in the House of Commons. By 1807 it also looked as though it would be possible to build an international coalition against the transatlantic slave trade, something that had proved impossible during the 1790s. Denmark had already abolished the trade in 1802. The United States was expected to follow suit in 1808, while for different reasons Holland, Portugal and France were all highly susceptible to diplomatic pressure. Perhaps just as importantly, a modest increase in slave births over deaths in the Caribbean, notably in Barbados, held out the prospect that the British sugar colonies might be able to supply themselves.[21]

In this sense, abolition of the slave trade was a pragmatic decision made in the knowledge that Britain could probably afford to dispense with it. Yet there is little doubt that public opinion was behind the measure, or that many MPs were swayed by the moral arguments put forward by Wilberforce and his supporters. The death of William Pitt in 1806 also proved an important turning point. The new ministry, Lord Grenville's 'ministry of all the talents', was known to be in favour of the measure, and in figures like Charles James Fox it possessed vocal proponents of abolition. In 1806 Grenville's government brought in a Bill prohibiting the slave trade to conquered Dutch Guiana. Seizing this opportunity, Wilberforce began to attach the provisions of his own Foreign Slave Bill to the proposed legislation. The tactic worked. The Foreign Slave Bill was passed into law in 1806, paving the way for the Abolition Act of 1807, which outlawed the British Atlantic slave trade outright.[22]

The abolition of slavery

After 1807 British abolitionism entered a new phase. The Society for Effecting the Abolition of the Slave Trade was replaced by the African Institution, whose principal aim was to ensure that the new legislation was enforced and that other countries would follow Britain's example. Thanks to the efforts of the Royal Navy, the first of these objects was soon realised. Supplementary legislation also reinforced Britain's continuing commitment to abolition of the slave trade; involvement in the trade was made a transportable offence in 1811 and then, in 1824, a capital crime.[23] Persuading other countries to join Britain in outlawing the trade proved much more difficult, however. Despite the efforts of the African Institution and those of British ministers, the Congresses of Paris (1814) and Vienna (1815) both failed to reach specific agreement on abolition, not least because of French opposition. The results of the Aix-la-Chapelle Congress of 1818 were equally unsatisfactory.[24]

Suppression of the slave trade led, in turn, to a further innovation, namely slave registration. In 1812 an Order in Council set up a slave registry in Trinidad and by 1817 most of the British Caribbean islands had a system of public registration.[25] Despite these different initiatives, however, there was little evidence to suggest that suppression of the slave trade had done much to improve the treatment and condition of colonial slaves, which had obviously been the expectation. So it was that in 1823 some of the leading members of the African Institution, among them Thomas Clarkson and William Wilberforce, organised a new body, the Anti-Slavery Society, or, to give it its full title, the Society for the Mitigation and Gradual Abolition of Slavery Throughout the British Dominions. Modest in their ambitions, the members of the Anti-Slavery Society called for the adoption of measures to improve slave conditions in the British Caribbean, together with a plan for the gradual emancipation that would ultimately lead to complete freedom.[26] Only later, in 1832, did the more radical members of the Anti-Slavery Society embrace immediate emancipation.

Like the SEAST, the Anti-Slavery Society was a national organisation with its own network of local and regional auxiliaries. Unprecedented numbers of women were also involved in the movement. Estimates vary, but it seems likely that at least 70 ladies' associations were active between 1825 and 1833, perhaps the most influential of them being the Female Society for Birmingham. The opinion-building activities of the Anti-Slavery Society resulted in yet another petition campaign that dwarfed the early efforts of the SEAST. Between 1828 and 1833, when slavery was finally abolished in the British West Indies, Parliament was deluged by over 5000 petitions against colonial slavery, signed by 1.5 million Britons. Here again, women took an important lead in the campaign. The national female petition of 1833, for instance, contained 187,157 signatures, making it the largest single anti-slavery petition ever to be presented to Parliament.[27]

In organisational terms, there are obvious continuities between the eighteenth- and nineteenth-century British anti-slavery movements. But in another sense, of course, the nineteenth-century debate was different. For one thing, during the 1820s and

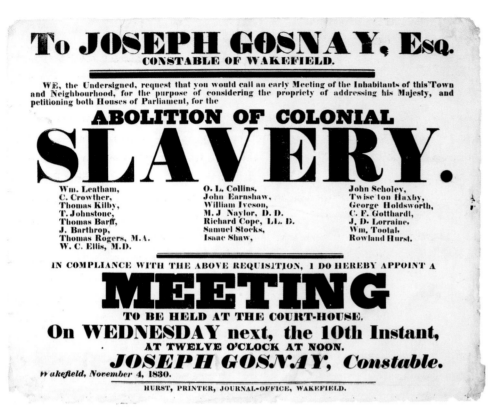

To **JOSEPH GOSNAY, Esq.**
CONSTABLE OF WAKEFIELD.

WE, the Undersigned, request that you would call an early Meeting of the Inhabitants of this Town and Neighbourhood, for the purpose of considering the propriety of addressing his Majesty, and petitioning both Houses of Parliament, for the

ABOLITION OF COLONIAL

SLAVERY.

Wm. Leatham,
C. Crowther,
Thomas Kilby,
T. Johnstone,
Thomas Barff,
J. Barthrop,
Thomas Rogers, M.A.
W. C. Ellis, M.D.

O. L. Collins,
John Earnshaw,
William Iveson,
M. J Naylor, D. D.
Richard Cope, LL. D.
Samuel Stocks,
Isaac Shaw,

John Scholey,
Twise ton Haxby,
George Holdsworth,
C. F. Gotthardt,
J. D. Lorraine,
Wm. Tootal,
Rowland Hurst.

IN COMPLIANCE WITH THE ABOVE REQUISITION, I DO HEREBY APPOINT A

MEETING

TO BE HELD AT THE COURT-HOUSE,

On WEDNESDAY next, the 10th Instant,
AT TWELVE O'CLOCK AT NOON.

JOSEPH GOSNAY, Constable.

Wakefield, November 4, 1830.

HURST, PRINTER, JOURNAL-OFFICE, WAKEFIELD.

1830s British colonial slavery came under fierce economic attack, as abolitionists picked over the implications of the works of Adam Smith, Jean-Baptiste Say and a third generation of classical economists led by John R. McCulloch.[28] The key here was free trade and the vision of an economic order untrammelled by restrictions and controls. From this perspective, colonial slavery began to seem anachronistic; the fact that the British people effectively subsidised the West Indian planters by paying high sugar duties was particularly irksome. If anything, these frustrations, along with the declining importance of Britain's Caribbean trade as a share of national wealth, only added to the growing clamour to abolish colonial slavery.[29] Put another way, by the 1830s the British Caribbean no longer seemed quite so vital to the state's hegemonic power, or, indeed, to its imperialistic ambitions, which after mid-century would be increasingly directed towards Africa and India.

British unease about slavery was further exacerbated by news of slave rebellions in the Caribbean. The period witnessed a series of large-scale slave insurrections, most notably Bussa's Rebellion in Barbados in 1816, the 1823 rebellion in Demerara (in modern Guyana), led by Jack Gladstone and, perhaps most significant of all, the 1831–2 Christmas Rebellion in Jamaica, led by Sam Sharpe, which involved over 20,000 slaves and is said to have caused more than a million pounds in damage. These rebellions, in turn, were met by fearsome reprisals from white planters (500 blacks were killed or executed in the wake of the Christmas Rebellion in Jamaica, for instance) that shocked many British observers and pushed them into the abolitionist camp.[30] Slowly, the Atlantic slave system was starting to unravel, although assessing the

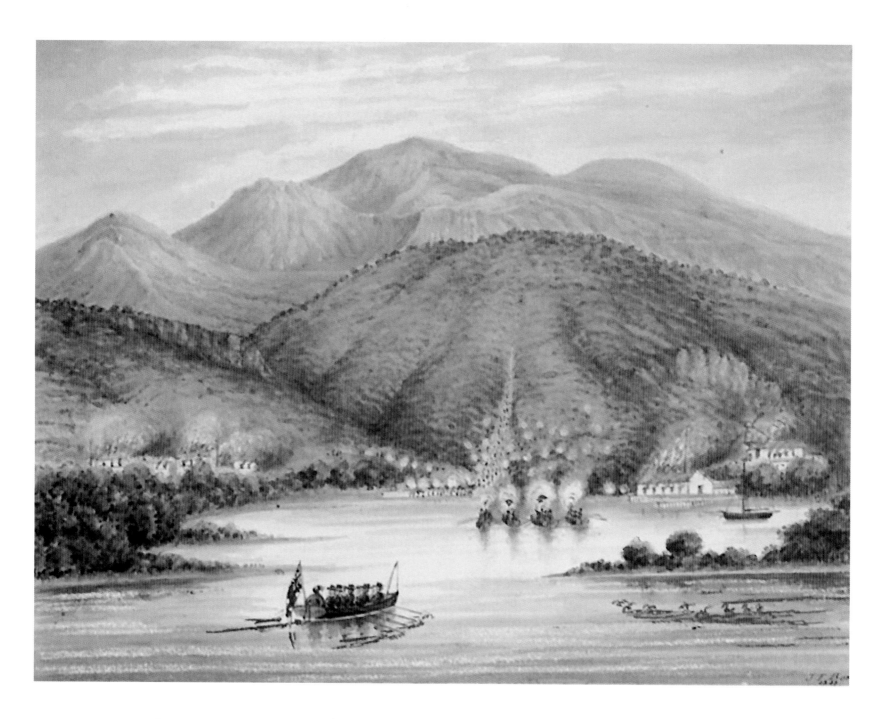

Fig.21: James Fuller Boxer, *The destruction of the Boyne estates by the rebel slaves*, 1831 (Cat.405) ZBA1585.

relative importance of moral dissent, on the one hand, and slave revolts, on the other, is necessarily difficult. The least that one can say is that the brutal cycle of slave discontent, upheavals, and white reprisals only added to a growing sense of imperial crisis in the British Caribbean, leading the State to question the economic cost of maintaining and protecting its slave colonies.[31]

Since 1823 the government's settled policy had been to back calls for the improvement or 'amelioration' of slave conditions in the Caribbean, thereby sidestepping the issue of emancipation, at least in the short term. By the 1830s, however, it was clear that amelioration was simply not working, and that most planters

were strenuously opposed to anything that they thought would threaten their property or basic (white) principles of authority and subordination.[32] Frustrated by the course of events in the Caribbean, in 1831 some of the Anti-Slavery Society's younger and more radical elements organised the Agency Committee, which formally separated from the parent body in 1832. Revivalist in tone, the Agency Committee took abolition out into the country and, to this end, employed its own lecturers or 'agents'. More controversially, it also committed itself to a more radical and far-reaching agenda, namely the *immediate* and *unconditional* abolition of slavery. For obvious reasons, the Agency Committee was ideally placed to exploit the struggle over the reform of Parliament and to win over the voters newly enfranchised by the Reform Act of 1832. Its efforts paid off. The first reformed Parliament was clearly sympathetic to the abolition of British colonial slavery; perhaps just as importantly the Cabinet supported the idea. In May 1833 Lord Stanley presented a plan to Parliament, which finally passed into law on 29 August.[33]

Rejecting 'immediatism', the 1833 Emancipation Act provided for the gradual abolition of slavery in the British West Indies: significantly, the territories of the East India Company, St Helena and Ceylon (Sri Lanka) were expressly excluded from the 1833 Act, and separate provisions were made for the gradual emancipation of slavery in Mauritius and the Cape of Good Hope. Under its terms, everyone over the age of six on 1 August 1834, when the law went into effect, was required to serve an apprenticeship of four years in the case of domestics and six years in the case of field hands.[34] Furthermore, the new legislation awarded colonial planters £20 million by way of compensation. Naturally, abolitionists were disappointed. But if there was little they could do about compensation, they made it their business to expose what they saw as the failings of the apprenticeship system. Led in the public realm by figures such as Joseph Sturge, and within Parliament by Daniel O'Connell and Henry Brougham, abolitionists succeeded in bringing an early end to apprenticeship, although by this date many planters were themselves wary of facing yet another confrontation with the imperial Parliament. Between May and June 1838 all of the colonies, with the exception of Jamaica, British Guiana and Trinidad, passed legislation ending apprenticeship on 1 August 1838. Reluctantly, the remaining three colonies followed suit and by the beginning of August slavery was officially 'dead'.[35]

* * * * *

In the space of some 30 years, Britain had not only outlawed the Atlantic slave trade but also abolished slavery throughout its West Indian possessions. For many, the struggle was over. For others, however, 1833 signalled a new beginning. Despite Britain's withdrawal from the transatlantic slave trade, the international traffic thrived; in fact, since 1807 it had steadily grown. The institution of slavery also still flourished, most notably in the Spanish island of Cuba and in the United States. Here was a fresh challenge. In 1839 abolitionists organised the British and Foreign Anti-Slavery Society, and with that the movement entered a new (international) phase that in many ways anticipated the work of Anti-Slavery International, which continues to the present day.

NOTES

1 Eric Williams, *Capitalism and Slavery* (Chapel Hill, North Carolina, 1944), p.169.

2 See Seymour Drescher, *Econocide: British Slavery in the Era of Abolition* (Pittsburgh, Philadelphia, 1977), pp 76–112; Kenneth Morgan, *Slavery, Atlantic Trade and the British Economy, 1660–1800* (Cambridge, 2000), pp 29–39.

3 See, for example, David Brion Davis, *The Problem of Slavery in Western Culture* (London, 1970); Roger Anstey, *The Atlantic Slave Trade and British Abolition, 1760–1810* (London, 1975); Seymour Drescher, *Capitalism and Antislavery: British Mobilization in Comparative Perspective* (New York, 1987).

4 John R. Oldfield, *Popular Politics and British Anti-Slavery: The Mobilisation of Public Opinion Against the Slave Trade, 1787–1807* (Manchester, 1995), pp 7–8, 19–20; John Gardiner, *The Victorians: An Age in Retrospect* (London, 2002), pp 8–15.

5 Robin Blackburn, *The Overthrow of Colonial Slavery, 1776–1848* (London, 1988), pp 33–63.

6 John Brewer, *Party Ideology and Popular Politics at the Accession of George III* (Cambridge, 1976), pp 201–16; H.T. Dickinson, *Liberty and Property: Political Ideology in Eighteenth-Century Britain* (London, 1977), pp 214–20.

7 Linda Colley, *Britons: Forging the Nation, 1707–1837* (New Haven, Connecticut, 1993), pp 143–5, 353.

8 Andrew Jackson O'Shaughnessy, *An Empire Divided: The American Revolution and the British Caribbean* (Philadelphia, Pennsylvania, 2000), p.245.

9 Oldfield, *Popular Politics*, pp 45, 74–84, 155–9.

10 For Equiano, see Vincent Carretta, *Equiano, the African: Biography of a Self-Made Man* (Athens, Georgia, 2005).

11 Oldfield, *Popular Politics*, pp 51–6.

12 Drescher, *Capitalism and Antislavery*, p.76.

13 Oldfield, *Popular Politics*, pp 50–51; Anstey, *The Atlantic Slave Trade and British Abolition*, pp 265–7; Herbert S. Klein, *The Atlantic Slave Trade* (Cambridge, 1999), pp 149, 162, 186.

14 John Pollock, *Wilberforce* (London, 1977), pp 96–103.

15 Oldfield, *Popular Politics*, pp 56–7; Thomas Clarkson, *The history of the rise, progress, and accomplishment of the abolition of the African slave trade by the British Parliament*, 2 vols (London, 1808), vol.2, pp 349–50.

16 Microfilm minutes of the Society of West Indian Merchants and the Society of West India Merchants and Planters, Institute of Commonwealth Studies, University of London, reel 11.

17 Oldfield, *Popular Politics*, pp 60–61.

18 Drescher, *Capitalism and Antislavery*, p.80.

19 Oldfield, *Popular Politics*, pp 61–2.

20 Oldfield, *Popular Politics*, pp 63–4.

21 J. R. Ward, 'The British West Indies in the age of abolition, 1748–1815', in P.J. Marshall (ed.), *The Oxford History of the British Empire, Volume II: The Eighteenth Century* (Oxford, 1998), pp 426–8.

22 Howard Temperley, *British Anti-Slavery, 1833–1870* (London, 1972), pp 5–6; Anstey, *The Atlantic Slave Trade and British Abolition*, pp 343–90.

23 British Acts of Parliament, 51 Geo III, c.23; 5 Geo IV, c.113.

24 Temperley, *British Anti-Slavery*, pp 8–9; Paul Michael Kielstra, *The Politics of Slave Trade Suppression in Britain and France, 1814–48: Diplomacy, Morality and Economics* (London, 2000), pp 31–57, 86–95.

25 The National Archives, London, http://www.movinghere.org.uk/galleries/roots/caribbean/slaves/slaveregister.htm (March 2006).

26 Temperley, *British Anti-Slavery*, pp 9–18.

27 Clare Midgley, *Women Against Slavery: The British Campaigns, 1780–1870* (London, 1992), pp 43–71; Colley, *Britons*, pp 354–5.

28 For a brilliant discussion of these classical economists, see Seymour Drescher, *The Mighty Experiment: Free Labor versus Slavery in British Emancipation* (New York, 2002), pp 54–72.

29 James Walvin, *Making the Black Atlantic: Britain and the African Diaspora* (London, 2000), pp 153–5.

30 James Walvin, *Black Ivory: A History of British Slavery* (London, 1992), pp 253–78.

31 Walvin, *Making the Black Atlantic*, pp 148–9.

32 For amelioration and amelioration schemes, see J.R. Ward, *British West Indian Slavery, 1750–1834: The Process of Amelioration* (Oxford, 1988).

33 Temperley, *British Anti-Slavery*, pp 12–16. See also William L. Burn, *Emancipation and Apprenticeship in the British West Indies* (London, 1937).

34 The exceptions were Antigua and the Bahamas, where slavery was immediately abolished, largely because apprenticeship was deemed inappropriate in those colonies where most of the slaves were engaged in maritime activities.

35 Temperley, *British Anti-Slavery*, pp 16–18, 36–41.

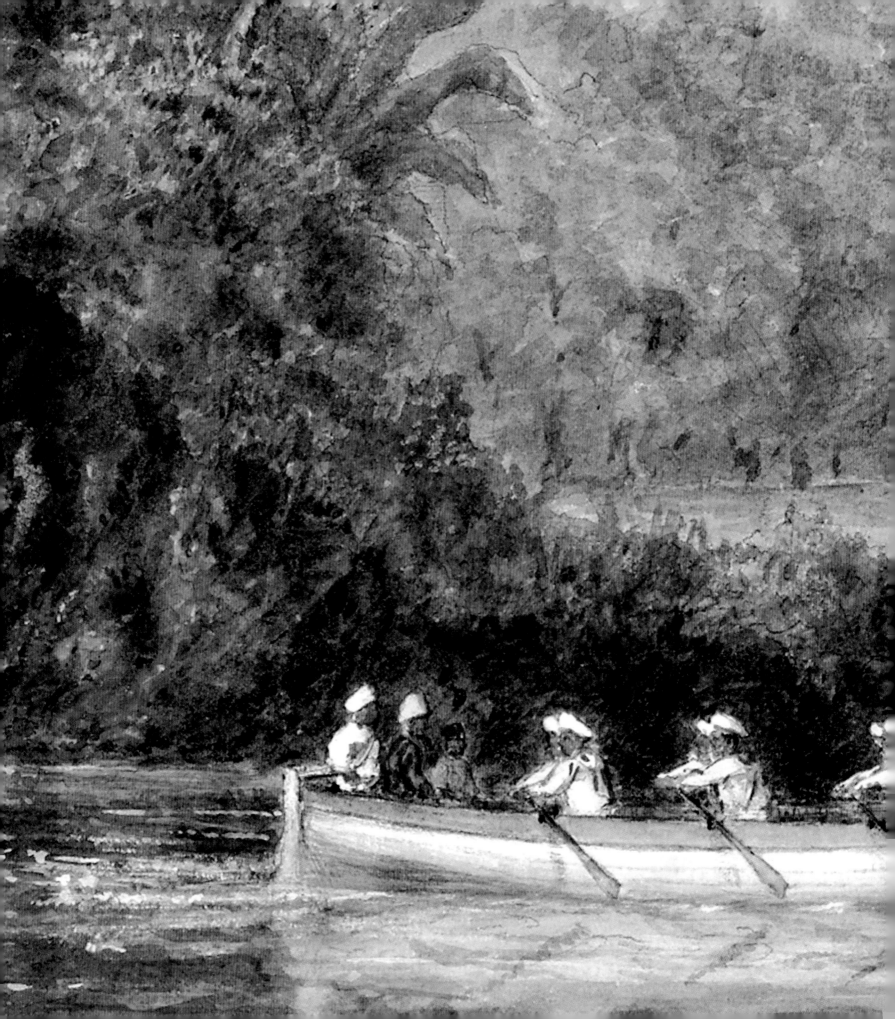

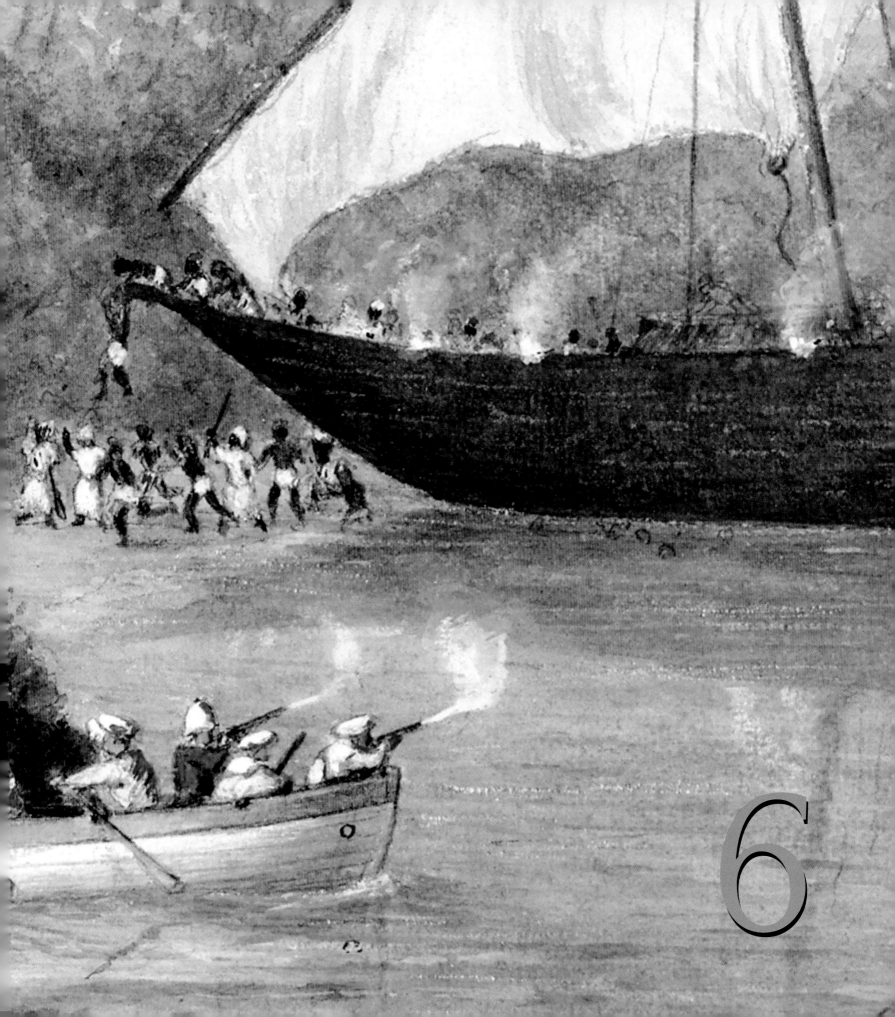

6

Britain, the Royal Navy and the Suppression of Slave Trades in the Nineteenth Century

Robert J. Blyth

WHEN PARLIAMENT FINALLY PASSED THE BILL to abolish the British slave trade on 25 March 1807, it created an immediate challenge: how best to enforce the legislation. The solution was threefold: firstly, to employ ships of the Royal Navy to intercept illegal slavers engaged in the trade; secondly, to use diplomatic pressure and a series of treaties to suppress the slave trades of other countries; and, thirdly, to maintain the public and political profiles of British anti-slavery, ensuring its continued importance as a significant element of Britain's foreign policy. Indeed, having been the pre-eminent slave traders of their day, the British turned to this new role of anti-slavery crusader with astonishing speed and remarkable zeal. The resulting campaign helped to define and underpin Victorian Britain's sense of national and moral supremacy.[1] This essay will explore Britain's efforts to secure the suppression of slave trades in the Atlantic and Indian Oceans and the impact of these operations.

Ending the transatlantic slave trade

The 1807 Act made it illegal for any British subject to be involved in the slave trade after 1 January 1808. The Act imposed penalties on those caught trading: ships could become forfeit to the Crown and a fine of £100 was imposed for every liberated slave. Additional legislation in 1811 made slave trading a felony punishable by transportation. A further Act of 1824 treated it as an aspect of piracy, with those convicted liable to 'suffer death without benefit of clergy, and loss of lands, goods, and chattels'. In 1837 this penalty was reduced to life transportation. Despite these harsh sanctions, British slave trading was not immediately eradicated and illegal activity continued after 1808.[2]

When the 1807 legislation came into force, Britain was at war with Napoleonic France and only a token naval force was earmarked for the initial anti-slavery patrols. The ageing frigate *Solebay* and the sloop *Derwent* were dispatched to West Africa but two ships could do little more than keep an occasional eye on the coast. The number

of vessels was increased to five in 1811 before the demands of war with the United States (1812–14) intervened. Peace in Europe from 1815, and British supremacy at sea thereafter, allowed a permanent squadron to operate off West Africa. It had three key tasks: to maintain a regular patrol along the coast; to find and capture illegal slave ships; and to condemn such captured prizes in the courts. As will become clear, each task presented the navy with very particular problems.[3] The West Africa squadron was supplemented by further patrols off South America and in the Caribbean Sea as part of an attempt to suppress the trade on both sides of the Atlantic. It was, of course, preferable to curtail slaving activity before its victims faced the horrors of the Middle Passage, and so West Africa became the focus of the Royal Navy's most sustained efforts.

Patrolling the coast was an unpleasant, tedious and often frustrating duty. Despite Britain's national commitment to the cause of suppression, the vessels employed on the West Africa station were frequently too old and too slow to catch the slave ships, and were always too few in number to be anything other than sporadically effective. Indeed, the number of ships wholly dedicated to anti-slavery patrols was never more than a small fraction of the Royal Navy's fighting strength. Sailing close to the shore was the most efficient method of intercepting slave ships but it was hampered by the perennial problems of very light coastal winds, inaccurate charts of the creeks, lagoons and river deltas of the region, and the often superior local knowledge of the slave traders. Moreover, tropical heat and endemic diseases made the West Africa station unpopular and dangerous: crews were frequently debilitated by the ravages of yellow fever and malaria, necessitating convalescent visits to Ascension and St Helena to restore some semblance of health. Indeed, West Africa had by far the highest mortality rate of any station maintained by the Royal Navy. As a result, the squadron was left chronically short of men. It was not until the mid-1850s and the widening introduction of quinine-based treatments that medicine began to counter some of the dangers of the 'fever coast', or the 'white man's graveyard' as it became known.[4]

A major part of the problem confronting Britain was how to counter the increase in the transatlantic slave trade in the first part of the nineteenth century, which rose to levels exceeding those of the 1780s. As well as enforcing Britain's abolition acts, the navy was also the instrument of diplomatic efforts to suppress the slave trades of other powers. This proved a tortuous process: there was no reduction in the demand for slaves from the Americas and other nations quickly filled the void left by British abolition. Some British traders breached the new laws but, rather than risk doing so under the red ensign, instead sailed under the colours of other European countries like France, Portugal or Spain, which created a considerable obstacle to active suppression. If its presence off the West African coast was to be more than purely symbolic, the Royal Navy needed the right to detain and search vessels suspected of illegal slave trading. But foreign powers were unhappy with the idea of their merchant shipping being harried by the British fleet and being subjected to what they regarded as the abolitionist peculiarities of Britain's external policy. Efforts to secure a general agreement on the abolition of slave trades failed at both the Congress of Vienna in

1815 and the Congress of Aix-la-Chapelle in 1818.[5] The solution to this impasse was a complex series of bilateral treaties between Britain and various European and American nations, and African rulers. These agreements and their scope had a direct impact on the nature of the trade and on the activities of the Royal Navy in the Atlantic.

In 1817, Britain entered into treaties with Portugal and Spain. Both nations agreed to outlaw their slave trades north of the Equator and allow the Royal Navy the right of search. Spain and Portugal set up Courts of Mixed Commission with Britain at Sierra Leone and elsewhere to adjudicate in cases of captured ships. In return, both countries received substantial payments from the British treasury to soften the blow of this partial abolition. The significant Portuguese trade from Angola to Brazil was unaffected, however, being south of the Equator, and various loopholes and local official collusion saw Spain's huge trade to Cuba continue largely unabated. During the 1830s, when the dynamic and forthright Lord Palmerston was at the Foreign Office, Britain obtained similar agreements from other European and Latin American countries. Although these treaties gave Britain the right to detain and search suspected slave ships, and to impound them and present a case for prosecution at the Vice-Admiralty or Mixed Commission Courts, they were still insufficient to guarantee a successful legal outcome.

The crux of the problem was proving that a ship was intended for a slaving voyage. The presence of enslaved Africans on board a captured vessel was, of course, undeniable evidence of slave trading; but an intercepted vessel found to be carrying manacles and chains, extra planking for the construction of slave decks and additional water storage beyond that required for the crew, could not always be successfully condemned as a slave ship. This caused immense frustration, severely hampered the suppression of the illegal trade and prompted the inclusion of an 'equipment clause' in new treaties to make such evidence admissible. The 1835 treaty with Spain contained this essential legal article, resulting in an almost immediate end of slaving under the Spanish flag. After a great deal of British diplomatic pressure, Portugal followed in 1842.

The introduction of the equipment clause allowed for far greater restriction of the trade, making it much more difficult for those caught to escape conviction. However, it proved impossible to persuade France to adopt similar measures and slave traders thus frequently exploited the protection of the *tricolore*, despite the regular presence of a French anti-slavery squadron off the West African coast. Reaching an agreement with the United States was equally fraught and Washington did not concede the right to search until 1862.[6]

These changes and other developments also affected the individuals involved in the suppression patrols. A series of generous bounties was enshrined in the 1807 Act to compensate for the dangers and discomforts of service on the West Africa station. A system of head money was used to add a financial incentive for the successful interception of slave ships: £60 was paid for each man captured (i.e. liberated), £30 for each woman and £10 for each child. Payments were cut to a flat rate of £10 per slave in 1824, with half the proceeds of the sale of the captured ship and any other goods

going to the Crown, and a percentage of the head money granted to the Royal Hospital for Seamen at Greenwich, for the care of sailors. The rate was cut again to £5 in 1830. The gradual acceptance of the equipment clause meant that empty ships could also be captured but they provided no head money. Further legislation in 1838 removed the Crown's moiety and introduced a payment based on the tonnage of captured ships. It has been calculated that over a million pounds was paid out in anti-slave-trade prize money between 1807 and 1846. However, throughout this period the slowness and cost of the prize courts that determined the awards, and the number of agents and intermediaries requiring payment, meant that very little reached the crews of the individual patrol ships.[7] Much of the enthusiasm shown by officers and men in the West African squadron was the result of personal commitment and evangelical zeal rather than the lure of prize money.

Britain's suppression activities also affected the nature of the slave trade. New slave ships, especially those bound for Cuba, were often built along the sleek lines of Baltimore and New York clippers.[8] They were much faster than the Royal Navy's lumbering brigs, sloops and frigates – which 'sailed like haystacks'[9] – and could carry more Africans than many eighteenth-century vessels. There was also a tendency to cram still more Africans on board to maximise profits on each slaving voyage, especially given the heightened risks of capture and prosecution. Despite the humanitarian intentions of the anti-slavery patrols, this produced an even greater overcrowding and worsened the already abhorrent conditions of the Middle Passage. Commodore Charles Bullen (1769–1853) reported to Admiralty on the scene he found aboard a Brazilian slave ship captured in 1827:

> I have to assure your Lordships that the extent of human misery encountered, as evinced by these unfortunate beings, is almost impossible for me to describe. They were all confined in a most crowded state below, and many in irons . . . The putrid atmosphere emitting from the slave deck was horrible in the extreme, and so inhuman are these fellow creature dealers, that several of those confined at the farther end of the slave-room were obliged to be dragged on deck in an almost lifeless state, and wasted away to mere shadows . . . all were crowded together in a solid mass of filth and corruption, several suffering from dysentery, and although but a fortnight on board, sixty-seven of them had died from that complaint.[10]

The sheer scale of the task confronting the Royal Navy and the sickening nature of the trade cannot be overstated. Nevertheless, there was much contemporary debate on the negative impact of the patrols on conditions aboard slave ships, which even led to calls for the trade to be regulated rather than suppressed, removing the need for the costly naval squadron.[11]

Although technical, legal and political difficulties bedevilled the Royal Navy in the Atlantic Ocean, there were notable successes against illegal traders and in the deterrence and disruption of trading. One method of gaining an advantage over the swifter slave ships was to employ a captured vessel as part of the West Africa squadron. The most famous and successful example was HM Brig *Black Joke*, previously the

Baltimore clipper *Henriquetta*, which was captured by HMS *Sybille* in 1828. The *Black Joke* proved highly effective. The ship was lightly armed with a single 18-pounder gun and carried a crew of 34. The *Black Joke*'s most famous action, against the Spanish slave ship *El Almirante* on 1 February 1829, also illustrates the dangers posed by active suppression.

The *El Almirante* was armed with 14 guns and was a formidable foe. In the desperate 80-minute action, fought at close range, there were significant losses: three British sailors were killed and seven wounded, with 15 Spaniards killed and 13 wounded. Casualties on this scale were not exceptional and, with large sums of money at stake, the crews of slave ships often fought ferociously to avoid capture. In another dramatic action on 5 June 1829, HM Schooner *Pickle*, commanded by Lieutenant McHardy, sighted the heavily laden Spanish slave schooner *Voladora* (or the *Boladora* or *Bolodora* as it is called in contemporary paintings and prints (Cats 272, 594)) off the Cuban coast near Havana. The ship was chased all day and at 11.15pm the *Pickle*, closing fast, fired a warning shot. From 11.30pm until 12.50am the two ships exchanged fire in the dark at musket range, with casualties on both sides. The *Voladora* finally surrendered when its mainmast was shot away. At daybreak, the British seized the ship, which was found to be carrying 335 Africans, who were later set free.[12]

The capture of infamous 'piratical slave ships' and the actions of the Royal Navy were celebrated in popular accounts by naval captains and in paintings and prints, which helped maintain public interest in Britain's suppression activities. The navy's technical capabilities were further enhanced by the deployment of steamships, especially after the 1840s. Although still not fast enough to catch slave ships on the open sea, they proved invaluable inshore where other vessels were hampered by light winds. Despite the navy's successes, it was only able to limit trading from certain parts of the West African coast, lacking the resources to mount an effective blockade.

In the mid-1840s and 1850s sustained Parliamentary attacks on the anti-slavery patrols and presence of a British squadron off the West African coast challenged the navy's efforts. In addition, British abolitionism appeared to be a spent force. With slave emancipation achieved in 1838, its efforts were now centred on the promotion of legitimate trade. This culminated in Thomas Fowell Buxton's ill-fated Niger expedition of 1841, which attempted to establish British settlements to raise the moral standing of Africans and extend British commercial and political influence in West Africa. It was a disastrous failure and had a negative effect on the cause in Britain.[13] The situation was further worsened by the increasing adoption of the doctrine of free trade. The British sugar market was opened to foreign competition in 1846, boosting Cuban production and resulting in a huge increase in the slave trade to Havana.

British domestic policies were now running counter to the suppression of the slave trade, but the abolitionists were too weak to be heard and were out of step with political opinion. Moreover, in Parliament powerful voices called for the withdrawal of the West Africa squadron. The free trade MP, Sir William Hutt (1801–82), chaired a Select Committee to investigate Britain's anti-slavery patrols. Its report presented a catalogue of indictments: the slave trade continued on a large scale, remained profitable

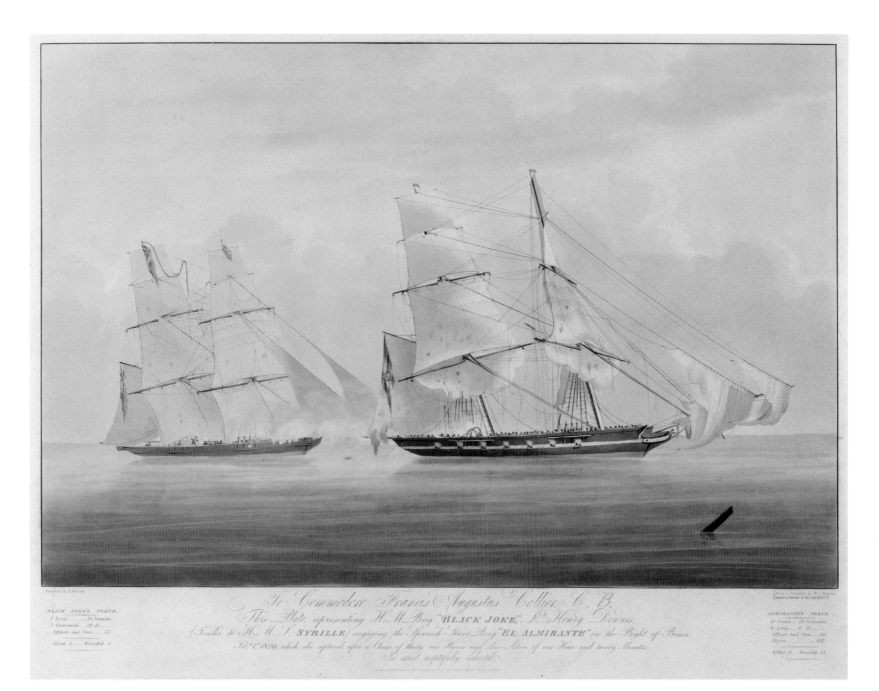

Fig.22: Edward Duncan after William John Huggins, *To Commodore Francis Augustus Collier ...H.M. Brig* Black Joke...*engaging the Spanish slave brig* El Almirante, 1830 (Cat.593) PAH8175.

and was increasing; the navy's patrols were costly, both financially and in the casualty rate from fever; they were extremely inefficient and added to the sufferings of the enslaved Africans. Hutt concluded that Britain had no hope of stopping the trade in its entirety. This assault, and the subsequent debates and additional reports, refocused Parliamentary attention on the suppression of the trade. Hutt and his supporters, however, were unable to present an alternative to the patrols other than complete withdrawal, which was deemed unacceptable. Hutt was defeated and the government, shaken by the controversy, resolved to increase its efforts in the Atlantic, targeting the Brazilian and Cuban trades with renewed vigour.[14]

The campaign against Brazil's trade had accelerated in 1845, when the foreign secretary, Lord Aberdeen, introduced an act allowing the navy to intercept Brazilian slave ships north or south of the Equator, in line with British policy towards Portugal. At the same time, however, the opening of the British sugar market encouraged new development in Brazil, sharply increasing slave imports. Lord Palmerston, who returned to the Foreign Office in 1846, then took the initiative and ordered the Royal Navy to begin active suppression off the Brazilian coast, often in that country's territorial waters and even up-river. The pressure on Brazil paid off and the government in Rio de Janeiro placed slave trading on the same illegal basis as piracy. By 1853, the Brazilian slave trade was officially ended.

At the same time, Britain adopted harsher measures on the West African coast, where the number of patrol ships was increased. The navy also made further use of treaties with African rulers and destroyed some of the infrastructure supporting the trade. This policy of more active intervention along the West African coast resulted in the annexation of Lagos in 1861, which was designed to achieve the complete suppression of the trade from the Bight of Benin. By the end of the 1850s, only the Spanish colony of Cuba remained as a major destination for European and American slave traders. The American Civil War (1861–5) signalled the end of the United States' involvement in the trade, making the Cuban one difficult to sustain in the early 1860s. Finally, changes in the Cuban administration at Havana, and a growing realisation in Cuba and Spain that the trade was unacceptable, brought the system to an end in 1865. The Atlantic trade had finally been defeated, with only an ever-diminishing handful of rogue traffickers prepared to run the gauntlet of the patrols and the increased penalties imposed by all governments.[15]

Ending the East African and Indian Ocean slave trade

The transatlantic trade was not, of course, the only oceanic slave trade. For centuries, significant numbers of Africans captured in the hinterlands of East and Central Africa were transported in dhows to Arabia, the Persian Gulf and South Asia, forming a key component of the Indian Ocean's trading complex. Perhaps a million slaves were exported from East Africa in the nineteenth century. Central to the operation of much of the system in that period was the commercial empire of the Omani sultanate, which developed along the monsoon trading routes of the western Indian Ocean. The sultanate had its eastern base at Muscat in south-east Arabia and its western base at Zanzibar, with other ports and islands along the Swahili coast under varying degrees of Omani control. In the nineteenth century, the activities of European explorers increasingly brought the nature of this trade to the attention of the British public. There was also an illegal trade to Mauritius (which became a British colony in 1810) and a Portuguese trade from Mozambique.[16] The suppression of the Indian Ocean trade was a part of Britain's wider efforts to eradicate slavery and a consequence of its growing imperial presence in the region.[17]

In the first half of the century the Royal Navy's priorities were to end the supply of slaves to the French-owned sugar plantations of Mauritius and prevent European slave traders shifting their efforts to the transatlantic theatre. In 1821, Captain Fairfax Moresby (1786/7–1877) was ordered to halt the trade to Mauritius, which was largely conducted by French merchants and some Arab dhows operating from East Africa and Madagascar. Sir Robert Farquhar, the British governor of Mauritius from 1810 to 1823, had adopted a rather lenient attitude towards the slave trade in a desire to see the economy grow and for fear of alienating the French planter class that dominated the island. The result was an increase in slave imports, which Farquhar tried unsuccessfully to hide before he was censured by his superiors in London and faced criticism from Parliament.[18] Moresby, in contrast, was a zealous abolitionist, enthusiastically committed to his suppression duties. He made an immediate impact, capturing several piratical traders around Mauritius. The more Mauritius and neighbouring Reunion were patrolled, the greater the risks taken by the slave traders, who packed increasing numbers of Africans into smaller, poorly maintained vessels and sailed in terrible weather conditions to avoid capture. Arab dhows of between 60 and 80 tons were crammed with as many as 400 or 500 Africans on platforms only 14 inches apart. As in the Atlantic, active suppression in the Indian Ocean worsened the conditions on board the slave dhows. During the 1840s and 1850s, regular patrols of the Mozambique Channel by Royal Navy ships from the squadron based at the Cape of Good Hope stemmed the supply of slaves from the east coast of Africa to the Atlantic.[19]

The Arab trade was the major focus of operations in the second half of the nineteenth century after the collapse of the Atlantic trade. Moresby had been keen to restrict the supply of slaves to Mauritius from East Africa and turned his attention to Zanzibar. Said bin Sultan (or Seyyid Said, *d*.1856), the imam or sultan of Oman, proved a useful ally for Britain in consolidating and extending its influence around the western Indian Ocean, in the Arabian Sea, in the Gulf and along the East African coast. Pressure was placed on Said, and subsequent rulers of Muscat and Zanzibar, to adopt anti-slavery measures. In 1822, Moresby persuaded Said to prohibit the traffic to India and to the Mascarene Islands (leaving the internal Omani trade unaffected) and to allow the navy to intercept ships operating outside the treaty limits.

Two years later, Captain William Owen observed the scale of trading while surveying the East African coast. The headstrong Owen was appalled at the seemingly unchecked activities of Arab traders. At Mombasa, he became involved in a dispute between the Mazrui, the rulers of the town, and Said. Owen unilaterally declared Mombasa a British protectorate after assurances that the Mazrui would cease trading. This infuriated the British authorities but the unofficial protectorate lasted until London finally condemned the action in 1826. Although motivated by humanitarian concerns, Owen's activities were premature: but the conclusion of the 'Moresby Treaty' had opened the way for a series of further restrictions on the export of slaves from Zanzibar.

The next assault on the trade was the 'Hamerton Treaty' of 1845. Colonel Atkins Hamerton was the first British agent at Zanzibar and he developed a good working

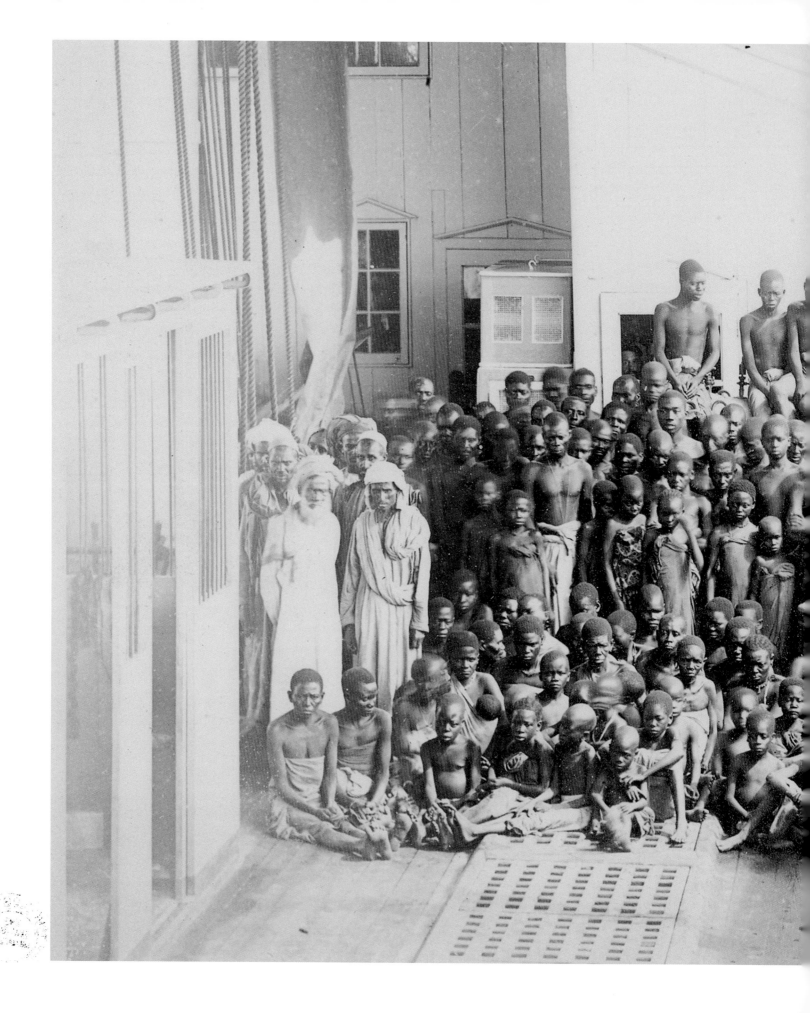

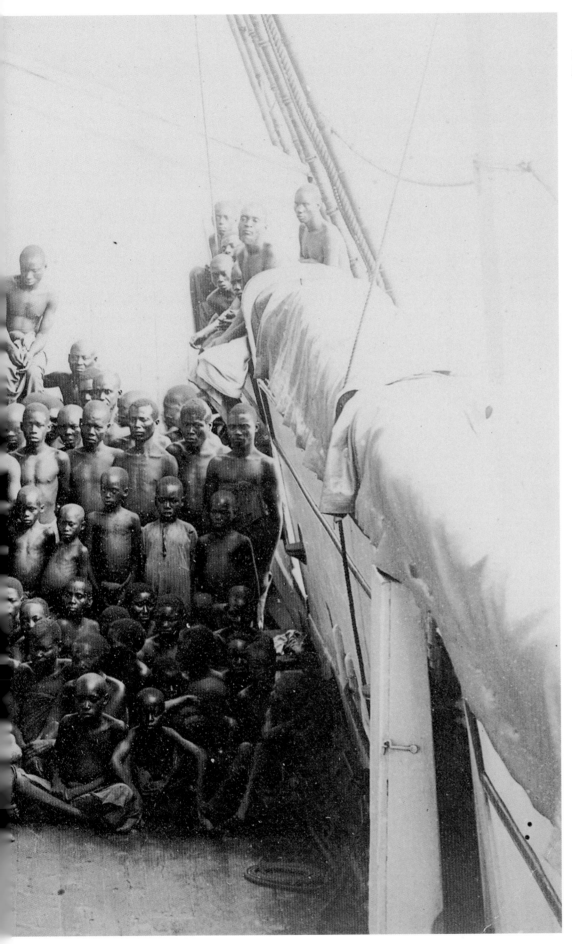

Fig.23: *Cargo of newly released slaves on board HMS* London, *c*.1880 (Cat.293) ZBA2617.

relationship with Said. Under pressure from London to revise the Moresby Treaty and achieve an outright ban on slave trading, Hamerton began a new set of negotiations with the sultan. Said successfully resisted a complete termination and a compromise was reached. Under the new treaty, which came into force in 1847, the traffic of slaves between Africa and Asia was declared illegal, leaving only a regulated trade from East Africa to Zanzibar itself. However, enforcing these new provisions proved almost impossible. The sultan lacked the means and the will to keep his part of the bargain and Britain committed inadequate resources to intercept the large number of dhows involved in the monsoon trade. Furthermore, with domestic slavery still legal in both Zanzibar and Muscat, it was extremely difficult to distinguish the illegal trade from the legitimate passage of slaves within the Omani empire. Sustained diplomatic activity, the presence of a superior naval force and changes in the economy of the region following Said's death and the division of the Omani empire, all brought considerable and conflicting pressures to bear upon the sultans of Zanzibar and of Muscat. But continued British attempts to strengthen the problematic Hamerton Treaty were rebuffed.

In the 1860s, David Livingstone's reports of Arab atrocities against enslaved Africans stirred up renewed British interest. Accordingly, in 1873, Sir Bartle Frere (1815–84), the former governor of Bombay, was sent to the Indian Ocean to secure the abolition of the Zanzibar trade, which he achieved following very difficult negotiations with the sultan, Barghash bin Said.[20] With the trade now illegal, Britain's suppression efforts began in earnest, both at Zanzibar and elsewhere on the coast. However, the nature of the Royal Navy's activities against the Arab trade was as complex as the trade itself and can only be summarised here.

The navy faced many of the same difficulties on the east coast of Africa as it had on the west. Moreover, the Indian Ocean patrols were never as high a priority as those in the Atlantic, and were even less well equipped. The vessels employed were, once more, too old and too slow. Captain Philip Howard Colomb commented on the speed of the Arab dhows and the inadequacies of the available naval ships:

> These vessels are enormously swift; they would tax the powers of our fastest yachts
> in light winds; the most speedy man-of-war, under steam or sail, has her hands full
> when she gives chase to them in a breeze. I have doubted of success, when rushing
> after them at ten and a half miles an hour.[21]

Nevertheless, progress was made using a tested system of operation. The navy stationed a depot ship at Zanzibar – HMS *London* is the most famous example – which acted as a floating base. The anti-slavery patrols were often undertaken by small sailing craft and steam launches that could sail through the shallow lagoons and waterways favoured by the traders. Intercepting the dhows inshore was more effective than trying to outpace them at sea but, as in the Atlantic, the overall impact of the navy's actions was very limited.

The withdrawal of the *London* in 1883 led to a revival in trafficking as the navy switched from a dedicated patrol to regular East African cruises, which continued to

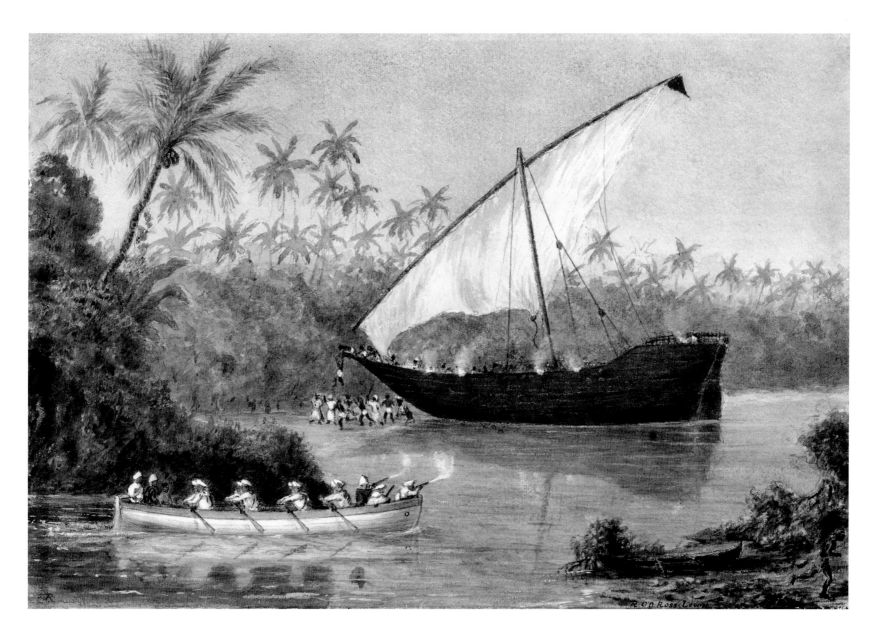

intercept slave traders into the early twentieth century. At this stage, East Africa had fallen more firmly into the European colonial orbit as part of the wider scramble for Africa, with British and German spheres carved out on the mainland and Madagascar becoming a French possession. In 1890, during Anglo-German negotiations over the future of the region, Zanzibar was formally declared a British protectorate and the ending of slavery and the slave trade became an issue for the newly established colonial governments. Between 1860 and 1890 some 1000 dhows were captured and around 12,000 slaves liberated as a result of the British patrols, but this was only a fraction of the huge number of vessels employed in the trade and a tiny proportion of the hundreds of thousands of Africans transported by Arab traffickers. It is clear, however, that the presence of the Royal Navy did discourage the trade and helped to maintain the profile of the British-led anti-slavery movement in the late Victorian era.[22]

Fig.24: Rev. Robert O'Donelan Ross-Lewin, *Pinnace of HMS* London *chasing a slave dhow near Zanzibar*, 1876–7 (Cat.610) ZBA2738.

Britain's suppression of the transoceanic slave trades represented a remarkable episode of sustained humanitarian activity. It involved intricate and problematic diplomacy between the great powers of Europe, African rulers and Asian states; difficult and dangerous naval patrols; and periods of intense political debate and questioning in Britain about the purpose and efficacy of the enterprise. Britain was certainly the foremost power in the long international anti-slavery campaign of the nineteenth century. Its sacrifice for the noble cause was considerable in terms of men, money and naval resources, and the officers and crews employed on the often perilous patrols frequently showed courage and zeal beyond that expected in normal duties. It is all too easy, however, to look upon the actions of Britain and the Royal Navy in suppressing the Atlantic and Indian Ocean slave trades with an unquestioning sense of pride, something which is encouraged by much of the rather dated writing on the subject.

Perhaps three factors need to be borne in mind when attempting to assess Britain's moral crusade against slavery. The first is to remember the long and significant British involvement in the transatlantic trade to 1807: Britain was a slave trader for centuries before its final conversion to abolition. The second is to keep the scale of Britain's commitment to the active suppression of slavery in perspective: it was never the navy's primary task and never the first call on its resources. And finally, it is important to place suppression within the broader history of Britain and Europe's engagement with Africa in the Victorian period. The undoubtedly high ideals of abolition and the promotion of legitimate trade were also among the precursors of partition and colonial rule in Africa.

NOTES

1 See, for example, Linda Colley, *Britons: Forging the Nation, 1707–1837* (London, 1994 edn), pp 350–60.

2 Christopher Lloyd, *The Navy and the Slave Trade: The Suppression of the African Slave Trade in the Nineteenth Century* (London, 1949; 1968 edn), pp 41–2. For the continuation of British slave trading, see Marika Sherwood, 'Britain, the slave trade and slavery, 1808–1843', *Race and Class*, 46, 2 (2004), pp 54–77.

3 W.E.F. Ward, *The Royal Navy and the Slavers: The Suppression of the Atlantic Slave Trade* (London, 1969), pp 43–5.

4 For mortality rates on the West Africa station, see Lloyd, *The Navy and the Slave Trade*, appendix F, pp 288–9; Philip D. Curtin, *Death by Migration: Europe's Encounter with the Tropical World in the Nineteenth Century* (Cambridge, 1989), p.18.

5 Paul Michael Kielstra, *The Politics of Slave Trade Suppression in Britain and France, 1814–48: Diplomacy, Morality and Economics* (London, 2000), chs 2–4; Lloyd, *The Navy and the Slave Trade*, pp 43–4.

6 Ward, *The Royal Navy and the Slavers*, ch.6; Lloyd, *The Navy and the Slave Trade*, ch.4.

7 Lloyd, *The Navy and the Slave Trade*, pp 79–81.

8 These clippers were fast schooners rather than the much larger, full-rigged ships like the *Cutty Sark*, which were used in the tea and wool trades later in the nineteenth century.

9 Lloyd, *The Navy and the Slave Trade*, p.71.

10 Cited in ibid. p.32.

11 See, for example, Robert Stokes, *Regulated slave trade: from the evidence given before the Select Committee of the House of Lords, in 1849* (London, 1851, 2nd edn) (Cat.47); David Eltis, 'The impact of abolition on the Atlantic slave trade', in David Eltis and James Walvin (eds), *The Abolition of the Atlantic Slave Trade: Origins and Effects in Europe, Africa, and the Americas* (Madison, Wisconsin, 1981), pp 155–76.

12 Ward, *The Royal Navy and the Slavers*, pp 135–7.

13 Ibid. pp 189–93.

14 Lloyd, *The Navy and the Slave Trade*, ch.8; Ward, *The Royal Navy and the Slavers*, pp 193–201. For greater detail on the Parliamentary debates, see William L. Mathieson, *Great Britain and the Slave Trade, 1839–1865* (London, 1929), ch.3.

15 Ward, *The Royal Navy and the Slavers*, chs 9–10; Lloyd, *The Navy and the Slave Trade*, chs 10–12. For the number of ships stationed off West Africa in the 1840s, see Serge Daget, 'France, suppression of the illegal trade, and England, 1817–1850', in Eltis and Walvin (eds), *Abolition of the Atlantic Slave Trade*, p.211.

16 There is an extensive literature on East African slavery, the Indian Ocean slave trade and the region's commercial networks. See, for example, Anthony J. Barker, *Slavery and Anti-Slavery in Mauritius, 1810–33: The Conflict between Economic Expansion and Humanitarian Reform under British Rule* (Basingstoke, 1996); R.W. Beachey, *The Slave Trade of Eastern Africa: A Collection of Documents* (London, 1976); Gerald S. Graham, *Great Britain and the Indian Ocean: A Study of Maritime Enterprise, 1810–1850* (Oxford, 1967); Abdul Sheriff, *Slaves, Spices and Ivory in Zanzibar: Integration of an East African Commercial Empire into the World Economy, 1770–1873* (London, 1987). On the number of Africans transported across the Indian Ocean, see William G. Clarence-Smith, 'The economics of the Indian Ocean and Red Sea slave trades in the 19th century: an overview', in idem. (ed.), *The Economics of the Indian Ocean Slave Trade in the Nineteenth Century* (London, 1989), p.1.

17 The best work on the suppression of the East African slave trade is Raymond Howell, *The Royal Navy and the Slave Trade* (London, 1987); see also Lloyd, *The Navy and the Slave Trade*, chs 13–19.

18 See Barker, *Slavery and Anti-Slavery in Mauritius*, ch.3.

19 Ibid. pp 91–3; Marina Carter and Hubert Gerbeau, 'Covert slaves and coveted coolies in the early 19th-century Mascareignes', in Clarence-Smith (ed.), *The Economics of the Indian Ocean Slave Trade*, pp 202–03; Lloyd, *The Navy and the Slave Trade*, ch.15.

20 Lloyd, *The Navy and the Slave Trade*, ch.16; Howell, *The Royal Navy and the Slave Trade*, esp. ch.4; R.J. Gavin, 'The Bartle Frere mission to Zanzibar, 1873', *Historical Journal*, 5, 2 (1962), pp 122–48. For the fullest account of Owen's activities at Mombasa, see Sir John Gray, *The British in Mombasa, 1824–1826* (London, 1957).

21 Philip H. Colomb, *Slave-Catching in the Indian Ocean: A Record of Naval Experiences* (London, 1873), p.38.

22 Howell, *The Royal Navy and the Slave Trade*, pp 220–21.

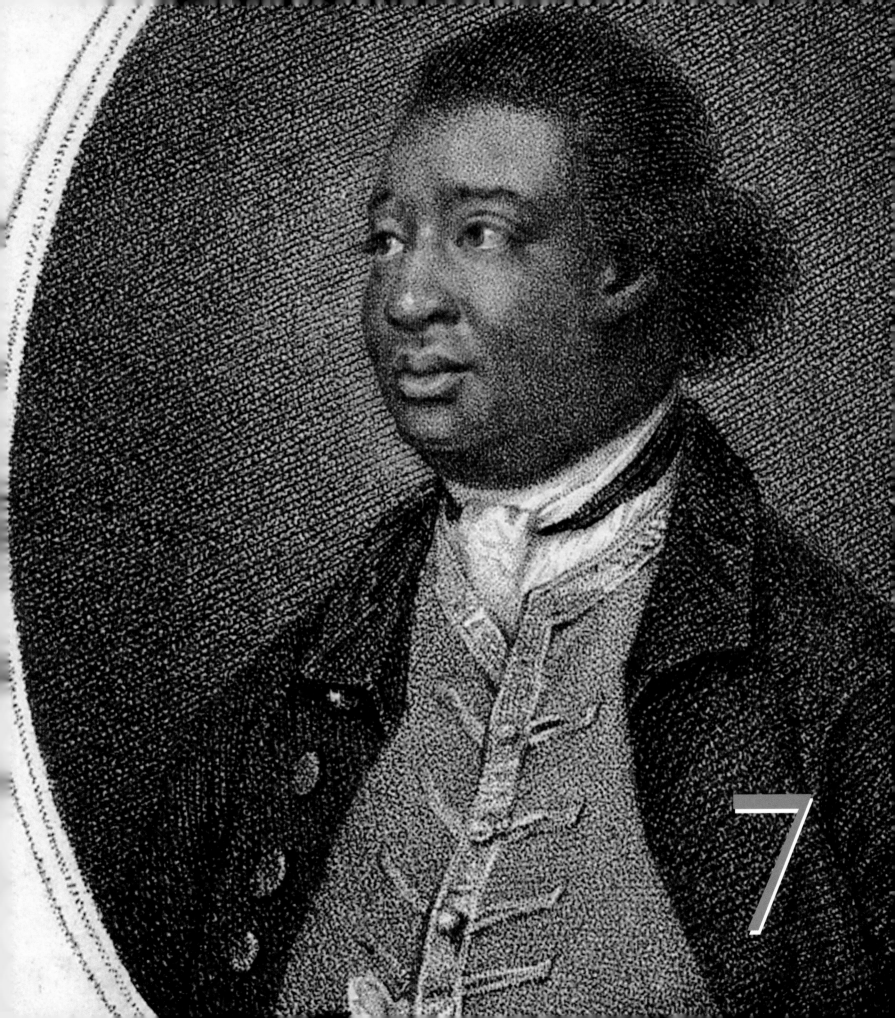

BLACK PEOPLE IN BRITAIN

HAKIM ADI

THE BICENTENARY OF PARLIAMENT'S ABOLITION of the trade in enslaved Africans, in 2007, is an occasion that has once again focused some attention on the sorely neglected history of black people in Britain; that is, all those of African descent. The 1807 Act did not, of course, end the participation of British citizens in the trafficking of enslaved Africans across the Atlantic, nor did it end Britain's interference in Africa: quite the contrary. From 1807 onwards British intervention in Africa can be said to have steadily increased, so that by the end of the nineteenth century Britain, the country that had been the world's leading slave-trading power in the eighteenth century, was poised to be the leading colonial power in Africa during the twentieth. Britain's relationship with Africa and the Caribbean during this whole period was therefore largely exploitative and one that created the conditions for the presence of people of African origin in Britain. It has also bequeathed another important but regrettable legacy: the racism and Eurocentrism that were inseparable from slavery and colonialism have endured, so that even the history of this relationship and of the black presence in Britain have been ignored and distorted.

As one historian has put it, there has been an 'ethnic cleansing' of Britain's history, so that the presence, participation and contributions of black people have been very largely obscured.[1] In 2005, for example, the Qualifications and Curriculum Authority noted in its annual report – and not for the first time – that what it called 'black history' was singularly lacking from the history curriculum taught in Britain's schools.[2] During the same year, the report of the Mayor of London's Commission on African and Asian Heritage highlighted similar omissions in the way that the history and heritage of London, the British city with by far the largest black population, has been presented.[3] The increasing prominence given to Black History Month throughout the country only underlines the fact that such history is 'ghetto-ised' and largely neglected for the rest of the year.

However, academic interest in the history of black people in Britain dates back at least as far as 1947, when Kenneth Little's *Negroes in Britain* was first published.[4] Although this was largely an anthropological study, it contained an important chapter entitled 'The Negro in Britain – 1600 AD to the present day', as well as other significant historical material, which has been the starting point for many subsequent studies. Pre-dating Little's research was the pioneering work of the African-American writer J.A. Rogers, while research into the presence of black people in Britain could be said to have begun in the nineteenth century with the work of David MacRitchie and others.[5] Yet, despite such early examples of research on the history of those of African origin in Britain, and a recognition that this history stretches back at least to Roman times, there

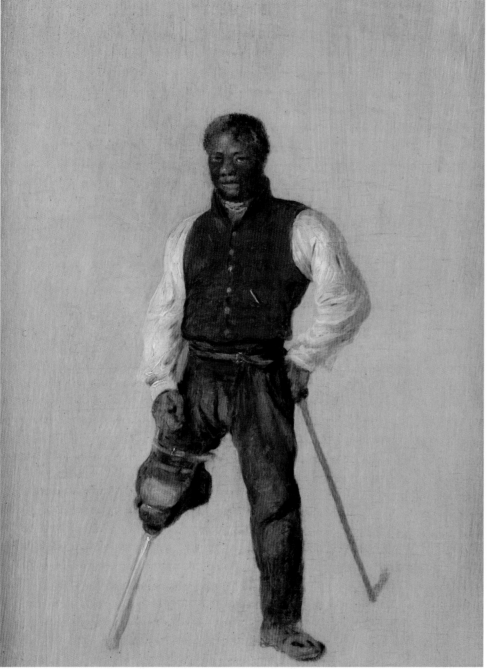

Fig.25: Sir David Wilkie (attr.), *Billy Waters*, *c*.1815 (Cat.279) ZBA2427.

is still a reluctance fully to incorporate evidence of this presence into mainstream British history. In recent years, however, there have been signs of some progress and increasing numbers of publications.[6]

The significance of such history lies not just in the fact that it relates to those of African origin who currently reside in Britain. It is equally important to recognise that failure to admit the historical diversity of Britain's population means that an important element of Britain's history is lost. Without such recognition we only receive a

distorted, one-sided picture of our shared historical past. Moreover, we need to ask what useful lessons can be drawn from a presentation of the past that is so distorted, particularly at a time when it is vital that all of us have a broad education and a truly enlightened understanding not only of our own society but also of the rest of the world.

The earliest arrivals

In the third century AD, when the Libyan-born 'African emperor' Septimus Severus ruled over Britain and the rest of the Roman Empire he was accompanied by several other African conquerors, a fact that has led to the assertion that Africans were in England before the ancestors of the English.[7] The details of the lives of most of them are still lost to us, but we know much more about Africans in Roman Britain than we do about them during the next thousand years or so. From the eighth century to the fifteenth Africans still appeared in Europe as conquerors. The Moors, as the rulers of the Iberian peninsula have become known, created, or at least bequeathed to Europe, a civilisation unmatched in the West during this period, but as yet we have little hard evidence regarding their connections with Britain. In the period before 1500, our knowledge is mainly restricted to glimpses of individuals: these include a young African woman buried in Norfolk about AD 1000, a runaway 'Saracen' slave and a 'Saracen' crossbow-maker in the thirteenth century, and North Africans visiting the shores of the British Isles both as pirates and as captives.[8]

Indeed it is not until the early sixteenth century that more solid evidence exists of an African presence in England and Scotland. The African musicians and performers at the royal courts of that time most probably came via Portugal, some of them accompanying Catherine of Aragon when she arrived in England in 1501. The names of some of them have been preserved for us, the two most well known being Elen More, who served at the Scottish court, and the royal trumpeter John Blanke, who was employed by Henry VII and is pictured in the Westminster Roll of 1511, one of the earliest images of an African in England. Another was Jacques Francis, an African diver, who participated in recovering items from the wreck of the *Mary Rose* in 1547. But they are just the most well known of what was to become a sizeable presence during Tudor times. So sizeable, in fact, that Elizabeth I issued two orders to remove 'blackamores' from her kingdom, orders that appear to have gone unheeded. Researchers in black history are only now fully investigating this.

The information currently available about black people in Tudor England is certainly sufficient to substantiate the view that people of African origin have continuously resided in Britain since that time. Research to quantify this is made more difficult by the fact that many different terms were employed at the time and later to describe 'people of colour', including Neger, Negro, Blacke, Ethiopian, Blackamore and several others. Most of the existing records suggest a presence in London and Plymouth for these African men, women and children, who appear to have been employed mainly as servants but not just at the royal courts. Robert Cecil, Francis Drake, Walter

Ralegh and John Hawkins all had black servants, as did the Earl of Leicester.[9] It was a period during which the English had their first direct encounters with Africans not only in the Caribbean but also in Africa itself. The kidnapping of Africans, such as those brought by John Lok to England in 1555, began at this time, but did not develop to the extent that it would in the following centuries. The status of Africans in Tudor and Jacobean England and the extent of this presence is a subject that demands further investigation.

The seventeenth and eighteenth centuries

The overriding reason for the presence of Africans in Britain during the seventeenth and eighteenth centuries is connected with Britain's involvement with the transatlantic trade in enslaved Africans. Clearly some of those Africans who were in England during Tudor times were also slaves, or little better than slaves. From the mid-seventeenth century, the numbers of Africans in Britain increased as England became more involved with the transatlantic trade, established a greater presence along the coasts of Africa and founded its own colonies in the Caribbean. Some Africans arrived in the country as free people, often as seafarers, a trend that would continue for several centuries; but acquiring Africans, especially children, as household slaves and servants became something of a fashion by the late 1600s. The arrival of significant numbers of African

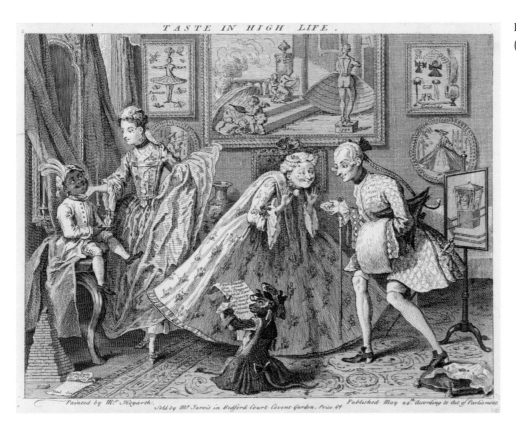

Fig.26: William Hogarth, *Taste in high life*, 1746 (Cat.514) ZBA2598.

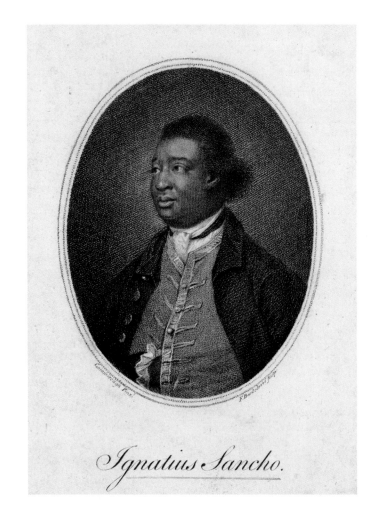

Ignatius Sancho.

Fig.27: Francesco Bartolozzi, *Ignatius Sancho*, 1781 (Cat.577) ZBA2573.

slaves in Britain in the seventeenth century naturally led to the birth of a black British population, as well the beginnings of a tradition of escape, resistance and liberation. The earliest adverts for runaway slaves date from this period, while there are numerous examples in the visual art of the period of enslaved African children: sometimes they were pictured wearing a metal collar denoting servile status; but at others, they were shown dressed in 'oriental' costumes (as in Figure 26). It used to be thought that people of African origin could only be found in the main port cities such as London, Plymouth, Liverpool and Bristol during the seventeenth and eighteenth centuries. However, all the latest research, and evidence from parish records, points to a much greater geographical spread than was hitherto thought possible: black people appear in towns and even villages throughout England from Dorset to Yorkshire.[10] (Of course it must be remembered that during this period many smaller ports were involved in the slave trade, including those of Devon and Cumbria.) One of these Africans still remembered is known only as Sambo, a young servant to a slave trader in Lancaster, who died shortly after being brought to Britain in 1736. One can still visit his grave at Sunderland Point, near Lancaster. Another is Scipio Africanus, the servant of the Earl of Suffolk who died at the age of 18 and is buried at Henbury, near Bristol. Africans in the seventeenth century had a variety of occupations. One, only known to us as Mingo, worked as a lighthouse-keeper in Harwich,[11] while John Moore, a black merchant, is listed in the 1687 freemen's rolls of York.[12]

By the end of the eighteenth century, contemporary commentators were expressing concern about the number of black people in Britain which may have amounted to as many as 30,000 in London alone. It is still not entirely clear if it was numbers or wider political concerns that led to a ban on apprenticeships for black people in London in 1731. Certainly black men and women were to be found all over the country during this century and engaged in a variety of occupations. They included the armed forces and merchant navy, highwaywomen and servants, grocers, writers and political activists. Many of the most notable figures were connected with the growing abolitionist movement that developed in the last quarter of the century; men such as Ukawsaw Gronniosaw, Ignatius Sancho, Ottobah Cugoano and, the most famous of all, Olaudah Equiano (Cat.565), whose autobiographical *Narrative* was a bestseller in its day. Africans in London clearly had their own political organisation, styling themselves the Sons of Africa. The campaigns for abolition were among the earliest and largest mass political movements in Britain's history, with men such as William Wilberforce generally taking the limelight as their central political figures. Unfortunately this has also tended to obscure the wider movement and the leading role played by black people themselves.

There is also evidence that black people organised their own social events and entertainment, as well as assisting each other to escape from slavery. It may be that it is from this period that we can begin to speak of recognisable black communities in certain parts of London. By the end of the century the numbers of black poor in London were swollen by hundreds of 'black loyalists' who had fought for Britain against American independence. Many were subsequently forced to leave the country and were deposited in Sierra Leone, Britain's first African colony, where the vast majority soon died.

The eighteenth century witnessed a determined struggle for liberation among black people in Britain. They not only liberated themselves but were also the subject of important legal cases relating to British slavery, which took place throughout the century and included the famous Mansfield Judgement of 1772. Perhaps just as importantly, a tradition of participation in all the major political events of the country was established. Equiano, for example, was not just a leading abolitionist but also a member of the radical London Corresponding Society.

The nineteenth and twentieth centuries

Some years ago an eminent historian wrote of the 'disintegration of black society' in Britain in the nineteenth century, but it would now seem that such claims were greatly exaggerated.[13] Undoubtedly intermarriage between black and white continued and, after the abolition of slavery throughout the British Empire had come into force in 1834, fewer black slaves and servants were brought to Britain. However, the black population continued to exist and from this time we can speak of established communities in the port cities such as Liverpool, Cardiff and London, as well as many other places. Many of Britain's oldest African populations, such as the Somalis, Kru and many others who worked as seamen, established themselves during this period, while the black community in Liverpool was probably established long before it, based not only on seafarers and other workers but students and merchants too.[14] In the 1860s Charles Dickens wrote about a pub in Liverpool used by black people and run by a black landlord; and it was Liverpool that produced Britain's first black mayor, John Archer.[15] By the beginning of the nineteenth century many of the black population were born in Britain, including the famous missionary Thomas Birch Freeman, the composer Samuel Coleridge-Taylor and the Chartist leader William Cuffay.

As in previous centuries, we know much more about those who were literate or prominent – such as Mary Seacole, the mid-nineteenth-century nursing pioneer, although she is still not as widely known or celebrated as Florence Nightingale. Many significant figures remain largely unknown, however, such as John Edmonstone, who taught Charles Darwin taxidermy and possibly much more besides.[16] Recent research suggests that there is much that is still undiscovered but that archival sources can produce not only written evidence concerning the black presence, but photographic evidence also.[17]

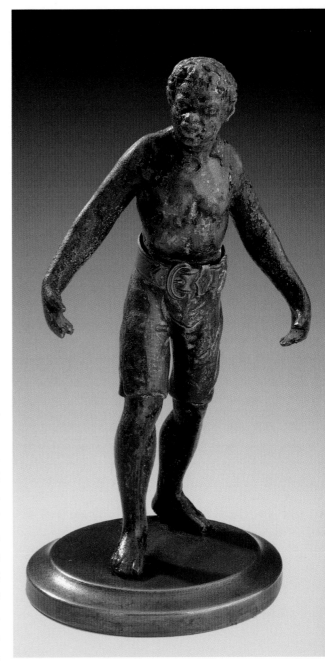

Fig.28: Prizefighter statue, 19th century (Cat.212) ZBA2470.

Black people in nineteenth-century Britain continued the tradition of participation in political activities, especially those directed against slavery and colonialism, and those concerned with defending the rights of all. Activists such as Robert Wedderburn, William Davidson and Cuffay upheld this tradition in the earlier part of the century just as Henry Sylvester Williams and the African Association did at its close. As the twentieth century dawned, the struggle against racism and for the rights of Britain's colonial subjects was advanced by the inception of many more political organisations and what might be referred to as a black press, as well as the emergence of the Pan-African movement in Britain. The first Pan-African conference, organised in London in 1900 by the African Association, attracted delegates from Africa and the African diaspora; and in the following half century, three further Pan-African congresses were held in Britain, the most famous in Manchester in 1945. Britain, as the hub of a worldwide empire, became an important meeting and lobbying place, a centre of Pan-Africanism and anti-colonialism frequented by all the major black political figures: Paul Robeson and C.L.R. James, Amy Ashwood and Marcus Garvey, Kwame Nkrumah and George Padmore. The organisations established by black people in Britain – for example the West African Students' Union, the League of Coloured Peoples and the Pan-African Federation – also had an internationally significant role.[18]

* * * * *

Unfortunately, however, racism remained legal in Britain until 1965 and in the early 1900s there was a wide-ranging 'colour bar'. A series of riots directed at black people and other minorities in nine different towns and cities in 1919 are now largely forgotten, as are similar attacks in Liverpool in 1948 and London in 1949.[19] They point to the problems faced by communities of black workers and their families in Britain, problems often exacerbated by openly racist legislation such as the 1925 Coloured Alien Seamen's Order.[20]

Long forgotten too are the sacrifices that black people, alongside others in Britain, made during two world wars, at a time when a colour bar and discrimination also existed in the armed forces and in other areas of British life, and long before governments encouraged mass immigration from the colonies to Britain to solve labour shortages and rebuild Britain's war-ravaged economy after 1945. The arrival of the *Empire Windrush* in 1948 has been used to symbolise the emergence in Britain of the large post-war Caribbean population – yet another legacy of the nation's historical involvement with slavery and colonialism, but only one chapter in a much longer history of black people in the British Isles.[21]

1 Ian Duffield, contribution to *A Son of Africa: The Slave Narrative of Olaudah Equiano* (BBC documentary, 1995).

2 Qualifications and Curriculum Authority, *History 2004/5 Annual Report on Curriculum and Assessment* (Qualifications and Curriculum Authority, 2005).

3 Mayor's Commission on African and Asian Heritage, *Delivering Shared Heritage* (Greater London Authority, 2005).

4 Kenneth Little, *Negroes in Britain: A Study of Racial Relations in English Society* (London, 1947).

5 See, for example, J.A. Rogers, *World's Great Men of Color*, 2 vols (New York, 1947; republished 1996); and David MacRitchie, *Ancient and Modern Britons*, 2 vols (London, 1884).

6 See, for example, David Dabydeen, John Gilmore and Cecily Jones (eds), *The Oxford Companion to Black British History* (Oxford, 2007). For a general history, see Peter Fryer, *Staying Power: The History of Black People in Britain* (London, 1984).

7 Paul Edwards, 'The early African presence in the British Isles', in Jagdish S. Gundara and Ian Duffield (eds), *Essays on the History of Blacks in Britain* (Aldershot, 1992), pp 9–29.

8 Sue Niebrzydowski, 'The Sultana and her sisters: black women in the British Isles before 1530', *Women's History Review*, 10, 2 (2001), pp 187–210. See also Edwards, 'The early African presence'; Marika Sherwood, 'Blacks in Tudor England', *History Today*, 53, 10 (2003), pp 40–42.

9 Sherwood, 'Blacks in Tudor England'.

10 See, for example, details of material in the 'Parish and other records' section of the *Black and Asian Studies Association Newsletter* from 1999 onwards.

11 See 'Parish and other records', *Black and Asian Studies Association Newsletter* (January 2003), pp 25–6.

12 See The National Archives' Black Presence website at http://www.nationalarchives.gov.uk/pathways/blackhistory/.

13 James Walvin, *Black and White: The Negro and English Society, 1555–1945* (London, 1973), ch.12.

14 On the Kru seamen, see Diane Frost, *Work and Community among West African Migrant Workers since the Nineteenth Century* (Liverpool, 1998); and on Liverpool, see Ray Costello, *Black Liverpool: The Early History of Britain's Oldest Black Community, 1730–1918* (Liverpool, 2001).

15 Charles Dickens, *The Uncommercial Traveller* (London, 1898 edn).

16 On Edmonstone, see R.B. Freeman, 'Darwin's negro bird-stuffer', *Notes and Records of the Royal Society of London* (1978–9), pp 83–6.

17 See, for example, David Killingray, 'Tracing peoples of African origin and descent in Victorian Kent', in Gretchen H. Gerzina (ed.), *Black Victorians/Black Victoriana* (New Brunswick, New Jersey, 2003); Caroline Bressey, 'Forgotten histories: three stories of black girls from Barnardo's Victorian archive', *Women's History Review*, 11, 3 (2002), pp 351–74.

18 On the West African Students' Union, see Hakim Adi, *West Africans in Britain 1900–1960: Nationalism, Pan-Africanism and Communism* (London, 1998). See also Hakim Adi and Marika Sherwood, *The 1945 Manchester Pan-African Congress Revisited* (London, 1995). For details of some of the personalities of this period, see Hakim Adi and Marika Sherwood, *Pan-African History: Political Figures from Africa and the Diaspora since 1787* (London and New York, 2003).

19 On the 1919 riots, see Jacqueline Jenkinson, 'The 1919 riots', in Panikos Panayi (ed.), *Racial Violence in Britain, 1840–1950* (Leicester, 1993), pp 92–111. On the 1948 riot in Liverpool, see Andrea Murphy, *From the Empire to the Rialto: Racism and Reaction in Liverpool 1918–1948* (Birkenhead, 1995).

20 See Laura Tabili, *'We Ask for British Justice': Workers and Racial Difference in Late Imperial Britain* (London, 1994).

21 On this period, see Trevor Phillips and Mike Phillips, *Windrush: The Irresistible Rise of Multi-Racial Britain* (London, 1998); Marika Sherwood, *Claudia Jones: A Life in Exile* (London, 2000).

THE MATERIAL CULTURE OF SLAVE SHIPPING

JANE WEBSTER

SHIPS, ALONG WITH THEIR FITTINGS and the many material things they transported, are artefacts (or man-made relics) of the transatlantic slave trade. By studying these artefacts we can gain important insights into many aspects of the shipping of human cargoes. At first sight, however, slave ships seem to be beyond direct reach. Although it is still possible to walk upon the decks of numerous ships from the age of sail including Nelson's flagship HMS *Victory* and the tea clipper *Cutty Sark*, no slave ship remains intact. In the absence of surviving vessels of any given period or type, wrecks would normally take on a particular importance. But here again we face difficulties: only a handful of slaver wrecks have been located, and only two of them – the English *Henrietta Marie* (1700) and the Danish *Fredensborg* (1768) – have so far been explored in detail by maritime archaeologists.[1]

Artefacts recovered from the *Fredensborg* and the *Henrietta Marie* range from trade goods and shackles to the personal effects of the ships' crews. These items speak to us about the transatlantic trade with a powerful voice, and it is unfortunate that we do not have more wreck sites at our disposal. But even without these, there are other ways in which we can study the material culture of slave shipping. At the simplest level, many of the artefacts used on slave ships were common to seventeenth- and eighteenth-century merchant ships of all kinds, and many examples can be found in the National Maritime Museum and other collections in Britain. More satisfactorily, contemporary documentary sources and paintings can help us to identify a range of items – from trade goods to food supplies, from deck modifications to shackles and other restraints – specific to slaving voyages. Examples of some of these things also survive in museum collections.[2]

This essay examines some of these artefacts by looking in turn at each leg of a slaving voyage in the so-called 'triangular trade'. On its outward journey to Africa, a 'Guinea' ship was laden with trade goods that would be exchanged for slaves. The second leg of the voyage comprised the infamous 'Middle Passage', the Atlantic crossing endured by Africans as they were forcibly transported to the Americas. On the final leg of its journey, a slave ship carried back to Europe from the Americas a cargo of colonial products such as sugar and rum. These imports were almost always the products of slave labour, but tell us nothing about slave shipping itself, and are not discussed here. Sailors returning to Europe on a slave ship, however, sometimes brought African things home with them and some suggestions are offered for further research here.

The outward voyage: Europe to Africa

On its outward voyage, a slave ship was laden with trade goods, carefully selected to meet the localised requirements of slave dealers on the West African coast. Africans were very selective consumers of European goods, demanding artefacts in media, styles and colours that accorded with their own traditions and tastes. Glass beads and metal goods for the slave trade – the most durable among a wide range of British-made products that also included cloth and alcohol – can be found in a number of British museums. Manillas (brass 'bracelets'), iron bars, and copper and brass 'rods' were all manufactured in standard weights and sizes, and served as the staple currency of the slave trade (Cat.2). Once they reached Africa, most of these objects, along with sheet brass 'battery wares' and pewter goods, would be melted down and the metal reused in a variety of ways.

Alcohol, in the form of rum or gin, was another important commodity carried by slave ships. Some of this, stored in enormous wooden casks, was rationed out to the crew and, during the Middle Passage, to the captives. But spirits were also traded directly for slaves and alcohol was very commonly presented to African traders and rulers during trading negotiations. Thus, among the inventory of trade goods listed in the 1759 account book of the slaver *Molly* we find 60 'wicker'd bottles', 50 'juggs' and 60 'caggs' (small casks) of brandy (Cat.114).[3] From the late eighteenth century onwards, Dutch gin, transported in cheaply manufactured blown glass bottles, was similarly given to African traders or employed as a trade good.

Through such negotiations, which often lasted for several months, a slave-ship master would gradually acquire a human cargo. An average ship would carry several hundred slaves, and these captives would require food and water throughout the Middle Passage, a voyage that lasted many weeks. Slave ships had the greatest daily food requirements of any craft on transoceanic trading voyages at this time, and the acquisition of provisions such as rice, maize, beans and yams entailed further complex

Fig.29: Gin bottle, 19th century (Cat.9) AAA2819.

Fig.30: Ivory and white metal bracelet, *c*.1785 (Cat.82) ZBA2494.

Fig.31: Plan of the *Hall*, from William Hutchinson, *A treatise on naval architecture*, *c.*1794 (Cat.24) PBB8247.

negotiations with local African traders.[4] Commercial relationships between Europeans and Africans sometimes resulted in the manufacture of artefacts such as bracelets.

Artefacts from the Middle Passage

On the second leg of its voyage, a slave ship carried human beings. Very few vessels were built expressly for that purpose, however. Indeed, three-quarters of the British ships employed as slavers had originally been involved in other maritime trades.[5] In order to accommodate the greatest human cargo possible, a series of temporary modifications therefore had to be made to a ship on its arrival in Africa. The most important of these was the construction of 'slave decks', partial decks and platforms inserted into the space below the main deck and above the second ('tween) deck. We know from measurements taken in 1799, towards the end of the British slave trade, that on ships of 250 tons and above, extra space equivalent to around three additional

decks was created by this means.[6] Africans would spend much of their Middle Passage to the Americas lying on these cramped and intolerably crowded platforms, with an average of around five to six square feet of living space per person.[7]

A second key temporary modification was the *barricado*, a wooden partition stretching across the quarterdeck, securing the area used by slaves when they were brought up from below for air, exercise and meals. Both modifications required timber, carried from Britain expressly for this purpose, and were overseen by the ship's carpenter. The carpenter was so important to the success of a voyage that many slave ships carried two, or even more. Additional modifications to slaving vessels included the construction of a 'house' (a shelter for the slaves, dismantled before the ship departed from Africa) and the placement of netting around the upper deck to deter captives from jumping overboard. Alexander Falconbridge, a Bristol man who served as a surgeon on four slaving voyages in the 1780s, provided a detailed description of these modifications. He noted the complicated construction of the 'house', involving spars and rafters, poles and latticework, mats and ropes. He also observed the building of the *barricado*.

> It is about eight feet in height, and is made to project near two feet over the side of the ship. In this barricado there is a door, at which a sentinel is placed during the time the Negroes are permitted to come upon deck. It serves to keep the different sexes apart, and as there are small holes in it, wherein blunderbusses are fixed, and sometimes a cannon, it is found very convenient for quelling the insurrections that now and then happen.[8]

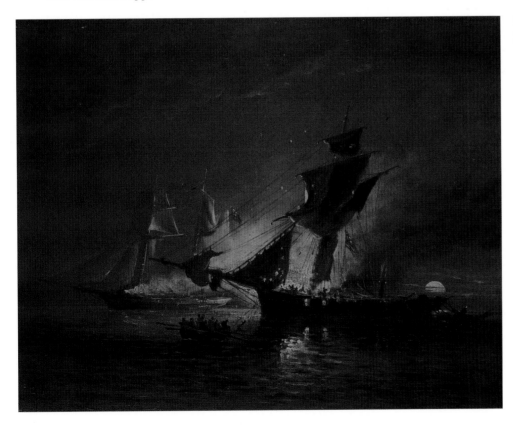

Fig.32: John Moore, *The capture of the slaver Boladora, 6 June 1829* (Cat.272) BHC0624.

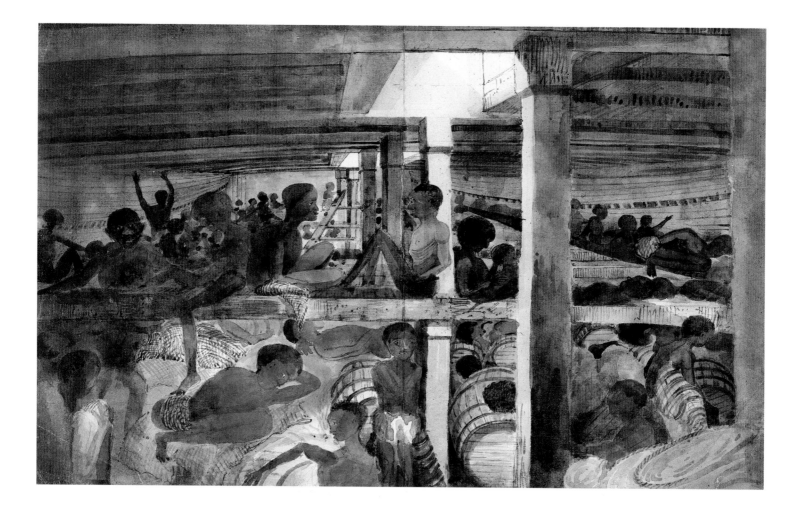

Fig.33: Francis Meynell, *Slaves below deck*, 1846 (Cat.499) MEY/2.

While relatively few in number, paintings of slave ships (including the Spanish vessel known as the *Boladora* – see Figure 32) are an important source of information on this series of modifications, which transformed a merchant cargo vessel into a slaver.

Identifying slave ships in paintings is not always easy, however. A good example here is William Jackson's painting *A Liverpool slave ship* (*c.*1780) at the National Museums of Liverpool.[9] Although ventilation holes can be seen just above the waterline on this unnamed vessel (a likely indicator of the presence of slave decks), the ship's identification as a slaver remained uncertain until recent cleaning of the background revealed the coast of West Africa, with longboats ferrying slaves to the vessel for embarkation on the Middle Passage. These details were presumably over-painted after the abolition of the British slave trade in 1807, a point which itself underscores the kinds of problem slave-ship paintings can pose for researchers.[10]

Various paintings and other depictions of conditions and stowage arrangements on board slaving vessels survive. Undoubtedly one of best-known slavery-related images in the National Maritime Museum collection is the *Brooks* print (Cat.481), depicting arrangements for stowing slaves on board a Liverpool slaver. Images of the interiors of British slave ships are extremely rare. The majority of paintings depict foreign vessels seized by British anti-slavery patrols in the 'illegal era' following the abolition of the

British trade in 1807. Lieutenant Francis Meynell's well-known drawings of the Spanish slave ship *Albanoz* fall into this category (see Figure 33).

Once a ship's slave 'quota' was met, the vessel began its journey to the Americas. We know something of the horrors of a Middle Passage voyage through the eyewitness testimonies of white sailors such as Thomas Phillips and Alexander Falconbridge, and from the famous account of Olaudah Equiano, but surviving artefacts also contribute to our understanding of the daily routines of slave ships. Many of these are items of restraint and punishment, such as single and double shackles (bilboes), thumbscrews, whips and branding equipment. Other items manufactured for slavers included the *speculum oris*, a device for opening the jaws, which was used to force-feed those unwilling or unable to eat. In 1788 the abolitionist Thomas Clarkson purchased shackles, a thumbscrew and a *speculum oris* from a Liverpool shop, and placed them in the mahogany chest in which he collected items illustrative of Africa and the slave trade (see Figure 34). The chest was presented to the Wisbech and Fenland Museum in 1870 but these specific items are unfortunately no longer among its contents.[11]

Components for 81 bilboes or double iron shackles were recovered from the wreck of the *Henrietta Marie*, enough to hold more than 160 people.[12] Bilboes comprised a pair of U-shaped shackles, which were fitted over the ankles or wrists. Commonly, two individuals would be coupled together in one double shackle (that is, the right ankle of one person would be shackled to the left ankle of another). Loops at each terminus slid onto a bolt of iron around a stock. An iron wedge was hammered into the stock to lock the shackles. Contemporary documentary sources suggest that slaves were not usually kept in irons throughout the entire Middle Passage. On the majority of ships the procedure described by Thomas Phillips, master of the *Hannibal* (1693) appears to have been followed:

> When our slaves are aboard we shackle the men two and two, while we lie in port, in the sight of their own country, for 'tis then they attempt to make their escape, and mutiny. . . . When we come to sea we let them all out of irons, they never attempting then to rebel, considering that should they kill or master us, they could not tell how to manage the ship, or must trust us, who would carry them where we pleas'd; therefore the only danger is while we are in sight of their own country.[13]

Women and children were rarely shackled, if contemporary accounts are to be believed. On the other hand, some of the bilboes recovered from the *Henrietta Marie* were diminutive, even if employed as wrist shackles.[14] Shackles, collars and thumbscrews were also used punitively, to chastise slaves who rebelled against their treatment. Thus John Newton's journal from the voyage of the *African* (1752) contains the entry:

> 11th [December] – made a timely discovery today that the slaves were forming a plot for an insurrection. Surprised 2 of them attempting to get off their irons, and upon farther search in their rooms, upon the information of 3 of the boys, found

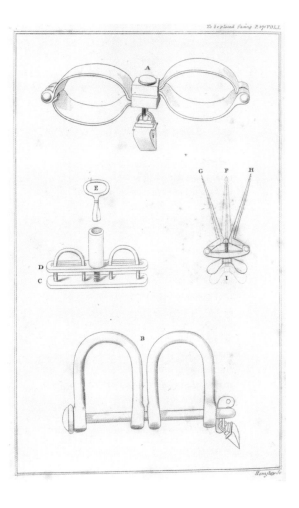

Fig.34: Thomas Clarkson's instruments, illustrated in Clarkson, *The history of the rise, progress and accomplishment of the abolition of the African slave-trade by the British Parliament,* 1808 (Cat.22) PBB3495.

some knives, stones, shot etc and a cold chisel. . . . put the boys in irons and slightly in the thumbscrews to urge them to a full confession. 12th – examined the men slaves and punished 6 of the principals, put 4 of them in collars.[15]

As has already been noted, slave ships making the Middle Passage needed to carry an adequate supply of provisions for both slaves and crew. Eyewitness accounts furnish a good deal of information about the food provided for slaves, and the feeding regimes employed upon British vessels. Thomas Phillips noted that:

> . . . they are fed twice a day, at 10 in the morning and 4 in the evening, which is the time they are aptest to mutiny, bring all upon deck; therefore all that time, what of our men are not employ'd in distributing their victuals to them, and settling them, stand to their arms; and some with lighten matches at the great guns that yaun upon them, loaden with partridge, till they have done and gone down to their kennels between decks: their chief diet is called dabbadabb, being Indiancorn ground as small as oat-meal in iron mills, which we carry for that purpose; and after mix'd with water and boil'd well in a large copper furnace, till 'tis thick as a pudding; about a peckful of which in vessels, called crews, is allow'd to 10 men with a little salt, malagetta, and palm oil to relish; they are divided into messes of ten each for the easier and better order in serving them: three days a week they have horse-beans boiled for their dinner and supper, great quantities of which the African company do send on board for that purpose; these beans the negroes extremely love and desire. . . .[16]

Almost one hundred years later, the surgeon Alexander Falconbridge reported that:

> The diet of the negroes, while on board, consists chiefly of horse-beans, broiled to the consistency of a pulp; of boiled yams and rice, and sometimes of a small quantity of beef or pork. The latter are frequently taken from the provisions laid in for the sailors. They sometimes make use of a sauce, comprised of palm-oil, mixed with flour, water and pepper, which the sailors call *slabber-sauce*. Yams are a favourite food of the Eboe, or Bight negroes, and rice or corn, of those from the Gold and Windward Coasts; each preferring the produce of their native soil.[17]

Grains and beans were ground or pounded to make them digestible. Phillips (above) mentions the use of an iron mill to grind maize, and one of the finds from the wreck of the *Fredensborg* was a large stone mortar, of the type used in West Africa to grind millet.[18] Cooking equipment has also been recovered from the wreck of the slaver *Henrietta Marie*, which foundered off the coast of Florida in 1700.

Conditions between decks on a slave ship were appalling. Dysentery and diarrhoea flourished as a result of overcrowding, poor diet, dehydration and the lack of sanitation, and on top of this slave ships were uniquely exposed to three separate disease environments (northern European, sub-Saharan African and American) in the course of any single voyage.[19] In order to minimise human, and therefore financial, losses, British slave ships usually carried surgeons and from 1788 were legally obliged to do so.[20] Valuable information on medical regimes comes from documentary sources,

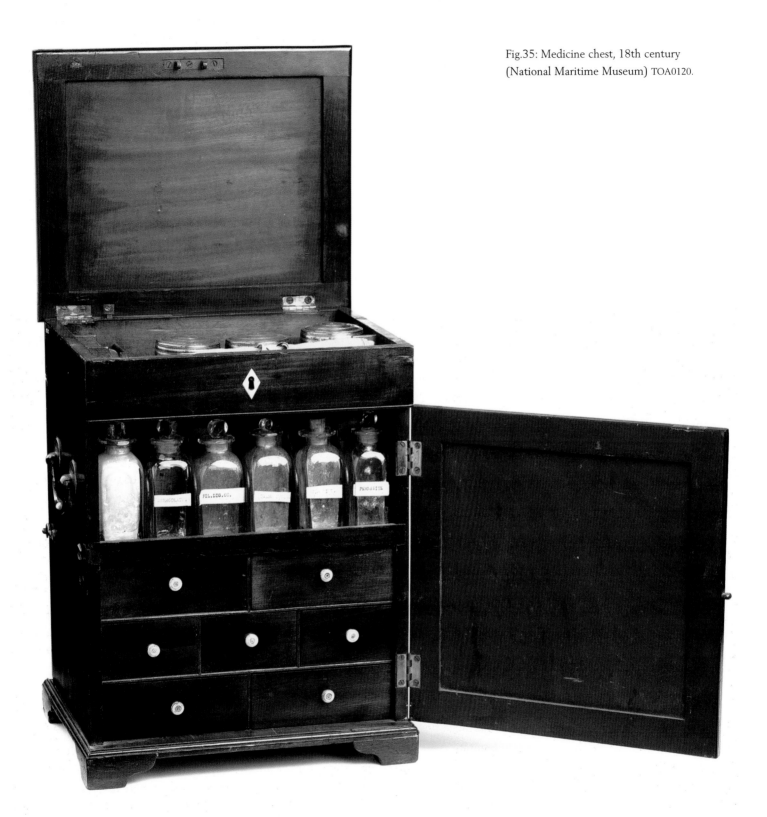

Fig.35: Medicine chest, 18th century
(National Maritime Museum) TOA0120.

one of the most notable being Thomas Aubrey's *The sea surgeon, or the Guinea man's vade mecum*, a 1729 'textbook' intended for the use of young slave-ship surgeons.[21] Aubrey makes reference to 90 separate ingredients and preparations in his treatise, and slave-ship surgeons routinely carried many of these ingredients in their medical chests. Several glass medicine bottles were recovered from the wreck of the *Fredensborg*, and a surgeon's saw from the *Henrietta Marie*.[22]

The return journey: the Americas to Europe

It was gold, not slaves, which originally drew Europeans to the coast of West Africa, and long after the slave trade had taken hold, gold and other African products continued to be imported to Europe. Elephant and hippopotamus ivory were common features of return cargoes, the ivory being favoured at home for combs, knife-handles, sewing

Fig.36: Ivory-handled dirk, *c*.1794 (National Maritime Museum) WPN1278.

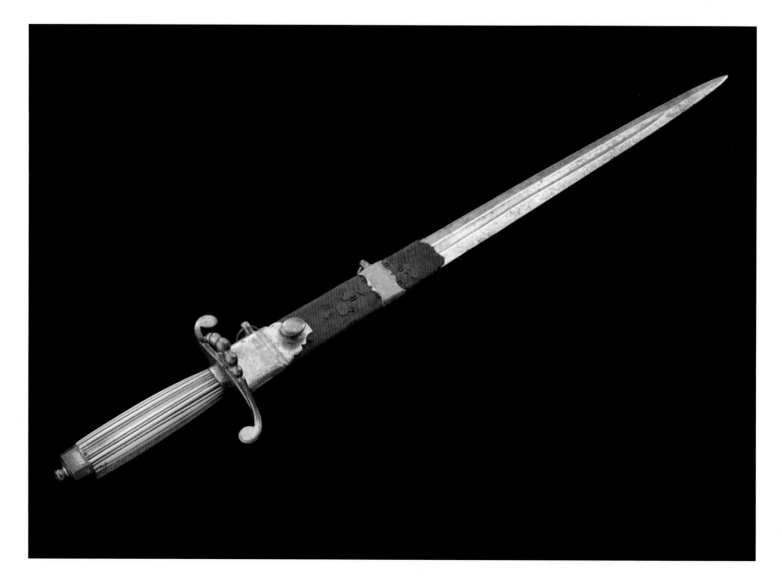

articles, instrument keys, billiard balls and decorative carving of many kinds. Before the Danish slaver *Fredensborg* left Africa in 1768, the master Johan Ferentz purchased 42 elephant tusks and 43 *creveller* (tusks weighing less than 6–7 kg), with a total weight of 927.75 kg. Two hundred years later, tusks were the first finds to be brought up by divers working on the wreck.[23]

From the earliest years of the slave trade, a 'souvenir' market flourished in Africa. As early as the fifteenth century, Portuguese travellers were commissioning ivory copies of saltcellars, horns, spoons and other small items of tableware from African artisans.[24] These ivories, carved by craft workers drawing on western models such as book illustrations, have been memorably described as the first 'airport' art.[25] Many of these exotic souvenirs later found their way into the 'cabinets of curiosities' fashionable among the Renaissance aristocracy, and subsequently into the great private collections that formed the nucleus of major museums in the nineteenth century. The finial of one example in the British Museum's collection depicts a single-masted Portuguese merchant vessel, with its rigging and crow's nest.[26]

The majority of Afro-Portuguese ivories were created between 1500 and 1600, during the earliest phase of the transatlantic slave trade. It seems reasonable to assume that a 'souvenir' trade from West Africa would have continued throughout the slave-trading era, but it is difficult to find evidence to support this suggestion. We know from surviving wills that, from the earliest days, sailors who travelled to Guinea often purchased gold, in the form of dust or grain.[27] Some voyagers also acquired small, easily portable items of Akan jewellery (sold by weight, in the same way as gold grains and nuggets). The Frenchman Jean Barbot, who made African slaving voyages in 1678–9 and 1681–2, later wrote an account of Guinea in which he illustrated forty Akan ornaments in his possession.[28] In this context, it is interesting to note that more than 350 fragments of worked Akan gold have been recovered from the wreck of the *Whydah*, a London-built slave ship captured by the pirate Samuel Bellamy in 1717, only to founder off Cape Cod, Massachusetts a few months later.[29]

Like many vessels, the *Whydah* had traded for both gold and slaves while in Africa. Gold items were not purchased for any perceived artistic merit; they would simply be melted down for bullion. Many of the fragments from the *Whydah* are chopped, flattened, folded, and the few pieces that are intact show signs of wear. It is likely that these items were acquired as scrap metal as the *Whydah* lay off Africa trading for slaves. Pirates frequently menaced merchant shipping on the African coast, however, and a member of Bellamy's crew may easily have acquired these items at another time. Most of the African collections in British museums contain some (often many) brass weights used by the Akan to measure out quantities of gold dust. Although the vast majority of these gold weights arrived in Europe in the nineteenth century, it is surely possible that some examples arrived in sailors' pockets long before this: small, portable reminders of voyages to the Gold Coast.

Few ordinary sailors would have had the means to purchase carved ivories or gold ornaments in West Africa. The 'everyday' items they could afford to buy would rarely have attracted the interest of collectors at home, and this is perhaps one reason why

maritime 'souvenirs' of the African trade are difficult to find today. Even so, it cannot be doubted that sailors did acquire keepsakes of various kinds. The late-eighteenth-century collector William Bullock, who was for some time based in Liverpool, acquired a number of 'African curiosities' from sea captains, some of whom may well have been engaged in the slave trade. These items are inventoried in Bullock's *Companion to the Liverpool Museum*, first published in 1808, a year after the abolition of the British slave trade. Among the items described there are an African amulet ('fetish') 'taken from the breast of a black man, engaged in battle, by Captain Clarke, of the ship *Roebuck*, of Liverpool' and a hammock, presented to the museum by Captain Roberts of

Fig.37: Akan gold weight, 19th century (Cat.92) ZBA2450.

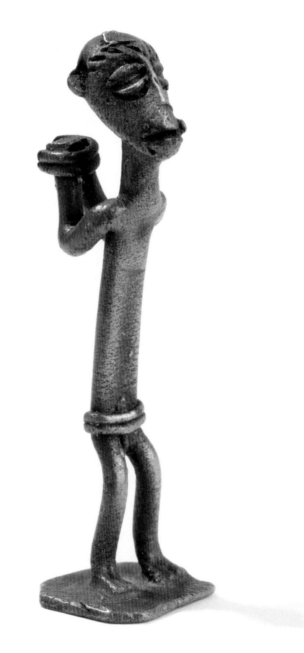

Liverpool.[30] Non-valuable exotica were sometimes also of interest to the great collectors of the day. An Asante drum from the Gold Coast was included in the few African pieces acquired by Sir Hans Sloane, whose collection formed the core of the British Museum (founded in 1753).[31] It was once believed that a Virginian slave of Asante origin carved the drum in the Americas, but some scholars think it more likely that it is of African origin, and arrived in Virginia by ship.[32] Drums were employed on slave ships, both during so-called 'slave dancing' (enforced exercise) and for recreation. Alexander Falconbridge tells us that:

> Exercise being deemed necessary for the preservation of their health, they are sometimes obliged to dance, when the weather will permit their coming on deck. If they go about it reluctantly, or do not move with agility, they are flogged: a person standing by them all the time with a cat-o'-nine-tails in his hand for that purpose. Their musick, upon these occasions, consists of a drum, sometimes with only one head, and when that is worn out they do not scruple to make use of the bottom of one of the tubs before described.[33]

It is by no means impossible that, like so many of the people of Africa, this artefact made the Middle Passage to the Americas on board a slaving vessel.

* * * * *

The documentary record for the economic aspects of British slave shipping is so extensive that other kinds of data, including the artefacts discussed above, sometimes tend to be overlooked by historians. As this brief overview has shown, however, the material residues of slave shipping are many and varied and, when studied in tandem with the documentary record, provide important insights into the physical and social world of the slave ship. Both in Britain and elsewhere, museums are beginning to recognise this potential, and the appearance of online catalogues and inventories for both individual slaving vessels and maritime collections will surely facilitate further research in this field.[34]

Notes

1 See Leif Svalesen, *The Slave Ship* Fredensborg (Kingston, 2000); Madeline H. Burnside, 'The *Henrietta Marie*', in *Captive Passage: The Transatlantic Slave Trade and the Making of the Americas* (Washington DC, 2002), pp 77–97. Informative websites exist for both vessels: http://www.unesco.no/fredensborg/ and http://www.melfisher.org/henriettamarie/.

2 For information on the *Material Culture of the Middle Passage* project, sponsored by the NMM, see Jane Webster, 'Looking for the material culture of the Middle Passage', *Journal for Maritime Research* (2005), http://www.jmr.nmm.ac.uk/server/show/ConJmrArticle.209.

3 National Maritime Museum (hereafter NMM) MSS/76 027.0 (see Cat.114).

4 Stephen D. Behrendt, 'Markets, transaction cycles, and profits: merchant decision making in the British slave trade', *William and Mary Quarterly*, 58, 1 (2001), pp 177–8.

5 Ibid. p.178.

6 Charles Garland and Herbert S. Klein, 'The allotment of space for slaves aboard eighteenth-century British slave ships', *William and Mary Quarterly*, 42, 2 (1985), pp 238–48.

7 Ibid. pp 240, 247.

8 Alexander Falconbridge, 'Account of the slave trade on the coast of Africa' [1788], in Christopher Fyfe (ed.), *Anna Maria Falconbridge: narrative of two voyages to the River Sierra Leone during the years 1791-1792-1793. With an account of the slave trade on the coast of Africa by Alexander Falconbridge* (Liverpool, 2000), p.197.

9 Anthony Tibbles (ed.), *Transatlantic Slavery: Against Human Dignity* (London, 1994), no. 87, p.141.

10 Geoff Quilley, 'Missing the boat: the place of the maritime in the history of British visual culture', *Visual Culture in Britain*, 1, 2 (2000), pp 79–92.

11 Thomas Clarkson, *The history of the rise, progress, and accomplishment of the abolition of the African slave trade by the British Parliament* (London, 1808), pp 375–6; David C. Devenish, 'The slave trade and Thomas Clarkson's chest', *Journal of Museum Ethnography*, 6 (1994), pp 84–9.

12 http://www.melfisher.org/henriettamarie/ironbilboes.htm

13 Thomas Phillips, 'A journal of a voyage made in the Hannibal of London...' [1693–4], in Awnsham Churchill and John Churchill (eds), *A collection of voyages and travels...*, 6 vols (London, 1732), vol.6, p.229. David Eltis, Stephen D. Behrendt, David Richardson and Herbert S. Klein (eds), *The Trans-Atlantic Slave Trade: A Database on CD-ROM* (Cambridge, 1999) (hereafter TSTD), voyage ID 9714.

14 http://www.melfisher.org/henriettamarie/ironbilboes.htm

15 Bernard Martin and Mark Spurrell (eds), *The Journal of a Slave Trader, 1750–1754: With John Newton's Thoughts upon the African Slave Trade* (London, 1962), p.71.

16 Phillips, 'A journal of a voyage', p.229.

17 Falconbridge, 'Account of the slave trade', p.208.

18 The ship had three of these mortars aboard. The *Fredensborg*, like the *Henrietta Marie*, also carried a 'slave stove'. See Svalesen, *The Slave Ship* Fredensborg, pp 33, 112, 186.

19 Richard B. Sheridan, *Doctors and Slaves: A Medical and Demographic History of Slavery in the British West Indies, 1680–1834* (Cambridge, 1985), p.109.

20 The 1788 Dolben Act (28 Geo. III 54. c.13) stipulated that every slave ship must carry at least one qualified surgeon, who could prove he had passed a recognised examination. Surgeons had been active in the African trade from its outset, but the Dolben Act made their presence on slave ships a legal obligation for the first time.

21 For Aubrey's understanding of the causes of disease and death on slaving voyages, see Sheridan, *Doctors and Slaves*, pp 114–8.

22 Aust-Agder Museum, Arendal, Denmark, nos 17150–56, 17182, 17184; http://www.melfisher.org/henriettamarie/drawings.htm

23 Svalesen, *The Slave Ship* Fredensborg, pp 18, 181.

24 See Ezio Bassani, *African Art and Artefacts in European Collections, 1400–1800* (London, 2000); Ezio Bassani and William B. Fagg, *Africa and the Renaissance: Art in Ivory* (New York, 1988).

25 Nigel Barley, 'West Africa', in John Mack (ed.), *Africa: Arts and Cultures* (London, 2000), p.86, fig.40.

26 British Museum Ethno 78.11.1.48. On this and other examples of ship carving in Afro-Portuguese art, see Bassani, *African Art and Artefacts*, pp 298–9.

27 Justin Goodwin, who travelled to Guinea on the early trading vessel *John the Baptist* in 1565, bequeathed 'one oliphant's tothe wayinge ffortie pounds' and 'twoo oliphantes teethe wayinge threescore pounds, and six peases of gold' to the master of his ship. Paul E. Hair and J.K. Alsop, *English Seamen and Traders in Guinea, 1553–1565: The New Evidence of their Wills* (Lewiston, New York, 1992), p.320. The National Archives, Kew, Prob. 11/48, f.162.

28 Paul E. Hair (ed.), *Barbot on Guinea: The Writings of Jean Barbot on West Africa, 1678–1712*, 2 vols (London, 1992), vol.2, p.494 (plate 43) and p.499, n.9.

29 For the wreck, see Christopher E. Hamilton, 'The pirate ship Whydah', in Russell K. Skowronek and Charles R. Ewen (eds), *X Marks the Spot: The Archaeology of Piracy* (Gainsville, Florida, 2006), pp 131–59. For the gold ornaments, see Barry Clifford, *Expedition Whydah: The Story of the World's First Excavation of a Pirate Treasure Ship...* (New York, 1999), pp 206–07, Bassani, *African Art and Artefacts*, no.681.

30 William Bullock, *A Companion to the Liverpool Museum, containing a brief description of upwards of seven thousand natural and foreign curiosities, antiquities, and productions of fine arts* (Liverpool, 1809, 7th edn), pp 10, 18; Bassani, *African Art and Artefacts*, nos 95, 116. TSTD documents one Liverpool Roebuck (TSTD voyage ID 84108 for 1796), but none of the three named masters was called Clarke. Two Liverpool-based slave ship masters named Roberts can be found in TSTD. Both were active *c.*1800–07 (TSTD voyage ID 80414, 81117, 81330–2).

31 British Museum Ethno SL.1386. The drum was collected by a Reverend Clerk, between 1730 and 1745.

32 This is the view expressed on the British Museum *Compass* website at http://www.thebritishmuseum.ac.uk/. For the alternative, again in a British Museum publication, see Mack, *Africa: Arts and Cultures*, p.23.

33 Falconbridge, 'Account of the slave trade', pp 209–10.

34 For example, the Aust-Agder Kulturhistoriske Senter, Arendal, has recently completed an inventory of finds from the wreck of the *Fredensborg*, and plans to make this available online in the near future. On maritime collections, see footnote 2 above, and the 'Port Cities' websites for Bristol (http://www.discoveringbristol.org.uk/) and Liverpool (http://www.mersey-gateway.org/).

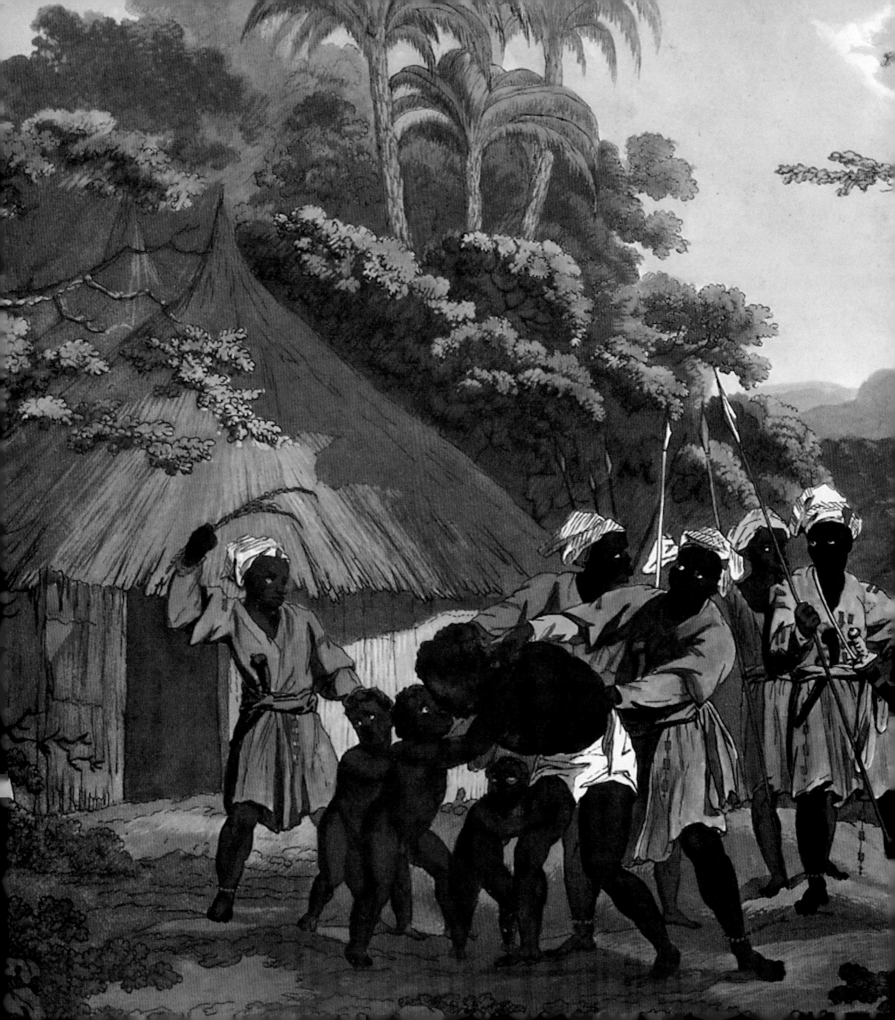

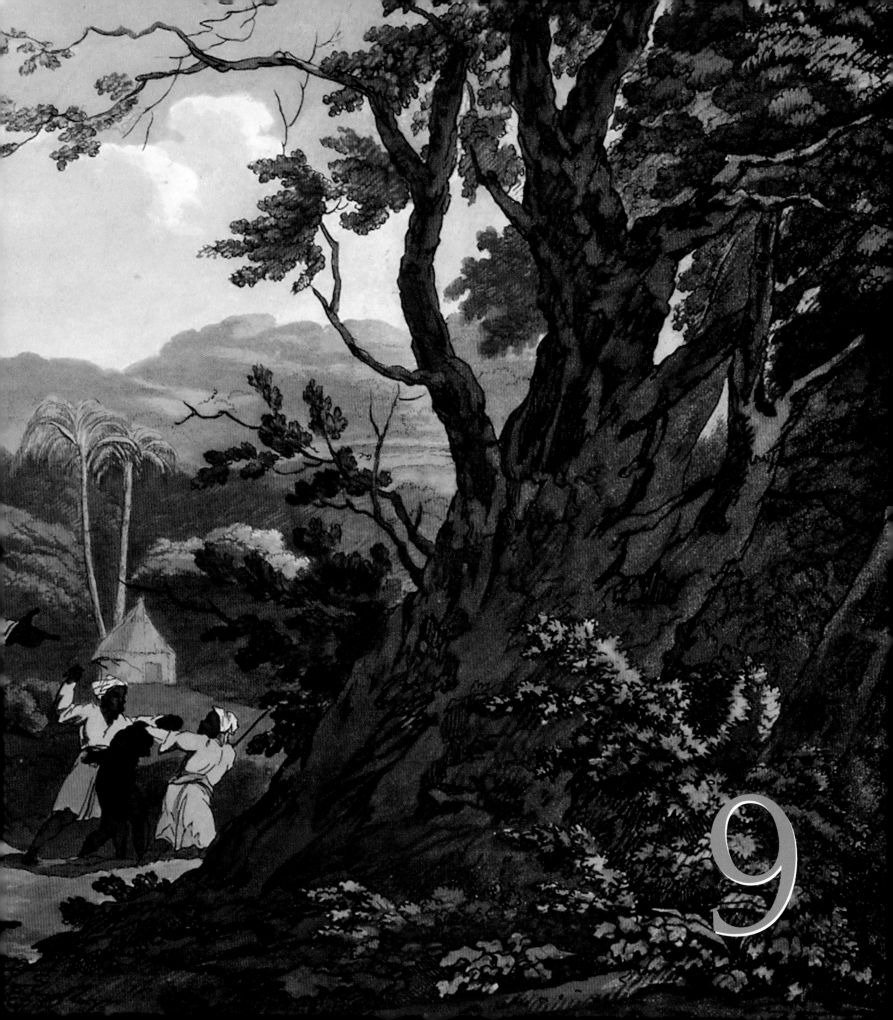

The lie of the land: slavery and the aesthetics of imperial landscape in eighteenth-century British art

Geoff Quilley

CARIBBEAN SUGAR PLANTATIONS were not only characterised by the huge consumption of human beings in the slave trade. They also had a bigger impact than any other single aspect of imperial practice upon the transformation of the landscape. Indeed, it has been argued that in certain respects the plantation system – sustained by and dependent on slavery – represented the ideology of empire for early-modern Europe, insofar as 'ideologically and discursively, *plantation* was often used as a synonym for *colony*'.[1] This not only cleared the land in preparation for planting but also turned it into empty space that allowed it to be appropriated as colonial possession, and then cultivated with the non-native crops and plants that sustained the economic value of the colony. In addition to the imported cash crops, a huge range of other foreign species radically altered the Caribbean landscape: 'Bamboo, logwood, cashew, casuarina, royal palm, imortelle [sic], coconut palm, citrus, mango, tamarind, breadfruit, banana, bougainvillea, hibiscus, oleander, poinsettia, thunbergia, and even pasture grass (guinea grass from West Africa) were all imported.'[2] This remarkable list immediately undermines any sense of an 'authentic' Caribbean colonial landscape. It also raises questions about the representation of that and other colonial landscapes in visual culture or aesthetic writing, and the degree to which aesthetic visual representation serves to naturalise the manipulated and transplanted plantation colony. This essay will pick up on aspects of these issues through a comparative analysis of the eighteenth- and early-nineteenth-century visual representation of the Caribbean and West African landscapes, using examples held in the National Maritime Museum's prints and drawings collection. Of particular interest are the works made by Lieutenant Gabriel Bray in the 1770s while on a naval voyage to West Africa, which help to highlight the ideological vision of the West Indies as a tropical paradise compared with the very different representation of the West African landscape at the opposite end of the Middle Passage. Rather than dwelling on the representation of the Middle Passage itself, therefore, I shall investigate how its distant terminal landscapes were influenced by the practice and discourse of slavery that formed their connecting link.[3]

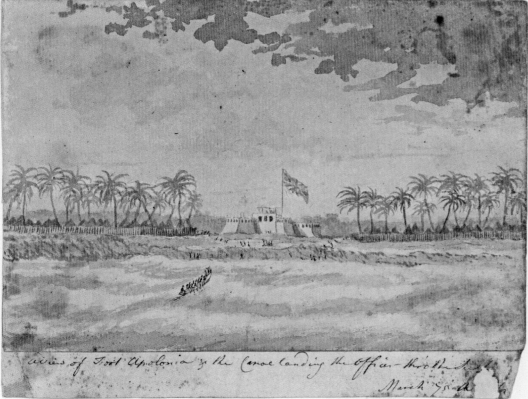

Fig.38: Gabriel Bray, *A view of Fort Apollonia,* 1775 (Cat.327) PAJ2020.

Fig.39: Gabriel Bray, *A view of a Dutch fort,* 1775 (Cat.327) PAJ2021.

Fig.40: Gabriel Bray, *A view of the fort at Senegal*, 1775 (Cat.327) PAJ2034.

Gabriel Bray's views of the Guinea coast

One of the principal aspects of visual representation to come under scholarly scrutiny with reference to imperial landscape is the visual technology of surveillance and control, particularly the use of the panoramic vista or modes of mapping.[4] The production at sea of coastal profiles – a fundamental technique for the recording of essential navigational data in which naval officers would be routinely trained from at least the mid-1700s – can be included within this category. The eighteenth-century visual record of West Africa is marked by the predominant use of coastal profiling techniques to represent the coast and its buildings as part of an organised economic system. There are virtually no views of the interior. As we shall see, this stands in distinct contrast to the depiction of the West Indies.

Between 1774 and 1777, HMS *Pallas* made a series of voyages to the West African coast to protect the slave trade and to survey and report on the forts and factories then under British control. Gabriel Bray was second lieutenant on at least two of these voyages. As a keen amateur artist, Bray made numerous watercolour drawings both of the places and people visited and also of daily life on board ship.[5] They are unique in their representation of lower-deck life at sea in this period. Included in the extensive and often remarkably intimate portraits of Africans and European sailors, is a series of coastal profiles of a more detached character, presumably related to Bray's role as one of the reporting officers on the voyages.

In contrast to Bray's other coastal profiles, which lack any overt signs of habitation and focus on the contours of the topography for purely navigational purposes, all his profiles of the African coast include forts as their principal subject. They can therefore be considered in the context of the wider discussions about the

British settlement of the West African coast. Indeed, Bray's work was of direct, material consequence to the metropolitan government debate over commercial policy for the West African coast and the slave trade in particular. With other officers he also produced directly observed written reports on British forts and factories that formed some of the material for official treatises criticising and recommending policy in the region.

The remit of the final voyage in 1777 was to report directly on the condition of nine British forts along the coast. At Anomabu, Bray and his fellow officer Thomas Wesgate found a scene of dilapidation. The fort was 'in a rotten, ruinous condition', with holes in its walls, the gun carriages 'falling to pieces', and the gate near to collapse.[6] Their account of decline is in keeping with other officers' reports on the remaining British forts and synonymous with the casual disregard for the coastal trade. Indeed, through neglect, the British trade in slaves had been overtaken by an opportunistic French captain ingratiating himself with the resident African dealer, who was in the pay of the British but evidently open to rival offers. While the condition of the fort at Anomabu was extreme (the more so since the building had been completed only as recently as 1761), it was consistent with the other forts on the coast. However, the severity of its condition was intensified by the fact that this was one of the two most important British forts on the Gold Coast, the other being Cape Coast Castle.[7]

This point was not lost on John Roberts, lately the Royal African Company's Governor of Cape Coast Castle. He used the set of reports compiled by the officers of the *Pallas* as evidence to denounce the administration of the forts by the Royal African Committee, based in London. It was the inefficiency, corruption and apparent unaccountability of the committee that were the target of Roberts's criticism, along with the vesting of authority with 'individuals as profoundly ignorant of the nature of this commerce, as of the Africans, their manners, customs, climate, soil, and all its

Fig.41: after William Smith, *South prospect of Dickscove fort, c.*1744 (Cat.349) ZBA2677.

various produce'.[8] The decline of the forts was not just an incidental result of maladministration, but struck at the heart of the commercial empire, by advancing 'the general decay of an important trade, on which the colonies, together with the navigation, and the revenues of Great Britain were so materially dependent'.[9] Roberts could not understand why British merchants were so unconcerned about the state of the trade: 'Amidst commercial revolutions of such particular importance, the whole empire is concerned; and all, whether considered as an aggregate body, or as separate individuals, will rise, or sink with the elevation, or depression of their most valuable trade.'[10] Both the nation at large, as an 'aggregate body', and the 'separate individuals' that comprised it were, in Roberts's view, irrevocably tied to the fortunes of British commerce in Africa and to its most important and valuable aspect – the slave trade. In some sense, therefore, for Roberts, the condition of the African forts was also a metaphorical portrait of the British nation and its citizens.

Bray's drawings on the *Pallas*, which must be considered in conjunction with his official duties of compiling reports and providing naval protection to British trade routes, may, in this light, be taken as a small but significant rendering of the British commercial empire in the Atlantic. While his drawings of the coastal forts broadly follow an established convention for West African coastal views, they also differ significantly from it. In formal terms, they certainly resemble the earlier views published by William Smith, surveyor to the Royal African Company, which present the forts as neat, clean, efficient and impersonal structures within an overall commercial system marked by its clarity and order. The view of Dixcove Fort (Figure 41) shows the building both in prospect and in plan, where the geometry of the structure is matched both by the English flag flying prominently from the south-east corner and by the regular divisions of the 'Dutch' garden leading down to the coast. The surrounding landscape assumes a quality of English countryside imposed upon the terrain of Africa (indicated only through the occasional palm tree), in which the native huts are made to appear incongruous and alien. The whole is represented as the appropriation of colonial territory through the 'civilised' transformation of the landscape into a site of agricultural industry: it presents the colonial environment as a form of garden. This is reinforced in the letterpress to the engravings, which deals briefly with pragmatic colonial concerns. The account of Dixcove gives the following assessment:

> The Air here is more wholesome than at *Gambia*, *Sierra-leone*, or *Sherbro*, tho accounted the worst on the *Gold Coast*. Fresh provisions here are pretty good tho not very plenty. The Cove, or, Landing-place is very Safe. Here are also two handsome Gardens belonging to the Fort which Supply their Table with several Sorts of Fruits, Roots, and Salads.[11]

Not only is the fort itself construed as a well-organised factory for the supply of plantation slave labour, but the conversion of the landscape to gardens also renders the fort itself the site of labour of a distinctly rural kind, in which the landscape is marshalled to provide for the Company factors and their trade.

By contrast, Bray's eyewitness depiction of the relation of the European fort to the indigenous landscape is altogether more problematic and conflicted. In the view of Fort Apollonia (Figure 38), the British fort is shown not elevated on the hillside, like Dixcove in Smith's view, commanding a cleared and ordered landscape, but low-lying and hemmed in to either side by two extensive and populous African villages. There is no sign of any garden here: rather, the presence of Britishness is signalled only by the lonely Union flag flying almost vainly among rows of palms, as though in defiance of the encroaching landscape rather than in control of it. Instead of towering above the trees and huts and enjoying authority over the African villages, the fort in Bray's drawing appears shrunken, timid and vulnerable, a sense that is still more acute in the view of a Dutch fort (Figure 39), which seems to be on the point of being consumed by the surrounding vegetation.

Bray's drawings, therefore, in contrast to Smith's clear and assertive line engravings, relate much more closely to his written comments on Anomabu, which express his concern over its state of disrepair and alarm at the 'very unsafe' British situation. The medium of watercolour – which lacks the definition of engraving and is much more alert to a sense of transience in the landscape, through the attention paid to passing effects of light and weather – enhances this ambiguity. More widely, when taken alongside his report on the dilapidation of the Anomabu fort, they offer a visual counterpart to Roberts's critical *Account of the state of the British forts*, with which they bear a more extensive comparison.

Overall, Roberts's *Account* is a relation of loss: the loss, both commercial and national, of valuable trade in slaves, gold and ivory through neglect, incompetence or corruption; and the loss, or potential loss, of colonised property. It was also a loss of self, of authority and control, in an uncompromisingly hostile environment. Reiterating one of the dominant ways of describing colonial encounter, Roberts saw the irreconcilable otherness of the environment and of Africans as an ever-present threat to self-identity and property in the region. Noting a drastic reduction in the number of slaves kept at the forts, he concluded: 'To this misfortune may be ascribed the destruction of that authority, so necessary in all countries, but, particularly, in Africa, to inforce [sic] obedience.'[12]

Current trading policy in Africa, therefore, had resulted in the loss of control and British commercial identity in the region. Moreover, Roberts suggested that the keeping of slaves was absolutely necessary to the maintenance of European authority, and that without such measures Europeans were in danger of being overrun by what he saw as the natural 'barbarity' of the Africans:

> Without religion to enlighten, or human edicts to instruct them, devoid of every principle of honesty, and strangers to the sense of pity, their whole conduct is at once ungovernable, and ferocious. . . . Of liberty, and property, the Negroes could never form the least idea; and . . . the mightiest were accustomed to dispossess, and lead to slavery the weakest. The whole race, existing in a state of anarchy, endeavour to engross an arbitrary sway.[13]

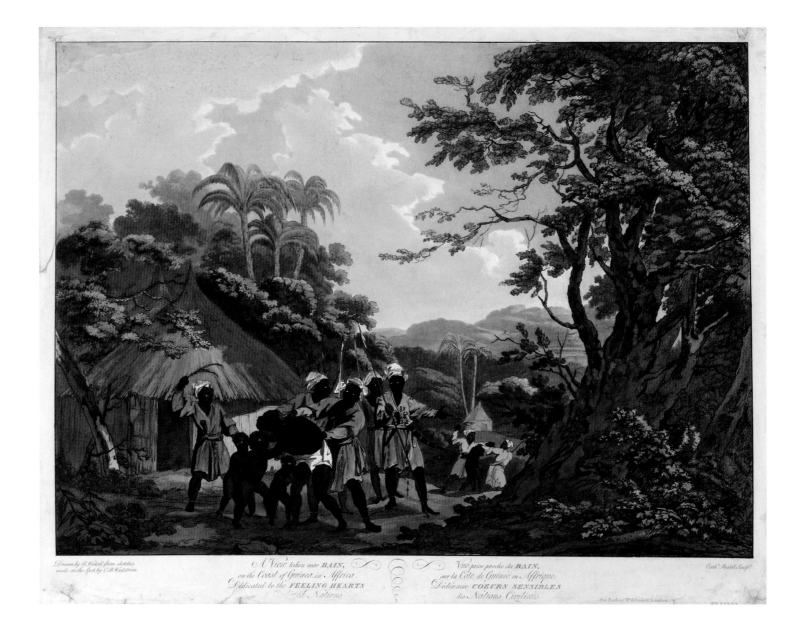

A View taken near BAIN,
on the Coast of Guinea, in Africa.
Dedicated to the FEELING HEARTS
of ... Nations

Vue prise proche du BAIN,
sur la Côte de Guinée en Affrique.
Dédiée aux COEURS SENSIBLES
des Nations Civilisées.

Fig.42: Marie Catherine Prestel after Carl Bernhard Wadström, *A view taken near Bain*, 1789 (Cat.328) ZBA2727.

This is one of lamentably numerous examples of the outright racist dogma that was used to justify the slave trade, by casting Africans as unreasoning savages, and that subsequently laid the ideological foundation for the growth of racist theory in the nineteenth century. However, the reverse of such a statement is the undercurrent of fear of such alien society, however fictitious and ideologically driven the image of it. The picture given of the experience of colonial encounter on the coast of West Africa is of civilised European values in a constant state of impending collapse in the face of African 'anarchy'. In this analysis, the fabric of the forts is synonymous with the 'principle of honesty' and 'sense of pity': both are equally susceptible to erosion from inimical 'native forces', with an equally disastrous result – the loss of European selfhood. It is no coincidence in this respect that, for Roberts, the ultimate cause of the near irresistible decline into anarchy was the incapacity of Africans to subscribe to the

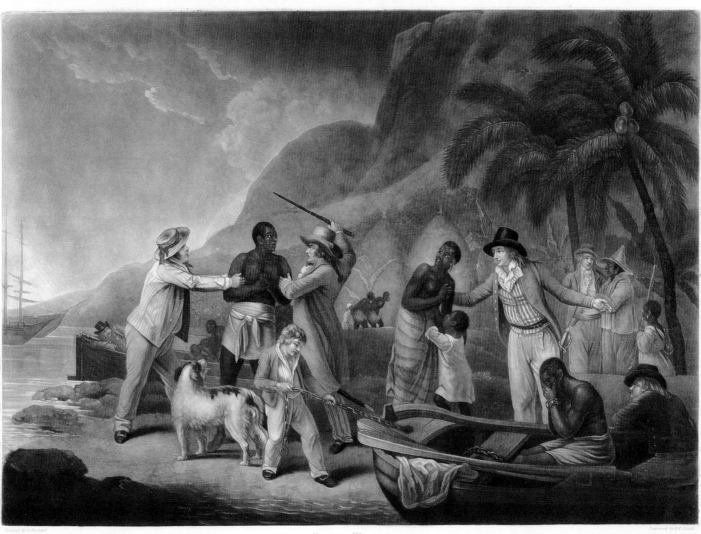

SLAVE TRADE.

Fig.43: John Raphael Smith after George Morland, *Slave trade*, 1814 (Cat.496) ZBA2507.

founding principles of 'liberty and property'. He does not appear to recognise the irony that his preferred means for combating the ensuing erosion of civilised values was to deprive Africans of their liberty by converting them into property. For Roberts, rather, the loss of colonial property entailed in the dilapidation of the forts was tantamount to the loss of European liberty in an otherwise naturally hostile environment.

Yet what also comes across is the disintegration of society brought about by the slave trade itself. This was a criticism repeatedly made by abolitionists, who argued that the trade encouraged the exploitative, self-serving individualism of both European and African slave dealers, and eroded all forms of natural social relations, which a commercial system was otherwise supposed to foster. Such men were evidently a common product of the trade: John Newton, among others, also wrote of this distinct type of person, who could thrive by being completely unprincipled.[14] But this form of

opportunism was merely one symptom of the larger social malaise brought about by slavery, which was the inversion of all civilised principles of commercial society. Thus the abolitionist Carl Bernhard Wadström concluded, from his own first-hand experience of a voyage to the Guinea coast over a decade after Bray, that the slave trade represented the purest corruption of western commercial ideals, which had become 'so debased, as to regard man himself as a merchandise'.[15]

Accompanying his anti-slavery tract, Wadström published a pair of prints representing the African landscape as the setting for eyewitness accounts of abduction of Africans for 'merchandise', to drive home the inversion of social and natural moral order entailed in the slave trade. The figure composition of *A view taken near Bain* (Figure 42) clearly owes much to George Morland's highly influential and popular painting and print *Execrable human traffick* (1788) (see Figure 43), though it transposes the scene from the coast to the dense forest inland, and substitutes the uniformed black militia of the 'King of Damel' for the white slave traders of Morland's image.[16] However, the appropriation of Morland's grouping allows Wadström to maintain the same moralising message: it places the family as the foundation stone of natural social order, which is threatened by the slave trade through the sundering of wife from husband and parent from child. This recurred throughout anti-slavery imagery: a later variant shows a Caribbean or American slave family being separated 'after being seized & sold upon a warrant of destraint for their master's debts' (Cat.390). In this sense, such moralisation of the landscape of slavery, both African and West Indian, parallels the abolitionist representation of the Caribbean landscape, not as the pastoral paradise that was represented in imagery produced for the Caribbean plantocracy, but as the setting for enforced diaspora, torture and execution (Cats 460, 462 and 490).

The visual representation of the British Caribbean

By contrast with the views of Africa, an insistent feature of the eighteenth-century artistic representation of the West Indies is the recourse to pastoral or picturesque modes.[17] This draws alternately on a tradition in English landscape poetry that idealises the bucolic aspects of the countryside; or else on a convention in visual art that represents the physical landscape by reference to the ideals of western landscape painting, and valorises it according to the degree to which it displays such pictorial characteristics. In the case of the West Indies, this reversion to the pastoral typically passes over or sublimates the material appropriation of the land and its conversion to sugar cultivation through the creation of plantations. Also ignored is any reference to the Middle Passage. Instead, what is presented in the work of an artist such as George Robertson, who worked in Jamaica in the in the early 1770s, or Agostino Brunias, who worked in Dominica during the same period, is an evocation of precisely the kind of tropical paradise that Jill Casid has identified – one created from the transplanted species imported from elsewhere in the empire.[18] Typically, this imagery also includes slaves or ex-slaves removed from any sign of the plantation, frequently at leisure or

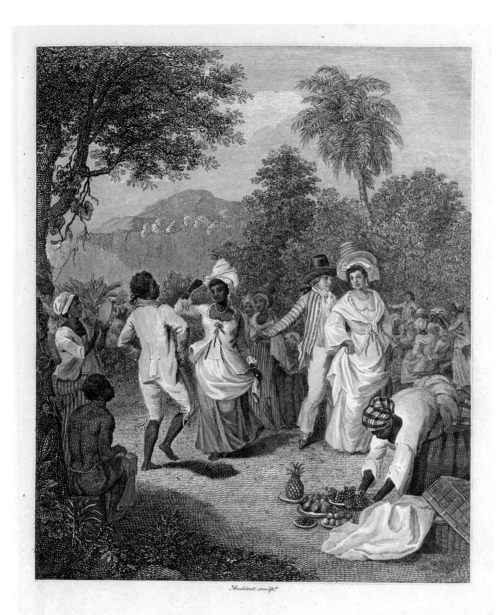

A NEGRO FESTIVAL drawn from Nature in the ISLAND of St VINCENT.

From an Original Picture by Agostino Brunyas, in the possession of Sir William Young Bart F.R.S.

Fig.44: Philipp Audinet after Agostino Brunias, *A Negro festival drawn from nature in the island of St Vincent, c.*1801 (Cat.393) ZBA2522.

dancing. In the foreground of Brunias's engraving of *A Negro festival* (Figure 44) the fruits of the same transplanted species are being prominently laid out as a further reinforcement of the spontaneous abundance of the tropical landscape. In turn, this visual imagery of the Caribbean landscape substantiates and reinforces contemporary verse and prose accounts of the islands, whether by resident gentleman-planters such as Robertson's patron, the planter William Beckford of Somerley, or visitors like Janet Schaw, a Scottish 'lady of quality'. She described the Eleanora estate in Antigua as 'a delightful Vision, a fairy Scene or a peep into Elysium; and surely the first poets that

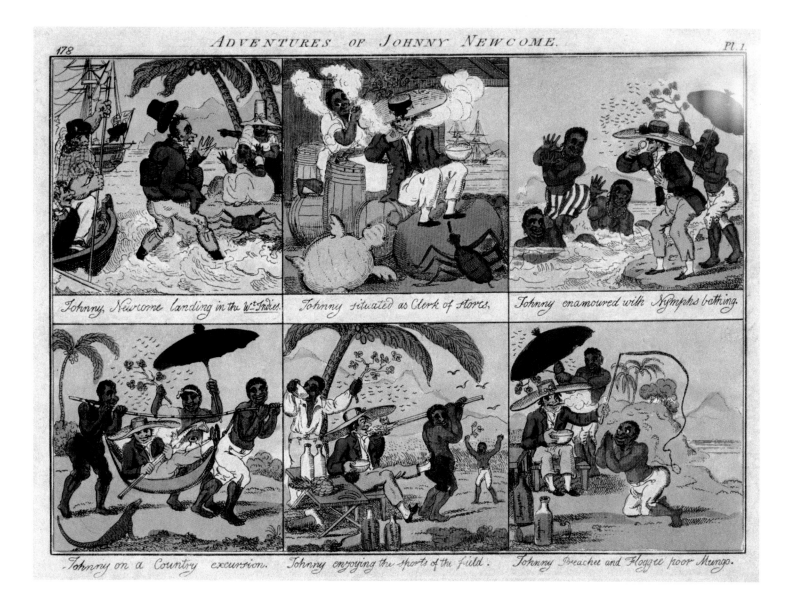

Johnny Newcome landing in the W.t Indies. *Johnny situated as Clerk of Stores.* *Johnny enamoured with Nymphs bathing.*

Johnny on a Country excursion. *Johnny enjoying the sports of the field.* *Johnny Preacher and Floggee poor Mungo.*

Fig.45: William Elmes, *Adventures of Johnny Newcome*, Plate 1, 1812 (Cat.529) PAF3747.

painted those retreats of the blessed and good, must have made some West India Island sit for the picture'.[19]

Conventionally, verse descriptions of the West Indies eulogised the variety and profuseness of the flora, frequently listing transplanted species in overt imitation of pastoral poetry.[20] For Beckford, this natural superabundance not only supplied the table but also fed the eye; it supported what he saw as Jamaica's very real claims to aesthetic beauty and artistic potential: 'The variety and brilliancy of the verdure in Jamaica are particularly striking. . . . It is hardly possible to conceive any vegetation more beautiful, and more congenial to a painter's eye, than that which universally prevails throughout every part of that romantic island.' He then proceeds to list the variety of Jamaican flora. For Beckford, this landscaping of Jamaica was of such aesthetic value that the island should be cultivated as a training ground for the aspirant landscape painter, as much as for sugar, in the expectation that 'views of the islands of the West Indies may

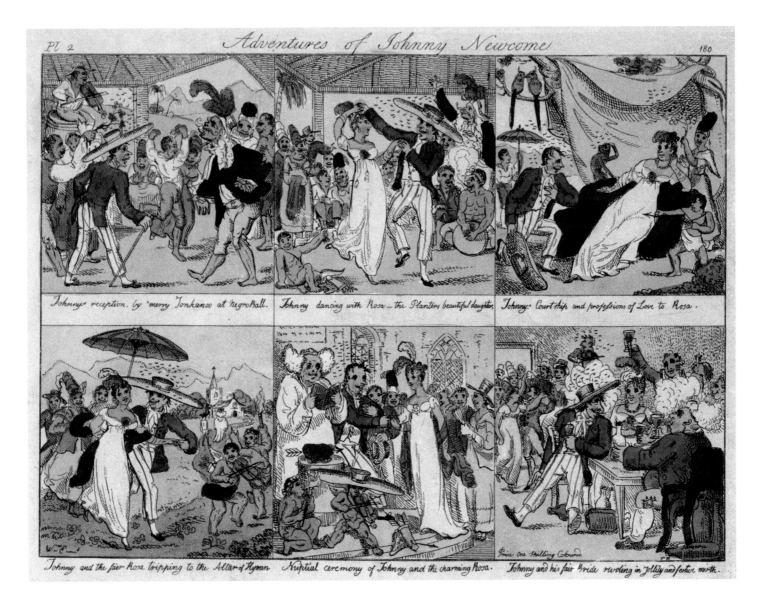

Johnny's reception, by 'merry Jonkanoo' at Negro Ball. *Johnny dancing with Rosa — the Planters beautiful daughter.* *Johnny Courtship and professions of Love to Rosa.*

Johnny and the fair Rosa tripping to the Altar of Hymen. *Nuptial ceremony of Johnny and the charming Rosa.* *Johnny and his fair Bride revelling in Jollity and festive mirth.*

give scope to a new expansion of picturesque ideas; may inspire his fancy, provoke his imitation, and reward his genius'.[21]

 The aestheticisation of the Caribbean landscape was not unproblematic, however. The difficulty rested with the economic reality of the colonies as plantations fuelled by slave labour. This rendered the landscape inadmissible as a proper subject for the established poetic and painterly traditions of the pastoral (which evoked an idealised landscape populated by happy shepherds in harmony with nature and free from the burden of labour) or the georgic (which presented a rural environment in which human beings had to work for subsistence, but honestly and virtuously). What Karen O'Brien has termed 'imperial georgic' could not accommodate slavery: 'its very presence broke the association between productive labor and civic virtue central to the tradition of imperial georgic'.[22] The virtuous labour of the georgic could not be reconciled with the non-virtuous labour of plantation slavery where, in one poet's

Fig.46: William Elmes, *Adventures of Johnny Newcome*, Plate 2, 1812 (Cat.530) PAF 3748.

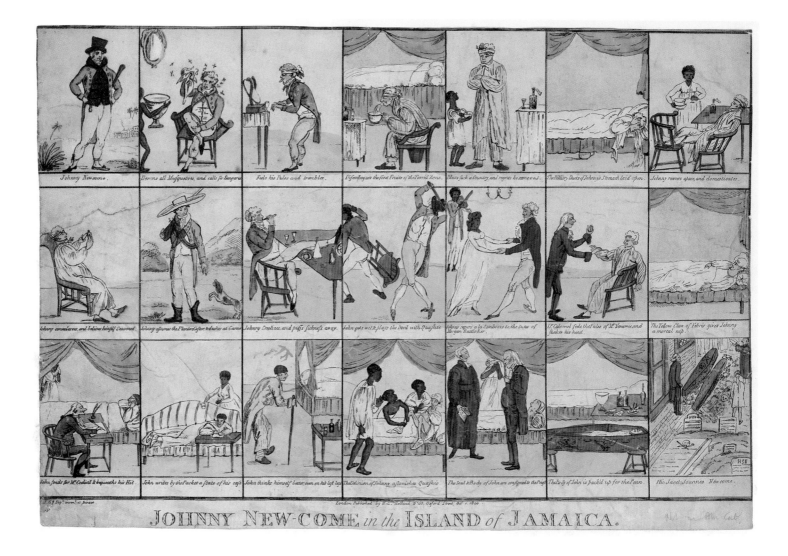

Fig.47: James Sayers, *Johnny New-come in the island of Jamaica*, 1800 (Cat.520) ZBA2722.

phrase, it was compelled through 'tortures, racks, whips, famine, gibbets, chains', identifying precisely the impossibility of describing the process of sugar cultivation in a georgic idiom.[23]

The contrast between slave labour and plantocratic leisure is also implicit in this tension between virtuous and non-virtuous labour. This is shown most sharply in satires on the planter class and their lifestyle, especially in the context of the abolition campaign. In William Elmes' early nineteenth-century prints *Adventures of Johnny Newcome* (Figures 45 and 46; Cats 529–33), Johnny's arrival in the West Indies heralds an existence of untrammelled ease and luxury, culminating in his marriage to the local planter's daughter. Within this narrative the landscape is again equated with pleasure. It functions as the site of voyeuristic entertainment, as Johnny ogles black women bathers in a scene that seems to be a direct pastiche of Brunias' views of Caribbean bathers. It is also the setting for ludicrous outdoor activities, in which Johnny's exercise is done for him by his slaves, who carry him in his 'country excursion' and even hold his rifle barrel, enabling him to enjoy 'the sports of the field' by shooting with one hand

while holding a bowl of *sangaree* in the other. Even the sunlit, paradisiacal landscape as the arena for slave punishment, in which Johnny flogs 'poor Mungo', is sent up as the site of pleasure on all sides. Although 'Mungo' is shown kneeling in the pose of the imploring slave in Wedgwood's celebrated anti-slavery medallion 'Am I not a man and a brother?', he looks up at his master and grins, as if at play. In the print narrating Johnny's courtship and marriage, the landscape again becomes the site of pleasure, through dancing. At the 'Negro ball' with 'merry Jonkanoo', Johnny meets Rosa the planter's daughter and professes his love for her to the hyperbolic accompaniment of a pair of birds of paradise and what seems to be a mulatto Cupid firing his arrow. They then skip through the idyllic landscape to their marriage at the village church in the distance, again accompanied by mulatto cherubs. It is an excessively and comically rosy narrative of the Caribbean migrant's life, in which punishment becomes pleasure and racial antagonism becomes unproblematic friendliness. It was no doubt mockingly directed at those exaggerated accounts of the West Indian planter class and the virtues of slavery that were being propounded in defence of the slave trade; accounts which pictured plantation life for slaves as beneficent and the Caribbean slave system as more humane than the condition of the labouring class in Britain. It thereby also mocks the attempts to render the Caribbean in terms of pastoral or georgic landscape. The only hints of disturbance in the 'natural' paradise are the land crabs that greet Johnny on his arrival and the perennial swarm of mosquitoes.

The discrepancy between this image of West Indian life and landscape and what was generally believed to be the unpleasant and unhealthy nature of the Caribbean climate and environment was pointed up in James Sayers' alternative version of the Johnny Newcome narrative, published by William Holland (Fig.47, Cat.520). Here, Johnny's swaggering but solitary arrival on the beach leads at once to dissipation and sickness, which culminates when the 'Yellow claw of Febris gives Johnny a mortal nip'. The landscape is here hardly depicted at all but is clearly no paradise for the planter's leisured consumption: it becomes instead a toxic environment that debilitates and consumes its unseasoned victim, being finally represented in the concluding scene as the graveyard in which Johnny's wasted corpse is buried.

* * * * *

At one level, the relation between the visualisation of the imperial landscape of slavery and the slave trade, in the Caribbean and on the west coast of Africa, is one of an ideological reciprocity, whereby the one begets the other. For example, Smith's panoramic, panoptic views of the African coast, which show it as a streamlined landscape of pseudo-georgic industry, complement the fabricated visual and textual accounts of the West Indian landscape as pastoral, 'imperial picturesque' paradise.[24] Yet the contingencies and fractures of this vision are evident. Above all, for this ideological relation between the landscapes to function, the traumas of the Middle Passage had either to be purified or omitted entirely. In addition, its fragility is apparent, on the one hand, in the uncertain, equivocal view of the European presence on the African coast in Bray's drawings and, on the other, in the difficulty of accommodating the economic

landscape of the Caribbean sugar plantation within a pastoral or georgic aesthetic. Similarly, in the moralisation of the landscape of slavery, the ideal model of the garden was supplanted by an abolitionist visual rhetoric: in the final resort, any attempt at an ideologically coherent imperial landscape aesthetic, like the poetics of imperial georgic, was unable fully to incorporate the fact of slavery.

NOTES

1 Jill H. Casid, *Sowing Empire: Landscape and Colonization* (Minneapolis, Minnesota, 2005), p.7.

2 Ibid.

3 The visual and textual representation of the Middle Passage has been dealt with particularly in Marcus Wood, *Blind Memory: Visual Representations of Slavery in England and America, 1780–1865* (Manchester, 2000); Anthony Tibbles (ed.), *Transatlantic Slavery: Against Human Dignity* (Liverpool, 1994).

4 See, for example, Michael Charlesworth, 'Thomas Sandby climbs the Hoober Stand: The politics of panoramic drawing in eighteenth-century Britain', *Art History*, 19, 2 (1996), pp 247–66.

5 See Roger Quarm, 'An album of drawings by Gabriel Bray RN, HMS *Pallas*, 1774–75', *The Mariner's Mirror*, 81, 1 (1995), pp 32–44.

6 *Extracts from an account of the state of the British forts, on the Gold Coast of Africa, taken by Captain Cotton, of his Majesty's Ship Pallas, in May, and June, 1777. To which are added observations by John Roberts, Governor of Cape Coast Castle, in the service of the late Royal African Company of England, for the management of their affairs on the south coast of Africa* (London, 1778), pp 5–6.

7 Alexander Falconbridge, *An account of the slave trade on the coast of Africa* (London, 1788), p.70.

8 *Account of the state of the British forts*, p.12.

9 Ibid. p.13.

10 Ibid. p.43.

11 William Smith, *Thirty different drafts of Guinea, by William Smith, surveyor to the Royal African Company of England* (London, 1730), plate 10. This is true not just of the view of Dixcove, but is a format common to all the engravings in Smith's series: see, for example, ZBA2678 (Cat.350).

12 *Account of the state of the British forts*, p.14.

13 Ibid. pp 16–17.

14 Bernard Martin and Mark Spurrell (eds), *The Journal of a Slave Trader, 1750–1754: With John Newton's Thoughts upon the African Slave Trade* (London, 1962), pp 15, 24.

15 Carl Bernhard Wadström, *Observations on the slave trade, and a description of some part of the coast of Guinea, during a voyage, made in 1787 and 1788, in company with Doctor A. Sparrman and Captain Arrehenius* (London, 1789), v.

16 M. C. Prestel after C.B. Wadström, *Explanation of a view near Bain, on the coast of Affrica, in the latitude of 14°44′ North*, hand-coloured engraving (1789) (Cat.328). The accompanying print, also engraved by Prestel and for which Wadström also provided an explanatory plate, was *A view of Joal, on the coast of Guinea, in Affrica. Dedicated to the sound politicians of all the trading nations in Europe*, hand-coloured aquatint.

17 Casid, pp 9–14, 45–8; Geoff Quilley, 'Pastoral plantations: the slave trade and the representation of British colonial landscape in the late eighteenth century', in Geoff Quilley and Kay Dian Kriz (eds), *An Economy of Colour: Visual Culture and the Atlantic World, 1660–1830* (Manchester and New York, 2003), pp 106–28.

18 Robertson is discussed in Quilley, 'Pastoral plantations' and Casid, pp 9–12, 62–3. His patron William Beckford was the cousin of his more famous namesake, the author of *Vathek* and creator of Fonthill

Abbey. For Brunias, see particularly Beth Fowkes Tobin, *Picturing Imperial Power: Colonial Subjects in Eighteenth-Century British Painting* (Durham, North Carolina, 1999), pp 139–73; Kay Dian Kriz, 'Marketing mulatresses in the paintings and prints of Agostino Brunias', in Felicity A. Nussbaum (ed.), *The Global Eighteenth Century* (Baltimore, 2003).

19 [Janet Schaw], *Journal of a lady of quality; being the narrative of a journey from Scotland to the West Indies, North Carolina, and Portugal, in the years 1774 to 1776*, (eds) Evangeline Walker Andrews and Charles McLean Andrews (New Haven, Connecticut, 1939), p.91.

20 See, for example, the anonymous *Jamaica, a poem, in three parts. Written in that island, in the year MDCCLXXVI* (London, 1777), pp 11–12, lines 70ff; John Singleton, *A general description of the West-India islands, as far as relates to the British, Dutch, and Danish governments, from Barbados to Saint Croix. Attempted in blank verse* (Barbados, 1767), pp 10–16, lines 109ff.

21 William Beckford, *A descriptive account of the island of Jamaica*, 2 vols (London, 1790), vol. 1, pp 31, 271.

22 Karen O'Brien, 'Imperial georgic, 1660–1789', in Gerald MacLean, Donna Landry and Joseph P. Ward (eds), *The Country and the City Revisited: England and the Politics of Culture, 1550–1850* (Cambridge and New York, 1999), p.176.

23 *Jamaica, a poem*, p.19, line 187.

24 This phrase is Casid's: pp 8–9, 45–8.

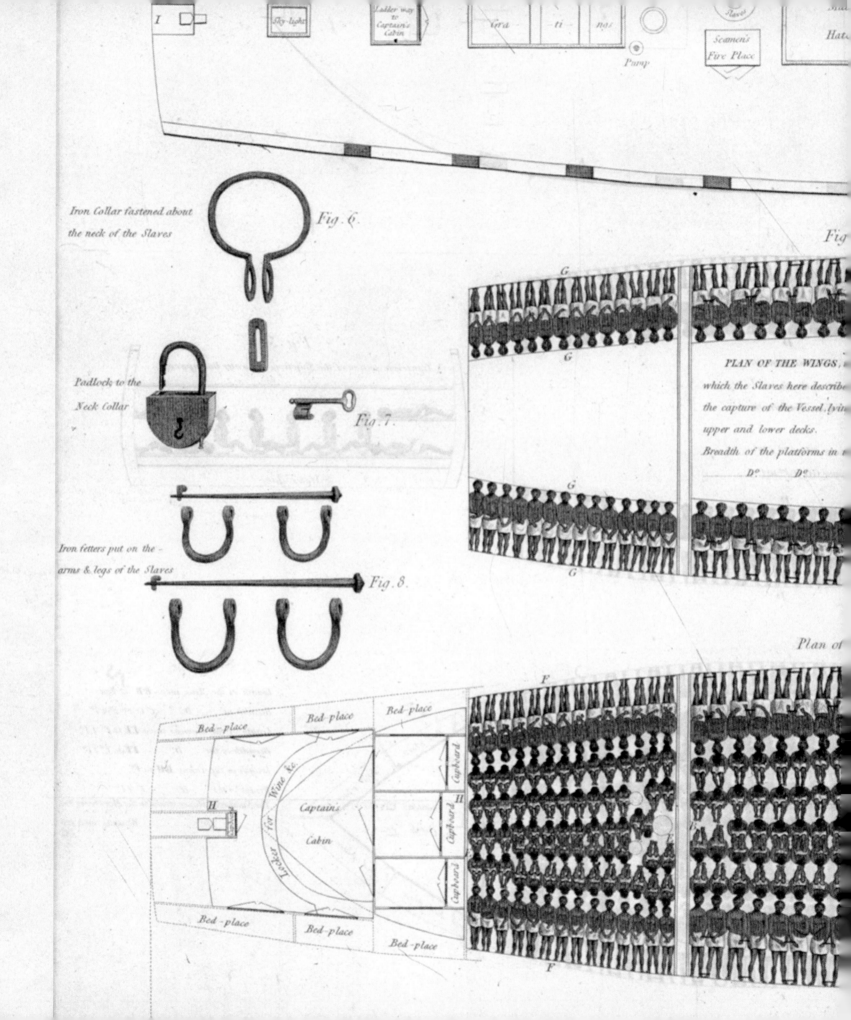

I

Sky-light

Ladder way
to
Captain's
Cabin

Gra ti ngs

Seamen's
Fire Place

Hat

Pump

*Iron Collar fastened about
the neck of the Slaves*

Fig. 6.

Fig

*Padlock to the
Neck Collar*

Fig. 7.

PLAN OF THE WINGS,

which the Slaves here describe

the capture of the Vessel, lyin

upper and lower decks.

Breadth of the platforms in

D° D°

G

*Iron fetters put on the
arms & legs of the Slaves*

Fig. 8.

Plan of

Bed-place

Bed-place

Bed-place

Locker for Wine &c.

Captains
Cabin

H

Cupboard

Cupboard

Cupboard

Bed-place

Bed-place

Bed-place

F

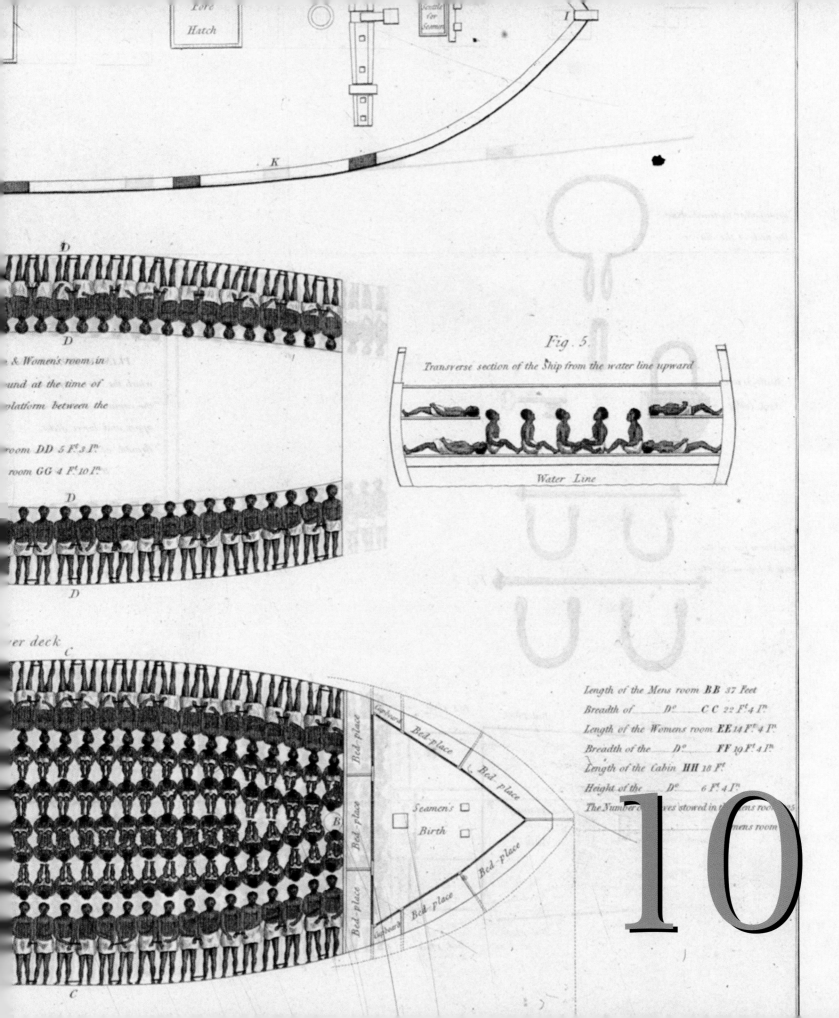

Fore
Hatch

Scuttle
for
Seamen

I

K

D

D

& Women's room, in

und at the time of

platform between the

room DD 5 F.t 3 I.n

room GG 4 F.t 10 I.n

D

D

Fig. 5.

Transverse section of the Ship from the water line upward

Water Line

ver deck

C

Bed-place

Cupboard

Bed-place

Bed-place

Bed-place

Seamen's

Birth

Bed-place

Bed-place

Bed-place

Cupboard

Length of the Mens room BB 37 Feet

Breadth of ____ D.o ____ C C 22 F.t 4 I.n

Length of the Womens room EE 14 F.t 4 I.n

Breadth of the ____ D.o ____ FF 19 F.t 4 I.n

Length of the Cabin HH 18 F.t

Height of the ____ D.o ____ 6 F.t 4 I.n

The Number of Slaves stowed in the Mens room

____ Womens room

C

Popular Graphic Images of Slavery and Emancipation in Nineteenth-Century England

Marcus Wood

A GREAT DEAL HAS NOW BEEN WRITTEN about the graphic satire generated around the first great wave of abolition publicity that dates from the late 1780s until the passage of the Bill for the Abolition of the British Slave Trade in 1807.[1] What has not been so frequently addressed is the body of imagery concerning slavery generated after this date. Abolition of the trade was followed by agitation for the abolition of slavery itself, first in the British sugar colonies, then in North America and finally in Brazil, and each of these movements generated a great variety of visual print materials on both sides of the Atlantic. The following discussion is focused on the imagery generated around abolition and emancipation in England in the period 1807 to 1850. Of particular interest are two questions: firstly, which earlier models of representation were most enthusiastically developed in the later period and, secondly, what aspects of slave life and its representation were shut out from graphic representation after 1807?

The abolition of slavery came into force in the British colonies in 1834, in the United States in 1862, and in Brazil in 1888. Each of these dates was marked with intense celebrations and, with the production of a variety of cultural materials, used by white power elites in order to establish a certain historical space in which officially to remember Atlantic slavery. The prints, songs, paintings, poems and sculptures created in what David Brion Davis so memorably termed the 'emancipation moment' are consequently of great importance.[2] These materials give the official version of how the power centres on both sides of the Atlantic wanted to remember and to memorialise Atlantic slavery. The propaganda generated around the emancipation dates has remarkable homogeneity, and tends to repeat a series of well-tried and trusted semiotic and narrative codes. The codification of emancipation might be seen to constitute an act of cultural policing by Britain, in which the freed slave, the slave trader, and the inherited guilt of Atlantic slavery, are all reinvented and monumentalised. What results is a series of historical fictions bedded in an agenda which invariably promotes the pacification and Christianisation of the black, the assuaging of white guilt and the demonisation of the planter class, in that order of importance.

The end of the slave trade

From this perspective 1807 remains perhaps the crucial date, because the prints and paintings produced to celebrate the end of the British slave trade put in place the fundamental visual language of white emancipation myths. What most of this material does is to substitute the refulgent and easy memory of the abolition for the dark and difficult memory of slavery itself. In other words slavery as an economic policy, an historical black hole and an ethical disaster, is replaced by the symbolically exaggerated moment of its theoretical cessation: an unending and infinitely repeated instant of jubilation, gratitude and mutual enlightenment. What has not yet been sufficiently addressed is the extent to which the place of the slave body within this celebratory space is frequently ambiguous, when it is not altogether erased.

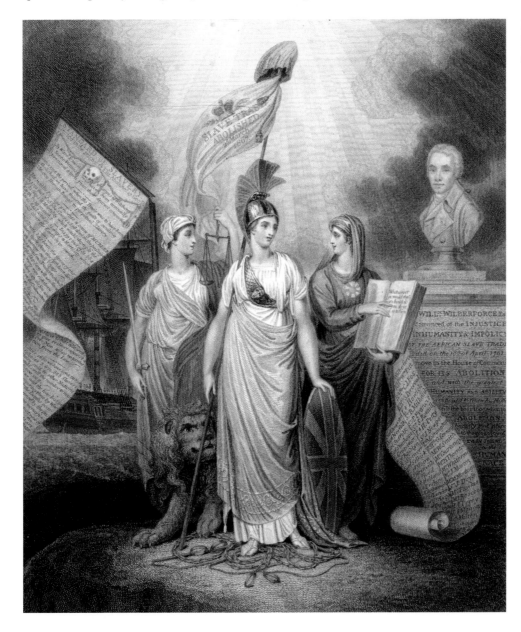

Fig.48: Joseph Collyer after Henry Moses, *Plate to commemorate the abolition of the slave trade*, 1808 (Cat.494) PAH7367.

Within popular graphic art an extreme example of these processes of effacement and re-inscription is the technically gorgeous engraving which Joseph Collyer developed out of the Henry Moses painting *Abolition of the slave trade* (Figure 48). This plate was produced in June 1808 as an official commemorative work celebrating the passage of the 1807 Act, and was distributed in large numbers both as a black-and-white and a hand-tinted engraving. As this print perfectly lays down the ground rules for the visual rhetoric of emancipation, it requires a close examination.

The crucial question is: what has become of the slaves in this version of events? The British may have dominated the Atlantic slave trade for over a century, and have shipped a combined estimated total of 3.4 million slaves from Bristol, Liverpool and London during this period, but where are those black bodies now? The print gives us a threesome of fleshy white females, who oversee the nativity of a new national fiction. The image is weighed down with massive amounts of text listing the evils of slavery, the names of the politicians who voted to pass the abolition bill, and the deeds and achievements of William Wilberforce, the politician who has come to be seen as the evangelical, and indeed saintly, popular face of abolition. That popular face is indeed the only portrait likeness, and yet the print is a most carefully calculated representational reality.

Wilberforce, although he was alive and well when the print was made, is not presented as a flesh-and-blood human presence. We are not invited to look upon a man but upon a simulacrum, a stone likeness that gazes back down at us, a marble bust on a plinth with a cold contented smile. The processes of Wilberforce's official sanctification are put in place at the very instant of abolition. He has been moved from man to myth; his flesh and blood have already been subsumed into the sterile white marble of official neo-classical statuary. He is an impassive neo-Roman monument, beyond reproach, beyond reality, and beyond the reach of the slaves. At a stroke the memory of slavery has become the memory of William Wilberforce's heroic battle for the abolition of the slave trade. What should be two discrete narratives have been elided. Wilberforce in body and reputation has undergone a process of total 'albinification', he is almost literally whiter than white, and was to remain so within the memory of Atlantic slavery, right down to the present century. All slavery's shadows and grey areas have evaporated in this tumultuously bright vision of abolition.[3] Indeed the entire upper third of this print is bathed in a divine radiance, its rays exploding out from a centre focused on Britannia's liberty cap, and the British crown, which flies conspicuously on her banner. These rays drive off heavy, dark clouds (presumably symbolising Britain's slavery inheritance) in order to illuminate the bust of Wilberforce.

The brutal truth is that there is not a single black body in this composition; the official history has conveniently eased the existence of black people – still enslaved – quite literally out of the picture. If the slave body is present it is by allusion, indeed by an allusiveness that suggests presence via traumatic absence. There are three details that invite us to fill in this massive void, and to bring the slave body back to cultural life. The first is the presence of the ship sailing through the picture plane middle left and nearly obliterated by the banner entitled 'Standard of Slavery'. Yet even here the

presence is ambiguous; is this ship supposed to represent a departing slaver? It may be, but it is placed behind the figure of Justice with her sword and scales, the symbols of judicial fairness. This may imply that the ship is one of the new Royal Navy patrol vessels, then cruising the Atlantic in the wake of the 1807 Act to stop other nations profiting from the trade Britain so recently dominated and even more recently renounced. As the nineteenth century progressed, these anti-slave-trade patrol vessels came to occupy a central position in Britain's morally self-aggrandising narrative of the history of slavery.

The second detail, which indisputably does gesture towards the traumatised slave body, lies under the substantial paw of the British lion and beneath Britannia's feet. Snaking around her sandals is a pile of chains and shackles, the restraints applied predominantly to male slaves on the Middle Passage. It is relevant, however, to analyse precisely how these objects represent the slave body. At their primary level of meaning they do not describe the limbs they once restrained, but the minds of the traders and torturers who operated the Atlantic slave system. The chains and fetters, hand-forged in Manchester and Birmingham, represent the economic vision of the ship-owners and the sailors who ran the trade. If they represent the slaves at all it is only as the trade's dehumanised victims. Surely, then, these objects are intended to symbolise white depravity and the mindset of the slave traders, rather than the suffering of the slaves. Their debased position of these objects surely supports this reading; Britannia is not trampling figuratively upon the bodies of slaves or their traumatic memory, but upon the greed and moral corruption which generated British dominance of the Atlantic slave trade.

The third detail which may allude to the slave body is the tiny death's head, hung about with leg irons and chains, which floats at the top of the broken slave standard like a macabre factotum. Yet again this is not a straightforward sign. The slave is presented as dead and gone, as a deceased victim, and finally not as black living flesh and skin, but as white bone. This is the only detail in the print that does present part of a black body and it presents a head, of unidentified gender, as a doomed fragment. This little death's head hangs there as a precise spatial counterpoint to that other white head directly opposite, with its soft hair; a head set above a tailored coat and a cravat; a head that carries the face of Wilberforce, and which is, by volume, about ten times the size of the slave skull.

The message of this print is all too clear: henceforth the history of slavery will make way for the history of abolition. The history of abolition is a white-evolved historical fiction in which the slave is given the gift of freedom by a beneficent patriarchy and a noble nation. The heroes of the emancipation moment are the white leaders of the abolition movement – men on a mission, martyrs to their cause – who must now be worshipped as the incarnation of a higher moral calling. The idea that the slave might have had any input into the processes of his or her own liberation – the concept of slave agency – finds no place in this remarkably effective allegory, which is also a statement of national moral abrogation. This print sets out a crushing agenda for what slaving nations will choose to forget, and what they will choose to embody in fantasy, when they have to confront the memory of slavery at the moment of its official demolition.

THE NEGROES' VIGIL!

Written expressly for the 1st of August, 1834, by James Montgomery.
The Music composed by John Valentine.

" They that watch for the morning"—*Psalm* cxxx. *Ver.* 6.

Hie to the mountain afar,
 All in the cool of the even,
Led by yon beautiful star,
 First of the daughters of Heaven:
Sweet to the slave is the season of rest;
 Something far sweeter he looks for to-night;
His heart lies awake in the depth of his breast
 And listens till God shall say—" Let there be light!"

Climb we the mountain, and stand
 High in mid-air to inhale,
Fresh from our old Father-land,
 Balm in the ocean-borne gale :
Darkness yet covers the face of the deep;
 Spirit of Freedom go forth in thy might,
To break up our bondage, like infancy's sleep,
 The moment her God shall say—" Let there be light!"

Gaze we, meanwhile, from this peak,
 Praying in thought while we gaze;
Watch for the dawning's first streak,
 Prayer then be turned into praise :
Shout to the valleys—behold ye the morn,
 Long, long desired, but denied to our sight!
Lo! myriads of slaves into men are new born;
 The word was omnipotent—" Let there be light!"

Hear it, and hail it ;—the call
 Island to island prolong,
Liberty! Liberty!—all
 Join in that Jubilee song:
Hark! 'tis the children's Hosannas that ring;
 Hark! they are Freemen whose voices unite
While England, the Indies, and Africa sing,
 Amen, Hallelujah, to " Let there be light!"

. The Profits arising from the Sale of this Publication will be given in aid of
Missionary Societies.

Published by Z. T. Purday, 45, High Holborn, London.

The end of slavery

Opposite: Fig.49: James Montgomery,
The Negroes' vigil!, 1834 (Cat.227) ZBA2572.

When the abolition of slavery in the British sugar colonies was declared in August 1834, it was met with ecstasy. Having rehearsed the process of occupying the moral high ground in 1807, new strategies were developed which celebrated white philanthropy ever more extravagantly, and which disempowered and misrepresented black people ever more effectively. Of course the official abolition of slavery at this moment was a convenient blanket fiction. On the ground in the colonies things were rather different; in reality, emancipation inaugurated the hated apprenticeship system, whereby slaves had to continue to work for their masters without pay for five years. Knowing that they still had this period in which to exploit their ex-slave labour force, and the full power of the military and judiciary to support their policies, the majority of slave holders exploited their nominally ex-slave workers with a terrible thoroughness. Within the year shocking reports began to circulate in the House of Commons, and led Lord Macaulay to draft a grim assault on the failings of the system and the dubious nature of the much-vaunted abolition. But the plight of the slaves under the apprenticeship never caught the British popular imagination in the way that abolition had done. The reason for this is obvious: once a nation has made a down payment on its own myth of abolition (in this case a literal cash payment of £20 million in compensation to planters) and been consumed by its own myth of liberation, no nation wants – or indeed may possess the moral capacity – to see beyond the veil of self-aggrandisement.

The slaves have been given the gift of freedom; they have been moved culturally, en masse, from bondage to liberty. Consequently, in the imagination of the people who created emancipation prints, wrote emancipation poetry, and marketed the gift of freedom, the slave at a certain level would never be free. The double standards in operation around the meta-narrative of emancipation come out powerfully in the illustrated handbill *The Negroes' vigil!* (Figure 49).

This sheet takes the form of a print accompanied by a poem written by that virtual laureate of the emancipation moment, James Montgomery. The poem purports to speak for the slaves; 'the spirit of freedom' mysteriously goes forth across the land. The arrival of freedom is presented as a Manichean conversion experience, in fact not merely as a conversion from slave to free, but as a literal rebirth: 'myriads of slaves into men are new born'. Whatever the slave was before the gift of liberty, he/she appears to exist outside humanity; slaves only become men and women with the gift of freedom, the implication being that the white can literally give the slave humanity. The poem climaxes with the conventional idea that, on being given freedom, the slaves will immediately espouse a form of passive Christianity predicated in an unending gratitude directed towards the generosity of their ex-masters and the British state:

> Hark! 'tis the children's Hosannahs that ring;
> Hark! they are Freemen whose voices unite
> While England, the Indies, and Africa sing,
> Amen, Hallelujah, to 'Let there be light!'

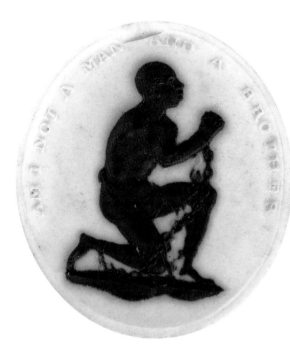

Fig.50: William Hackwood for
Josiah Wedgwood, *Slave Emancipaton
Society medallion, c.*1787–90
(Cat.178) ZBA2492.

Yet on examining the picture at the head of the handbill we are given a very different message. The wood engraving is a simple reworking of the image first designed as the seal of the Society for Effecting the Abolition of the Slave Trade (Figure 50). This vastly influential little icon carried beneath it the inscription 'Am I not a man and a brother?', the slave notoriously asking the white viewer if he deserves to be granted an equal share in the human condition.

The poem may show the slave as jubilant and liberated but the accompanying image crucially re-inscribes the central icon of slave passivity and disempowerment. Why not an image of the slave celebrating freedom? Surely the answer is that the slave must always be seen as subservient, as a figure who can only ask to be liberated, and who when liberated will still carry the cultural aura of enslavement deep within. This comes out powerfully in a number of prints showing the moment of emancipation where one or more of the newly freed slaves, although no longer enchained, kneel with clasped hands, adopting precisely the same pose as the original figure in the seal. The iconography had in fact been rehearsed even before emancipation. So, for example, the engraving accompanying *A Negro woman's lamentation* of *c.*1805 shows an apparently freed black woman, her chains lying broken on the shore (Figure 51). Yet she still kneels in the supplicatory position of the original female version of the 'seal', and of course clutches the Bible: the only good free slave is a Christian one. It is as if white artists and audiences would not, or could not, see beyond the imprisoning mechanisms of the earlier image. Such pervasive graphic conservatism speaks volumes about white anxiety over the figure of the free black.

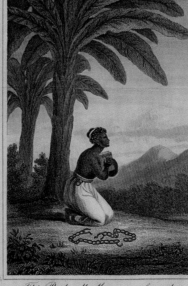

A NEGRO WOMAN'S LAMENTATION.

BORN on Afric's golden coast,
 Once I was as blest as you ;
Parents tender I could boast,
 Husband dear, and children too.

With the baby at my breast,
 (Other two were sleeping by,)
In my hut I sat at rest,
 With no thought of danger nigh.

From the beach at even-tide,
 Rush'd the fierce man-stealing crew,
Seized the children by my side,
 Seized the wretched Yamba too.

Then, for love of filthy gold,
 Straight they bore me to the sea,
Cramm'd me down a slave-ship's hold,
 Where were hundreds stow'd like me !

I in groaning pass'd the night,
 And did roll my aching head ;
At the break of morning light,
 My poor child was cold and dead !

Happy, happy, there she lies—
 Thou shalt feel the lash no more ;
Thus full many a Negro dies,
 Ere we reach the destined shore.

*This Book tell Man not to be cruel ;
Oh that Maſſa would read this Book.*

Driven like cattle to a fair,
 See, they sell us, young and old ;
Child from mother too they tear,
 All for love of filthy gold.

I was sold to massa hard ;
 Some have massas kind and good ;
And again my back was scarr'd ;
 Bad and stinted was my food.

Poor and wounded, faint and sick,
 All exposed to burning sky,
Massa bids me grass to pick,
 And I now am near to die.

What and if to death he send me,
 Savage murder though it be ?
British laws shall ne'er befriend me,
 They protect not slaves like me.

But though death this hour may find me,
 Still with Afric's love I burn ;
There I've left a spouse behind me—
 Still to native land I turn.

Cease, ye British sons of murder !
 Cease from forging Afric's chain ;
Mock your Saviour's name no further ;
 Cease your savage lust of gain.

" Indeed I was stolen away out of the land."—GEN. xl. 15. " Trust not in oppression, and become not vain in robbery."—PSALM lx. 10.
 " Whatsoever ye would that men should do to you, do ye even so to them."—MATT. vi. 12.
 " Remember them that are in bonds, as bound with them."—HEB. xiii. 3.
 " Open thy mouth, judge righteously, and plead the cause of the poor and needy."—PROV. xxxi. 29.
 " Whoso stoppeth his ears at the cry of the poor, he also shall cry himself, but shall not be heard."—PROV. xxi. 13.

Fig.51: *A Negro woman's lamentation, c.*1805
(Cat.490) ZBA2552.

Emancipation

Let us look forward another five years beyond the 1833 emancipation propaganda to a work entitled *Celebration of the 1st of August 1838 at Dawkins Caymanas* (Figure 52). In this elaborate image, depicting the celebration of the anniversary of emancipation on the occasion of the final abolition of the apprentice system in Jamaica, the design is still imprisoned within the dynamic of a white anxiety about black freedom. This 1838 lithograph was developed out of a drawing by William Ramsay, a witness of the event. His drawing was then sent to London, where R. A. Leighton carefully refined it into a propaganda print. The image unambiguously celebrates black gratitude for the abolition of slavery and the apprentice system, while simultaneously reinforcing the idea that in terms of power relations and the harmonious cultivation of sugar, nothing has really changed.[4] The image is an extreme control fantasy.

The Governor of Jamaica and the white planter – with his family and entourage, including the overseer and the local clergyman – dominate the foreground, where they sit at a square table that is separated from the ex-slaves' table.[5] The latter disappears into the background of the picture along a perspectival line of infinity, as if there were no end to the ordered ranks of anonymous ex-slaves. Black servants decorously wait on the masters from sideboards loaded with food, and silver vessels for wine and spirits. The entire scene is bordered by a series of arches that have been composed out of coconut branches and sugar-cane leaves. While the whites sit relaxed, with males, females, infants and adults promiscuously intermixed, the supposed ex-slaves, or 'apprentices', are all adult and have been rigorously divided along gender lines, the women and men all dressed in identical pristine uniforms. The implication is that things go on precisely as they did under slavery: the cane flourishes and still forms the background or framing device for the whole of life; the 'ex-slaves' are submissive, contented and well disciplined, turning out in their Sunday best for the feast day. The overseer is still the overseer, the master and mistress still in control, and the planter family still the unit around which all domestic power turns, while 'His Excellency the Governor', the representative of British imperial dominion, oversees all. Floating in space above the whole scene are a series of banners bearing the names of the queen and the British politicians involved in seeing through the abolition bill and the implementation of the brutal apprentice system. The accompanying text explained that these are both political and sacred names, British implementation of abolition being specifically sanctioned by a higher power, namely the Parliamentary representatives of a very white, English and imperial God: 'The inside was fitted up in a style…chaste and elegant, being…adorned with flags or various coloured silk bearing in gold and silver letters the names of the illustrious living characters who under God achieved the glorious triumph the assembly met to celebrate.'

The print, and indeed the event it depicts, is a carefully orchestrated fantasy designed to reassure white British audiences that all goes on efficiently in the colonies, and that emancipation is only a term, not a social revolution. The accompanying prose account observed that when the governor's coach arrived, the apprentices

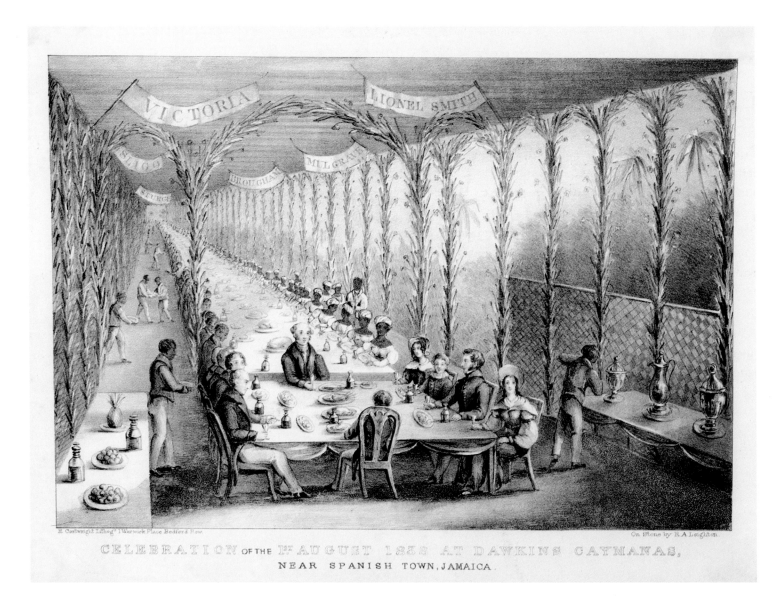

CELEBRATION OF THE 1ST AUGUST 1838 AT DAWKINS CAYMANAS,
NEAR SPANISH TOWN, JAMAICA.

Fig.52: R.A. Leighton after William Ramsay, *Celebration of the 1st of August 1838 at Dawkins Caymanas*, 1838 (Cat.511) ZBA2501.

spontaneously insisted on taking the places of the horses and drawing the grand visitors to the banquet: 'a body of the most Athletic of the late apprentices surrounded the Carriage... and, removed the horses and dragged them [his excellency and suite] along to the scene of interesting conviviality in the midst of volleys of enthusiastic huzzas'. 'Athletic' slave flesh and horse flesh are, despite the gift of liberty, still locked within that sinister equality which saw them advertised alongside each other in auction notices during the days of slavery.

The fiction that this print embodies takes the controlling mechanisms of British emancipatory rhetoric to a point of perfection. Black resentment, violence, traumatic memory, sexuality and above all agency, are ruthlessly locked out of this version of events. Controlled, yet contented, happy to choose a state of continued servitude, this black labouring population not only suggests that it will continue to produce sugar, but implies that it was always happy under a benevolent white patriarchy. In this sense the

print relates to another very prominent graphic tradition. Up to and beyond abolition, popular propaganda continued to engender the myth that the slaves' lot might well be preferable to that of the free black, or indeed the free white labourer in Britain. This myth was not only potent in the thought and writing of pro-slavery figures but was also a common refrain among radicals and socialists. The notion that slaves in the sugar colonies were contented and protected, while white labourers were barbarically exploited within the nascent capitalist systems of British domestic labour, was reiterated throughout the nineteenth century. It was a constant theme in the work of such popular social critics as William Cobbett, Henry Hetherington and Thomas Carlyle.

A particularly effective articulation of the position in graphic satire is the print *Cocker's solution of the slave question* (Figure 53). It was published in 1831, when popular debates around emancipation were at their height, and when Chartist agitation for labour reform in British factories was a prominent domestic issue. The print is dialogic, setting up two equations: the well-to-do soldier is faced off against the starving white factory operative and this pairing is seen to provide a perfect counterbalance to the affluent slave family who are set against the diseased and starving 'free Negro'. The latter, who is afflicted with elephantiasis, addresses the black slave with unintended and cruel irony as 'massa' (master). The highly Carlylean argument here is that it is all too

Fig.53: *Cocker's solution of the slave question*, 1831 (Cat.507) ZBA2704.

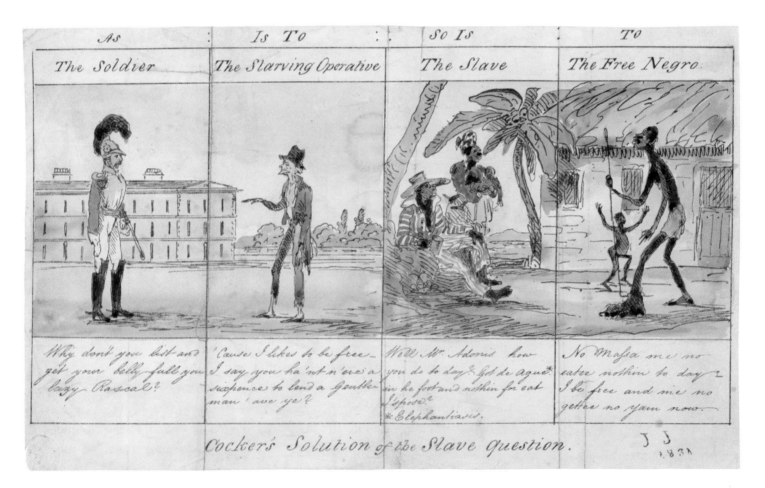

Opposite: Fig.54: John Hawksworth after S. Croad, *The slave ship* Vigilante, 1823 (Cat.498) PAH7370.

easy to become a very real victim of liberty within a free market economy, and that old-style plantation life is an infinitely preferable state for the black.

To end with a summarising generalisation, it could be said that the majority of white-engendered imagery dealing with the representation of slaves in the nineteenth century was involved in the production of a series of fictions, which would reassure white audiences about black inferiority and white benevolence. If slaves were to be thought about seriously then it was as disempowered and passive beings who suffered, who were instinctively servile and loyal to their white owners. In other words, black people were created as images of patient suffering onto which white people could project their sentimental and empathetic emotions. The most influential, and aesthetically the most complete, body of imagery relating to these representational impulses came out of the depiction of slaves on the Middle Passage. The notorious print of the slave ship *Brooks* evolved by the London Society for Effecting the Abolition of the Slave Trade in 1789 entitled *Description of a slave ship*, and showing shackled rows of slave bodies reduced to what is almost an abstract pattern, remained hugely influential throughout the nineteenth century (Cat.481). Once British anti-slavery patrols were regularly liberating slave cargoes from French and Spanish vessels, a constant stream of updated and variant versions of the original 1789 broadside appeared. So, for example, in 1823 a print appeared entitled *The slave ship 'Vigilante'*, showing a French vessel captured off the African coast by a British anti-slavery patrol under one Lieutenant Mildmay (Figure 54). The slaves have been seamlessly carried over from the *Brooks*, decorously filling the outline of the new ship like some outrageous form of cut-out paper decoration. What is the reason for the longevity of this image and its mass cultural recirculation across a huge variety of representational media (a process which, incidentally, continues to the present day)? The answer lies partly in the exceptional aesthetic beauty of the design, but also in the fact that this is the way white audiences wanted to think about black slaves. Silent, supine, suffering: in their quiet order they provide a space for white meditation, but not for black empowerment.

* * * * *

If we survey the entire range of graphic representations of slavery in the nineteenth century, we see that it was only very rarely – and then only in the work of satirists – that an alternative vision emerged, suggesting that blacks might feel fury about their abuse under slavery and that they might want to express this fury. George Cruikshank's peculiar 1818 etching *Every dog has his day – or black devils amusing themselves with a white negro driver*, produced at the height of Cruikshank's engagement with the British ultra-radical movement for Parliamentary reform, is a good example of the anxieties generated around this theme of black insurrectionary violence (Figure 55). Here the naked white overseer is presented as a parodic religious martyr, burned at the stake, while the slaves are presented as deformed and diminutive devils. The association of blackness with the diabolic was by this stage deeply engrained in popular culture. The black faces display elements of extreme Negrophobe caricature: they all possess

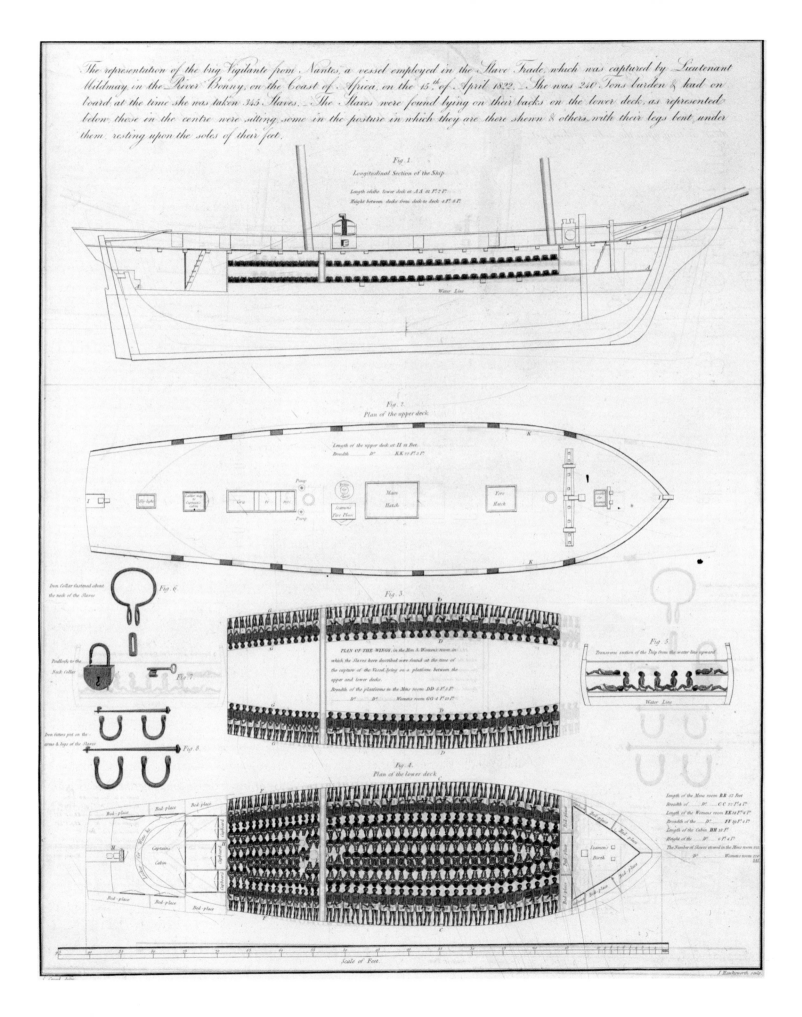

The representation of the brig Vigilante from Nantes, a vessel employed in the Slave Trade, which was captured by Lieutenant Mildmay, in the River Bonny, on the Coast of Africa, on the 15th of April 1822. She was 240 Tons burden & had on board, at the time she was taken 345 Slaves. The Slaves were found lying on their backs on the lower deck, as represented below, those in the centre were sitting, some in the posture in which they are there shewn & others with their legs bent under them, resting upon the soles of their feet.

Fig. 1.
Longitudinal Section of the Ship

Length of the lower deck at A A 81 Ft. 7 In.
Height between decks from deck to deck 4 Ft. 6 In.

Water Line

Fig. 2.
Plan of the upper deck

Length of the upper deck at II 81 Feet.
Breadth Do. KK 27 Ft. 2 In.

Sky light

Ladder way to Captains cabin

Gra ti ng

Pump

Pump

Seamens Fire Place

Main Hatch

Fore Hatch

K

K

Fig. 6.
Iron Collar fastened about the neck of the Slaves

Fig. 3.

PLAN OF THE WINGS, in the Men & Womens room, in which the Slaves here described were found at the time of the capture of the Vessel, lying on a platform between the upper and lower decks.
Breadth of the platforms in the Mens room DD 5 Ft. 3 In.
Do. Do. Womens room GG 4 Ft. 10 In.

G

G

G

G

D

D

D

D

Fig. 5.
Transverse section of the Ship from the water line upward

Water Line

Fig. 7.
Padlock to the Neck Collar

Fig. 8.
Iron fetters put on the arms & legs of the Slaves

Fig. 4.
Plan of the lower deck

Bed place
Bed place
Bed place

Captains Cabin

H

H

H

Bed place
Bed place

Bed place
Bed place
Bed place

Seamens Birth

Length of the Mens room BB 37 Feet
Breadth of Do. CC 25 Ft. 4 In.
Length of the Womens room EE 14 Ft. 4 In.
Breadth of the Do. FV 19 Ft. 4 In.
Length of the Cabin HH 10 Ft.
Height of the Do. 6 Ft. 4 In.
The Number of Slaves stowed in the Mens room 223
Do. Womens room 122

C

C

Scale of Feet.

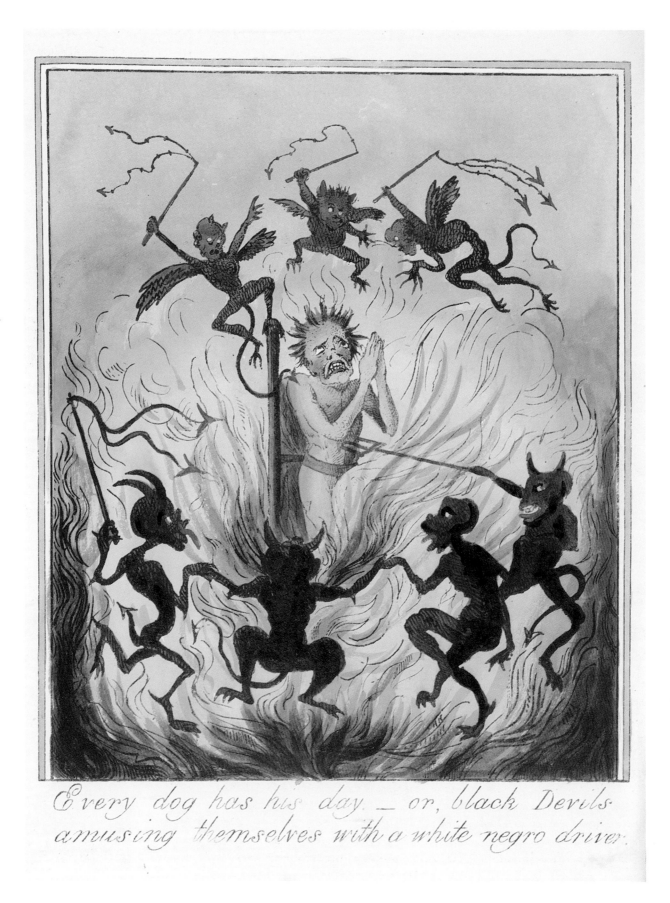

Every dog has his day. — or, black Devils amusing themselves with a white negro driver.

massively exaggerated lips, and those shown in profile have exaggerated jaws, flat noses and low foreheads. Yet the figures do not constitute straightforward racial satire; they are so deformed as to slip out of the realm of black caricature and into some other realm of animalistic or demonic fantasy. Comic, trivial, devolved denizens of a fantastic world, they are more like imps or sprites than actual slave revolutionaries operating in a real world of social grievance. It might be said that this print is in one way typical, in that white artists throughout the nineteenth century seemed incapable of producing visual art which dealt seriously with the subject of black revolutionary violence.

Opposite: Fig.55: George Cruikshank, *Every dog has his day*, 1818 (Cat.536) ZBA2502.

NOTES

1 The best account of the popular propaganda generated by the first phase of the abolition movement is J.R. Oldfield, *Popular Politics and British Anti-Slavery: The Mobilisation of Public Opinion Against the Slave Trade, 1787–1807* (Manchester, 1995).

2 David Brion Davis, *The Emancipation Moment* (Fortenbaugh Memorial Lecture, Gettysburg, Pennsylvania, 1983).

3 For Wilberforce's dubious positioning on domestic politics, his support of Pitt's excessively repressive domestic legislation, and the consequent hatred in which he was held by the entire spectrum of political radicals, see Marcus Wood, *Blind Memory: Visual Representations of Slavery in England and America, 1780–1865* (Manchester, 2000), pp 293–5.

4 In an accompanying letter sent with his original drawing, Ramsay stated that the local Jamaican printers would not be capable of producing the work, adding that his drawing of the scene 'could be well worked up in England and at a small expense: done here I think a sad job would be made'. Michael Graham-Stewart, *Slavery Collection, Autumn 2001* (printed privately, 2001), p.23.

5 The National Maritime Museum's copy of the print is accompanied by a double-page printed commentary on the event and the participants (ZBA2501.1). The details relating to the participants, and subsequent quotations in my text, are drawn from this document.

Select Bibliography

Berlin, Ira, *Many Thousands Gone: The First Two Centuries of Slavery in North America*, Belknap, Cambridge, Massachusetts, 1998

Blackburn, Robin, *The Overthrow of Colonial Slavery, 1776–1848*, Verso, London, 1988

Blackburn, Robin, *The Making of New World Slavery: From the Baroque to the Modern, 1492–1800*, Verso, London, 1997

Brown, Christopher L., *Moral Capital: Foundations of British Abolitionism*, University of North Carolina Press, Chapel Hill, 2006

Burnard, Trevor, *Mastery, Tyranny, and Desire: Thomas Thistlewood and his Slaves in the Anglo-Jamaican World*, University of North Carolina Press, Chapel Hill, 2004

Carretta, Vincent (ed.), *Unchained Voices: An Anthology of Black Authors in the English-Speaking World of the Eighteenth Century*, University of Kentucky Press, Lexington, 1996

Davis, David Brion, *Inhuman Bondage: The Rise and Fall of Slavery in the New World*, Oxford University Press, New York, 2005

Drescher, Seymour, *Econocide: British Slavery in the Era of Abolition*, University of Pittsburgh Press, Pittsburgh, 1977

Eltis, David, *The Rise of African Slavery in the Americas*, Cambridge University Press, Cambridge, 2000

Eltis, David; Behrendt, Stephen D.; Richardson, David and Klein, Herbert S. (eds), *The Trans-Atlantic Slave Trade: A Database on CD-ROM*, Cambridge University Press, Cambridge, 1999

Fryer, Peter, *Staying Power: The History of Black People in Britain*, Pluto Press, London, 1984

Hall, Douglas, *In Miserable Slavery: Thomas Thistlewood in Jamaica, 1750–86*, University of the West Indies Press, Kingston, Jamaica, 1999

Heuman, Gad, *The Caribbean*, Hodder Arnold, London, 2006

Heuman, Gad & Walvin, James (eds), *The Slavery Reader*, Routledge, London, 2003

Hochschild, Adam, *Bury the Chains: The British Struggle to Abolish Slavery*, Macmillan, Basingstoke, 2005

Howell, Raymond, *The Royal Navy and the Slave Trade*, Croom Helm, London, 1987

Klein, Herbert S., *The Atlantic Slave Trade*, Cambridge University Press, Cambridge, 1999

Lloyd, Christopher, *The Navy and the Slave Trade: The Suppression of the African Slave Trade in the Nineteenth Century*, Longmans, London, 1949

Lovejoy, Paul E., *Transformations in Slavery: A History of Slavery in Africa*, Cambridge University Press, Cambridge, 2000

Morgan, Philip D., *Slave Counterpoint: Black Culture in the Eighteenth-Century Chesapeake and Lowcountry*, University of North Carolina University Press, Chapel Hill, 1998

Northrup, David (ed.), *The Atlantic Slave Trade*, D.C. Heath, Lexington, Massachusetts, 1994

Oldfield, John R., *Popular Politics and British Anti-Slavery: The Mobilisation of Public Opinion Against the Slave Trade, 1787–1807*, Frank Cass, London, 1998

Sparks, Randy J., *The Two Princes of Calabar: An Eighteenth-Century Atlantic Odyssey*, Harvard University Press, Cambridge, Massachusetts, 2004

Thornton, John, *Africa and Africans in the Making of the Atlantic World, 1400–1800*, Cambridge University Press, Cambridge, 1998

Tibbles, Anthony (ed.), *Transatlantic Slavery: Against Human Dignity*, Liverpool University Press, Liverpool, 2006

Walvin, James, *Black Ivory: A History of British Slavery*, Blackwell, Oxford, 2001

Walvin, James, *Atlas of Slavery*, Pearson, Harlow, 2005

Ward, W. E. F., *The Royal Navy and the Slavers: The Suppression of the Atlantic Slave Trade*, George Allen and Unwin, London, 1969

Wood, Marcus, *Blind Memory: Visual Representations of Slavery in England and America, 1780–1865*, Manchester University Press, Manchester, 2000

CATALOGUE

INTRODUCTION

The following sections are arranged by object type (artefacts, books and pamphlets, coins and medals, prints and drawings etc.) to give a sense of both the range and the richness of the National Maritime Museum's slavery collections. Most of the sections are subdivided by theme or by a further refinement of object type; the objects are then listed either in date order or in some cases – for example, books and oil paintings – alphabetically by author or artist.

Wherever possible, we have provided details of the place and date of production or publication, the maker and basic measurements. Also provided at the end of each entry is the Museum's own unique object number, followed where appropriate by the reference number for the negative of any photographs of the object. The catalogue entries are numbered sequentially (from 1 to 622), with cross-references to the illustrations provided in the accompanying essays. The exception to this sequence is Cat.124a, the logbook of the *Juverna*, which the Museum only acquired just as the catalogue went to press.

ARTEFACTS

Slavery and the slave trade have left behind a range of artefacts relating to the capture of Africans, their terrible transportation across the Atlantic and their enslavement in the Americas. This small collection of objects includes some of the goods of exchange employed along the West African coast and examples of the instruments of restraint and repression used on slave ships and plantations.

1
Identification band
1746
Steel, 150 × 87 × 18 mm

Slave identification band and key. Engraved 'S. Bosanquet. Layton 1746'. This band would be locked on to a slave's wrist when they were sent on an errand to a different plantation. See Fig.17 (p.59).

ZBA2474 / E9103

2
Manillas
1750
Copper, largest 25 × 65 mm

Manillas, metal rings sometimes worn on the arm or wrist by certain African societies, were widely used as a medium of exchange. Huge quantities were imported into western Africa from Europe as part of the slave trade. See Fig.8 (p.36).

AAA2820–21 / D9623

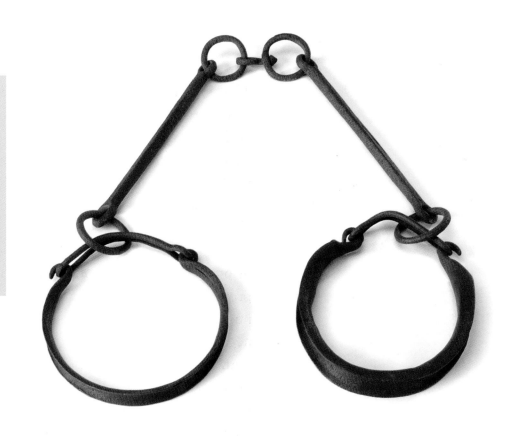

Cat.3

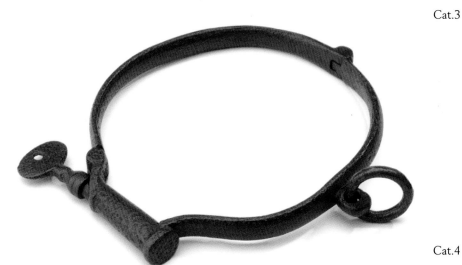

Cat.4

3
Neck rings
c.1790
Iron, 850 × 140 × 27 mm

ZBA2434 / E9107

4
Neck ring
18th century
Iron, 30 × 170 × 185 mm

The ring is hinged and has a detachable key and a connecting loop.

ZBA2473 / F5732

5
Handcuff
*c.*1800
Steel, 165 mm

ZBA2455

6
Handcuff
*c.*1810
Iron, 102 × 102 × 25 mm

ZBA2456

7
Handcuff
*c.*1810
Iron, 35 × 93 × 60 mm

ZBA2457

8
Whip
*c.*1890
Hippopotamus hide, 25 × 90 × 87 mm

Inscribed on handle 'C [?] D, Ford 1893'.

ZBA2483 / F2515

9
Gin bottle
V. Hoytema & Co., Netherlands,
19th century
Glass, 235 × 80 × 80 mm

See Fig.29 (p.105).

AAA2819 / D9637

10
Leg-irons
Congo, 19th century
Iron, 390 mm

ZBA2471 / E9106

11
Leg-irons
West Africa, 19th century
Iron, 350 mm

ZBA2481

12
Restraining irons
19th century
Iron, 32 × 1170 × 137 mm

ZBA2486

13
Whip
19th century
Steel and hippopotamus hide,
25 × 90 × 1425 mm

ZBA2484

14
Chicotte
19th century
Hippopotamus hide, 20 × 35 × 905 mm

The *chicotte* was a type of whip made of
twisted hippopotamus hide and developed
by Portuguese slave traders in the eighteenth
century. This example has two twisted strips
and a pierced handle.

ZBA2485

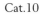

Cat.10

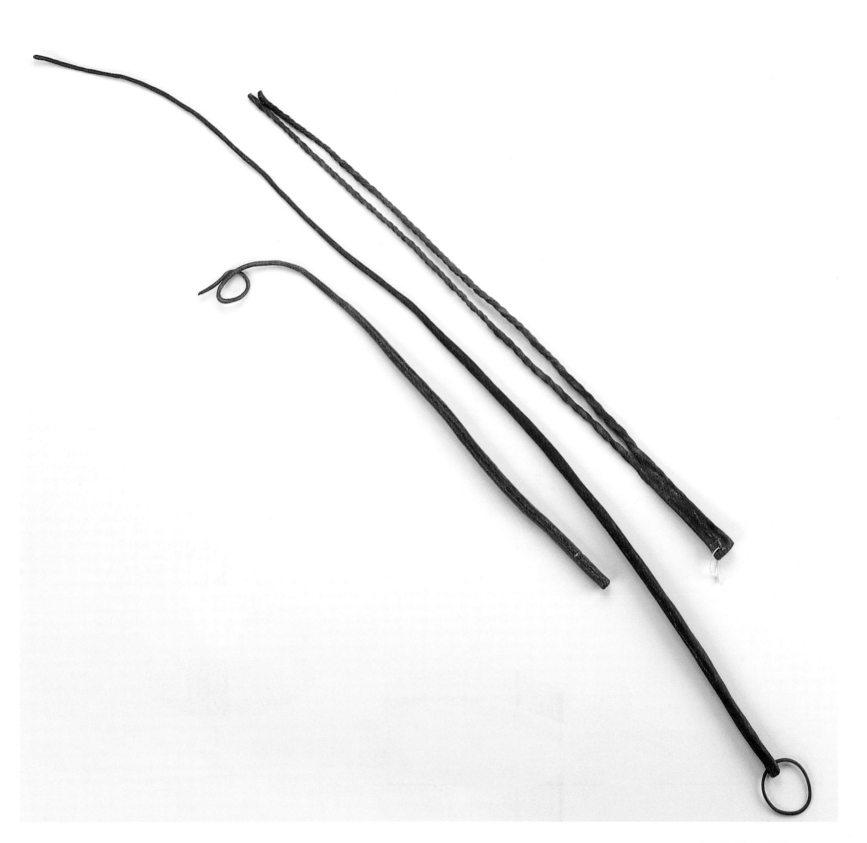

Cats 8, 13, and 14

BOOKS, PAMPHLETS AND OFFICIAL PUBLICATIONS

The rare books, pamphlets and official publications held in the Caird Library at the National Maritime Museum contain a wealth of material relating to colonial slavery, the slave trade and their abolition and suppression. Printed works from the sixteenth century onwards cover a diverse range of topics from navigation and exploration, naval operations and warfare, to medical treatises and political and commercial tracts. The following selection is representative of some of the riches of this collection.

15
John Atkins (1685–1757)
A voyage to Guinea, Brazil and the West Indies in His Majesty's ships the Swallow *and* Weymouth
Ward & Chandler, London, 1737, 2nd edition

PBD4133

16
Thomas Aubrey
The sea-surgeon, or the Guinea man's vade mecum: in which is laid down the method of curing such diseases as usually happen abroad, especially on the coast of Guinea; with the best way of treating Negroes both in health and in sickness
John Clarke, London, 1729

PBC5732

17
Willem (William) Bosman
A new and accurate description of the coast of Guinea, divided into the Gold, the Slave, and the Ivory Coasts
James Knapton and Daniel Midwinter, London, 1705

PBC6084

18
Rev. George Bourne
Picture of slavery in the United States of America
Edwin Hunt, Middletown, Connecticut, 1834

Signed and dated inside the front cover.

MGS/58

19
John Campbell (1708–75)
Candid and impartial considerations on the nature of the sugar trade; the comparative importance of the British and French islands in the West Indies: with the value and consequence of St Lucia and Grenada, truly stated
R. Baldwin, London, 1763

Includes three coloured maps of Caribbean islands. Campbell was a historian born in Edinburgh. The politician Lord Bute commissioned him to write this book on the sugar trade as a vindication of the Peace of Paris, which ended the Seven Years War with France in 1763.

PBF7499

20
Lydia Maria Child (1802–80)
The patriarchal institution, as described by members of its own family
American Anti-Slavery Society, New York, 1860

A scathing collection of quotes, runaway slave advertisements and extracts from legal cases

tried in the southern United States. Child wrote a number of anti-slavery books in the early 1860s.

MGS/59

21
Colin Chisholm (c.1747–1825)
An essay on the malignant pestilential fever, introduced into the West Indian islands from Boullam, on the coast of Guinea, as it appeared in 1793, 1794, 1795, and 1796
J. Mawman, London, 1801, 2nd edition, 2 vols.

Chisholm was a graduate of King's College, Aberdeen, and a doctor in Grenada. He also owned a plantation in Demerara.

PBC5808

22
Thomas Clarkson (1760–1846)
The history of the rise, progress and accomplishment of the abolition of the African slave-trade by the British Parliament
Longmans, London, 1808, 2 vols.

See Fig.34 (p.109).

PBB3495, PBB3489 (new edition in one volume, J.W. Parker, London, 1839) / F5779

23
James Houston (b. c.1690)
Some new and accurate observations geographical, natural and historical, containing a true and impartial account of the situation, product, and natural history of the coasts of Guinea, so far as relates to the improvement of that trade, for the advantage of Great Britain in general, and the Royal African Company in particular
J. Peele, London, 1725

PBB7343

24

William Hutchinson (1715–1801)
A treatise on naval architecture founded upon philosophical and rational principles . . .
T. Billinge, Liverpool, 1794, 4th edition

See Fig.31 (p.106).

PBB8247 / F5778

25

Jan Huygen van Linschoten
(1563–1611)
John Huighen van Linschoten, his discours of voyages into ye Easte and West Indies
John Wolfe, London, 1598
Translated by W. Phillip.

PBD6084

26

Captain George Francis Lyon
(1795–1832)
A narrative of travels in Northern Africa, in the years 1818, 19, and 20
John Murray, London, 1821

Lyon's account of the trans-Sahara expedition of 1818–20 makes reference to the North African slave trade and practices of slavery (ch.7). The volume contains several coloured engravings of Lyon's sketches and watercolours, including 'A slave kafflé' (p.325). The mission is the focus of George Cruikshank's satirical print *Puzzled which to choose!!* (Cat.535).

PBC4525

27

Sieur de Montauban
(*c*.1650–*c*.1700)
A relation of a voyage made by the Sieur de Montauban, captain of the French privateers, on the coasts of Guinea, in the year 1695: with a
description of the kingdom of Cape de Lopez; and an account of the manners, customs and religion of the natives of that country
London, 1698

PBB0271

28

James Field Stanfield (1749–1824)
Observations on a Guinea voyage in a series of letters addressed to the Rev. Thomas Clarkson
James Phillips, London, 1788

A first edition bound with other pamphlet letters relating to the slave trade and its proposed abolition. Stanfield, a well-educated Irishman, later an actor and writer, made the full triangular voyage to Jamaica and home as a seaman in the Liverpool slavers *Eagle* and *True Blue* in 1774–6. His account is a notable early one on the mortality of the trade to European seamen caught up in it. He published a second edition in Edinburgh (J. Robertson) in 1807.

PBF5766

29

John Gabriel Stedman (1744–97)
Narrative of a five years' expedition against the revolted Negroes of Surinam in Guiana on the wild coast of South America from the year 1772 to 1777
J. Johnson, London, 1806, 2nd edition
With engravings by William Blake and Francesco Bartolozzi.

PBD4145

30

Rev. D. Gath Whitley (active *c*.1893–1910)
The capture of the slaver
The Universities Mission to Central Africa, London, *c*.1895
A popular account of the suppression of the Indian Ocean slave trade.

MGS/62 / F5776

31

An answer of the Company of Royal Adventurers of England trading into Africa
Company of Royal Adventurers of England trading into Africa, London, 1667

PBB7333, PBP6930

32

Certain considerations relating to the Royal African Company of England, in which the original, growth, and national advantages of the Guiney trade are demonstrated: as also that the same trade cannot be carried on, but by a company and joint-stock
Royal African Company, London, 1680

PBB7334

33

Considerations upon the trade to Guinea
London, 1708

PBB7350

34

The falsities of private traders to Africa discover'd, and the mischiefs they occasion demonstrated: and an account of the settlements on that coast purchased, built, and now possest, by the Company
Royal African Company, London, 1708

PBE9187

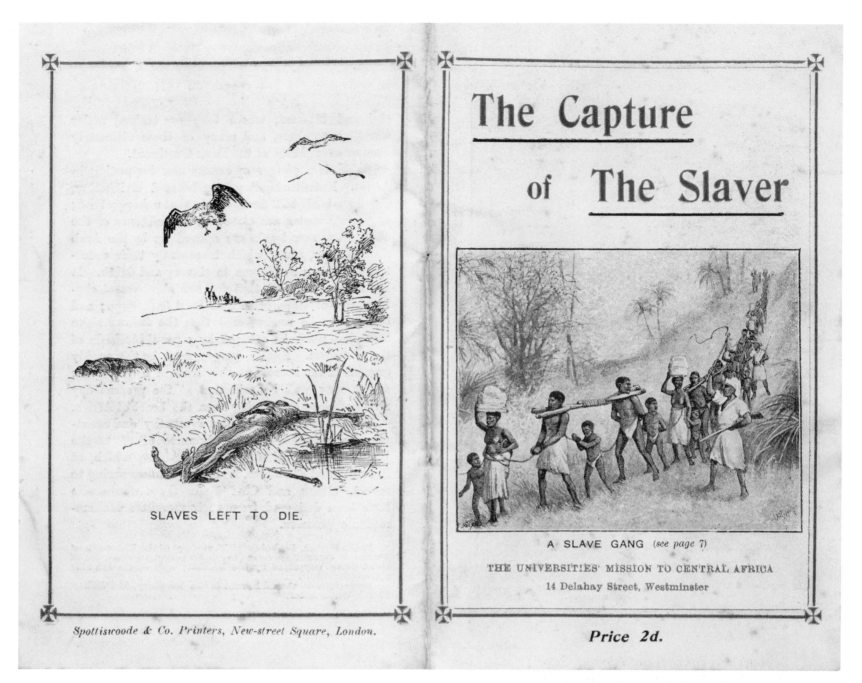

SLAVES LEFT TO DIE.

Spottiswoode & Co. Printers, New-street Square, London.

The Capture
of The Slaver

A SLAVE GANG (see page 7)

THE UNIVERSITIES' MISSION TO CENTRAL AFRICA
14 Delahay Street, Westminster

Price 2d.

Cat.30

35

A letter from a merchant in Jamaica to a Member of Parliament in London, touching the African trade. To which is added, a speech made by a black of Gardaloupe, at the funeral of a fellow-Negro

A. Baldwin, London, 1709

PBB7346

36

The case of the Royal African Company of England, to which is added a supplement in answer to a paper intitled, The state of the British trade to the coast of Africa consider'd

Royal African Company, London, 1730

PBB7345

37

Collection of British Parliamentary papers relating to the abolition of the slave trade and slavery

London, 1788–1879

MGS/64/1–85

38

Doubts on the abolition of the slave trade; by an old Member of Parliament

J. Stockdale, London, 1790

PBP2561

39

An abstract of the evidence delivered before a Select Committee of the House of Commons, in the years 1790 and 1791; on the part of the petitioners for the abolition of the slave trade

J. Robertson, Edinburgh, 1791

Includes a wood engraving of the slave ship *Brookes* of Liverpool, showing the manner in which the maximum number of slaves could be legally carried on board the ship (see Cats 481–2).

MGS/56

40

A letter to the Members of Parliament who have presented petitions to the honourable House of Commons for the abolition of the slave trade. By a West India merchant

J. Sewell, London, 1792

This 'letter', which is actually an 84-page pamphlet, was part of the spirited anti-abolition campaign fought by West India merchants and planters. The author attacked the abolitionists and stressed the importance of the West Indies (and of slavery) to Britain. He argued that a great many ordinary people in Britain relied on the slave trade. He highlighted the risk of slave rebellions arising from discussions of abolition, and suggested that 'savage' Africans would become civilised by their association with Europeans through slavery. However offensive these views now appear, the West India planters and merchants formed a powerful lobby in Parliament and were able to delay the progress of abolition for many years.

PBC1319 / F5777

41

A very new pamphlet indeed! Being the truth: addressed to the people at large, containing some strictures on the English Jacobins, and the evidence of Lord McCartney, and other, before the House of Lords, respecting the slave trade

London, 1792

MGS/60

42

The speech of the Right Honourable William Pitt, on a motion for the abolition of the slave trade, in the House of Commons, Monday the second of April, 1792

James Phillips, London, 1792

MGS/61

43

The debate on a motion for the abolition of the slave-trade, in the House of Commons on Monday and Tuesday, April 18 and 19, 1791, reported in detail

James Phillips, London, 1792

MGS/57

44

Negro slavery – no. v: conduct and treatment of missionaries in the West Indies

Ellerton and Henderson, London, 1823

MGS/65

45

At a meeting of planters, merchants, and others, interested in the colonies of Trinidad, British Guiana, St Lucia, the Cape of Good Hope, and the Mauritius, held at the West India Dock House, the 1st October, 1831, comprising minutes and the conclusion of a pro-slavery meeting chaired by Joseph Marryat, MP

Maurice & Co., London, 1831

Joseph Marryat was a Member of Parliament and the colonial agent for Grenada. He wrote several pamphlets in defence of slavery.

MGS/66

46

Prospectus of the Society for the Extinction of the Slave Trade and for the Civilisation of Africa

London, 1840

Bound with Sir Thomas Fowell Buxton (1786–1845), *The African slave trade and its remedy*, John Murray, London, 1840.

PBB3505

A
LETTER

TO THE

MEMBERS OF PARLIAMENT

WHO HAVE PRESENTED PETITIONS

TO THE

HONOURABLE HOUSE OF COMMONS

FOR THE

ABOLITION OF THE SLAVE TRADE.

By a WEST-INDIA MERCHANT.

Ad Reipublicæ firmandas vires, fanandofque populos omnis noftra pergit oratio. Cic. de Leg.

Væ cæcis ducentibus! Væ cæcis fequentibus! S. Aug.

LONDON:

SOLD BY J. SEWELL, CORNHILL; J. MURRAY, FLEET-STREET; AND J. DEBRETT, PICCADILLY.

1792.

(PRICE ONE SHILLING AND SIXPENCE.)

Cat.40

47

Bound collection of five pamphlets, 1848–51:

Rev. J. Leighton Wilson (1809–86)
The British squadron on the coast of Africa. With notes by Capt. H.D. Trotter
James Ridgway, London, 1851.

Robert Stokes (1783–1859)
Regulated slave trade: from the evidence given before the Select Committee of the House of Lords, in 1849
James Ridgway, London, 1851, 2nd edition

J.S. Mansfield
Remarks on the African squadron
James Ridgway, London, 1851

Lt Henry Yule (1820–89)
The African squadron vindicated
James Ridgway, London, 1850, 2nd edition

Remarks on the present state of our West Indian colonies, with suggestions for their improvement
Smith, Elder & Co., London, 1848

The Stokes pamphlet includes a fine reworking of the *Brookes* broadside. The volume also includes two autographed letters from Sir Thomas Fowell Buxton (President of the British and Foreign Anti-Slavery Society) to Sir George Young (1837–1930), 29 July and 2 August 1900, and a note from the British and Foreign Anti-Slavery Society, dated 4 August 1900.

PBF7717

COINS AND MEDALS

Coins and medals offer important insights into the history of slavery, the slave trade and the abolition movements. Seventeenth- and eighteenth-century medals celebrating voyages and wishing success to slave ships and trading companies were joined by a mass of abolitionist material from the late 1780s onwards. Some of these coins and medals were professionally produced and formed a significant part of the abolition campaign, commemorating its victories and spreading its message to new and wider audiences through powerful iconography. Other examples are amateur engravings that demonstrate individuals' commitment to the cause of abolition.

48
Medal commemorating the voyage to Guinea, 1681
Johann Bernhard Schultz (d.1695), Berlin, 1681
Silver, 48 mm

Obverse: A bust of Frederick William, Elector of Brandenburg (1620–88), facing right. Legend: 'FRID: WILH: D. G. M. BR: S. R. IMP: ARCH: EL:'. Reverse: In the foreground, a decorated compass and stand on a tiled floor, with a coast and ships in the distance to the left. Legend: 'HUC NAVES AURO FERRUM UT MAGNETE'. Inscription: 'GUINEA' (left); 'TRAHUNTUR' (right). Inscribed on edge: 'NAVIGATIO AD ORAS GUINEA'.

MEC0377

49
Medal commemorating the voyage to Guinea, 1681
Germany, c.1681
Silver, 65 mm

Obverse: An African woman kneels on a beach, holding a basket containing ivory. To the left, a fort partly obscures a ship flying the Brandenburg flag; to the right, ships sail away. Above, out of the clouds, cherub heads blow wind. Legend: 'COEPTA NAVIGATIO AD ORAS GVINÆ AN. MDCLXXXI. FELICITER' (Navigation to the coasts of Guinea happily begun 1681).
Reverse: A three-masted ship with flags under sail, cherubs above blow a favourable wind. Legend: 'DEO DVCE AVSPICYS SERENISSIMI ELECTORIS BRANDENBVRGICI AD
(Under the guidance of God and the auspices of the most Serene Elector of Brandenburg).

MEC0376 / F5761-1

50
Ducat commemorating the voyage to Guinea, 1681
Germany, 1682
Gold, 22 mm

Obverse: Bust of Frederick William, Elector of Brandenburg, facing right. Legend: 'FRID. W.D.G.M.BR. & ELEC.' Reverse: Starboard broadside view of a three-masted ship under sail. Legend: 'DEO. DVCE. 1682'.

MEC0378

51
Medal commemorating St George Del Mina
Netherlands, 1683
Silver, 44 mm

Obverse: A fortress above 'S. G. DELMINA'; a ship below. Legend: 'FVLCRA NON MINIMA'. Reverse: The arms of the

Cat.49

Directors of the West India Company of Groningen set in a circle with a central monogram of the Company's initials. Legend: 'SOCIETAT. IND. OCCID. DIRECTORES. GRON. ET. OM'.

MEC0125

52
Counter commemorating the safe return of the French West Indian Fleet, 1708
Thomas Bernard (1650–1713), Paris, 1709
Silver, 29 mm

Obverse: Head of Louis XIV of France (1638–1715), facing right. Legend: 'LUDOVICUS. MAGNUS. REX.' Reverse: Hercules leaning on his club holding the apples of Hesperides in his raised right hand, trees in the distance to the left. Legend: 'EXTREMO ADUEXIT AB ORBE' (He has brought (them) from the ends of the world). Exergue: 'MARINE. 1709.'

MEC0632

53

Medal commemorating the West Indian Company of Denmark

Georg Wilhelm Wahl (active 1726–64), Copenhagen, 1749

Silver, 40 mm

Obverse: A bust of Frederick V of Denmark and Norway (1723–66), facing right. Legend: 'FRIDERICVS V D. G. DAN. NORV. V. G. REX.' Reverse: A port with shipping. Legend: 'REDDVNT HAEC PRAEMIA MERCS'. Exergue: 'MDCCIL'.

MEC0443

54

Danish West Indian coin: XII skilling

Denmark, 1764

Silver, 21 mm

Obverse: Crowned monogram of Frederick V. Legend: 'D. G. DAN. NOR. DAN. NORV. V. G. REX'. Reverse: Port broadside view of a ship under sail. Legend: 'XII SKILL DANSKE AMERICANSKE'. Exergue: '1764'.

MEC0444

55

Halfpenny

Britain, engraved c.1770

Copper, 28 mm

Obverse: Bust of George II (1683–1760), laureate. Legend: 'GEORGIVS. II. REX.' Reverse: Erased and re-engraved with a bust of an African man, surrounded by a detailed notched border.

ZBA2795

56

Anti-slavery medal

Britain, c.1787

White metal, 33 mm

Obverse: A chained slave kneeling; the body of the slave has been painted with contemporary black enamel. Legend: 'AM I NOT A MAN AND A BROTHER?' Reverse with the inscription: 'WHATSOEVER YE WOULD THAT MEN SHOULD DO UNTO YOU, DO YE EVEN SO TO THEM.'

ZBA2790

57

Anti-slavery medal

Britain, c.1787

White metal, 33 mm

Obverse: Enchained slave kneeling. Legend: 'AM I NOT A MAN AND A BROTHER?' Reverse with the inscription: 'WHATSOEVER YE WOULD THAT MEN SHOULD DO UNTO YOU, DO YE EVEN SO TO THEM.'

As Cat.56 but without enamel decoration and the reverse inscription struck with slightly different dies.

ZBA2789, ZBA2796, ZBA2798

58

Anti-slavery medal

Britain, c.1787

Bronze, 32 mm

Obverse: A chained slave kneeling. Legend: 'AM I NOT A MAN AND A BROTHER?' Incuse with additional engraving: 'AG', 'Amo*DP', 'W*P*'. Reverse: 'WHATSOEVER YE WOULD THAT MEN SHOULD DO UNTO YOU, DO YE EVEN SO TO THEM.'

The Society for Effecting the Abolition of the Slave Trade was founded in London in 1787 and was most likely the issuer of these medals.

ZBA2791

59

Barbados penny

John Milton (active 1760–1802, d.1805), Barbados, 1788

Bronze, 31 mm

Obverse: A pineapple. Legend: 'BARBADOES PENNY 1788'. Reverse: Bust facing left wearing crown and Prince of Wales's feathers. Legend: 'I SERVE'.

John Milton was a gifted young engraver at the Royal Mint, who designed the Barbados penny in 1788. Although struck locally, the coins were never recognised as official colonial currency.

ZBA2802

60

Engraved coin, the *Amacree*

Britain, 1788

Bronze, 33 mm

Engraved token. Obverse: Port broadside view of the slave ship *Amacree* in full sail. Legend: 'Success to the Amacree'. Reverse: Inscription 'John Cread Liverpool 1788'. Inscribed around the rim: 'ON DEMAND IN LONDON LIVERPOOL OR ANGLESEY'.

The *Amacree*, built in 1788, was registered as a trader between Liverpool and Africa. In ten voyages, it carried nearly 3200 slaves from ports in West Africa, principally to the Caribbean island of Dominica.

ZBA2816 / F5759-2

Cat.60

61
Anti-slavery halfpenny
Britain, c.1790
Copper, 27 mm

Obverse: A chained slave kneeling. Legend:
'AM I NOT A MAN AND A BROTHER'.
Reverse: A pair of clasped hands. Legend:
'MAY SLAVERY & OPPRESSION CEASE
THROUGHOUT THE WORLD'. Inscribed
around the rim: 'PAYABLE IN LANCASTER
LONDON OR LIVERPOOL'.

In 1787 official copper coinage was in very
short supply and private firms throughout
Britain struck pennies and halfpennies in
a variety of designs. Designs used included
famous persons, buildings, coats of arms, local
legends and political events. This halfpenny
was produced by the abolitionist movement
and circulated c.1790–97. In the latter year
these tokens were declared illegal, though
they were re-introduced in 1811 when
industrial districts suffered another shortage
of copper coinage.

ZBA2793

62
Anti-slavery halfpenny
Britain, c.1790
Bronze, 29 mm

Obverse: Enchained slave kneeling right.
Legend: 'AM I NOT A MAN AND A
BROTHER'. Reverse: Two hands joined.
Legend: 'MAY SLAVERY & OPPRESSION
CEASE THROUGHOUT THE WORLD'.

ZBA2800

63
Engraved commemorative halfpenny
Britain, c.1790
Copper, 26 mm

Obverse: Engraved with scrolling initials
'TMN', 'LG'. Reverse: Engraved with 'Pity
AFRIC'S Sons'.

ZBA2794

64
Grocer's token – penny
Britain, 1794
Copper, 29 mm

Obverse: View of the facade of a building,
with 'INDIA HOUSE' above. Legend:
'M. LAMBE & SONS TEA-DEALERS &
GROCERS. BATH'. Exergue: '1794'.
Reverse: A laden camel in the centre.
Legend: 'TEAS COFFEE SPICES &
SUGARS'.

This penny from a Bath grocer suggests
the global origins of popular consumer goods
in 18th-century Britain. For example, tea
from China, imported by the East India
Company and sweetened with slave-grown
sugar from the West Indies, had already
become a typically 'British' drink. Lambe &
Sons also sold coffee and spices, which could
have come from the slave colonies in the
Americas and the islands of south-east Asia.
The produce of slavery and global trade
seeped into all corners of British life from
those who consumed it to those who were
enriched by its profits. See Fig.4 (p.24).

ZBA2804 / F5742-1

65
Anti-slavery farthing
Britain, eighteenth-century
Bronze, 22 mm

Obverse: Enchained slave kneeling right.
Legend: 'AM I NOT A MAN AND A
BROTHER'. Exergue: 'JAMES'. Reverse:
Inscription 'THOS. SPENCE/ SIR THOS.
MORE/ THOS. PAINE/ 1795'. Legend:
'ADVOCATES FOR THE RIGHTS OF
MAN'.

ZBA2799

66
Thomas Hall advertising token
William Lutwyche, Birmingham, 1795
Bronze, 31 mm

Obverse: A full-length figure of a woman in
European dress. Legend: 'MRS. NEWSHAM
THE WHITE NEGRESS'. Reverse: Legend:
'TO BE HAD AT THE CURIOSITY
HOUSE CITY ROAD'. Inscription: 'NEAR
FINSBURY SQUARE LONDON 1795'.

Mrs Amelia Lewsam (or Newsham) 'the
white Negro woman' was brought from
Jamaica in 1754 aged about five and was
offered for sale as 'the greatest Phænomenon
ever known', priced 400 guineas. A year
later she was exhibited at Charing Cross
with tickets sold at a shilling each. Newsham
was described as having 'all the features of
an Æthiopian with a flaxy woollen head,
a skin and complexion fair as alabaster'.
She was exhibited again in 1788 at the
Bartholomew Fair, an event renowned for
its theatrical booths. Thomas Hall was a
taxidermist, curiosity dealer and proprietor
of an exhibition. Trade tokens like this one
advertised his curiosities on show at Finsbury
Square and also touring at Bartholomew
Fair, where he made use of such human
exhibits like Mrs Newsham.

ZBA2792

67
Engraved anti-slavery halfpenny
Britain, c.1795
Copper, 27 mm

Obverse: Depiction of Caroline, Princess of
Wales (1768–1821). Legend: 'PRINCESS OF
WALES.'. Reverse: Image of clasped hands.
Legend: 'MAY SLAVERY & OPPRESSION
CEASE THROUGHOUT THE WORLD'.

ZBA2803

68

Medal commemorating the abolition of the slave trade
G. F. Pidgeon (active *c*.1795–1819) and John Phillip (active 1804–11), Birmingham, 1807
Bronze, 36 mm

Obverse: A European and an African stand facing each other shaking hands; in the distance is a stylised landscape with palm trees and huts to the left, and Africans dancing around a tree and tilling the soil to the right. Legend: 'WE ARE ALL BRETHREN'. Exergue: 'SLAVE TRADE ABOLISHED BY GREAT BRITAIN 1807'. Reverse: Arabic inscription: (translation) 'Sale of slaves prohibited in 1807, Christian era, in the reign of George III; verily we are all brothers'.

This medal, produced for distribution in Sierra Leone, was intended to deter African traders from sending slaves to the coast.

ZBA2788 (with an original wooden case), ZBA2808, ZBA2817–18 / F5743-1, F5743-2

69

Medal commemorating the abolition of the slave trade
Thomas Webb (active 1804–27), Birmingham, 1807
Bronze, 53 mm

Obverse: A bust of William Wilberforce, facing right. Legend: 'WILLIAM WILBERFORCE M.P. THE FRIEND OF AFRICA.' Reverse: Britannia, seated upon a dais, attended by figures representing medicine, trade and knowledge; Faith hovering above. On a tablet below: 'I HAVE HEARD THEIR CRY'. Exergue: 'SLAVE TRADE ABOLISHED MDCCCVII'.

ZBA2819

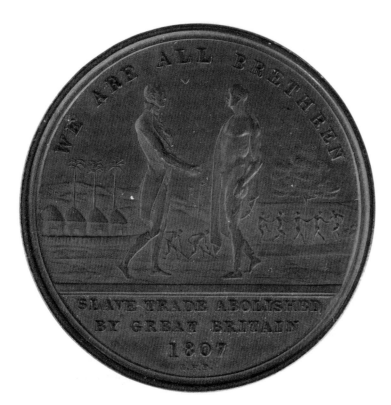

Cat.68

Yorkshire election tokens

The 1807 Yorkshire parliamentary election became known as the 'Austerlitz of electioneering'. Yorkshire had two Members of Parliament and at the 1807 election there were three candidates: the two sitting MPs, William Wilberforce (1759–1833) and the Hon. Henry Lascelles (1767–1841), and a challenger, Charles Fitzwilliam, Lord Milton (1748–1833). Milton was the son of a local landowning family, Wilberforce was the leader of the abolition movement, and Lascelles was the son of the Earl of Harewood, whose vast wealth was based on his Caribbean enterprises. The Lascelles campaign spent prodigiously and booked up most of York's facilities for his voters and supporters. £64,415 was subscribed to pay Wilberforce's expenses, most of which was returned. He was triumphantly elected at the head of the poll, narrowly defeating Milton (who was also elected) with Lascelles trailing in third (Wilberforce 11,806 votes, Milton 11,177, Lascelles 10,979). In subsequent electoral reforms, paying for conveyances to take electors to the poll was made illegal. The election is often presented as a battle between the country's pre-eminent abolitionist and a member of one of its largest slave-owning families. The reality, however, is more complex. Lascelles and Wilberforce, although on opposing sides on the issue of the slave trade, shared similar views on many other issues, and had even campaigned together in previous elections.

70
Election token: William Wilberforce
Britain, 1807
White metal, 40 mm

Obverse: Legend: 'WILBERFORCE'. Inscription: 'FOR EVER'. Reverse: Inscription: 'HUMANITY IS THE CAUSE OF THE PEOPLE'.

ZBA2814

Cat.73

71
Election token: Henry Lascelles
Edward Thomason (1769-1849), Birmingham, 1807
White metal, 40 mm

Obverse: Legend: 'LASCELLES'. Inscription: 'FOR EVER'. Reverse: Inscription: 'IN MIND INDEPENDENT IN EXERTION INDEFATIGABLE'.

ZBA2813

72
Liverpool election token
Thomas Halliday (active 1810–54), Birmingham, 1816
Silver, 38 mm

Obverse: A cormorant. Legend: 'LIVERPOOL BE FREE'. Reverse: Inscription: 'T. Morison/

ONE OF THE INDEPENDENT MINORITY 738 WHO VOTED FOR THOS. LEYLAND ESQ. AT THE LIVERPOOL ELECTION 1816'.

Thomas Leyland was born in Yorkshire and moved to Liverpool in 1770. Having won £20,000 in a lottery, he married his employer's daughter and ploughed the money into slave trading. He was a partner in a series of slave ship voyages, which carried almost 5000 African slaves to the Caribbean between 1784 and 1805. The success of this business eventually allowed Leyland to establish his own bank.

ZBA2815

73
Engraved halfpenny
c.1820
Copper, 28 mm

Obverse: A slave standing, his hands held up, tied to a pole, being flogged by a man in a top hat, with the inscription, 'Mercy Massa'. Reverse: A chained slave kneeling, facing left, with a spade in the ground behind him to the right.

ZBA2801 / F5758-1, F5758-2

74
Medal commemorating the coronation of William IV
Thomas Halliday, Birmingham, 1831
White metal, 46 mm

Obverse: Busts of William IV (1765–1837) and Queen Adelaide (1792–1849), facing right. Legend: 'THEIR MOST GRACIOUS MAJESTIES WILLIAM AND ADELAIDE'. Reverse: William IV and Queen Adelaide seated under a canopy with allegorical figures offering gifts and a slave in broken chains kneeling in the foreground. Legend: 'CORONATION'. Exergue: 'SEP 8. 1831'.

ZBA2821

75

Medal commemorating the abolition of slavery

Thomas Halliday, Birmingham, 1834

Bronze, 41 mm

Obverse: William IV seated beneath a canopy, attended by courtiers. Exergue: 'I ADVOCATE THIS BILL AS A MEASURE OF HUMANITY'. Reverse: Seven Africans with hands linked dance around a palm tree. Exergue: 'SLAVERY ABOLISHED BY GREAT BRITAIN 1834'.

ZBA2809

76

Medal commemorating the abolition of slavery

Joseph Davis (active 1828–52), Birmingham, 1834

White metal, 44 mm

Obverse: An African standing holding broken chains in his raised hands. Legend: 'THIS IS THE LORDS DOING; IT IS MARVELLOUS IN OUR EYES. PSALM 118 V. 23'. Exergue: 'JUBILEE AUGT. 1 1834'. Reverse: Inscription: 'IN COMMEMORATION OF THE EXTINCTION OF COLONIAL SLAVERY THROUGHOUT THE BRITISH DOMINIONS IN THE REIGN OF WILLIAM THE IV AUGT. 1 1834'.

ZBA2810

77

Medal commemorating the abolition of slavery

Thomas Halliday, Birmingham, 1834

White metal, 41 mm

Obverse: An African woman with shackled wrists, kneeling before the figure of Justice. Legend: 'AM I NOT A WOMAN AND A SISTER?'. Exergue: 'LET US BREAK THEIR BANDS ASUNDER AND CAST AWAY THEIR CORDS. PSALM II.3'.

Reverse: A wreath with the names 'PENN/ GRANVILLE SHARP/ WILBERFORCE/ BENEZET/ CLARKSON/ TOUSSAINT LOUVERTURE/ STEPHEN/ D. BARCLAY', and the inscription 'TO THE FRIENDS OF JUSTICE, MERCY, AND FREEDOM'.

ZBA2811

78

Anti-slavery penny

United States, 1838

Copper, 26 mm

Obverse: Enchained slave kneeling right. Legend: 'AM I NOT A WOMAN & A SISTER 1838'. Reverse: Inscription within a wreath 'LIBERTY 1838'. Legend: 'UNITED STATES OF AMERICA'. The 'N' is reversed.

ZBA2797

79

Medal commemorating Negro emancipation in the West Indies

Thomas Halliday, Birmingham, 1838

White metal, 42 mm

Obverse: An African man shakes hands with a European man attended by an African woman and child and a European woman wearing a bonnet. Legend: 'WE ARE ALL BRETHREN'. Exergue: 'EMANCIPATION/ AUG. 1. 1838'. Reverse: Legend: 'THEIR NAMES SHALL BE SACRED IN THE MEMORY OF THE JUST'. Inscription within a palm wreath: 'PENN/ GRAN. SHARP/ WILBERFORCE/ BENEZET/ CLARKSON/ BUXTON/ BROUGHAM/ STURGE/ SLIGO'.

ZBA2812

80

Medal commemorating the convention of the British & Foreign Anti-Slavery Society

Joseph Davis, Birmingham, 1840

White metal, 52 mm

Obverse: Draped bust of Thomas Clarkson facing right. Legend: 'THOMAS CLARKSON'. Reverse: An African slave kneeling, his manacled hands raised. Legend below: 'AM I NOT A MAN AND A BROTHER?'. Surrounded by inner legend: 'BRITISH & FOREIGN ANTI-SLAVERY SOCIETY'; and outer legend: 'GENERAL ANTI-SLAVERY CONVENTION HELD IN LONDON 1840. PRESIDENT Thomas Clarkson AGED 81'. Clarkson's name is presented as a facsimile signature.

ZBA2820

81

Badge: Liberian Order of African Redemption

19th century

Silver gilt and enamel, 70 mm

Double-sided pendant badge, in silver gilt and enamel. The badge is made up of a five-pointed star in white enamel. Each of the points terminates in a silver gilt ball; between the points are gilt metal rays. On the obverse, in the centre of the star, a copper roundel with two applied silver figures with broken chains at their feet kneeling at the base of a cross bearing the Christian crucifixion legend 'INRI' (Iesus Nazarenus Rex Iudaeorum – 'Jesus of Nazareth, King of the Jews'). This is surrounded by a metal wreath of laurels and berries, with traces of green and red enamel. On the reverse, a coloured enamel plaque depicts a ship in full sail with the sun on the horizon to the left; to the right, a plough and palm tree form the foreground. This is encircled with a champlevé frame of blue enamel with a legend in gilt metal letters: 'THE LOVE OF LIBERTY BROUGHT US HERE'.

ZBA2822

ETHNOGRAPHY

This small ethnographic collection reflects the diversity and sophistication of African and Caribbean societies. The artefacts show not only the impact of slavery but also the complex interaction of Britain and West Africa during the period of naval suppression and colonial expansion in the nineteenth century.

82
Bracelet
*c.*1785
Ivory and white metal, 7 × 17 × 80 mm

One half of the bracelet is engraved 'King Aqua', the other 'Prince'.

There were numerous late-eighteenth- and nineteenth-century Kings of Aqua, inland from Calabar, and the designation remained current after the abolition of the British slave trade. It is likely that this bracelet is an artefact of British-African slave-trading relations. It is possible that the word 'Prince' engraved on one side of the bracelet refers not to a person but to a ship; at least one Liverpool-based *Prince* is known to have traded for slaves at Calabar. See Fig.30 (p.105).

ZBA2494 / F6191

83
Akan gold weight
West Africa, 18th century
Bronze, 25 × 50 × 7 mm

Cast as a pistol. See Cat.92 for details.

ZBA2466 / F5748

84
Knife and sheath
West Africa, *c.*1800
35 × 245 × 57 mm

The sheath has a shell and a lead model of human teeth attached to it. The red-dyed shell is characteristic of Baule culture (from the Ivory Coast), while the human jaw is more typical of the Akan people (from present-day Ghana) and suggests a trophy attached to the knife to indicate the power of its owner. Before European contact, Akan peoples had migrated into

Cat.84

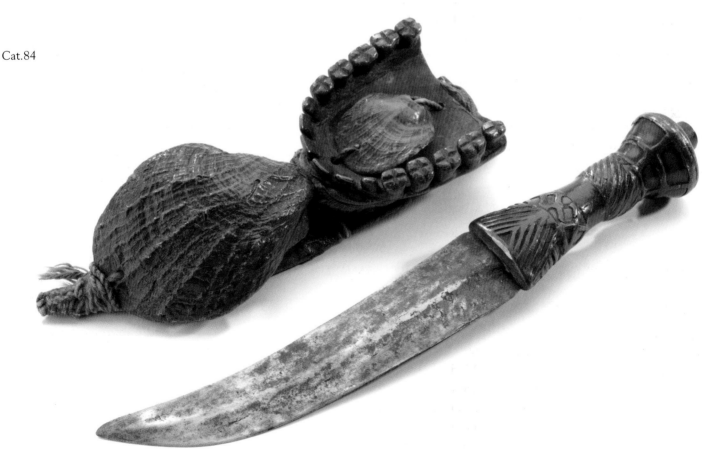

Baule territory and there were extensive trade connections between the Akan and the Baule. It is likely that this knife and sheath are the result of cultural interactions: either the knife was purchased by Akan traders from the Baule who then added the jaw, or the Akan had influenced the Baule in the making of this artefact.

ZBA2487 / F5735

85
Engraved powder horn
1812–13
Ivory, 345 × 55 × 18 mm

A faceted and engraved powder horn. It is engraved 'Ben*Freeman*Born at, Krew Cetra is a Sober Honest Man. Has sailed in HM Ship *Thais* from Sierra Leone to Ambriz to the satisfaction of the officers' and is decorated with geometric and floral patterns. It has two suspension holes at the top and one at the base. Ben Freeman, from the Kru coast in present-day Liberia, was one of four men taken on board HMS *Thais* as additional crew from 19 November 1812 to 16 March 1813. They embarked and were discharged at Sierra Leone. While on board, the four black men were given only a two-thirds allowance. The names of the other three were Ben Coffee, Prince Will and Jack Savey.

ZBA2465 / F5320

86
Flag from a slave ship
Probably West Africa, 1862–6
Cotton, 2794 × 4572 mm

A hand-sewn flag made of fine cotton sheeting with a cotton hoist. The flag is appliquéd in brown fabric with a stylised figure of an African, holding a staff. A paper label, pinned to the hoist, is inscribed 'Flag taken from a slaver captured off the east coast of Africa & sent to my father (W. H. Wylde of the Foreign Office) by Commodore Eardley Wilmot', although it is more typical of flags used along the West African coast. In 1862, Wilmot (1815–86) was appointed as commodore in HMS *Rattlesnake* and was involved in the suppression of the slave trade on the west coast of Africa. Wylde became head of the slave trade department at the Foreign Office.

AAA2003 / D2318

Cat.85

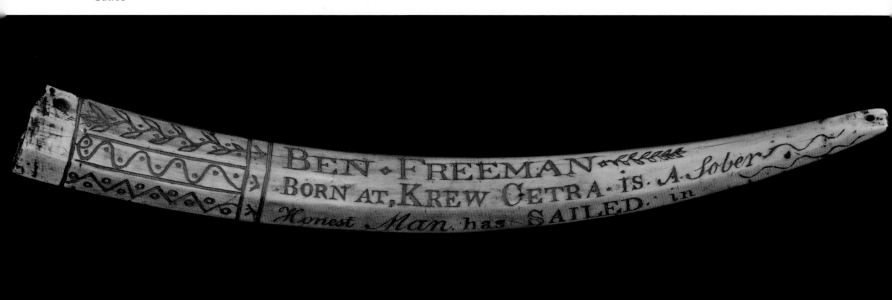

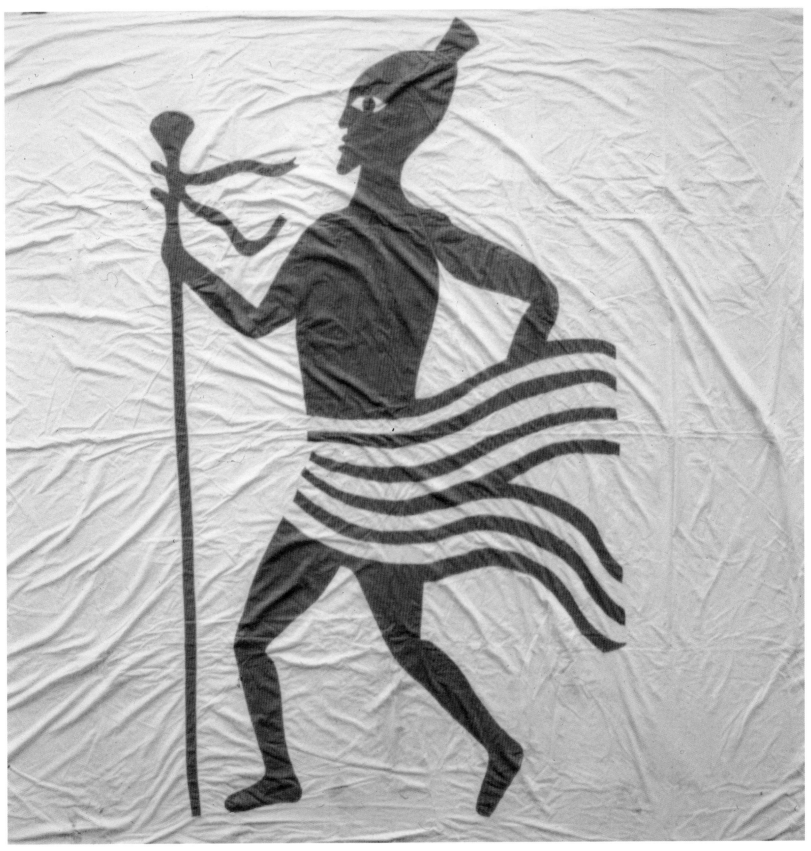

Cat.86

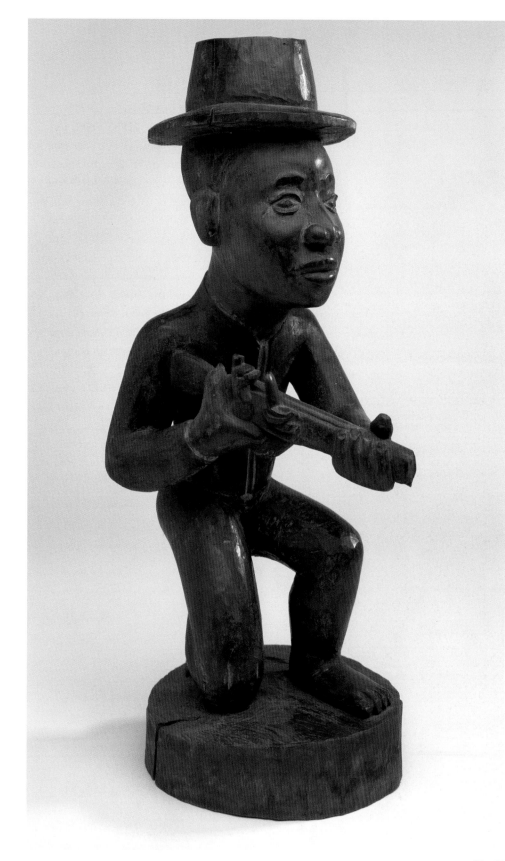

87

Yombe carved figure

West Africa, *c.*1870

Wood, 585 × 270 × 190 mm

This figure is a Yombe funerary effigy. It is a painted carving of a figure with African features wearing European dress of a short jacket and a hat. It is holding a flintlock gun. The Yombe, who are a sub-group of the Kongo people, come from the lower Zaire River in the present-day Democratic Republic of Congo. The figure probably represents the wealth and status the deceased accrued through trade and contact with Europeans. Figures like these were not meant to capture the spirit of the deceased but instead were intended to commemorate their successful life. This figure was collected by Vice-Admiral R. F. Hammick (1843–1922), who served on the west coast of Africa in 1876–7 in HMS *Cygnet* and again in 1883 in HMS *Flirt*.

AAA2818 / D9640

Cat.87

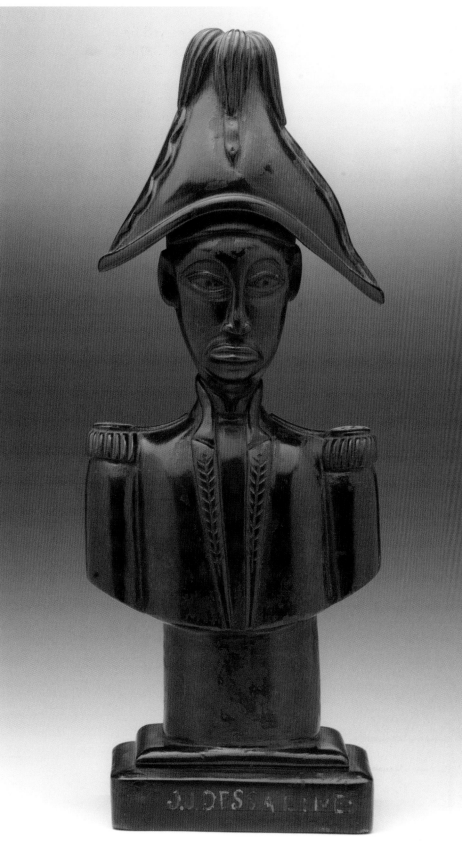

Cat.88

88
Bust of Jean-Jacques Dessalines
19th century
Wood, 370 mm

Inscribed on the base 'J. J. Dessalines'.
Jean-Jacques Dessalines (1758–1806) was
born a slave in the French Caribbean colony
of Saint-Domingue. In 1791, he became a
part of the freedom movement that led to
the total abolition of slavery in Haiti in 1793.
After fighting under Toussaint L'Ouverture
(c.1743–1803) against British and Spanish
soldiers attempting to take the Haitian colony
from France, Dessalines fought again under
Toussaint to expel the French. In 1802,
France tried to retake Saint-Domingue and
to reintroduce slavery. When Toussaint was
arrested and deported, Dessalines became
the revolution's leader. The French, under
General Rochambeau (1755–1813), were
finally defeated and, in 1804, Dessalines
declared the colony the independent country
of Haiti, assuming the title of governor
general for life. Political rivals murdered
him in 1806.

ZBA2482 / F0906

89

Drum

West Africa, 19th century
Leather and wood, 560 × 700 × 490 mm

Drum hollowed out of a single block of
wood. Hide stretched over the top with
leather thongs. Hide carrying handles. Rear-
Admiral Sir Frederick George Denham
Bedford (1838–1913) probably obtained the
drum in operations against Nana Olomu in
September 1894 or during the Brass River
expedition of February 1895.

AAB0232

90

Necklace

West Africa, 19th century
Shell and metal, largest 10 × 280 × 30 mm

Cowrie-shell necklace joined with metal links.
Cowrie shells were prized trade goods along
the West African coast.

AAA3072–76

91

Loango tusk

Congo, 19th century
Ivory, 765 mm

This carved elephant tusk was produced
on the Loango coast, between Cape Lopez
and the Zaire River in West Africa. Loango
carvers specifically made it in the late
nineteenth century for sale to European
buyers. Using iron tools it has been carved
spirally with scenes of West African life,
which represent the region's encounters with
Europeans. The tusk depicts the arrival of
Europeans and the enslavement of Africans,
who are shown being taken to the coast to
be sold to slave traders. Other scenes show
a European delegation, a band of African
musicians, and a man carrying an umbrella,
which was a status object associated with
trade with Europeans. Still more scenes show

representations of animals, such as the one
with two men drinking with a dog at their
table. Animals like dogs and lizards are
particularly linked to the supernatural in
Kongo religion and represent the spiritual
elements of life on the Loango coast and its
interactions with Europeans. See Fig.7 (p.33).

ZBA2430 / F5780-1–15

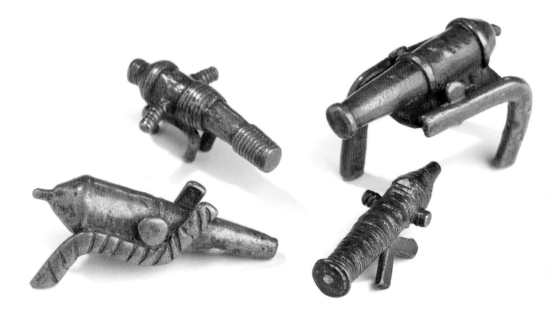

Cat.92a

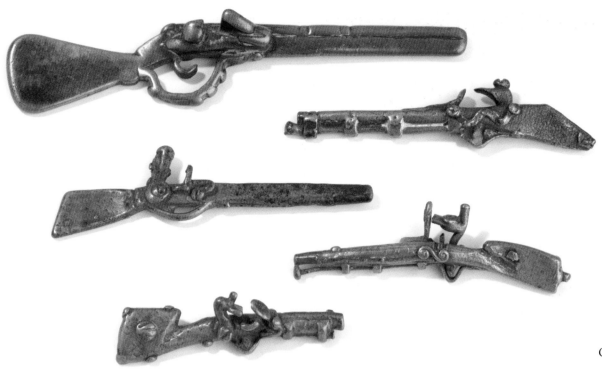

Cat.92b

92
Akan gold weights

West Africa, 19th century

Brass, 30 × 50 × 19 mm

The Akan are a group of related peoples who
live in central and southern Ghana and the
eastern part of Côte d'Ivoire. From the late
fourteenth century, when they imported the
technique of metal casting from North Africa,
the Akan developed a system of weights for
measuring gold dust, which was their main
currency. By the seventeenth century the
Akan also began producing weights that
related to European standards based on the
ounce. During the eighteenth and nineteenth
centuries, gold weights developed as an art
form as well as units of measure. They
remained in use until the late 1800s. Weights
were often made from brass, and represented
a wide range of artefacts in use in Akan
society. These examples, in the form of guns
and cannon, depict the weaponry imported
by Europeans to West Africa. See also Fig.37
(p.114).

ZBA2441–50 / F5746, F5747, F5749

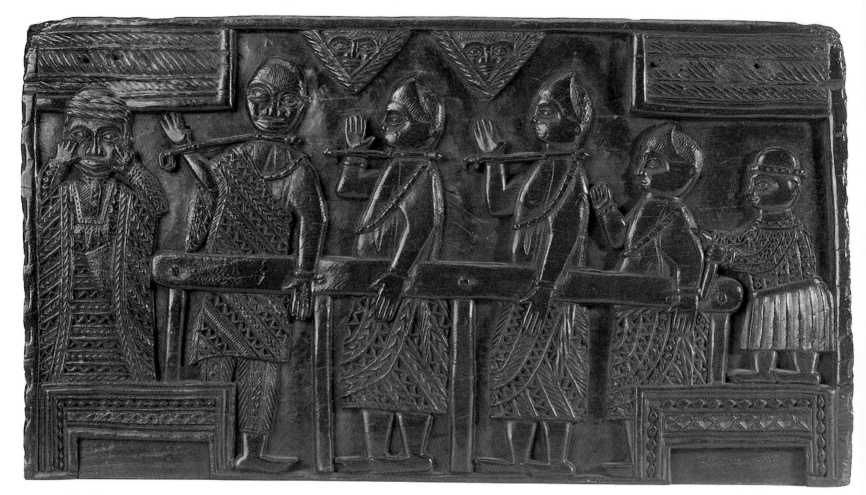

Cat.93

93

Carved panel, Benin

West Africa, late 19th century
Wood, 335 × 630 mm

This carved panel was a decorative stool seat.
The precise date of the carving is uncertain.
It was carved by the Omada, who were the
palace servants of the king of Benin. If it
dates from an earlier period, around 1870,
it is likely to be a depiction of an African
tribunal. However, it is more probable that
it represents, through the device of an earlier
conquest, the punitive expedition carried
out the British against Oba Ovonramwen
Nogbaisi, the king of Benin in 1897. Under

the authority of Ralph Moore, the British
governor of the Niger Coast Protectorate,
Lt James Phillips, the acting consul in the
Niger Delta, along with ten soldiers entered
the independent Kingdom of Benin to demand
an end to the customs duties collected by the
Oba. They were attacked as they made their
way to the capital. The British responded by
sending 1200 men who took control of the
kingdom in 17 days, despite fierce resistance.
To pay for the expedition, British forces
looted Benin's bronze art treasures – the
famous Benin Bronzes – and sold them to
collectors in Europe.

ZBA2454 / E9099

94
Fon bronze group
West Africa, *c.*1900
Bronze, 130 × 170 × 75 mm

Bronze sculpture.

ZBA2463

95
Carved stool
Dahomey, *c.*1902
Wood, 205 × 515 × 315 mm

This three-legged stool comes from Porto
Novo in the former French colony of
Dahomey (now the Republic of Benin)
with a central design inscribed on the seat
(the original African carving). Additional
carving consists of ships' names
('HMS Sokoto'), European names, toasts
and mottos ('Softly softly catch monkey').
On the underside is carved 'Oh, beware of
the Bight of Benin. Its few go out, but many
come in'. This is a version of a shanty –
'Beware and take care of the Bight of Benin,
there's one comes out for forty goes in' –
that reflects the high European mortality
on the 'fever' coast in Africa. See Fig.9 (p.38).

AAA3751 / D5953-1

96
Spatula
Surinam, early 20th century
Wood, 10 × 470 × 80 mm

A pierced and interlaced pattern is carved on
the handle and a loop pattern in the middle
of the shaft. It has a leaf-shaped blade. Used
while cooking rice, this distinctive spatula
evolved among runaway slave communities.

ZBA2472

MANUSCRIPTS

The National Maritime Museum's extensive manuscript collections help to illuminate the extraordinary scale and scope of slavery. They cover not only the trade along the West African coast and the operation of plantations in the Americas, but also the complex and shifting role of the Royal Navy, protecting British trade routes and colonial possessions in the eighteenth century and suppressing slave trades in the nineteenth century. The sheer volume of these rich and important collections, especially relating to the navy and its personnel, makes it impossible to provide a comprehensive list here. What follows is a representative selection of some of the most immediately relevant material.

ROYAL NAVY PATROLS AND SUPPRESSION ACTIVITIES

97
A relation of a voyage made in the years 1695, 96, 97, to the coasts of Africa, the Streights of Magellan, Brasil, Guyana and the Antilles or Caribby islands.
1695–7

AND/47

98
Plans of the Royal African Company's forts on the west coast of Africa, made by Captain Pye of HMS *Humber*
Sir Thomas Pye (1708/09–85), 1749–50

Pye surveyed the forts at the places he recorded as James's Island, Duck's Cove, Commenda, Seccondee, Cape Coast Castle, Tantamquerry, Wynnebah, Accra and Whydah and lists the slaves and military stores given for each location. In 1752, he was appointed commander-in-chief of the Leeward Islands.

ADM/Y/A

99
Journals of Philip Carteret in the *Endymion*
Philip Carteret (1733–96), 1779–81

Carteret was a naval officer and explorer, particularly of the Pacific Ocean. These journals describe his service off the West African coast and in the Caribbean. The journals cover the period in considerable detail and include his letterbook.

CAR/3/1–10

100
Sir George Collier's reports on the settlements of the Gold Coast and the slave trade
Sir George Ralph Collier (1774–1824), 1818–20

Collier commanded a six-ship anti-slavery squadron off the west coast of Africa between 1818 and 1821. He was a convinced abolitionist, making important and respected reports to Parliament on slavery and the slave trade. Collier was elected an honorary life member of the African Institution in 1820.

WEL/10

101
Report on the slave trade in Mozambique and Portuguese East Africa
Vice-Admiral William Fitzwilliam Owen (1774–1857), 1822–3

In 1821, Owen undertook a major survey of the East African coast in the sloop *Leven*, which he completed in 1825. During the survey, he found that Seyyid Said, the sultan of Oman (ruled 1804–56) had laid siege to Mombasa. Disgusted by the sultan's slave trading, he responded to the appeals of the Mazrui, the beleaguered ruler of the port and, on his own initiative, raised the Union flag and declared Mombasa a British protectorate. In return, the Mazuri promised to abolish slavery. The British government disowned Owen's actions but the protectorate lasted for more than two years.

COO/3A

102
Hinde papers
1829–36

Letters written by Edwin Hinde to his family when on board the *Atholl*, *Black Joke*, *Fair Rosamond* and *Dryad* on anti-slavery duty off the west coast of Africa (1829–32) and in the Caribbean on the *Serpent* (1833–6).

HIN/1–2

103
Correspondence/orders relating to capture of slaves
Sir Watkin Owen Pell (1788–1869), 1835–7

Pell was the senior officer on the Jamaica station 1833–7.

LBK/39

104
Journal of Dr McIlroy, RN
1841

Written on board HMS *Persian* on anti-slavery patrol off the west coast of Africa.

LBK/41

105

Log of HMS *Sealark*
Charles T. Williamson, 1850–51

Logbook of HMS *Sealark* with track charts and sketches of the west coast of Africa. Contains a short log, kept by Williamson, of the captured Brazilian slaver *Phaon*.

LOG/N/P/9C

THE SLAVE TRADE AND THE MERCHANT NAVY

106

Commission from the Company of Royal Adventurers of England
10 July 1667

A commission to Benjamin Simmonds, captain and commander of the *African Frigott*, authorising him to seize vessels infringing the Company's trading monopoly. Signed Sir Ellis (Elisha) Leighton (*d.*1685), secretary. Includes seal, half missing.

MSS/89/054

107

Papers relating to the *Hart*, pink, and to the *Katherine*
1704–07

Slave lists.

MSS/84/179.3–4

108

Royal African Company petition and report
1708

A petition from the Royal African Company to Queen Anne (*b.*1665, reigned 1702–14), requesting an extension to its monopoly; and a report from the Board of Trade and Plantations, Whitehall, to Queen Anne, recommending that an 'open trade' in slaves be allowed.

AML/A/5

109

Share certificate of the South Sea Company
24 August 1723

UPC/2 DOC 29

110

Day book of the slave ship *Castle*
Captain John Malcolm, 1727

Malcolm's ship called at several places along the West African coast, where he recorded the variety of goods that he was using to exchange for slaves.

AMS/4

111

Report on the slave trade and a letter, *c.*1730, by Capt. William Snelgrave of the *Katherine* of London
William Snelgrave, *c.*1730

This is the original manuscript version of Snelgrave's *New account of some parts of Guinea, and the slave trade* (1734). Snelgrave made a number of voyages to the West African coast for a variety of employers, the most important being Humphrey Morice (*c.*1679–1731), governor of the Bank of England. Snelgrave made at least six successful voyages for Morice. In all, he seems to have carried some 2718 Africans to the Americas, of whom 402 died en route. On his return he published his book, which is part justification for the slave trade, part instruction manual for slave-ship captains, part political history and part adventure story. This manuscript version contains drafts of two of the three sections of that publication: one is on the series of mutinies he witnessed and the 'reasonableness' of the slave trade; the other is an account of the invasion of Ouidah by the Kingdom of Dahomey. A third published section, on Snelgrave's capture by pirates, was written separately. Although Snelgrave was a slave trader, he provides an insight into the different ways in which Africans were involved in the slave trade – as the enslaved, as traders and as interpreters, but also as those who resisted Europeans, either by political means or by insurrection on board slave ships. His book was reprinted many times and was attacked by abolitionists many years after his death, as well as being influential in the work of the anti-abolitionists, most notably in Archibald Dalzel's *History of Dahomy* (1793; Cat.564).

WEL/29

112

Letter regarding the Royal African Company
1749

A letter dated 31 October 1749 from Charles Hayes (1678–1760) to Robert Mann. Hayes, a noted mathematician, was appointed a deputy governor of the Royal African Company, having made a voyage to Africa and studied its geography.

AGC/H/22

113

Log of the slave ships *Duke of Argyll* and *African*
John Newton (1725–1807), 1750–4

A journal kept by John Newton, master and slave trader (Cat.574), covering three voyages in the *Duke of Argyll* and two in the *African*.

LOG M/46

Negroes purchased att Bonny in the Molly Snow 1759	Men	Women	Boys	Girls	Blunderbusses	Musquetts	Cags Powder	Neptunes	Iron Barrs	Chelloes	Niccanees	Romells	Corangoes	Bottle Brandy	Juggs Brandy	Cags Brandy	Barrs Brandy	D° Manilla	D° Hatts	D° Caps	D° Knives	D° Iron Potts	Barrs
Brought forward	18	12	4	17	1	88	211	5	40	52	52	52	15			14	39	3½	1	14	10	1	1323
Febry 8th King Iron	1					2	4		1	1	2		1			2		½		1	1		30
D° D° Jack Pepper		1				1	4			1	1	1	1			2				1	1		25
D° D° Tillebo				1		1	4			2		1			1	2				1	1		25
D° D° Robin Norfolk	1					2	4			1	1	2				2				1	1		30
D° D° Jack Norfolk			1			2	4			1	1	1	2			2				3			30
D° 9th John Mendoss	1					2	5	1		2											1½		30
D° D° Young Priest				1		2	5			1	1	1							½				25
D° D° Will	1					2	4		2	1	1	1	1								4		30
D° D° Trade Trumpett			1			2	4			1	2	1	2						½		1		30
D° D° Black Jack		1				1	4		1	1	1	1	1								1		25
D° D° Tillebo				2		3	8		1	4		2				1					2		50
D° D° George		1				1	4			1	1	1	1								1		25
D° D° Embassie		1	1			3	8		2	3	2	2	1			2		½			2		55
D° 10th Embassie	5	2				12	33	7	8	7	7	7	7				1	½					200
D° D° Jemmy			1			2	5			1	1	1									½		25
D° D° John Faubery		1				1	4		1	1	1	1	1			1				1			25
D° D° Duke Cumberland		1				2	4			1	1	1											25
Carried forward	27	20	7	22	1	129	319	13	56	82	75	77	33			20	50	6	1	23	27	1	2008

114

Account book for the snow *Molly*, a slave ship
1759

This account book provides details of the Africans purchased at Bonny, in the Bight of Biafra, for a voyage to the Caribbean. The *Molly* was a Bristol slave ship, owned by Henry Bright (1715–77), a merchant with substantial interests in the West India trade, and captained by William Jenkins. It set sail in 1758 and traded on the African coast in 1759. The account book itemises the number of men, women, boys and girls purchased, from whom, and for which commodities. Among the goods used to buy Africans were metal, muskets, gunpowder, textiles, brandy and knives. It is brutally clear that for the merchants involved, both European and African, these were transactions in which African people were regarded as commodities to be exchanged rather than as human beings.

MSS/76/027.0 / F2506

115
Shipping bill
1763

Shipping bill certifying the loading of 'one boy slave on the proper account and risque [sic] of the shipper', valued at £6, shipped by Alexander Young on the ship *Loretta* (Robert Poulsney, master), on the River Sierra Leone, bound for Jamaica, dated 3 January 1763.

MGS/14

116
Bill of lading
1763

Bill of lading from Custom House, Jamaica, 27 June 1763, certifying prize goods, including sugar, coffee and timber, carried by Robert Poulsney, master of the *Loretta* of London.

MGS/16

117
Bill of lading
1764

Bill of lading, Hutchison Mure Esq. and owner of the *Loretta* to Alexander Belsches [?], dated 18 May 1764, detailing goods, including peas and beans, kiln-drying, commissions etc. with costs totalling £75.13.4.

MGS/17

118
Log of the *Trio*
Thomas Sanders, *c*.1782

Logbook kept by Thomas Sanders, third mate on a voyage to the West Indies from London. Contains some navigational workings dated 1782.

LOG/M/32

119
Documents relating to the *Zong* case
1783

Documents relating to a case of 1783 in the Court of King's Bench, involving the ship *Zong*. In 1781, the *Zong*, a Liverpool slave ship, was sailing to Jamaica with a cargo of 470 enslaved Africans. Fearing that the ship was running short of water, the captain ordered the sick Africans and those weakened by the long voyage to be thrown overboard to preserve stocks for the healthier slaves and the crew. In the course of three days, 131 Africans were drowned; plentiful rain followed and the *Zong* arrived in Jamaica with 420 gallons of water on board. The trial, heard by Lord Justice Mansfield (1705–93), was not for murder but an attempt by the ship's owners to claim the insurance on the slaves. The case shocked contemporary society and proved to be an important turning point for the abolition movement.

REC/19

120
Log of the *African Queen*
1790

Logbook of a voyage from Bristol to Africa, 1790

LOG/M/64

121
Log of the slaver-ship *Sandown*
Captain Samuel Gamble, 1793

The *Sandown* was a slave ship that sailed from London in April 1793, arriving at the Iles de Los off West Africa in June. Its captain, Samuel Gamble, called at Rio Nunez in Sierra Leone to buy slaves. The log provides a detailed account of trading in slaves, as well as descriptions of the African interior, its peoples and its flora and fauna. Gamble, who travelled inland, illustrated his log with a series of colour sketches, one of which shows African slaves being brought to the coast at Sierra Leone by the Fulani people. After leaving Africa, Gamble set sail for Jamaica with a cargo of Africans. The voyage was beset by problems – disease was rife, and the Africans rose up against their enslavement. The *Sandown* eventually arrived in Jamaica where over 200 slaves were disembarked and sold.

LOG M/21 / D7596

122
Shipping bill
1794

Shipping bill for the ship *Ascension* inwards from Havana (Samuel Chase, master), June 1794, including 'to cash pay the Officers and People for 8½ slaves @ 100 dollars each... £255... to cash pay the Widow Babcock 2½ slaves... £75'.

MGS/15

123
Journal of a voyage
1794–5

Journal of a voyage from Whitehaven to Virginia on board the ship *Esther*, master Samuel Wise.

WEL/43

124
Receipt
1804

Receipt dated 9 May 1804, Kingston, Jamaica, for 26 'new Negroe men' from the ship *Ann* bought by His Majesty's Government from George Kinghorn for £2340 (at £90 per head) as recruits for the Second West India Regiment at Fort Augusta.

MGS/8

Representation of a Lott of Fellow's bringing their Slaves for sale to the Europeans. which generaly commences anually in December, or early in January, being prevented from coming down sooner by the rains, being overflowed and their paths impassable, from the heavy rains which end in November. they sometimes come upwards of one Thousand Miles out of the interior part of the Country are Arm'd with Bows Arrows & Spears, one quiver of Arrows the early are poison'd to defend themselves with, another not so which they hunt with and are very dextrous seldom missing their game. the Slaves they make fast round the Neck a long stick, which is secured round the others waist from one to another so that one Man can secure fifty and stop them at his pleasure. at Night their hands are tied behind their backs.

Cat.121

124a

Log of the *Juverna*

Robert Lewis 1804–5

Logbook of the slave schooner *Juverna*'s voyage in 1804–5, first from Liverpool to West Africa to acquire slaves, and then to Surinam where the Africans were sold.

LOG/M/81

125

Receipt

1807

Receipt from John Hinde & Co., dated 30 May 1807, Kingston, Jamaica, for the purchase by Miss Maria Potinger of 'one new Negro woman' at £110 from the *Bedford*, Captain Newman.

Interestingly, this transaction dates from the very last days of the slave trade. The high price paid for the woman also reflects the steep increase in the cost of slaves.

MGS/9

126

Certificate of sale

1829

Certificate of sale, dated Loango 15 June and 20 October 1829, relating to the sale of 30 slaves – 'good men, justly and lawfully obtained' – by Mapica Macoiso Macay, captain of the schooner *Phoenix*, and signed by Iquacis Joze da Purificacao.

MGS/6

127

Journals kept by Captain Turner of the *John Lilley* and *Celma*

1838–47

Two journals kept by Turner while trading to Calabar for palm oil.

LOG/M/22/23

128

Indenture

1741

Indenture, St Christopher (St Kitts), 28 May 1741, on vellum with wax seals. It concerns estates on the island of St Christopher, with a schedule of 140 slaves, and a settlement relating to the White Gates and Caines Plantations.

MGS/32

129

Indenture

1759

Indenture made on Nevis, 19 July 1759, regarding the sale of the Road Plantation of 70 acres, including goods and slaves, in the Parish of St Thomas by the Hon. Rowland Oliver of Antigua and his son, Richard, to Edward Parris. Signed and dated 8 August 1760. Rowland Oliver (*d*.1767) was a judge in the Leeward Islands and owned estates in Antigua. Richard Oliver (*c*.1735–84) was sent to London to work for his uncle, a draper and West Indian merchant. A political radical, he was elected MP for the City of London in 1770. In 1778/9 he returned to Antigua to run his estates. Richard Oliver died on board the packet ship *Sandwich* in April 1784, while bound for Britain.

MGS/33

130

Douglas papers

1762–7

Letterbook containing correspondence relating to the Weilburg Estate in Demerara, owned by Sir James Douglas (1703–87). Douglas was a naval officer and appointed commander-in-chief at the Leeward Islands in 1760. He was Rodney's second-in-command at the capture of Martinique in February 1762.

DOU/6

131

Slave passport

1774

Slave passport, Surinam, October 1774, for five named slaves to travel to Rio Demerary. In Dutch with a wax seal.

MGS/18

132

Valuation

1782

A valuation of estate slaves, Antigua. On the reverse: 'A list of Negroes when the estate was rented to Mr Thibou in 1781'. When plantations were rented or sold, they often included the enslaved population as part of the price. This list itemises the slaves on this estate, and shows their names (that is, the names given them by the planters rather than their African names), their occupations, their 'value' and, in some cases, their family relationships. It is another example of the ways in which the enslaved were regarded as chattel possessions – it was common for livestock or other assets to be listed in a similar way to the enslaved. The list can also reveal much about the structures in enslaved societies, however. (See Chapter 4, pp 55–6.)

MGS/30

133

Slave-carried letter

1785

Letter (with two original enclosures), dated Kingston, Jamaica, 30 June 1785. Carried by Scipio from the Blue Mountain Estate to Kingston. Enclosures include: (i) a list of the names, state and jobs of the 458 slaves

employed on the Blue Mountain Estate as of 1 January 1785, also with details of the cane crop and the land (in two parts); and (ii) a report on the overall condition of the estate from William Sutherland, also dated 30 June 1785.

MGS/19

134
Papers of Admiral Sir Charles Middleton, 1st Baron Barham
1788–1805

Letters dated 1788–1805 from William Wilberforce to Charles Middleton (1726–1813; Cat.276). Middleton was a notable naval administrator, being enobled for his role as the First Lord of the Admiralty for a brief period before and just after Trafalgar in 1805. He was also a noted evangelical Christian.

MID/1/198

135
Inventory
1796

Plantation slave inventory of the Waterhouse and Tunbridge Plantation, British West Indies, entitled 'A list of slaves on Waterhouse & Tunbridge', taken on 1 January 1797. Inventory includes 62 men, 65 women, 10 boys, 8 girls, 6 male invalids, 9 female invalids, 13 male children, 25 female children, and increase/decrease in slave numbers for 1796.

MGS/23

136
Bills of sale
1801–4

Five slave bills of sale (three pages, two stitched together), Lima, Peru, dated 8 January 1801 to 27 January 1804. In Spanish.

MGS/5

137
Documents relating to Barbados plantations and estates
1803–60

A collection of documents relating to the plantations and estates of Applewhaites, Mullineux and Stepney on Barbados belonging to the Cobham family. It includes accounts, inventories and appraisals for various years between 1803 and 1860, which give details of the names, occupations and values of individual slaves, and the wages paid to hired hands. The papers provide an insight into the impact of abolition and emancipation on three plantations.

MGS/40/1–20

138
Indenture
1813

Indenture, Cape of Good Hope, dated 1 February 1813, between Charles Blair, Collector of Customs, and Jacob van Reenen, relating to the transfer of 'Neproga a male Negroe' from the custody of the Royal Navy to van Reenen for the term of 14 years as an apprentice in the trade of a 'home servant'. The slave was forfeited as prize to the King by a sentence of the Vice-Admiralty Court.

MGS/34

139
Inventory
1816

Plantation slave inventory, entitled 'Inventory of Plantation Mon Repos, the property of Joseph Hamer Esquire, deceased, situated on the east coast of Demerary, taken the 1st July 1816'. It details the plantation acreage and buildings, followed by a list of the names (under 'Negroes') of 85 men, 70 women, 43 male children and 46 female children slaves, totalling 244 individuals.

MGS/24

140
Correspondence of Admiral Sir William Sidney Smith
1818–20

Five letters to William Sidney Smith (1764–1840) referring to the anti-slavery campaign.

SMT/14

141
Inventory
1820

Prospect Sugar Estate slave return for the Parish of Hanover, Jamaica, dated 28 June 1820, including 213 males and 219 females, with names and dates of those slaves born, deceased (with cause of death) and manumitted since the last return. Slaves in the possession of James Colquhoun Grant and John Blyth as attorneys to John Wedderburn, signed 13 September 1820.

MGS/29

142

Inventory

*c.*1820

Inventory of goods and slaves from a plantation, about 1820, including 15 named men, women and children, certified by appraisers Simeon Heiner and Isaac Frink (two pages).

MGS/25

143

Letter

1821

Letter to William Atkinson of Sheffield, addressed from Augusta, Georgia, 23 March 1821, commenting on the subject of slavery and particularly a state law in Georgia forbidding the education of slaves. Cross-written.

MGS/20

144

Indenture

1822

Appointment of a new Trustee of Plantation, Slaves and Stock in Jamaica, 29 June 1822, containing details of ownership of all children born to female slaves, with signatures. From Andrew Fitzgerald Reynolds and others to Robert Eden. On vellum with wax seals.

MGS/35

145

Dawson papers

1823–43

Letters from the Dawson brothers to their father, William Dawson (1779–1844). Letters from Dugald Dawson (1805–41) while he was overseer on a Trinidad plantation, River Estate: he comments on the effect of the weather on sugar-making, planters losing their jobs and securing work for his brother John

[October 1823 to September 1840]. Letters from William Dawson Jr (1810–58), from various locations, including Demerara, regarding life on board ship and the poor crops in Trinidad [December 1828 to October 1843]. A letter by John Dawson, written in Trinidad, relates mostly to family matters, but also mentions efforts to free the slave population [22 July 1833].

DWS/1/1–3, DWS/2/1, DWS/5

146

Affidavit

1825

Affidavit of a man claiming not to be a slave, Cape Town, 28 February and 10 March 1825. The letter is written to J. Renyvelt, Deputy Fiscal, Cape Town, from Thomas, with pencil notes relating to the slave registration of Thomas.

MGS/21

147

Registration document

1825

Registration of a slave sale at the Office for the Enregisterment of Slaves, Cape Town, dated 29 March 1825. Records the sale of a female slave, Alima, aged 14¾ years, by Mrs Cloete to Mrs van Reenen.

MGS/1

148

Slave registration certificate

1826

Slave registration certificate, Slave Registry Office, Cape Town, 15 August 1826, detailing the registration of a male infant, named Japi, born on 4 August 1826. The child's mother, Theresia, was a housemaid and the property of Daniel Krynauw Sr.

MGS/2

149

Slave registration certificate

1826

Slave registration certificate, Slave Registry Office, Cape Town, 27 December 1826, detailing the registration of a female infant, named Jamiela, born on 10 December 1826. Her mother, Aurora, was the property of Mrs Jacob van Reenen.

MGS/3

150

Inventories

1827

Brichin Castle Estates monthly inventory reports for January and February 1827, including details of 53 slaves; the production of sugar, rum and livestock; goods received and delivered; and the employment of an overseer, with observations on the plantation.

MGS/26–27

151

Inventory

1829–32

Blackenburg Estate monthly inventory entitled 'Journal of plantation', dated January 1832, including details of: 324 slaves; the production of sugar, rum and livestock; goods received and delivered from the plantation; and employment of overseers from 31 August 1829 to 9 January 1832.

MGS/28

Montgomery, Ala., _____ 186_

Received of _____

_____ Dollars, in full payment for a
Negro Boy named _____ about _____
years of age, which Negro __ warrant sound in body and
mind and a Slave for life. __ also guarantee the title
free from all encumbrance.

M. HARWELL, Auctioneer.

Barrrett & Wimbish, Printers.

Cat.161

152
Court recovery
1831

Court recovery to the Sheriff of Lawrence County, Alabama, raised on 19 April 1831, against Isaac Johnson for payment of debts to John Gilmer. The reverse records taking possession of 'a Negro man about twenty-seven and George, a boy of about fifteen years all as property of the within defendant', 30 April 1831, signed John Griggstiff.

MGS/36

153
Receipt
1834

Contract/receipt from Virginia, United States, dated 1 January 1834, for the hire of a Negro slave named 'Phill' by Willis Wooten Jr and John Bailey from Francis B. Whiting, guardian of P.C.L. Burwell for the year 1834, at a cost of $15.25.

MGS/10

154
Valuation
1834

Antigua slave valuation entitled 'Return of the number of slaves and estimated value', dated 1 August 1834, itemising 264 slaves, valued at £14,595 in various categories, for the purpose of claiming compensation. Return completed by Folly Division of Falmouth for the owner, Godschall Johnson.

MGS/31

155
Cheque
1834

Cheque from the Anti-Slavery Society, London, 10 August 1834, signed by William Smith (1756–1835) and Zachary Macaulay (1768–1838) and drawn on Messrs Hoare Barnetts, Hoare & Co. totalling £68.11.8.

MGS/38

156
Counterclaim for compensation
1835

Counterclaim for compensation, Camden Estate, Quarter to Caraplachaima, Trinidad, 24 October 1835, in the names of Hugh Duncan Baillie, James Evan Baillie and George Henry Ames, all of Bristol, by their attorney, Matthew Hale, in respect of slaves in the possession of Alexander Fraser.

MGS/37

157
Bill of sale
1838

Notarised copy of a bill of sale, New Orleans, Louisiana, dated 23 May 1838, for $800 cash in hand paid for a 'mulatress' slave named Lucy, aged about 18 years. She was sold by George Ann Botts to Samuel Marmaduke Dinwiddie Clarke.

MGS/7

158
Letter
1839

Letter from J. Leese to William Hobbs of Worcester, 2 March 1839, written on abolitionist notepaper printed for the Anti-Slavery Society. With an engraving of an overseer flogging a slave in shackles.

MGS/22

159
Receipt
1843–4

Two receipts from the Southern United States: (i) tax receipt for 1843 from Susan Catron to the Sheriff of Wythe County, itemising amounts paid for land, slaves and horses etc., totalling $5.51; and (ii) bill for expenses incurred by R.M. Campton during 1843, detailing miscellaneous items including 'mending of Negroes shoes – $1.63', dated 1 January 1844.

MGS/11

160
Confederate bond
1863

Confederate $300 bond, no.306, Richmond, Virginia, dated 4 August 1863, to Francis E. Woodson, redeemable after 1 July 1868 with interest from 10 July 1863 at 7% per annum.

MGS/13

161
Receipt
1864

Receipt for the purchase of a slave by M. Harwell, auctioneer, Montgomery, Alabama, dated 5 April 1864, for $3000 in payment for 'a Negro boy named Frederick about eighteen years of age'. With an engraved vignette of a male slave collecting cotton in a basket, with a paddle steamer in the background.

MGS/12 / F5775

162
Autographed quotations
Wendell Phillips (1811–84), 1860s

(i) 'Libertate Quietem', signed January 1864; (ii) 'Count that day lost whose low . . .', dated March 1868. Phillips was an American abolitionist and an associate of William Lloyd Garrison (1805–79) and the president of the Anti-Slavery Society.

MGS/39

163
Spanish slave registration document
1872

Slave registration document (Registro de Esclavos), detailing the registration of a slave named Reyes, 54 years, property of Ortiz of Puerto Rico, 25 January 1872.

MGS/4

164
Papers of the Adam family, Mauritius
19th century

The papers relate to sugar plantations, slavery and trade in nineteenth-century Mauritius. Mostly in French.

AAM

MAPS, CHARTS AND ATLASES

Maps and charts of Africa and the Americas reflect Europe's growing knowledge of and interest in the Atlantic world from the sixteenth century. They are also an indication of its economic and political importance. The following selection represents only a fraction of the extensive and diverse collection of maps, charts and atlases held at the National Maritime Museum.

165
Africæ Tabula Nova
[New Map of Africa]
Abraham Ortelius (1527–98), Antwerp, 1570
365 × 480 mm

G.290:1/10

166
Map of Ralegh's Virginia
Johann Theodor de Bry (1528–98) after John White (active 1577–93), c.1590
Etching, 300 × 412 mm

Cat.166

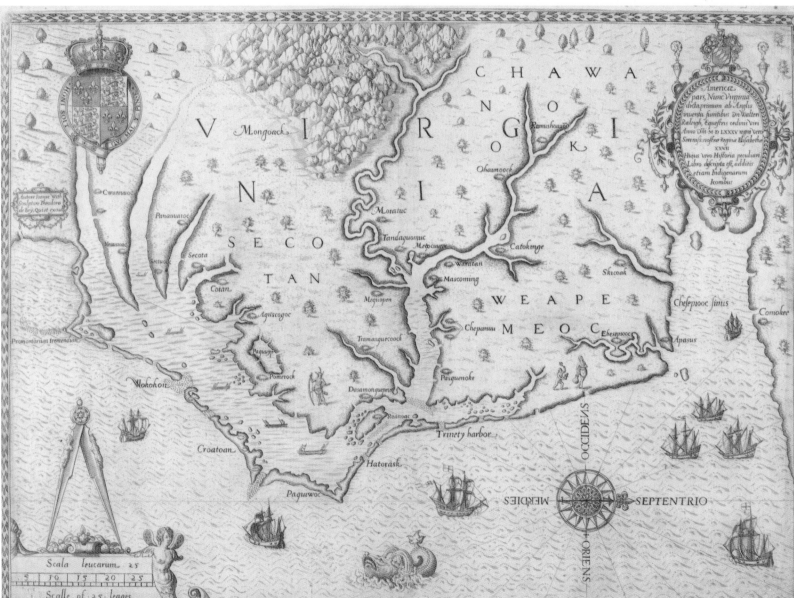

This map was drawn by John White, the official artist on the expedition to North America in 1585, which was promoted by Sir Walter Ralegh (1552/4–1618). His work, including this map, was engraved by Theodor de Bry, who illustrated Thomas Harriot's *Briefe and true report of the new found land of Virginia*. Harriot's book was published in Latin, English, French and German editions in 1590, creating an impact across Europe. The map shows America as a lush land, with safe harbours and an easily accessible interior, which were key features for prospective settlers and imperialists. It also indicates this was a land already populated by Native Americans. This was not a 'new world' that was 'discovered' by Europeans, but one in which sophisticated societies were already well established. On his return to Britain, White was appointed by Ralegh to establish a new colony in the Chesapeake Bay, but he landed at Roanoke by mistake in 1587. He quickly went back to London to seek further help, but when he finally returned to the colony at Roanoke he found it deserted and ransacked.

PAG7335 / PX7335

167
Map of Jamaica
John Ogilby (1600–76), 1671
560 × 450 mm

The publisher and geographer John Ogilby used existing works to compile a series of atlases in the early 1670s. His *America* was published in 1671.

G.245:11/3

168
Map of Barbados
John Ogilby, 1671
295 × 360 mm

See Fig.1 (p.19)

G.245:15/44 / D4733

169
Map of Africa
Frederick de Wit (1630–1706), 1672
1000 × 1230 mm

The map of Africa is surrounded by descriptions of the continent in French, Latin, Dutch and English with 20 views of cities and ports. It carries the inscription 'Nova Totius Africæ Tabula Emendata a F. de Wit' [Map of the whole of Africa corrected by F. de Wit]. De Wit was one of last great Dutch cartographers. See Fig.1 (p.19).

G.290:1/4

170
Caribbean & West Indies from Guyana to Chesapeake Bay
Nicolaus Visscher, *c*.1700
435 × 540 mm

G.245:1/8

171
A book of mapps
Herman Moll (*c*.1654–1732), 1717

This rare collection includes a map of Africa (no.5) and of the West Indies (no.8).

PBD5426

172
West India atlas
Thomas Craskell and James Simpson, 1763

Includes a detailed map of Jamaica in six sheets with the names of many plantations.

PBD8475

173
Gulf of Mexico and West Indies, 1770
Jacques Nicholas Bellin (1702–72), 1775, 2nd edition
535 × 805 mm

Bellin spent over 50 years in the French Hydrographic Service, producing a large number of high-quality sea charts.

G.245:1/14

174
Map of Africa
Aaron Arrowsmith the Elder (1750–1823), London, 1 November 1802
1280 × 1480 mm

This map is dedicated 'TO /The Committee /AND /Members OF THE British Association,/ FOR/ Discovering the Interior parts of/ AFRICA/ By their most obedient/ and humble servant.'

G290:1/12

175
Chart of HMS *Bittern*
1843
645 × 475 mm

A chart of the tracks of HMS *Bittern* while on anti-slavery patrol off the west coast of Africa, showing the dates that slave ships were captured.

G.241:6/9

176

Sketch of the south coast of Africa

George Giles, RN, *c.*1846–9
Ink and washes on paper mounted on card,
590 × 460 mm

A sketch map of the south-west African
coast, from Cape Lopez (Gabon) through
Cape Padrao (Congo River delta, Zaire),
Ambriz (Angola), Novo Redondo (Angola)
to Lobito Bay (Angola). The remarks and
annotations on this map give nautical,
topographical and provisioning information,
with the exception of a note written near
Cape Padaroa (Padrao), marked by crosses:
'About a mile to the southward of Cape
Padaroa where the crosses are is a small inlet
where they ship their slaves without going up
the river.' Giles then notes how the *Grappler*
captured a slave ship, the *Sapphir*a, carrying
479 slaves.

MGS/41

177

Sketch of the west coast of Africa

George Giles, RN, *c.*1846–9
Ink and washes on paper mounted on card,
470 × 585 mm

Manuscript map drawn and annotated by
George Giles of HMS *Grappler, c.*1846–9.
Giles gives detailed descriptions of where to
find slavers and how to treat released slaves.
'In a very crowded vessel, after being taken,
you'll find the slaves very violent and
frightened, and inclined to jump overboard...
no time should be lost in lighting the slave
galley fire and cooking some provisions,
others in the meantime giving them a
little water.'

MGS/42

MATERIAL CULTURE

During the eighteenth and nineteenth centuries, abolitionist imagery, especially the iconic figure of the kneeling African in chains, appeared on a bewildering range of items, both practical and ornamental. Africans, often shown wearing silver collars, were also depicted on many objects as a form of decorative motif. In addition, Britain's involvement in slavery and abolition inspired further artefacts, proving a rich legacy of material culture.

ABOLITION CAMPAIGNS

178
Slave Emancipation Society medallion
William Hackwood (c.1753–1836) for Josiah Wedgwood (1730–95), c.1787–90
Jasperware; glass, 30 × 27 mm

In *pâte de verre*, with an applied figure in black of a kneeling slave and the legend 'Am I not a man and a brother?' The master potter and industrialist, Josiah Wedgwood, was a key member of the abolition campaign and first produced his famous medallion for the London Abolition Committee in 1787. The design was based on a seal created by an eight-man sub-committee. William Hackwood, an expert sculptor and moulder who worked for the Wedgwood company for 63 years, translated the image into the famous medallion. The design proved immediately popular and served as a rallying icon for the campaign, being adapted into many forms. Wedgwood, with his commercial skills and

many useful contacts, joined the London Abolition Committee in 1791. See Fig.50 (p.144).

ZBA2492 / F5738

179
Slave Emancipation Society medallion
William Hackwood for Josiah Wedgwood, c.1787–90
Jasperware, 3 × 32 × 35 mm

Oval design based on the seal of the London Abolition Committee. The medallion is in beige jasperware with applied figure of a kneeling slave and suspension hole. Legend: 'Am I not a man and a brother?'

ZBA2478 / F5739

180
Handle with mounted abolitionist plaque
Britain, c.1790
Enamel; brass, 67 × 46 mm

Mounted as the front of a drawer handle, with the legend 'Am I not a man and a brother'.

The Wedgwood plaque image of the kneeling slave was quickly adapted for use across an extensive range of goods and media. Abolitionist households might have had prints, crockery, glassware, soft furnishings etc. all decorated with versions of the original. Here, a coloured enamel plaque, showing a pleading African with huts, trees and a ship in the distance, has been mounted into a drawer handle. The manifestation of abolitionist material in the domestic sphere is a further indication of the significant role played by women in promoting and advancing the cause.

ZBA2451 / F5737

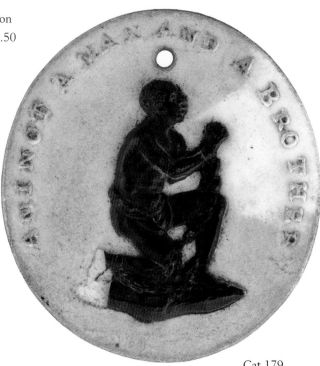

Cat.179

181
Abolitionist seal
Britain, c.1790
Ceramic, 26 × 20 mm

The seal is moulded with the legend 'Am I not a man and a brother?'

ZBA2488

182
Figure of an African
Britain, c.1790
Iron, 103 × 83 × 30 mm

This kneeling slave figure based on the Hackwood/Wedgwood pattern is presumably a domestic ornament intended for those of abolitionist sympathies.

ZBA2491

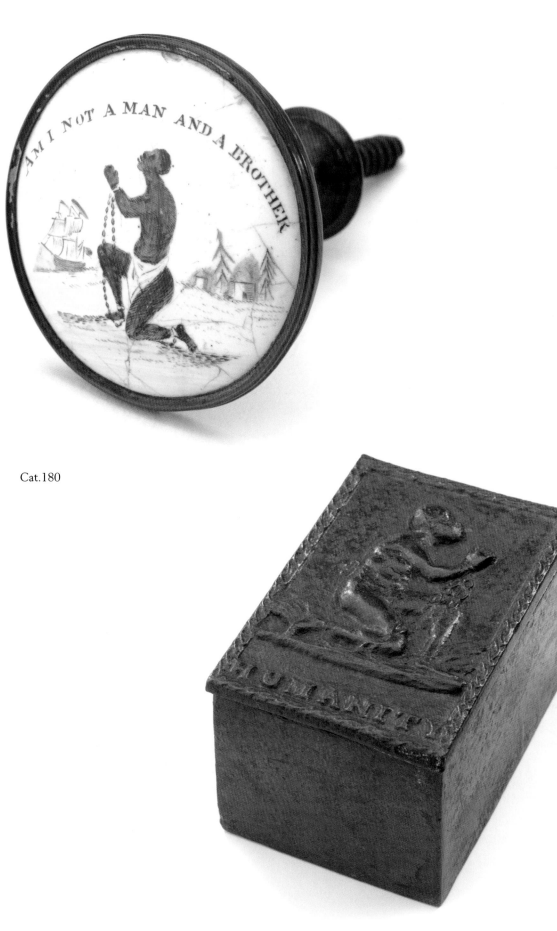

Cat.180

Cat.184

183

Abolitionist seal

*c.*1800

Brass; basalt, 26 × 17 mm

Brass-mounted basalt, moulded with the legend 'Am I not a woman and a sister?'

ZBA2493

184

Tobacco box

Britain, *c.*1800

Iron, 75 × 138 × 90 mm

Iron tobacco box, possibly made in Coalbrookdale, cast with the figure of a kneeling African and the inscription 'Humanity' on the lid.

ZBA2439 / F5733

185

Tobacco box lid

Britain, *c.*1800

Iron, 133 × 90 × 12 mm

Similar to Cat.184.

ZBA2480

186

Button

Britain, *c.*1820

Silver, 11 × 21 mm

This button depicts the head of an African man, in relief, wearing a headband and a beaded collar or necklace flanked with broken chains.

ZBA2438

187

Saucer

Britain, *c.*1820

Earthenware, 37 × 178 mm

A sage green earthenware saucer with a gilt rim. It has a black transfer print in the centre showing a kneeling female slave, her wrists chained, with a palm tree in the background to the left.

ZBA2458

188

Kneeling figure of an enslaved African

Britain, *c.*1820

Bronze, 120 × 90 × 40 mm

Figure of a slave kneeling, with caption 'Am I not a man and a brother?'

ZBA2479 / E9101

Cat.188

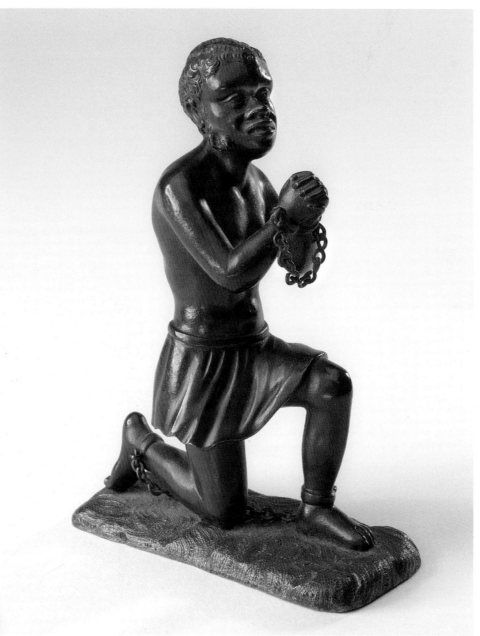

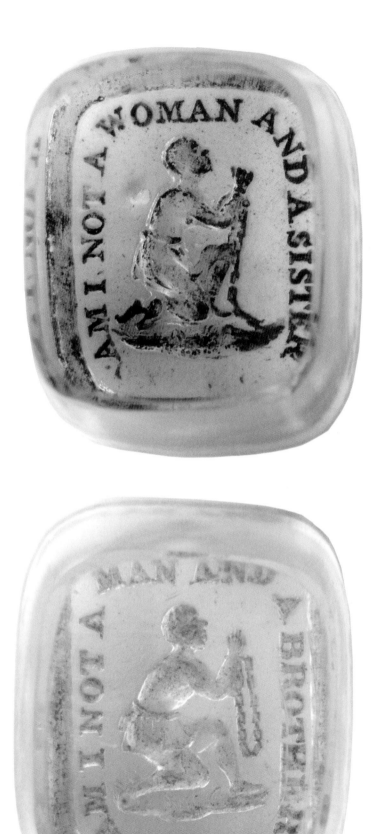

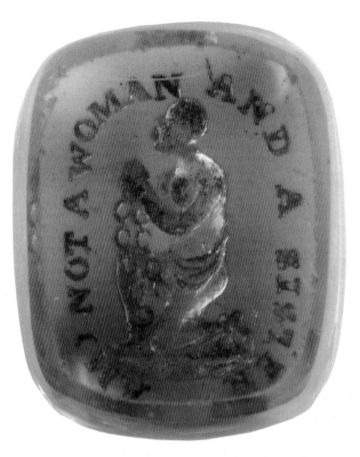

Cats.190–193

189

Anti-slavery woolwork picture

Britain, *c.*1820

Wool; canvas, 323 × 353 mm

A Berlin woolwork picture on canvas, with a pale blue background. The central image depicts a kneeling African in black and grey, facing right. In the top corners are two white roses, the details worked in red; two shells in the bottom corners. Inscribed above the slave: 'Nelson moniment' [sic]. The whole has a black and yellow Greek key border.

ZBA2840

190

Abolitionist glass seal

William Tassie (1777–1860), London, *c.*1825

Glass (amber), 17 × 14 × 10 mm

Moulded with 'Am I not a woman and a sister'. William Tassie was a renowned glass and gem engraver and portraitist, living and working in London's Leicester Square.

ZBA2459 / F5744-1

191

Abolitionist glass seal

William Tassie, London, *c.*1825

Glass (clear), 16 × 13 × 12 mm

Moulded with 'Am I not a woman and a sister'.

ZBA2460

192

Abolitionist glass seal

William Tassie, London, *c.*1825

Glass (amethyst), 16 × 14 × 10 mm

Moulded with 'Am I not a man and a brother'.

ZBA2461

193

Abolitionist glass seal

William Tassie, London, *c.*1825

Glass (clear), 17 × 14 × 10 mm

Moulded with 'Am I not a man and a brother'.

ZBA2462

194

Pincushion

Britain, *c.*1827

Silk, 50 mm

A pincushion with an image of a kneeling African. The reverse has an extract from the *Royal Jamaican Gazette* of 1 August 1827, with a notice of a sale of a black child aged seven with a biblical quotation beneath. While the public face of abolitionism was middle-class, white and male – exemplified by Wilberforce and Clarkson – the cause attracted support from a broad cross-section of society. Women played a prominent part at both the local and the national level. Particular aspects of the campaign allowed them to take the lead, especially when abolitionism entered the domestic sphere, e.g. in the organisation of West Indian sugar boycotts. This pincushion demonstrates how women could be associated with, and involved in, the movement even through the most basic day-to-day tasks.

ZBA2453 / F5760-1, F5760-2

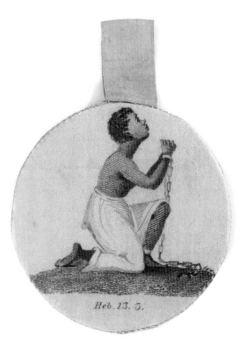

Cat.194

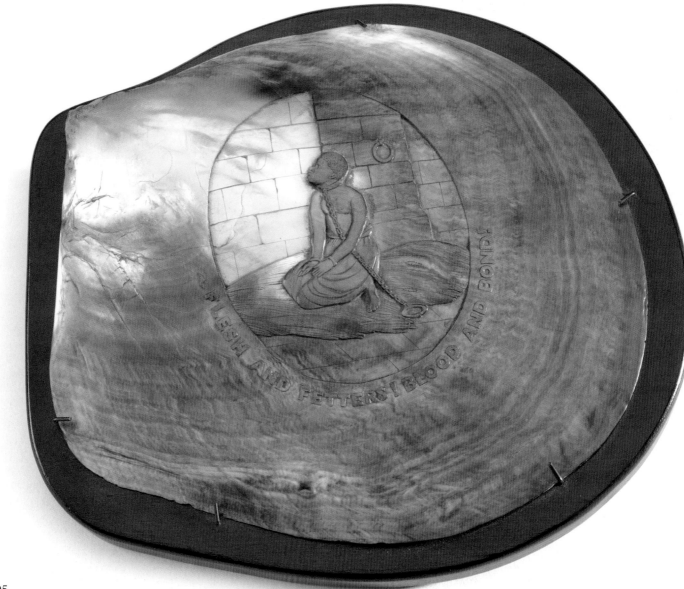

Cat.195

195
Shell
Britain, *c*.1830
Mother-of-pearl mounted on wood,
204 × 227 × 48 mm

A depiction of a kneeling African in chains
on a straw floor in a cell is engraved on the
convex side of the shell. Legend: 'Flesh and
fetters! Blood and bond!'

ZBA2431 / E9100

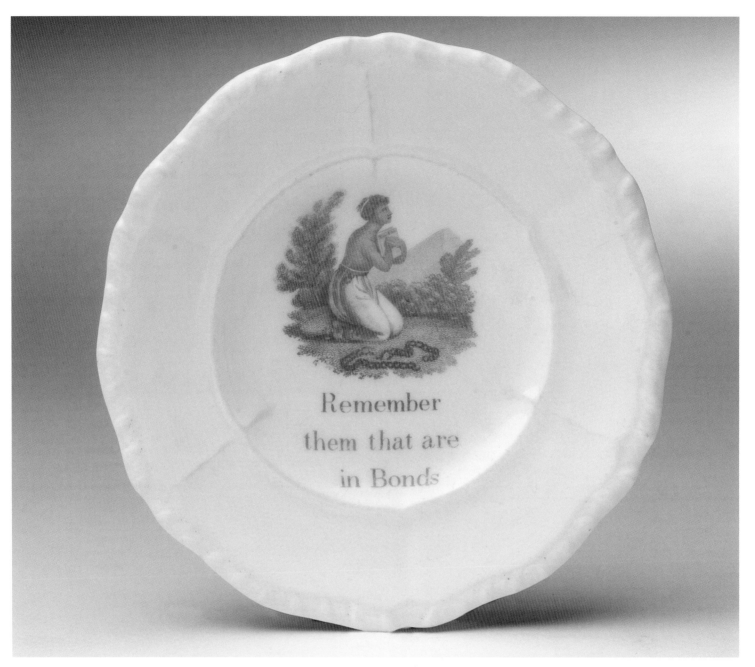

Cat.197

196
Abolitionist plate
Britain, *c.*1830
Porcelain, 15 × 120 mm

Abolitionist ceramic plate, in white porcelain
with a black transfer print depicting a
kneeling female slave in chains, a palm tree
to the left. The plate has a moulded edge.

ZBA2467

197
Abolitionist plate
Britain, *c.*1830
Porcelain, 15 × 120 mm

Abolitionist ceramic plate, in white porcelain
with a black transfer print of a kneeling
female slave holding a Bible, broken chains
beside her. Inscribed: 'Remember them that
are in bonds'. The plate has a moulded edge.

ZBA2468 / F0909

Cat.198

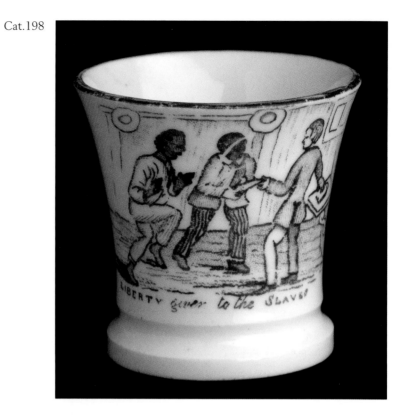

Cat.199

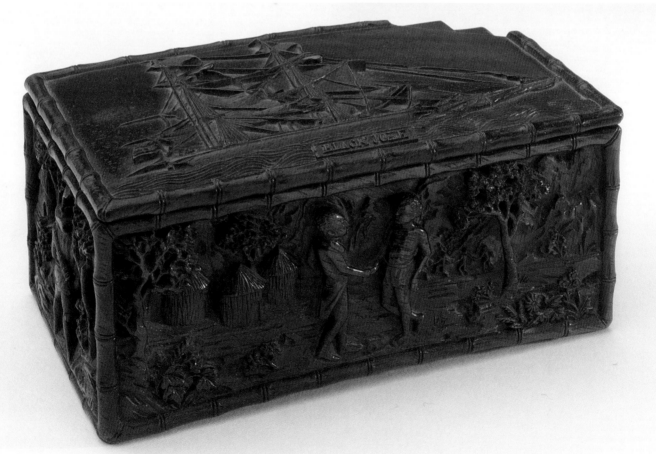

198
Commemorative cup
Britain, *c*.1834
Porcelain, 55 × 56 × 70 mm

A white porcelain cup with black painted
rim. It is decorated with a black transfer print
depicting a European handing a paper to
two Africans, one of whom is dancing for joy.
Inscribed below: 'Liberty given to the slaves'.

ZBA2469 / F6186

199
Snuffbox
China, *c*.1840
Wood, 103 × 50 × 48 mm

This snuffbox was made from the timbers
of the brig *Black Joke* (Cat.593). The *Black
Joke* was one of the best-known vessels
involved in the Royal Navy's anti-slavery
patrols. Originally built as a fast-sailing slave
trader, the Baltimore-based *Henriquetta*, the
Black Joke proved highly successful, capturing
Spanish and South American slave ships in
a series of spectacular actions off the West
African coast in the late 1820s and early
1830s. She worked off Australia until 1839

when she sailed for China via Singapore
and was sold for the last time at Macao.
The snuffbox has bamboo-pattern borders,
with a view of the ship fully rigged on the
top. The back and sides are carved in deep
relief with representations of African life;
the front is similarly carved with a scene
copied fromthe medal commemorating
the abolition of the slave trade (1807).
The box contains an example of the medal
and various nineteenth-century documents
supporting its provenance.

ZBA2435 / E9105

200
The effects of American slavery...
Britain, *c*.1840
Porcelain, 23 × 160 mm

A porcelain plate with a moulded border.
In the centre is a disturbing transfer print,
showing a chained female slave, naked from
the waist up, kneeling in prayer. She is about
to be flogged by an African-American man.
Legend: 'The effects of American slavery/
whipped for wanting to live a Christian life.'

ZBA2464

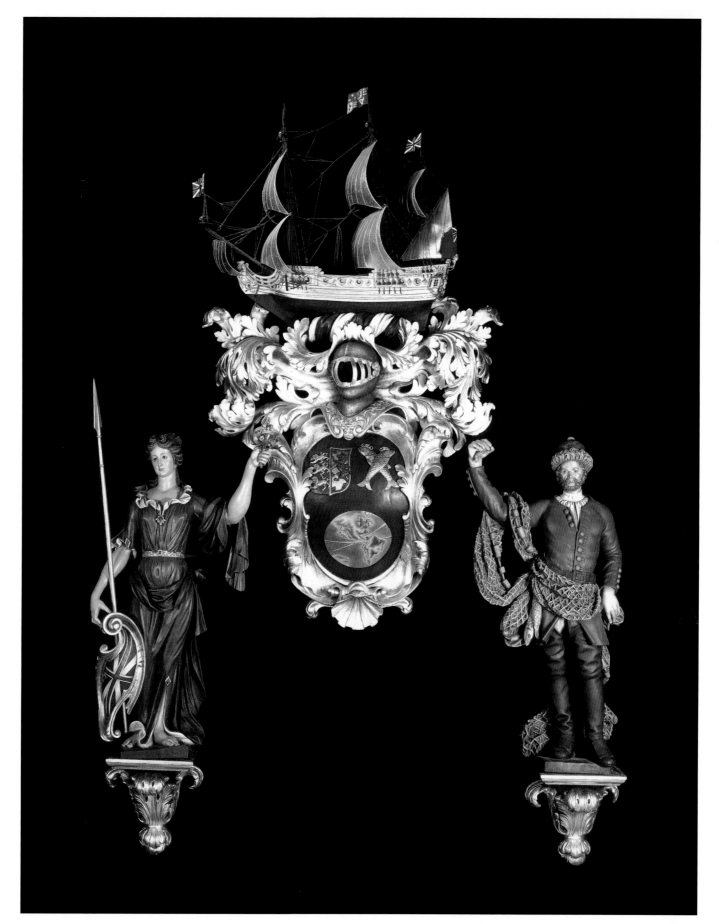

MISCELLANEOUS

201
South Sea Company coat of arms
Robert Jones (*d*.1722), *c*.1711
Carved, painted and gilded wood with metal embellishments, overall 2184 × 1346 mm

The South Sea Company was formed in 1711 with the aim of monopolising British trade with Spanish South America. In 1713, the Company was vested with the *Asiento*, giving it the right to trade slaves to the Spanish colonies. This coat of arms was mounted
in the lobby of Company's headquarters in London.

HRA0043 / D4847

202
Snuffbox
William Hutchinson, London, *c*.1740
Silver; glazed ivory, 24 × 75 × 58 mm

This silver gilt snuffbox has a painted ivory panel set inside the lid. It shows a European woman in a blue dress, baring her left breast. Behind her is a young male African servant or slave, dressed in livery and a silver collar with his right hand raised. A second, hidden compartment would have held another painting but only the ivory insert remains. During the seventeenth and eighteenth centuries, African servants were regarded as a status symbol and were often depicted in society portraits.

ZBA2452

203
Punchbowl
China, *c*.1782
Porcelain, 160 × 400 mm

A Qing dynasty Chinese export porcelain punchbowl with a deep foot. It is decorated on the outside with a grisaille painting of the Battle of the Saints on 12 April 1782, after the published engraving by Robert Dodd (1748–1815). On one side are the arms of Sir Charles Douglas (*d*.1789), Admiral Rodney's Captain of the Fleet during the battle, with the family motto 'lock sicker' (be sure). The inner rim of the bowl is bordered with a pattern of green and gold, and there is a small floral motif on the bottom. The image was taken to China, where it was hand painted by Chinese artists onto the bowl, and then returned to Britain

Cat.203

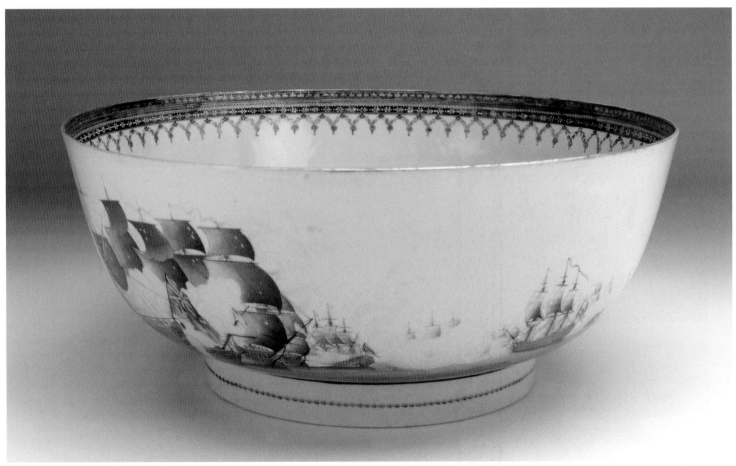

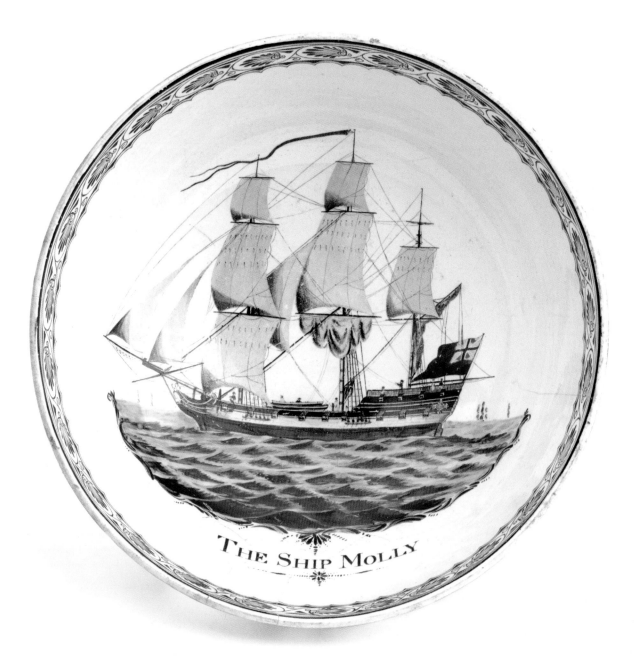

THE SHIP MOLLY

Cat.204

to commemorate a battle between the British and French fleets in the Caribbean. It represents the growing 'globalisation' of the eighteenth-century world. It is significant that the bowl would have contained rum punch, made from slave-grown sugar. Admiral Rodney's defeat of the French fleet in the West Indies during the Battle of the Saints saved Britain's valuable sugar colonies.

AAA4357 / D9638

204
Punchbowl
Liverpool, late 18th century
Earthenware, 130 × 300 mm

A creamware punchbowl painted on the interior with a ship portrait, inscribed: 'The ship Molly'. The hull is coloured yellow and black, and the ship flies a red ensign and pennant. During the eighteenth century, Liverpool rapidly grew to become the largest slaving port in Europe. The slave trade dominated the city's commercial life.

Commemorative wares, like this bowl, were produced in large numbers. There were many slave ships called *Molly* sailing from Liverpool in the late eighteenth century (19 are recorded between 1776 and 1800), and they traded all along the West African coast before sailing to the Caribbean, usually to Jamaica. It has not been possible precisely to identify which ship this commemorative bowl depicts.

AAA4433 / F5757-2

205
Sugar nippers
Britain, *c*.1800
Steel, 15 × 240 × 100 mm

A pair of nippers with opposed blades to
crack the sugar loaf; hinged with a spring
and decorated with engraved patterns. In the
eighteenth century people did not buy sugar
as granules or lumps as we do today. Instead,
it came in large cone shapes, wrapped in
paper, called sugar loaves. These were made
from sugar grown on plantations in the
Americas. Sugar nippers like these were
used for cutting off small pieces from sugar
loaves for domestic use.

ZBA2490 / F0908

206
Figurehead of the Royal Yacht *Royal George*
1817
Mahogany, 1930 × 914 × 1016 mm

The *Royal George* was launched in July 1817
as a new royal yacht for the Prince Regent,
later George IV (1762–1830). The figurehead
shows George III (1738–1820) dressed in
Roman style with an African supporter on
each side, their hands clasped together
pleading. It is possible that it was carved in
reference to, or as a celebration of, the
abolition of Britain's slave trade in 1807
based on the Hackwood/Wedgwood plaque
(Cat.178), in compliment to the benevolence
of George III.

FHD0099

207
Wine cooler
Thomas Walker II, London, 1830–31
Wood and silver gilt, 323 × 220 mm

The wine cooler is made from the timbers
of the slaver *El Almirante* (Cat.593), captured
on 1 February 1829 by HMS *Black Joke*,

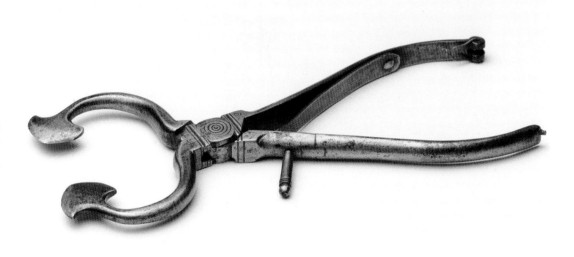

Cat.205

commanded by Lieutenant Henry Downes.
The wooden base is made from the timber
of the Spanish war ship *Bahama* captured at
the Battle of Trafalgar in 1805. The cooler
is carved with oak leaves and has ormolu
mounts of moulded branches. The metal
handles are in the shape of fungi. A gilded
plate on the front, within a laurel wreath, is
inscribed: 'A tribute of admiration and respect
from Commodore Collier CB to Lieutenant
Henry Downes for his gallant conduct in
command of HM Tender Black Joke'.
Francis Augustus Collier (1783–1849) was
commodore on the west coast of Africa from
1826 to 1830.

ZBA3083–84

208
Miniature tableau
style of Gerrit Schouten (1779–1839),
Surinam, *c*.1830
Mixed media, 100 × 140 mm

Pair of mixed media tableaux depicting
Africans of two different ethnic groups.
Life around a fire and watercraft are shown.
One shows a settlement with wooden houses.
The other appears to show a camp, consisting

of a roofed shelter with no walls containing
hanging seats. Schouten was the first recorded
artist of creole origin in Surinam (Dutch
Guiana). He produced elaborate tableaux
documenting life in indigenous and escaped
slave communities. He is also known for his
paintings of the flora and fauna of the colony.

ZBA2496–97

209
Jug
Ridgway & Abington, Hanley, Staffordshire,
1853
Stoneware and pewter, 220 × 190 × 130 mm

Stoneware jug with a pewter lid, the interior
is glazed. The jug is moulded with two scenes
from *Uncle Tom's Cabin* by the American
author Harriet Beecher Stowe (1811–96).
The story was originally published in weekly
instalments in the American abolitionist
newspaper *National Era* between June 1851
and April 1852. The subsequent book was
massively popular, with multiple editions
published on both sides of the Atlantic.
One side shows a slave auction; the poster
on the auctioneer's podium is inscribed
'By auction this day a prime lot of healthy

Negroes'. The other side depicts one of the most dramatic incidents from the book. Eliza, the young black mother, is shown clutching her infant son while fleeing from Haley, the evil slave trader. Eliza runs barefoot across the frozen Ohio River, using the floating blocks of ice as stepping stones. The handle is in the form of a praying African; there is a palm tree moulded under the lip of the jug and a leaf pattern around the base. Impressed on the bottom of the jug: 'Published by Ridgeway & Abington, Hanley, January 1, 1853'. It seems likely the jug was produced to coincide with Stowe's visit to Britain in 1853.

ZBA2475

210
Gun

Persia, *c*.1853
Brass, Gun: 230 × 430 × 160 mm; Carriage: 170 × 330 × 200 mm

The gun was found in an Arab slave dhow captured by HMS *Penguin* in the 1860s.

KTP0069

211
Handkerchief

Britain, *c*.1890
Printed cotton, 611 × 570 mm

The four border panels of this printed cotton handkerchief, produced around the period of the European partition of Africa, parody the impact of British policy on the continent. The first depicts the slave trade with Africans in chains being driven through the country by European slave traders. The second border –

entitled 'The rescue' – shows soldiers from a Scottish regiment in kilts (one playing the bagpipes) freeing the enslaved Africans. The soldiers take the slave traders into captivity while the freed Africans dance with joy. The narrative continues in the third border – 'result' – where the now emancipated African population are tempted on the one hand by the 'legitimate' European trader with his rum and tobacco, and on the other by the Christian missionary. The final border depicts 'civilization'. The Africans are now garishly attired in western-style dress and have adopted European habits and mores. Western technology and consumerism have also arrived in the form of railways, bicycles, newspapers etc., completing the transformation and modernisation of this imagined African country.

ZBA2476 / F5762-2

Cat.211

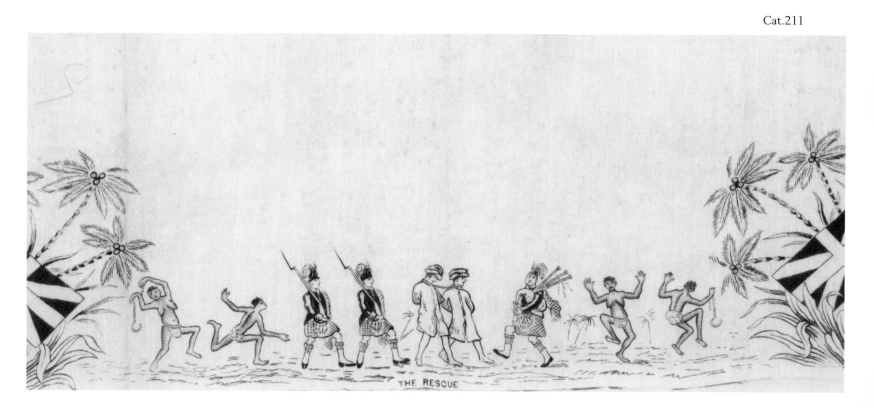

THE RESCUE

212
Prizefighter statue
Britain, 19th century
Spelter and bronze, 120 × 70 × 60 mm

The spelter figure, with arms outstretched, stands on a bronze plinth with a bronze belt carrying traces of black paint. The figure's strong and powerful stance is in sharp contrast to the pleading African of earlier abolitionist iconography. Prizefighting was one of the ways in which black men could earn money and acquire financial status in nineteenth-century British society. The subject of this sculpture is unknown, but a man like Bill Richmond (1763–1829) might have provided the inspiration. Richmond was born on Staten Island, New York, the son of slaves. He came to Britain when he was 14, and was apprenticed to a cabinetmaker in York. His talent for fighting was discovered as he defended himself against racist abuse. He moved to London in the early 1800s and became a professional boxer. With the money he earned from prizefighting he was able to buy the Horse and Dolphin pub in St Martin's Street in Westminster and to retire from competitive fights, though he continued to offer advice to aspiring boxers. See Fig.28 (p.99).

ZBA2470 / F2514

213
Perpetual cigar lighter
19th century
Brass, 236 × 120 × 150 mm

The base and stem of the lighter take the form of a stylised bird's leg. On top of this is a bust of an African man, wearing a studded metal collar and smoking a cigar. A lid at the back of his head allows it to be filled with spirit; a flame would then burn from a wick inserted through the tube that forms the cigar.

ZBA2495 / F5750

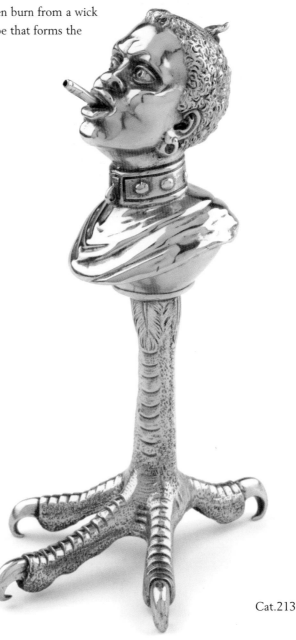

Cat.213

Newspapers, Broadsides and Press Illustrations

Newspapers and illustrated journals provide a rich source of information on, and an insight into, changing public attitudes towards slavery and abolition. Printed ephemera in the form of broadsides, posters and advertising reveal the media employed both by plantation owners trying to sell slaves or recover runaways and by abolitionists trying to shape public opinion.

Newspapers and Periodicals

214
The Jamaica Mercury & Kingston Weekly Advertiser
Kingston, Jamaica, vol.1: nos 19–20, 28 August to 11 September 1779;
no.32, 27 November to 4 December 1779
With 'Supplement to the Jamaica Mercury'.

The newspapers include references to slavery and numerous advertisements for runaways, many with engraved vignettes. See Fig.16 (p.58).

MGS/43–5

215
The Cornwall Chronicle & Jamaica General Advertiser
Montego Bay, Jamaica, February 1785

With references to slaves for sale and notices of rewards for escaped slaves.

MGS/46

216
Kentish Gazette
Canterbury, 27 April, 15 May, 25 May, 19 June, 3 July and 13 July 1792

MGS/47–8

217
Bell's Weekly Messenger
London, 14 July 1811

The back page contains an account of the trial and execution of the Hon. Arthur William Hodge for the murder of his African slave, Prosper.

MGS/49

218
The Royal Gazette
Jamaica, vol.33, no.36, 31 August to 7 September 1811

Contains references to slaves for sale and rewards for escaped slaves etc.. 'Mr Street' handwritten on the front page.

MGS/55

219
Bell's Weekly Messenger
London, 12 September 1813

Contains an account of the high mortality rates among slaves in Charleston as a result of poor conditions.

MGS/50

220
Barbados Mercury and Bridge-Town Gazette
Barbados, 16 June 1818

Includes advertisements offering rewards for runaway slaves.

MGS/51

221
The Tourist, or Sketch Books of the Times
Vol.1, no.1, 26 November; no.3, 3 December 1832

Contains articles: 'Vindication of colonial slavery' and 'Futility of the objections to the immediate abolition of colonial slavery'.

MGS/52

222
The Wisbech Monthly Record
Wisbech, no.44, May 1859

Contains an account of 'The great slave auction in Georgia'.

MGS/53

223
The Edinburgh Evening Courant
Edinburgh, 7 October 1862

Contains President Abraham Lincoln's proclamation on the emancipation of slaves, with annotations in ink throughout.

MGS/54

Broadsides and Posters

224
Advertising bill
Printed by Hurst, Wakefield, 1830
Letterpress, 445 × 560 mm

Letterpress poster advertising a meeting for the abolition of colonial slavery. The meeting was to be held in Wakefield (Yorkshire) on 4 November 1830. The poster provides a list of Wakefield's leading abolitionists. Rallies held in support of the abolition campaign frequently attracted very large crowds. See Fig.20 (p.71).

ZBA2508 / E9124

225

The humble petition of the West India planters to the people of England with every Englishman's answer
Printed and sold by B. White, Reading, c.1830
Letterpress, 115 × 165 mm

This abolitionist poem uses the voice of the planters to detail the terrible conditions on Caribbean sugar plantations and their various justifications for the continuation of colonial slavery. It concludes with an appeal to the buy West Indian sugar. This is followed by 'Every Englishman's answer': 'Go, and loosen the captives! No longer will I/ Spend a farthing, thou human-flesh-monger, with the[e]/ For the sake of a penny, I never will buy/ E'en an ounce of thy sugar, *till Negroes are free*'.

ZBA2709

226

Persecution and slavery
B. White, Reading, c.1830
Letterpress, 115 × 165 mm

Abolitionist leaflet sold by B. White, Broad Street, Reading. The leaflet seeks to persuade the reader to stop the purchase of slave-grown sugar by describing the treatment of slaves. It was hoped that sugar boycotts would create an economic imperative for the abolition of colonial slavery.

ZBA2658

227

The Negroes' vigil!
Printed by Z.T. Purday, London, 1834
Broadside, 206 × 92 mm

A poem 'written expressly for the 1st August 1834' by James Montgomery (1771–1854) and set to music by John Valentine. The broadside has a small vignette of a kneeling slave in chains; profits from its sale were 'given in aid of Missionary Societies'.

Montgomery was a prolific poet and hymn writer. His missionary parents moved from Scotland to Barbados in 1783. He wrote a number of abolitionist poems, including *The West Indies* (1809). See Fig.49 (p.142).

ZBA2572 / F0707

228

Slave market of America
American Anti-Slavery Society, New York, 1836
Letterpress broadside with nine wood-engraved vignettes, 710 × 540 mm

The text quotes scripture, the American Declaration of Independence, the Constitution and various public documents to bring attention to the injustice of using publicly funded jails in the Washington area as depots for private slave traders.

ZBA2551

229

A man of colour, and a native of Jamaica
February 1843
Letterpress broadside with wood-engraved vignette, 345 × 240 mm

This broadside tells the life story of Samuel Sharpe, which he sold to fund his passage to Jamaica. It includes graphic detail of his experiences as a slave and his conversion to Christianity.

ZBA2712 / F5771

230

Slave sale poster
c.1850
Letterpress, 520 × 340 mm

This poster lists the buildings and slaves included in the sale. An inscription on the reverse reads: 'An original 'announcement' of a sale of slaves in the West. Given to me by a gentleman (Mr Bray) returned from a tour in North America. Gilbert P. Gamou, Lancaster 1894.'

ZBA2726

231

Land and Negroes for sale!!
Jackson, probably South Carolina, 16 May 1855
Letterpress, 450 × 300 mm

A poster advertising the sale of four tracts of land as a result of a court case. Four slaves are also listed: Frederick aged about 50, Susan aged 25, Wesley aged 10 and Elijah aged 16. See Fig.5 (p.26).

ZBA2707 / F0726

232

Reward poster
Missouri, 12 March 1858
Letterpress broadside, 270 × 237 mm

Printer's proof of a reward poster for a runaway slave with the following inscription: '$00,00/ Reward!/ Ranaway from the subscriber, on the/ 10th inst., a Negro Man named Jack, about/ 35 years of age, about 5 feet 5 inches/ high, weighs 125 or 130 lbs., dark copper/ color, some teeth out before, has an impedi-/ ment in his walk as if he were stiff in the hip/ joint, his clothing consisted of black cloth pan-/ taloons, blue cloth close bodied coat, and black/ over coat, boots and over shoes – boots have/ been lately half-soled; – also a black oil cloth/ satchel. I will give $25 if taken in the coun-/ ty, $50 if taken out of the county, or $100/ if taken out of the State, or lodged in any jail/ that I may get him, or delivered to me in/ Haynesville, Clinton County, Missouri./ Taylor Hulen./ March 12, 1858.'

ZBA2549

☞ Ladies and Gentlemen, in soliciting your consideration, the man leaving this paper, is

A MAN OF COLOUR, AND A NATIVE OF JAMAICA,

and having since his arrival in this Christian Country received the blessings of Education, he purposes on his arrival in his native Country to become a Teacher, and instruct the poor who still remain in a sad state of Ignorance, and having no other means of raising the sum required for my passage &c., saving by the sale of the Narrative of my Life, which is the price of ONE PENNY, or what you may please to give will be thankfully acknowledged with heartfelt gratitude,

By your most Obedient & humble Servant,
SAMUEL SHARPE

A LETTER OF RECOMMENDATION.

This is to certify that the bearer of this letter (SAMUEL SHARPE, a man of colour, a native of Jamaica,) having no friend in this country is desirous of returning to Jamaica, and is under the necessity of offering the Narrative of his Life for sale, in order to defray the expenses of his passage,

I confidently recommend him as a man of sober habits, and moral principles, and firmly believe that he is a pious Christian, and I trust he may meet with that sympathy which as a stranger he so much requires, and so well deserves.

REV. GEORGE UPPLEBY.

Near Market Lane, Barton, Lincolnshire.

THE LIFE OF SAMUEL SHARPE, (A Person of colour,) WRITTEN BY HIMSELF.

I am a native of Kingston in Jamaica, born in the year 1808, in a state of slavery, not having the privilege of being blessed with Christian parents, but those who paid their devotion to Gods of their own invention, viz, wood & stone. The manner in which I was brought to the knowledge of the Truth.—-I went to hear a Christian minister from this country (one Sunday) of the name of Whitehouse, and for which crime (as my master considered it) he sentenced me to receive 39 lashes ; I went a second and third time and the punishment was repeated ; I yet put my trust in God, and continued going ti l my Master found that he could not prevent me from attending divine worship, I was therefore taken to a public market and sold to Mr. Barratt, of the Oxford Estate. It appeared as if providence had interposed on my behalf, for I found in Mr. Barrat a kind friend and a true Christian, he allowed me to attend divine worship regularly, and gave me the opportunity of purchasing my freedom by working extra hours. I then left Jamaica with an intention to come to England, but went to Charles Town, in the south States of America, and by going into company and drinking with Slave buyers I was again taken fifty miles up the country and sold for a slave. The master to whom I was sold, was a cruel one, which caused me to make my escape on board a British vessel, the officers came on board to see if there were any slaves who had absconded, and they found me in the ship's hold, which caused me to receive 50 lashes, 30 pounds weight of Iron on my body, with an iron hoop round my neck, with points upward, and then turned into the fields to work. While I was considering to myself whether there was a probability of my ever being free again, the overlooker came and inflicted a blow on my back, which caused me to receive a dreadful wound in the neck by the points of the ring which I had on me for punishment, I was then taken into the Negro's Hospital, and as soon as I had recovered myself I walked ten miles, and swam across a lake, a distance of five miles, depending upon that God who was able to save from the perils of the water and lived in the woods in the day time, eating wild fruit of the country, & by travelling at night I came to a little sea-port, and entered on board a Dutch vessel, and sailed to Hamburgh, in Germany : the captain of the vessel behaved very kind to me. I went afterwards on board of an American ship, and went to Havannah, in the Island of Cuba, & Havannah was a slave country

and one of her Maje-ty's ships, a sloop of war, came into port, and I went on board for three years, which proved a most providential engagement, there being a Christian minister on board, and prayer offered to the Most High, regularly, and the Sabbath revered by the crew attending divine service three times every Lord's day. There was many who belonged to the ship that received punishment for drinking intoxicating liquors to excess, which caused me to come to the resolution of abstaining from intoxicating liquors altogether.

I received my discharge at Portsmouth, and then took shipping and went to the United States of America, feeling an inward belief of the presence of God being with me wherever I went ; from thence I went to my own country, & lived a short time with my father & mother & afterwards by the strength of God I joined the Wesleyan denomination in Jamaica. After coming to this country, I have met with great trials and difficulty ; but from the Scriptures I learn that God's children are to meet with trials and difficulties in the present state, and like Paul I rely on the sentiment of his knowing, the trials and afflictions of the present time are not to be compared with " the joy that shall be revealed," & awaits the people of God in another world where there is no sin or sorrow, and where " all tears shall be wiped from their eyes " by having no trade that I can work at in this country, I am compelled to dispose of these few outlines of my life, towards enabling me to return to my native country. Therefore I will conclude with the remark of our blessed Saviour, "That he who gives a cup of cold water in the name of a disciple, shall in no wise lose his reward.

SEASONABLE WARNINGS

TO THE UNPREPARED.

Are you unprepared ! Is it possible ! Unprepared at this period, when a new form of disease has reached us, and may very soon commence its fatal ravages in our own houses ! Unprepared to come into the presence of your Maker and your Judge ! Unprepared to stand before the great white throne, to answer for yourself, before the " Searcher of hearts," and to hear the sentence, " Come, ye blessed of my Father, inherit the kingdom ! " which shall thrill the souls of the righteous with immortal joy : or " Depart ye cursed, into everlasting fire ! " which shall pierce the wicked with unutterable terror and despair. I think not you will repent to-morrow . " Now is the accepted time, this is the day of salvation. If to-day is deemed too soon, to-morrow may be too late. To-morrow you may be in eternity " Thou fool ! this night thy soul shall be required of thee," was the summons to one who counted on years of life and enjoyment. Do you feel

some feeble conviction of the danger of your state ? Do you feel disposed to cry, " What shall I do to be saved ? The reply of the Divine word " Believe in the Lord Jesus Christ, and thou shalt be saved ! " Hasten, then, to the mercy seat of Christ.

TO THE PREPARED.

Happy thrice happy are you ! In this life you have a happiness that the world knows not of, a joy and peace in believing, for which no earthly pleasure can form an equivalent. Happy, for you are in the charge of the " good Shepherd," and " none can pluck you out of his hand." Happy, for your house is built upon a rock," and it shall not fall when the wind blows and the rain beats upon it. Happy, for nothing can "separate you from the love of God, which is in Christ Jesus our Lord, neither death nor life, neither things present nor things to come " Happy, for when flesh and heart fail, God shall be the strength of your heart, and your portion for ever." If the pestilence should attack us, then let us see what christian faith can do for its subjects. Let the christian set an example of calm courage, of mild resignation, of active self denying benevolence ; and having shown to others how a christian should live, teach them also how a christian can die. In our dying hour and at the day of judgment, we shall never think we have done too much for Christ and for the souls of men.

LINES.

See a stranger come to view,
Tho' he's black, he's comely too ;
Come to join the choirs above,
Singing of redeeming love.

Welcome, Negro, welcome here,
Banish doubt and banish fear,
You, who Christ's salvation prove,
Praise and bless redeeming love.

HYMN.—-Mark 1. 37.

Would you find the Saviour
Seek him while 'tis day ;
Would you have his favour ?
Take it while you may ;
Seek him in the manger,
Lowly, meek, and mild—-
What should make a stranger
Of a simple child ?

Seek him in lonely places,
In the crowded press
Seek him in all traces,
Of his sore distress
In each dark temptation,
When the storms abound—-
Him and his salvation,
Seek and he is found.

Seek where seraph legions,
Loud thanksgivings roll ;
Seek him in fallen regions
Throned in the soul ;
In air, earth, and ocean,
In each sight and sound,
In earth's last commotion—-
Seek and He is found.

ONE PENNY,
Or what you please to give.

"Remember the poor and needy."

T. Watts, Printer, 14, Snow Hill, Birmingham.

Cat.229

233
Reward poster
Missouri, 5 October 1858
Letterpress broadside, 193 × 242 mm

Printer's proof with manuscript corrections. The text is as follows: '$100.00 reward/ Ran away from A.M. Creek liv-/ ing in Clinton County, two miles east of Platts-/ burg, boy from 25 to 28 years old, 5 feet 10/ or 11 inches high, weighs 160 or 170 pounds/ named Raph, he is a bright mulatto, had on/ when he left an old plush cap, brown Janes/ pants, and home made boots, nearly new. I/ will give 25 dollars if taken in Clay County,/ or 50 out of the county or in the State, or the/ above reward if taken out of the State and de-/ livered, or confined so I can get him./ October 5th 1848.'

ZBA2517

234
Reward poster
Missouri, 3 April 1860

Letterpress broadside, 320 × 240 mm
A printer's proof with manuscript corrections offering a reward for the return of a runaway slave belonging to Robert Thomson: 'ranaway from the subscriber . . . 15 miles north of Liberty, a negro boy named Sandy . . . whiskers on his chin, quick when spoken to . . .'

ZBA2669

235
The persuasive eloquence of the sunny South
Envelope printed by King & Baird, Philadelphia, c.1860
Wood engraving vignette with letterpress, 86 × 145 mm

ZBA2653

236
John Brown
Envelope printed by Stimson & Co., New York, c.1860
Wood engraving vignette with letterpress, 86 × 145 mm

Envelope with image of John Brown and the following caption: 'I die for the inalienable right of mankind to freedom, whatever hue the skin may be.'

ZBA2654

237
The 'peculiar institution'
Envelope printed by Harpel, Cincinnati, Ohio, c.1860
Wood engraving vignette with letterpress, 86 × 145 mm

Envelope with image and the following caption: 'Secession's Moving Foundation. Tendency due North – via 'Monroe''.

ZBA2655

238
Abolitionist cachet
Envelope, c.1860
Wood engraving vignette, 86 × 145 mm

ZBA2656

The Graphic and *The Illustrated London News* extensively covered the issues of slavery and the suppression of the transatlantic and Indian Ocean slave trades. Both journals increasingly used photography as a basis for their engravings, which provided powerful depictions of the horrors associated with the East African trade in particular. The selection below, which forms part of the Michael Graham-Stewart collection, consists of illustrations and cuttings representative of the rich source provided by the Victorian pictorial press.

From the pages of *The Graphic*

239
The slavery question in Eastern Africa – Negroes taken from a captured slave dhow in a state of starvation
8 March 1873
100 × 156 mm

ZBA2574

240
Slave-dealers and slaves – a street scene in Zanzibar
3 May 1873
150 × 225 mm

ZBA2569

241
An Arab slave ship in the Red sea, with British cruiser in sight
H. Harrell, 25 April 1874
162 × 225 mm

ZBA2568

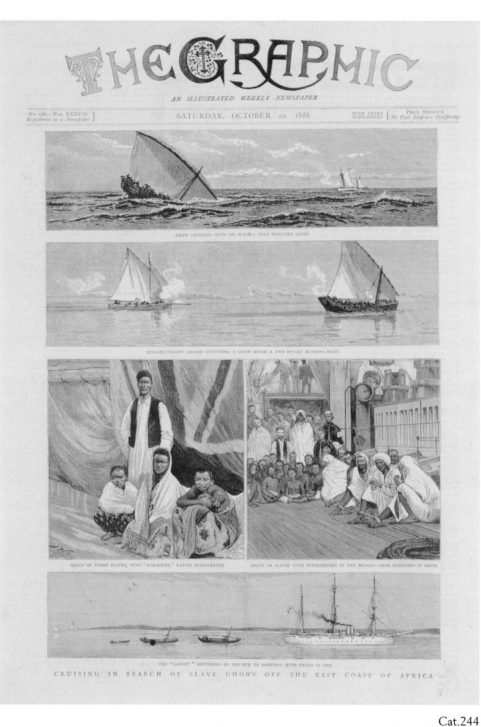

THE GRAPHIC

AN ILLUSTRATED WEEKLY NEWSPAPER

No. 986.—Vol. XXXVIII. *Registered as a Newspaper* | SATURDAY, OCTOBER 20, 1888 | WITH EXTRA SUPPLEMENT | PRICE SIXPENCE *By Post Sixpence Halfpenny*

DHOW CAPSIZING WITH 100 SLAVES; ONLY EIGHTEEN SAVED

SUB-LIEUTENANT PALMER CAPTURING A DHOW AFTER A TWO HOURS' RUNNING FIGHT

GROUP OF THREE SLAVES, WITH "KORROCHE," NATIVE INTERPRETER

GROUP OF SLAVES WITH INTERPRETERS IN THE MIDDLE—ARAB PRISONERS IN IRONS

THE "GARNET" RETURNING IN TRIUMPH TO ZANZIBAR WITH PRIZES IN TOW

CRUISING IN SEARCH OF SLAVE DHOWS OFF THE EAST COAST OF AFRICA

Cat.244

242
The African slave-trade – slaves taken from a dhow captured by HMS Undine
7 June 1884
138 × 225 mm

ZBA2570

243
A slave raid in Central Africa
Harry Johnston (1858–1927), 29 September 1888
301 × 499 mm

ZBA2589

244
Cruising in search of slave dhows off the coast of Africa
20 October 1888
405 × 290 mm

Consists of a series of images relating to the capture of slave dhows by HMS *Garnet*.

ZBA2590 / F0729

245
The history of a slave
Harry Johnston, 13 April 1889
403 × 270 mm

Consists of six monogrammed engravings by Johnston.

ZBA2663

246
A dhow episode: the capture of a slaver off the East Coast of Africa, and the matrimonial agency which settled the freed slaves in life
J.N., 10 June 1893
397 × 584 mm

This is a rare depiction of chattel slaves after their release, and comprises ten images with the following captions: 1. 'One day, at dusk, a mysterious personage came silently on board HMS *Catcher*'; 2. 'The succeeding evening we left, and at dawn met a dhow rounding the point'; 3. 'We overhauled the dhow, took out the slaves, and away she flew'; 4. 'And the cutter, with her cargo of women and children, pulled back to the ship'; 5. 'Meanwhile the slavers look in vain across the sea for the expected dhow and her cargo'; 6. 'For the fact was that the captain of the dhow, finding the owners were not playing fair with him, had planned this little game of his own on shore'; 7. 'The slaves are taken on shore, and on the Black Battalion being told that those who desire to select wives are to take two steps forward, the whole line advances as one man';

8. 'A matrimonial agency: none but the brave deserve the fair'; 9. 'The 'Drippies' (Egyptian soldiers) are not forgotten: they get a few wives, but not the most youthful or lovely'; 10. 'One of the boys is kept on board and christened 'Corney O'Dhow, Esq.''

ZBA2666

247
The capture of Mlozi's stockade
Harry Johnston, 25 April 1896
395 × 277 mm

Article detailing the capture of Mlozi's stockade, with two illustrations: 'The breach made in Mlozi's stockade' and 'Slaves found in Mlozi's town after its capture'. Mlozi led a band of Arab slave traders operating in the Great Lakes area of Central Africa. Johnston was the British consul in the region and was heavily involved in the suppression of the slave trade.

ZBA2664

From the pages of
The Illustrated London News

248
Slave sale, Charleston, South Carolina
after Eyre Crowe (1824–1910),
29 November 1856
281 × 403 mm

ZBA2650

249
Capture of a slaver
20 June 1857
405 × 280 mm

ZBA2665

250
A slave auction in Virginia
16 February 1861
277 × 407 mm

A two-page article with illustrations: 'The principal church in Charleston, S.C.' and 'Dealers inspecting a Negro at slave auction in Virginia'.

ZBA2649

251
The cutter [of] HMS Daphne *capturing a slave dhow off Bora*
27 February 1869
397 × 267 mm

ZBA2668

252
Vessels used in the Zanzibar slave trade
1 March 1873
404 × 271 mm

Article including five illustrations entitled (from top left): 'Badane of the Arabian Coast'; 'Matapa boat of the Northern Rivers'; 'Bateele, or Muscat Arab vessel'; 'Bugala, or dhow' and 'Section of vessel, showing the manner of stowing slaves on board'.

ZBA2661

253
The East African slave trade: destruction of a dhow
16 August 1873
188 × 294 mm

ZBA2576

254
Slave gang passing along the edge of the Lushivi marsh
15 April 1876
401 × 262 mm

ZBA2667

255
The East African slave trade: examination of captured slaves in

the British Consul-General's court at Zanzibar
W.H.O., 17 December 1881
132 × 228 mm

ZBA2578

256
Zebehr, slavery and the Soudan
after Charles Auguste Loye (Montbard) (1841–1905), 10 May 1884
398 × 284 mm

Article on the front page including two engraved portraits of 'The Mahdi' and 'Zebher Pasha', both after Montbard and taken from a portrait lent by Egmont Hake. On the reverse is an engraving titled 'Convoy of Slaves in the Soudan'. Alfred Egmont Hake (1849–1916) was the biographer of General Charles Gordon (1833–85), who was killed defending Khartoum against the forces of the Mahdi.

ZBA2662

257
The East African slave trade: rescued female slaves and children questioned on board a British ship of war
W.H.O., 23 February 1889
152 × 233 mm

ZBA2567

258
A slave gang in Zanzibar
W.A. Churchill, 16 March 1889
152 × 234 mm

ZBA2566

259
The slave trade in Egypt: Negresses from Siwah
Photograph, 26 September 1894
116 × 157 mm

ZBA2659

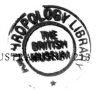

Cat.260

OIL PAINTINGS

There are more than 4500 oil paintings in the National Maritime Museum's collection. A large number have some connection with the broader history of slavery and abolition either as paintings of particular naval battles in the Caribbean, for example, or as portraits of officers who served on the West Indies station. The selection here, however, consists of paintings of slave ships and of naval actions connected with the suppression of the slave trade; portraits of Africans in Britain and of individuals connected with slavery and abolition.

The Luxborough Galley *series*

The Luxborough Galley, captained by William Kellaway, carried slaves for the South Sea Company. The ship left Britain in October 1725 on the first leg of the voyage, reaching Cabinda, West Africa, three months later. Captain Kellaway exchanged his cargo of Indian cottons and trade goods for 600 slaves 'without any material occurrence, except that he with some other commanders, narrowly escaped death from the resentment of the natives, for an affront given by a white man to a relation of the king'. An outbreak of smallpox killed 203 Africans and eight of the crew during the Middle Passage from Africa to the Caribbean. The ship arrived in Jamaica in October 1726. After selling the slaves, the Luxborough Galley sailed for home in May 1727, laden with 90 hogsheads of sugar and rum, and 80 tons of other goods. On 25 June 1727 the ship caught fire and sank. Kellaway and his crew were then set adrift in a small,

open boat (or yawl) in the mid-Atlantic for nearly two weeks with almost no provisions before being rescued by fishermen off the coast of Newfoundland on 7 July. The survivors resorted to cannibalism, drinking the blood of those who died at sea in order to stay alive. Kellaway endured the ordeal in the boat but died the day after he reached shore. This series of paintings by John Cleveley the Elder (c.1712–77) follows the fate of the crew from the time they abandon the ship for the small boat until their rescue by Newfoundland fishermen. The six paintings (of which another set is known) were presented in 1781 to the Royal Hospital for Seamen at Greenwich, whose Lieutenant-Governor, Captain William Boys, was one of the survivors. For the rest of his life Boys kept the dates of 25 June to 7 July as a period of fasting and prayer in thanks for his deliverance. The paintings remain in the Greenwich Hospital Collection.

260
The Luxborough Galley *on fire, 25 June 1727*
John Cleveley the Elder (*c*.1712–77)
Oil on canvas, 495 × 648 mm

BHC2389 / BHC2389

261
The Luxborough Galley *burnt nearly to the water, 25 June 1727*
John Cleveley the Elder
Oil on canvas, 495 × 648 mm

BHC2388 / BHC2388

262
The Luxborough Galley *burnt right down*
John Cleveley the Elder
Oil on canvas, 495 × 648 mm

BHC2386 / BHC2386

263
Escape from the Luxborough Galley
John Cleveley the Elder
Oil on canvas, 495 × 648 mm

BHC2387 / BHC2387

Cat.261

Cat.262

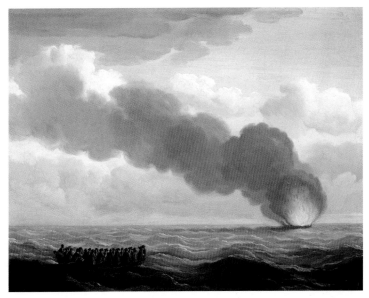

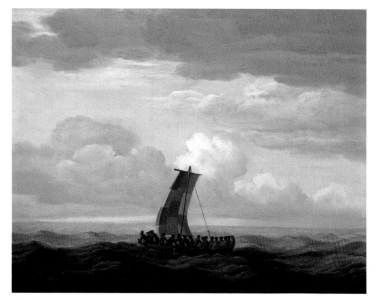

Cat.263

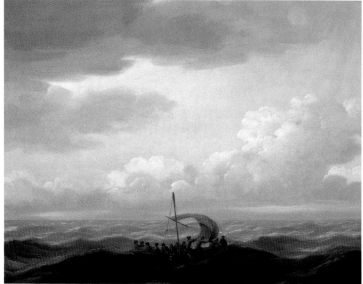

Cat.264

Cat.265

264

The yawl of the Luxborough Galley

John Cleveley the Elder

Oil on canvas, 495 × 648 mm

BHC2385 / BHC2385

265

The yawl of the Luxborough Galley *arriving in Newfoundland, 7 July 1727*

John Cleveley the Elder

Oil on canvas, 495 × 648 mm

BHC2391 / BHC2391

266

The capture of the slaver Gabriel *by HMS* Acorn, *6 July 1841*

Nicholas Matthew Condy the Younger (1818–51)

305 × 406 mm

BHC0628

267

Captain Lord George Graham in his cabin

William Hogarth (1697–1764), *c.*1745

Oil on canvas, 685 × 889 mm

Captain Graham (1715–47) is shown at dinner with his civilian secretary/companion in his cabin. The singer between them is accompanied by a fashionable 'blackamore' servant playing a fife and drum. Hogarth's dog, Trump, apes the captain's official state, wearing his wig, on the right.

BHC2720 / BHC2720

Cat.267

268

The capture of the slaver Formidable *by HMS* Buzzard, *17 December 1834*
William John Huggins (1781–1845)
Oil on canvas on panel, 381 × 546 mm

BHC0625

269

HMS Pearl *capturing the slaver* Opposicao, *1838*
William Adolphus Knell (1801–75), dated 1840
Oil on canvas laid down on board, 308 × 410 × 11 mm

BHC0627

270

Admiral Sir William Penn
Sir Peter Lely (1618–80)
Oil on canvas, 1270 × 1015 mm

Sir William Penn (c.1621–70), the naval commander in the capture of Jamaica from Spain in 1655. The portrait is part of Lely's 'Flagmen of Lowestoft' series.

BHC2946 Greenwich Hospital Collection

271

The ship Castor *and other vessels in a choppy sea*
Thomas Luny (c.1759–1837), 1802
Oil on canvas, 822 × 1263 mm

This painting shows a line of merchant ships with a coastline in the distance. They were engaged in transatlantic trade and it is probably the coast of New England that is shown on the horizon. The *Castor*, 18 guns, traded to Philadelphia, the West Indies and New York. It was in service for seven years, commanded by Daniel Brocklebank, after which time it was sold.

BHC3251

272

The capture of the slaver Boladora, *6 June 1829*
John Moore (1820–1902)
Oil on panel, 231 × 291 mm

HM schooner *Pickle*, under the command of Lieutenant I.B.B. McHardy, was attached to the Jamaica station between 1826 and 1830. Although out-gunned, the crew of the *Pickle* captured the *Boladora* (or *Voladora*) off the north coast of Cuba in June 1829 after a particularly violent engagement. Slaves rescued by British forces in the Atlantic or Caribbean frequently had to endure a return journey to Sierra Leone in West Africa before being granted freedom. Moore's oil painting is based on William John Huggins' aquatint of 1831 (Cat.594). See Fig.32 (p.107).

BHC0624 / BHC0624

273

The United Service
Andrew Morton (1802–45), 1845
Oil on canvas, 1168 × 1473 mm

Exhibited at the Royal Academy in 1845, Morton's oil painting is an interpretation of a meeting of Greenwich pensioners in blue coats and their Chelsea counterparts in red in the Painted Hall at Greenwich, at that time used as the Naval Gallery of Greenwich Hospital. All nine of the Greenwich pensioners shown in the central composition served with Horatio Nelson. Second from the right, leaning on a chair and wearing a red hat, is the veteran black sailor John Deman, who was with him in the West Indies early in his career.

BHC1159

274

Admiral George Brydges Rodney, 1st Baron Rodney
Jean-Laurent Mosnier (1743–1808), dated 1791
Oil on canvas, 1270 × 1015 mm

George Brydges Rodney (1719–92) had a long naval career, becoming a rear admiral in 1759. In 1761 he was appointed Commander-in-Chief in the Leeward Islands and was victorious over the French, taking Martinique, St Lucia, Grenada and St Vincent. In 1779, Rodney was ordered to relieve Gibraltar on his outward voyage to command in the Leeward Islands for a second time. During the voyage he encountered a Spanish squadron of nine ships off Cape St Vincent and, in the ensuing night action, one Spanish vessel blew up and six were captured. Following his success, Rodney continued to carry out an effective campaign against powerful French opposition. This culminated in the Battle of the Saints, 1782, when his victory over the Count de Grasse's fleet destroyed French naval power in the West Indies. Victory ensured the security of the British sugar islands, which might otherwise have been lost to the French. He is shown in admiral's full-dress uniform, wearing the ribbon and star of the Order of the Bath.

BHC2970 / BHC2970

275

View of Port Royal, Jamaica
Richard Paton (1716/17–91), c.1758
Oil on canvas, 635 × 1219 mm

Paton adopts an aerial perspective for his view of Port Royal, Jamaica in 1758, showing merchantmen and other vessels in the approaches. As a wealthy sugar island, Jamaica was a very valuable British colony and a major destination for slave ships. In the early years of the eighteenth century,

Cat.274

Port Royal was a notorious den of iniquity for pirates and brigands of all kinds. It was devastated by an earthquake in 1692, but subsequently rebuilt as Britain's principal naval and mercantile port in the Caribbean.

BHC1841 / BHC1841

276
Admiral Sir Charles Middleton, 1st Baron Barham
after Isaac Pocock (1783–1835)
Oil on canvas on board, 755 × 632 mm

Admiral Charles Middleton (1726–1813) was noted as a skilled, though domineering, administrator and one of the navy's leading evangelical Christians. Born in Bo'ness in Scotland, he joined the Royal Navy and served in the Caribbean during the Seven Years War (1756–63). He rose to become

Comptroller of the Navy in 1778–90, and was briefly First Lord of the Admiralty in 1805–6 at the time of Trafalgar. Middleton had long been in favour of abolition and corresponded with William Wilberforce (Cat.134).

BHC2529

277
The Ann *off Birkenhead*
Robert Salmon (1775–c.1845), c.1810
Oil on canvas, 851 × 1359 mm

This painting shows the merchant ship *Ann*, flying the 1801-pattern red ensign, probably on its return from a voyage to the West Indies. The ship is shown in three positions, a common convention of ship portraiture: in port-broadside view in the foreground, in stern view on the left and in bow view on the right. In the main

view the figures on deck are preparing to lower the anchor. In the foreground on the right, three figures have lowered the sails on their small fishing craft; the inclusion of such a boat was a typical motif adopted by the artist. The *Ann* was not a slave ship, but a merchant ship that carried plantation stores and supplies to the colonies of the West Indies, and which returned carrying Caribbean produce, like sugar, rum and cotton, to Liverpool for sale to the British market.

BHC3196 / BHC3196

278
Shipping off Amsterdam
Abraham Storck (1644–1708)
Oil on canvas, 528 × 668 mm

A scene showing shipping near Amsterdam. A flagship and Dutch West India Company

barge are shown in the centre of the picture. The stern of the barge shows the carved figure of a saint together with accompanying attributes. It is flying the flags and pennants of the company.

BHC0924

279
Billy Waters
Attributed to Sir David Wilkie (1785–1841), *c.*1815
Oil on panel, 274 × 212 mm

Bill Waters (*c.*1778–1823) was born in America during the War of Independence. He was a sailor and lost his right leg as a result of falling from the topsail yard of the *Ganymede*. Unable to serve at sea, he became a famous London street entertainer and was often to be seen busking with his fiddle to support his family. Waters featured in Pierce Egan's *Life in London* (1820–1) and was one of the characters illustrated by George Cruikshank. Indeed, Waters appeared in several Cruikshank cartoons, including *The New Union Club* (Cat.537). When Egan's book was adapted into a play and performed at the Adelphi Theatre, Waters – who had been busking outside – was invited on stage to play himself. He repeated the performance at the Caledonian Theatre in Edinburgh. Waters ended his days in St Giles's Workhouse, having fallen ill and been forced to pawn his fiddle. He was elected 'king of the beggars' shortly before his death. See Fig.25 (p.95).

ZBA2427 / F5915

280
The wedding
American school, second half 19th century
Oil on canvas, 290 × 440 mm

A humorous depiction of a wedding. Two identically dressed black brides, possibly twin sisters, and their grooms – one tall and thin, the other short and stout – stand before the preacher with a small congregation to the right.

ZBA2437

Painting undergoing restoration Cat.277

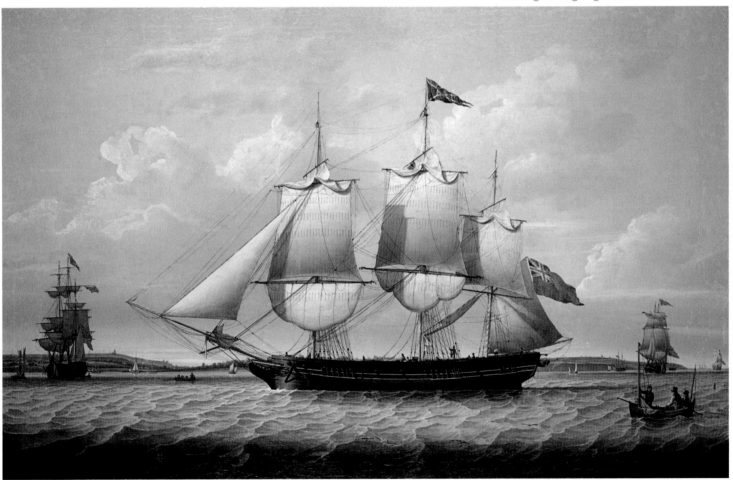

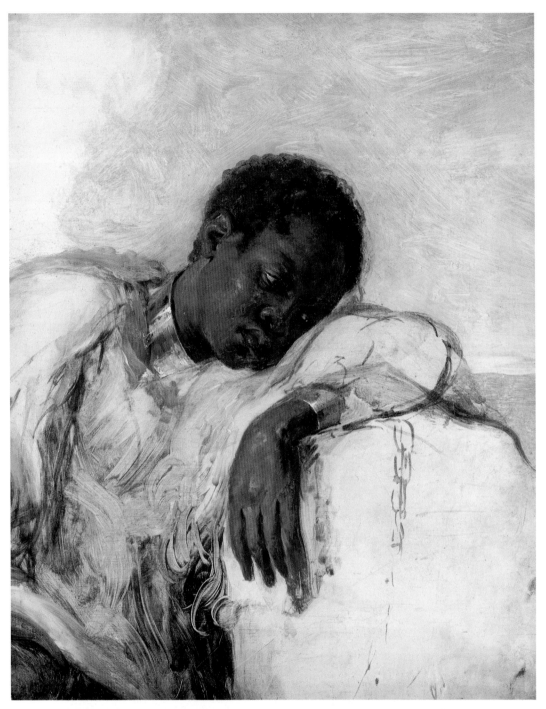

Cat.281

281
Slave in chains
British school, *c.*1820
Oil on board, 277 × 222 mm

This affecting portrait of an enslaved African by an unknown artist conveys some of the misery and desolation of capture and enforced transportation to the Americas.

ZBA2428 / E9148

282
Sir John Hawkins
English school, 16th century, dated 1581
Oil on panel, 622 × 521 mm

John Hawkins (1532–95) was the first English slave trader and a highly successful merchant in other areas of maritime commerce. He made four voyages to Sierra Leone between 1564 and 1569, taking a total of 1200 Africans across the Atlantic to sell to the Spanish settlers in the Caribbean island of Hispaniola. On his first voyage he described capturing 300 Africans 'by the sword and partly by other means'. In the Caribbean he sold them to the Spanish for a range of tropical goods, including sugar. In 1567, on his last slaving voyage, in which his younger kinsman Francis Drake accompanied him, all but two of his ships and some treasure were seized by the Spanish in the port of San Juan de Ulloa, Mexico, though he escaped and was later able to recover some of his captured men from Spain. Hawkins died off Puerto Rico while on a naval expedition to the West Indies in 1595–6.

BHC2755 / BHC2755

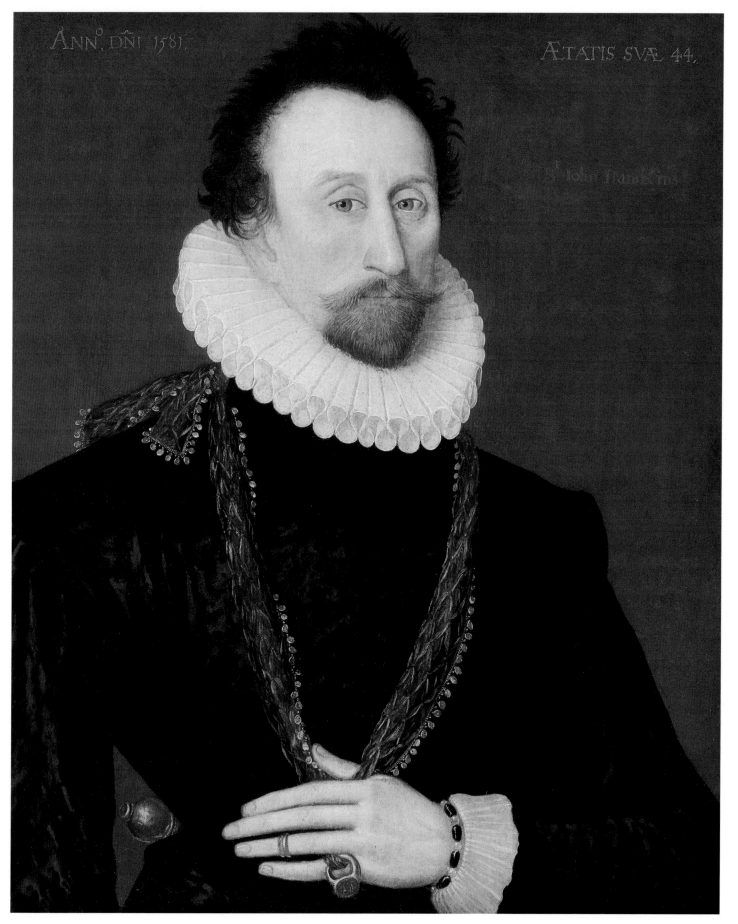

ANN° DÑI 1581. ÆTATIS SVÆ 44.

Cat.282

PHOTOGRAPHS

This remarkable collection of photographs, largely of slavery in Zanzibar, demonstrates the longevity of the Indian Ocean slave trade and its protracted suppression by the Royal Navy.

283
Stereoscopic view of slave market
Lt Col. James Augustus Grant (1827–92), Zanzibar, 1860
Stereoscopic print on non-matt salted paper, 87 × 176 mm

This photograph and the print below came from James Grant's family album, since split up, that contained the first photographs ever taken in this part of East Africa. Grant brought photographic apparatus for his expedition with John Hanning Speke (1827–64) into the interior but he found the equipment too cumbersome to use in the African heat and left it at the coast, having taken a small number of images. There appear to be only two copies of these photographs in existence; Grant sent the other ones to the Royal Geographical Society.

ZBA2601

284
Slaves in Zanzibar marketplace
Lt Col. James Augustus Grant, Zanzibar, 1860
Stereoscopic albumen print, 75 × 153 mm

The Royal Geographical Society copy has further information in Grant's somewhat illegible hand below the image. He states: 'Slave Market-place Zanzibar, very difficult to take. Slaves and Arabs kept running away leaving only a line of women slaves whose legs and a face or two may be observed. The women's entire . . . [?] . . . is a blue cotton

sheet or cloth tied tight under arms and extending as far as the knee. Their heads are cropped as . . . [? close] . . . as scissors can crop them. Very often they have for ornament a hole through the upper lip. At the market they come out very clean.'

ZBA2602

285
Kaffirs watching a missionary counting money
c.1862
Silver gelatin print, 58 × 90 mm

A photograph of six Africans sitting and standing on a carpet watching the missionary and abolitionist Horace Waller (1833–96). It is not clear that Waller is counting money; he may instead be reading from an improving text or demonstrating some useful skill. Waller joined the first Universities' Mission to Central Africa and spent the early 1860s in Nyasaland, where he met David Livingstone (1813–73) and fought against the predations of Yao slave raiders. In 1870, he was elected to the committee of the British and Foreign Anti-Slavery Society.

ZBA2637

286
Slave merchant
Cairo, c.1864
Albumen print in carte-de-visite format, 86 × 55 mm

ZBA2607

287
Seyyid Majid Said, Sultan of Zanzibar
Maull & Co., London, c.1865
Albumen print in carte-de-visite format, 88 × 59 mm

Majid's reign (1856–70) saw the first serious attempts by Zanzibar to dominate the East

African mainland of modern-day Tanzania, which was exploited for ivory and the supply of enslaved Africans. Zanzibar was the main port for the export of slaves to Arabia and the Gulf. African slave labour was also used on the island's many clove plantations. The export of cloves and other tropical produce and African slaves were valuable sources of revenue for the sultanate. Majid was placed under increasing British pressure to abandon Zanzibar's involvement in the East African and Indian Ocean slave trades.

ZBA2625

288
Stanley and Kalulu
London Stereoscopic Co., c.1872
Albumen print in carte de visite format, 89 × 60 mm

The print shows Kalulu standing serving a drink to the African explorer and adventurer Henry Morton Stanley (1841–1904) while he sits cross-legged on the ground. Kalulu (Ndugu M'Hali, c.1864–77) was given to Stanley as an eight-year-old by a slave trader and became his close personal companion until his death. He drowned crossing the Congo River on Stanley's 1874–7 expedition.

ZBA2626

289
Slaves on HMS London
1880
Albumen print, 100 × 140 mm

Shows slaves rescued from Arab dhows on the deck of HMS London, the depot ship at Zanzibar.

ZBA2631

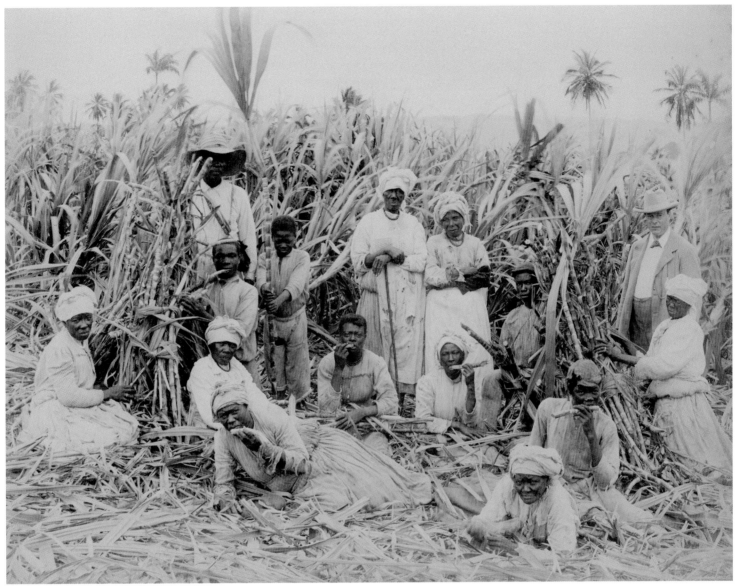

Cat.290

Cane cutters, c.1880

These two photographs (Cats 290–1) show life
in Jamaica in the latter part of the nineteenth
century. The sugar industry, although in decline
in this period, did not end with the emancipation
of slaves in 1838. Instead it continued, with
black people becoming employees rather than
slaves. As these images suggest, however,
emancipation did not bring equality, nor did it

end the rigours of working in the cane fields.
This failure on the part of plantation owners
and the colonial governments significantly to
improve the day-to-day conditions and rights
of ex-slaves and their descendents provoked
resentment, and occasionally rebellion, among
people in the Caribbean.

290
Sugar-cane cutters in Jamaica
c.1880
Albumen print, 175 × 227 mm

ZBA2612 / E9087

291
Jamaica W.I., cane cutters
c.1880
Albumen print, 220 × 175 mm

ZBA2613

292
St John's Church, freed slave estate,
Mbweni, Zanzibar
Zanzibar, *c.*1880
Albumen print, 134 × 198 mm

ZBA2616

293
Cargo of newly released slaves
on board HMS London
*c.*1880
Albumen print, 100 × 150 mm

See Fig.23 (pp 86–7).

ZBA2617 / E9085

294
Zanzibar group of slaves
Zanzibar, *c.*1883
Gelatin collotype print, 101 × 140 mm

ZBA2629

Cat.296

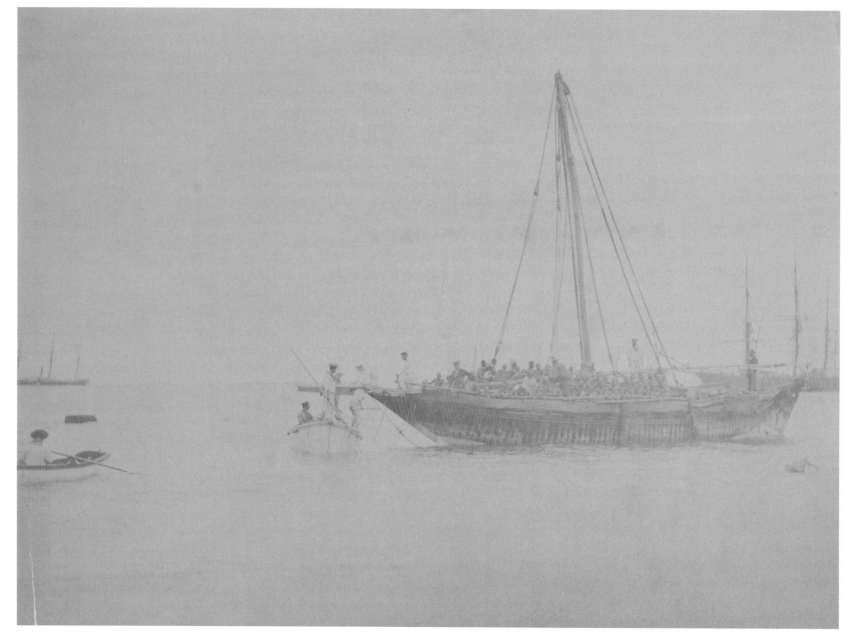

295
Slave-girls, Suakin
1885
Albumen print, 274 × 216 mm

The port of Suakin, on the Red Sea coast of Sudan, exported enslaved Africans to Arabia.

ZBA2634

296
Boarding a slave dhow
*c.*1885
Albumen print, 145 × 200 mm

A rare image of British sailors boarding an Arab dhow during an anti-slavery patrol off the East African coast.

ZBA2608 / F5766

297
Slaves outside a consulate
*c.*1885
Albumen print, 155 × 210 mm

ZBA2609

298
Released slaves
*c.*1885
Albumen print, 240 × 300 mm

ZBA2610

299
Group of slaves aboard ship
*c.*1885
Albumen print, 242 × 300 mm

ZBA2611

300
A slave
*c.*1885
Albumen print, 262 × 205 mm

Photograph of a female slave with a baby strapped to her back.

ZBA2630 / E9089

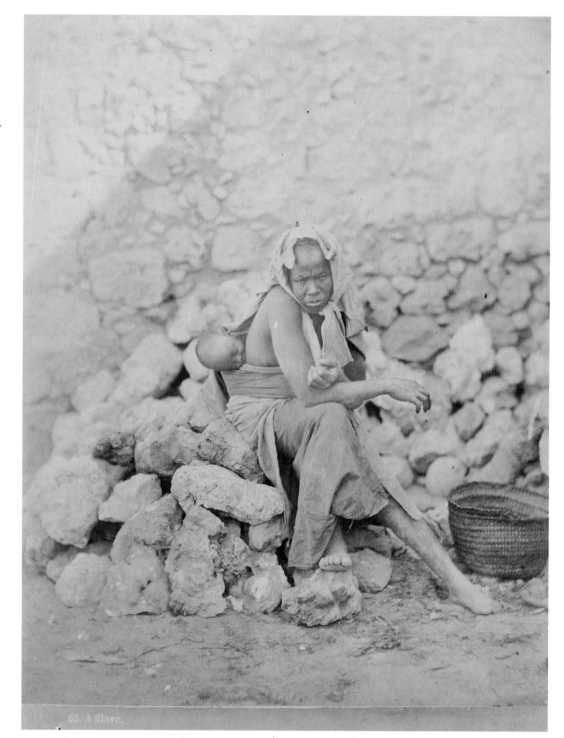

Cat.300

301
Natal cotton field
B.W. Caney, Durban, c.1885
Albumen print, 160 × 102 mm

Shows three workers picking cotton in South Africa. As on sugar plantations, day-to-day conditions for cotton pickers changed little after emancipation.

ZBA2623

302
A group of Zanzibar ladies who coaled the Agamemnon
Zanzibar, c.1888
Albumen print, 190 × 240 mm

A posed group of women and girls, some holding shovels. The print is inscribed 'Agamemnon returned to Malta Nov. 1889'. HMS Agamemnon was employed in a

similar role to that previously fulfilled by HMS London. Its small boats were used for patrolling while it remained at Zanzibar as a depot and supply vessel, as well as a holding station for slaves rescued from dhows prior to their release. It is unknown how many, if any, of those set free in Zanzibar found their way home. Domestic slavery was not abolished in Zanzibar until 1911.

ZBA2620

303
Tippo-Tip
E.C. Dias, Zanzibar, c.1890
Silver gelatin print, 200 × 152 mm

Photograph of Mohammad bin Hamed, or Tippu Tip (c.1830–1905). He was born in Zanzibar and became involved in the lucrative caravan trade in eastern and central Africa. In the 1870s and 1880s, Tippu Tip was the most powerful figure in what is now the Democratic Republic of Congo, having some 50,000 guns at his command. He accrued enormous wealth from slave trading and ivory dealing to clients such as the sultan of Zanzibar, to whom he remained fiercely loyal, and Henry Morton Stanley. Despite his efforts, he was unable to maintain his position around Lake Tanganyika in the face of the European partition and conquest of the region. In the late 1880s, he was briefly appointed governor of Stanley Falls by King Leopold II of the Belgians (1835–1909), whose imperial and commercial activities came to dominate the Congo Basin. Tippu Tip eventually retired to Zanzibar and wrote his autobiography, which became a classic of Swahili literature.

ZBA2600 / F5763

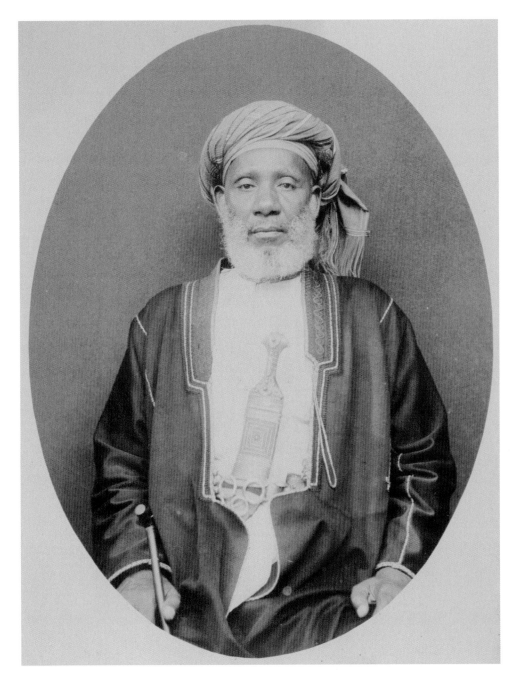

Cat.303

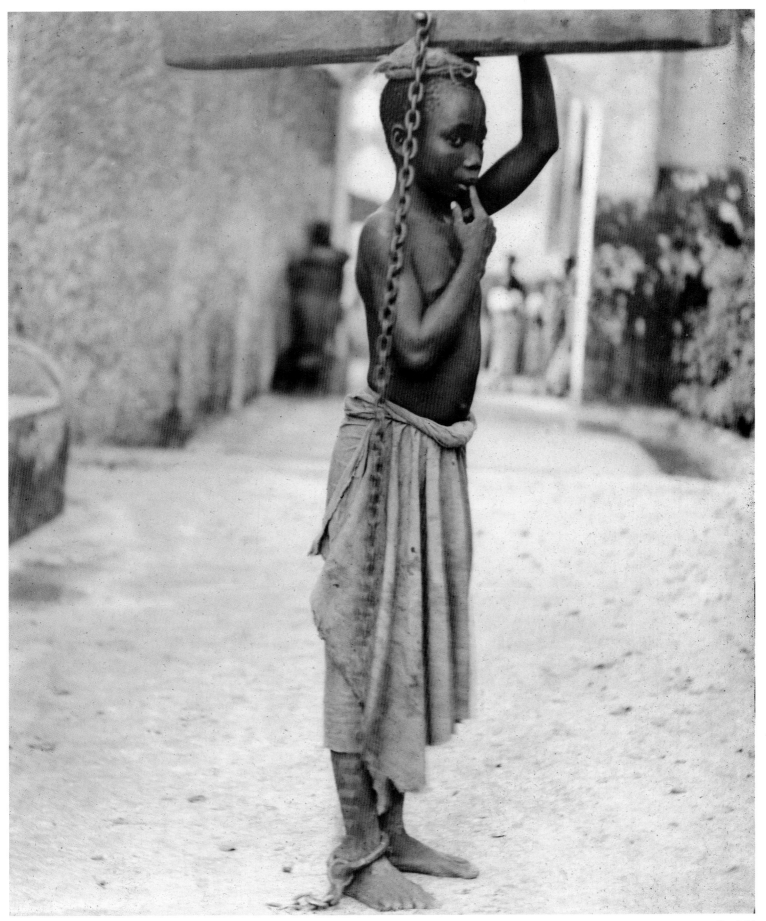

Cat.304

304

Slavery in Zanzibar

Zanzibar, *c*.1890

Silver gelatin glass lantern slide, 83 × 83 mm

This extraordinary lantern slide is inscribed: 'An Arab master's punishment for a slight offence. The log weighed 32 pounds, and the boy could only move by carrying it on his head. An actual photograph taken by one of our missionaries.' From at least the 1860s onwards, photography was a powerful weapon in the abolitionist arsenal. Photographic images of slavery provided vivid and irrefutable evidence of the ongoing cruelty of the East African and Indian Ocean trades. They were often used as the basis for engravings reproduced in popular journals such as *The Graphic* and *The Illustrated London News*.

ZBA2618 / E9093

305

Slave dealers caught in the act

c.1890

Silver gelatin glass lantern slide, 83 × 83 mm

Inscribed: 'They had kidnapped 70 children and were sailing them out of the harbour flying the French flag to deceive our sailors, when they were caught'.

ZBA2619 / E9138

Cat.305

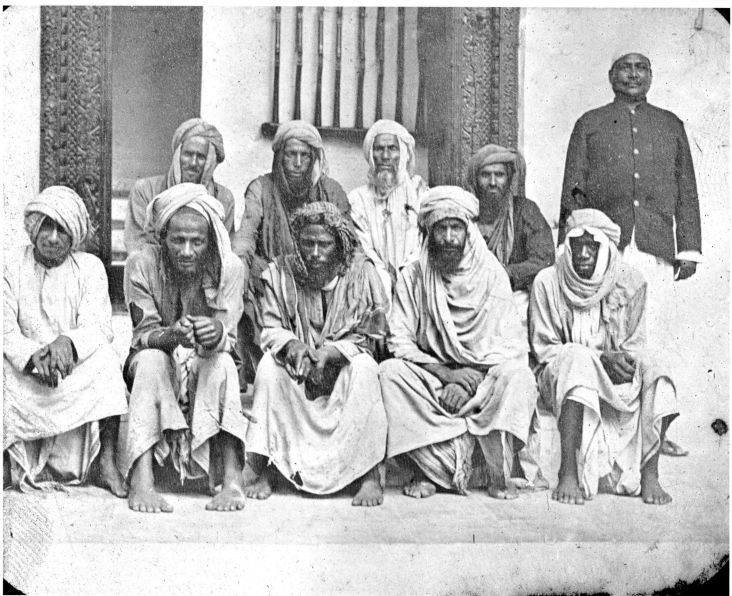

306
Slaves captured from a dhow
*c.*1890
Silver gelatin print, 150 × 205 mm

ZBA2622

307
Slaves released
*c.*1890
Silver gelatin glass lantern slide, 83 × 83 mm

Group of released slaves posed on the deck
of a ship.

ZBA2606

308
A group of slave children
*c.*1890, possibly Aden
Albumen print, 220 × 280 mm

Aden, a British possession in south-west
Arabia, was frequently used as a convenient
location to disembark rescued slaves.

ZBA2603

309
Turkish lady with her slave
*c.*1890
Albumen print, 255 × 195 mm

ZBA2627

310
Slaves captured from a dhow
*c.*1890
Silver gelatin print, 152 × 205 mm

ZBA2628

311
Zanzibar Sklaven kewte
Zanzibar, *c.*1890
Albumen print, 150 × 205 mm

Print showing slaves standing in a row all
chained together, each carrying a basket.

ZBA2624

312
Slaves sifting root of Samoa plant
Zanzibar, *c.*1890
Albumen print, 135 × 202 mm

Inscribed: 'Zanzibar'.

ZBA2633

313
*A capture of slaves made in Zanzibar
in 1892 by HMS S [?]*
Zanzibar, 1892
Silver gelatin print, 146 × 202 mm

ZBA2636

314
Slaves captured from a dhow
*c.*1892
Silver gelatin print, 150 × 205 cm

Shows a large group of rescued slaves sitting
in a doorway.

ZBA2621

315
Slaves rescued by HMS Philomel,
*April 1893, many of the children
received by the Universities' Mission*
Postcard, 1893
Half-tone letterpress, 88 × 140 mm

ZBA2604, ZBA2814 (inscribed: 'July 20th 1904')

316
Slaves, Zanzibar
J. Barnett & Co., Johannesburg, *c.*1895
Silver gelatin print, 140 × 195 mm

Originally from an album of photographs
by Barnett, the image depicts female slaves
posed outside the doorway to a building.

ZBA2605

317
Group of natives, Zanzibar
Ali Piar Harji, Zanzibar, *c.*1900
Hand-tinted gelatin collotype postcard,
90 × 144 mm

Hand-tinted collotype postcard made from a
photograph. It was originally entitled 'Slaves
captured from a dhow'. Large group posed in
grand doorway.

ZBA2615

318
Maid De'ah
*c.*1900
Silver gelatin print, 270 × 215 mm

Photograph of a black maid and a young
white American girl playing with toy bricks.
A note on the back of the print states: 'Maid
De'ah – mother was a slave, she joined the
Musson family aged 14 yrs Miss Gabriel
Frances Musson'.

ZBA2635 / E9084

319
*Showing 33 slaves captured
by the boats of the* Racoon
1901
Albumen print, 195 × 245 mm

Inscribed: 'altogether during the years
1901.2.3.4. Nine craft were captured by our
boats running slaves I have forgotten total
nos. but this was one batch'.

ZBA2632

320
Applewhaites Barbados sugar works
*c.*1906
Mounted albumen print, 153 × 208 mm

'Applewhaites Barbados sugar works – facing
N.E. from lower [. . .]'. Annotated on the
front, 'Taken from here facing N.W.'

MGS/40/21

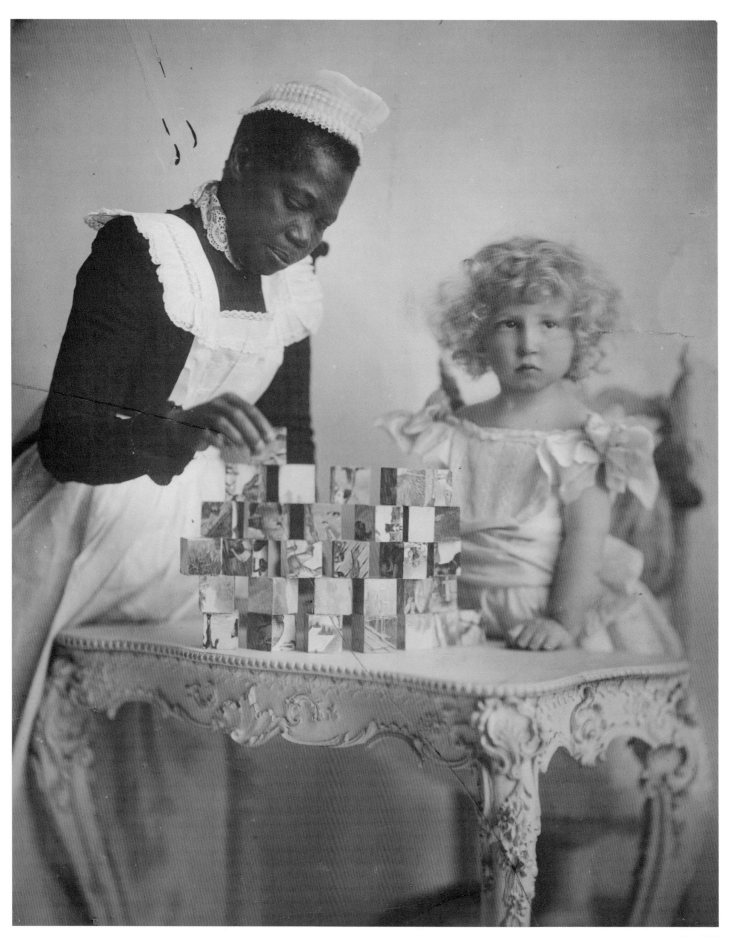

Cat.318

321

Applewhaites Barbados sugar works

*c.*1906

Mounted albumen print, after 1904,
153 × 211 mm

'Applewhaites Barbados sugar works
destroyed by fire April [. . .] 1904 and
restored – from end of [. . .] facing N.W.'
Annotated on the front, 'Taken from here
facing N.W.'

MGS/40/22

322

Applewhaites Barbados sugar works

*c.*1906

Mounted albumen print, 152 × 214 mm

'Applewhaites Barbados sugar works – inside
view of new building'.

MGS/40/23

323

Rescued slave on HMS Sphinx
and freed slaves

Sepia print, 1907, 857 × 112 mm

Two negative images from 1907, one showing
a slave having his chains removed by a British
sailor on board HMS *Sphinx* while on patrol
in the Indian Ocean off the Batinah Coast
(Oman); the other shows a group of six freed
slaves.

P49756CT, P49757CT

PRINTS AND DRAWINGS

For prints the measurement given is the plate size, unless otherwise stated. For all watercolours and drawings the measurements are sheet size. Exact description of various methods used in printmaking can be complex and for practical reasons a few broad conventions have been adopted here. No distinction is made between wood engravings, strictly done on fine end-grained blocks, and woodcuts (the more common sort) done on the side grain, all such items being described under the former general term. Wood engravings are, however, intaglio prints; woodcuts print from the inked, flat surface that remains after the pattern is cut away. Intaglio methods – literally 'cutting-in' with acid-etched line, aquatint, and manual engraving – print from the ink retained in the pattern bitten or cut into the surface of often a metal plate, 'white' resulting from the untouched smooth areas that remain. Such prints usually start with some degree of etching to establish the pattern before manual engraving follows, or can involve further acid work (e.g. aquatint) to add areas of tone or stronger line. Here a broad judgement has been made on the principal, rather than all, methods used and the image described accordingly. Lithographs are not an intaglio process but exploit the antipathy of oil and water. They print from a stone 'plate' bearing the image in a greasy chalk medium: oil-based inks applied to the wetted stone adhere to the marked pattern only and print from it, leaving unmarked areas blank. Most but not all prints here described as 'hand-coloured' are in original publishers' colourings, in watercolour. Some lithographs have tinted base tones and a few are early colour prints (chromolithographs). In both cases the separate elements of tint, colour and line result from separate printings to build up the image.

PRINTS AND DRAWINGS: AFRICA

WEST AFRICA: PEOPLE AND AFRICAN LIFE

324
Voyage of the Dutch to the Gold Coast of Guinea, 1600.
Natives of the Gold Coast
Johannus Theodorus de Bry (1561–1623), 1604
Etching, 137 × 185 mm (image)

Johannus de Bry was the son of the Flemish engraver Johann Theodor de Bry (1528–98). The de Brys published a series of volumes on early European voyages of exploration containing many prints of encounters with the indigenous people of Africa, Asia and the Americas. These depictions provide an insight into late-sixteenth- and early-seventeenth-century European attitudes towards the wider world and its inhabitants.

PAG7537

325
Voyage of the Dutch to the Gold Coast of Guinea, 1600.
The market at Cape Corso
Johannus Theodorus de Bry, 1604
Etching, 305 × 200 mm (image)

PAG7538 / PX7538

326
Voyage of the Dutch to the Gold Coast of Guinea, 1600.
How the Negroes came out in canoes to trade with the Dutch
Johannus Theodorus de Bry, 1604
Etching, 305 × 200 mm (image)

PAG7539 / PX7539

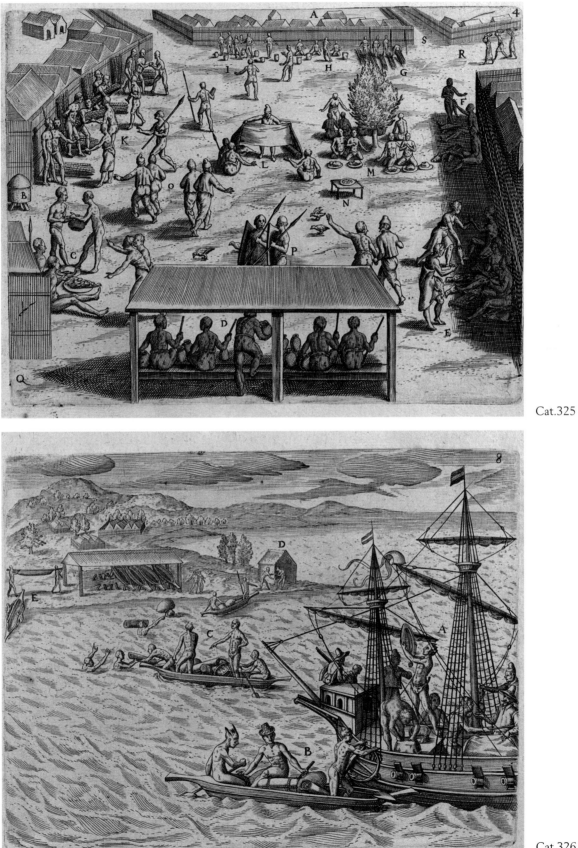

Cat.325

Cat.326

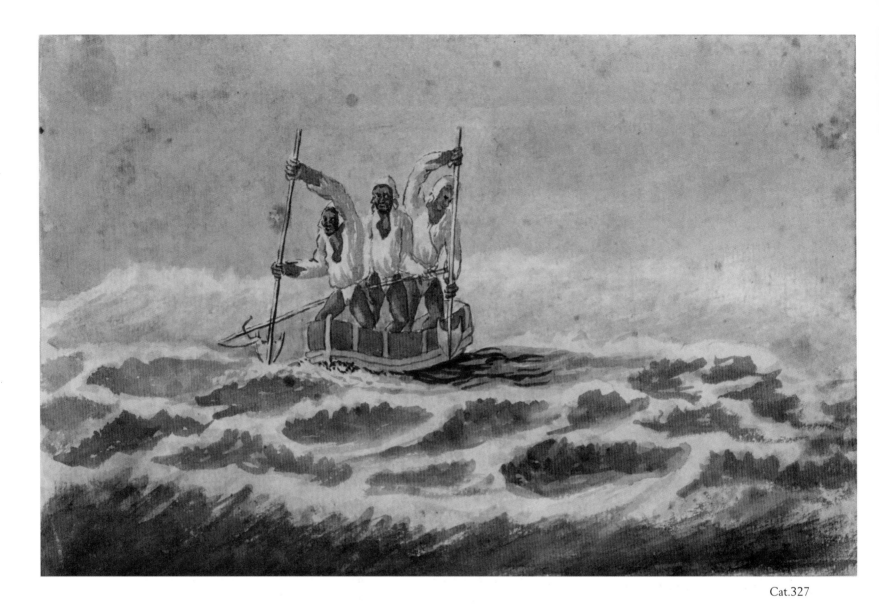

Cat.327

327

Bray album

Gabriel Bray (1750–1823), *c.*1775

Watercolours, various sizes

Gabriel Bray was a second lieutenant in HMS *Pallas*, which made a number of voyages to West Africa between 1774 and 1777 to report on the British forts and to survey the coastline. Bray was a committed amateur artist and his album of watercolours contains not only the coastal profiles and landscapes that were part of his survey duties but also a series of sketches of Africans. These provide an important record of contact with West African peoples in the period of the slave trade. See also Figs 6 (p.32) and 38–40 (pp121–2).

PAJ1995, 2011, 2020–22, 2028–29, 2032–34, 2038–40 / PT1995, PT2020, PT2021, PT2034, PT2038

328

A view taken near Bain, on the coast of Guinea in Affrica, in the latitude of 14°44´ North. Dedicated to the feeling hearts in all civilized nations

Marie Catherine Prestel (1747–94) after Richard Westall (1765–1836), based on a sketch by Carl Bernhard Wadström (1746–1799), published by James Phillips (1745–99), London, 1789
Hand-coloured aquatint,
337 × 527 mm (image)

See Fig.42 (p.126).

ZBA2727 / F0879

329

Africa

G. Wagner, published by Carrington Bowles (1724–93) and Robert Sayer (1724/5–94), London, c.1790
Hand-coloured engraving,
488 x 328 mm (image)

ZBA2591

330

African slavery

I. Clark and M. Dubourg (active 1786–1808), from a sketch by 'an officer', published by Edward Orme (1774–1848), London, 20 July 1813
Hand-coloured aquatint, 226 × 275 mm

Below the image is a caption: 'A portrait of a slave in the Portuguese settlement of Benguela, on the western coast of Africa, (one of the many unhappy objects of cruelty, in that part of the world) guarding sheep, he has an iron collar fastened round his neck, which would entangle him in the bushes, if he attempted to escape to his relations. The wounds on his body were inflicted by the whip. This miserable being was purchased & made free, by a British naval officer, for sixty dollars, who brought him to England in 1813, and had him christened at Norwich when he was 14 years old, where he is now at school by the name of Charles Fortunatus Freeman'.

ZBA2440

331

The first day of the Yam Custom

Robert Havell & Son after Thomas Edward Bowdich (c.1791–1824), published by John Murray, London, 2 December 1818
Hand-coloured aquatint,
220 × 732 mm (image)

Bowdich was a writer with the Royal African Company. In 1816 he was part of a mission to West Africa, under Frederick James, the governor of Fort Accra, to negotiate a treaty with the king of Asante. Bowdich, despite his youth, assumed command and secured a treaty, which promised peace for the British settlements on the coast in return for various political and commercial concessions. He returned to Britain in 1818 and published his account in *A mission from Cape Coast Castle to Ashantee, &c.* (1819). Unhappy at his lack of financial reward, Bowdich launched a bitter attack on the Royal African Company that led to its forts being transferred to the Crown. He died in 1824 during an expedition to the Gambia. The Yam Custom was an important and colourful festival, involving various forms of tribute being paid to the king.

ZBA2739 / F5774

332

African. Coromantee lad

Griffith after Charles Hamilton Smith (1776–1859), published by George Byrom Whittaker (1793–1847), London, March 1827
Engraving, 97 × 90 mm (image)

Portrait showing facial tattoos.

ZBA2782

333

Nulu, in her own country, before she was sold to make sugar for Christians
c.1827
Watercolour with prickwork,
230 × 177 mm
Watermarked 1827.

ZBA2753

334

Slave in wood yoke

British school, c.1840
Ink and brown wash, 230 × 200 mm

Signed with monogram 'H'.

ZBA2518

335

Scene on the coast of Africa

Charles Edward Wagstaff (1808–50) after François-Auguste Biard (1799–1882), published by Leggatt, London, 1844
Steel engraving, 515 × 712 mm

The original painting was shown in Berlin in 1835 and exhibited at the Royal Academy in 1840 as *The slave trade*. It was given to Sir Thomas Fowell Buxton, whose widow presented it to Wilberforce House, Hull. The famous painting of a slave ship, *Slavers throwing overboard the dead and dying – typhon coming on*, by J.M.W. Turner (1775–1851) was shown at the same Royal Academy exhibition.

ZBA2509 / E9127, ZBA2729 and ZBA2761 (entitled *Sklavenhandel/Slave trade*)

336

Scene on the coast of Africa

after François-Auguste Biard, c.1844
Lithograph, chalk, 425 × 594 mm (image)

Print embellished with details highlighting jewellery, ornaments and weapons. Medium includes gum arabic. See Fig.2 (p.20).

PAI2626 / PZ2626

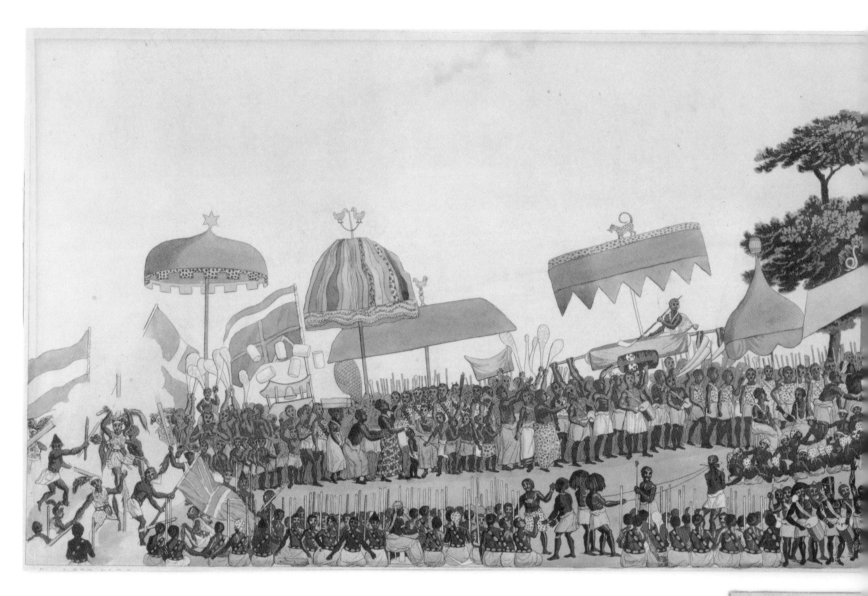

THE FIRST DAY

Published Decr 4...

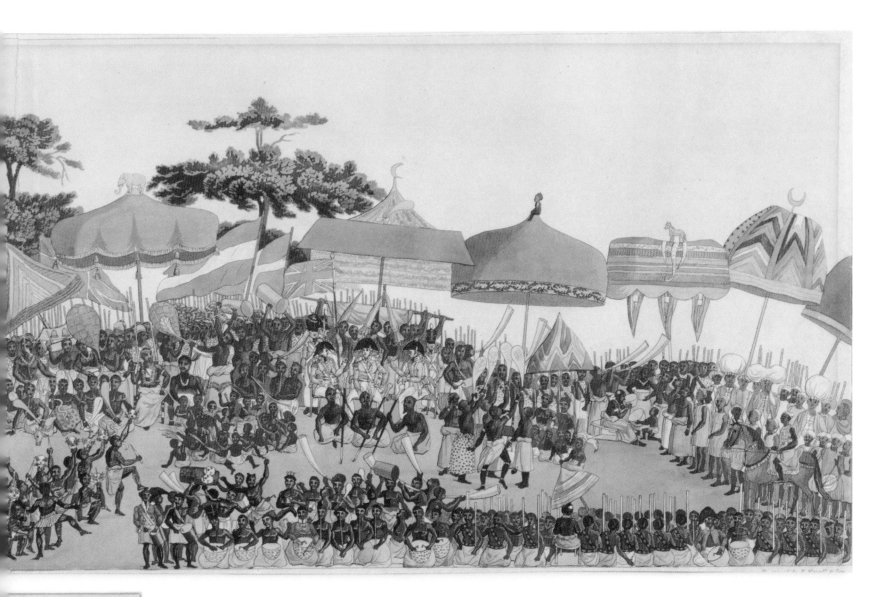

YAM CUSTOM.

Cat.331

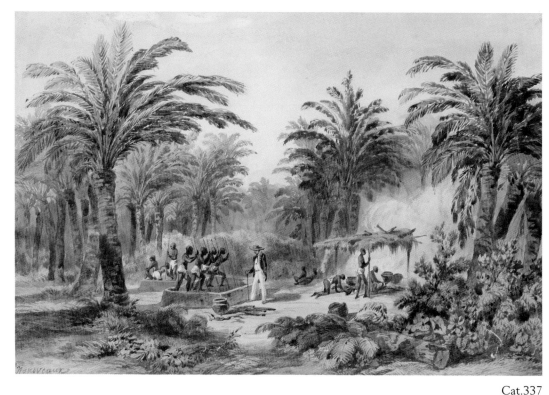

Cat.337

Cat.339

337

Fabrication de l'huile palme à Whydah, coate Oxidentale, Afrique

Edouard Auguste Nousveaux (1811–67), c.1845

Watercolour, 385 × 526 mm

The French artist Edouard Auguste Nousveaux visited Senegal in West Africa between 1842 and 1845. Upon his return to France, he exhibited a series of West African views at the Paris Salon in 1845–7. This watercolour shows the production of palm oil, which was one of the most important of the new 'legitimate' commodities exported from West Africa after the end of the slave trade. Palm oil had a range of industrial applications and was used in soap manufacture and later in the production of margarine.

ZBA2730 / F0751

338

Sketch of a Sierra Leone native

C.G. Nelson, c.1849

Graphite, and brown and grey wash, 136 × 224 mm

PAF8616

339

West African chiefs on board a naval vessel

J.T.C. Webb, c.1850

Graphite with watercolour, 135 × 196 mm

ZBA2685 / E9899

340

Black woman and child

J.T.C. Webb, c.1850

Ink with brown and grey wash, 324 × 202 mm

Below the drawing is the inscription: 'Black woman and child, She took a passage in *Penelope* from Accra to Sierra Leone to act

Cat.341

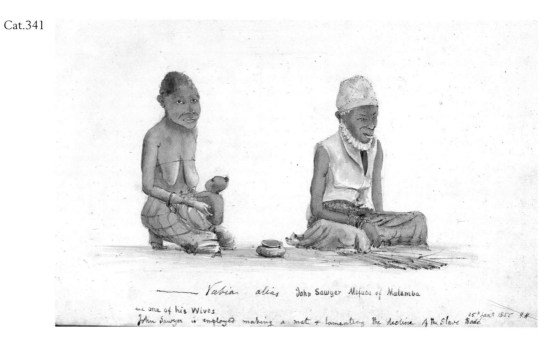

Vabia alias John Sawyer Mfuca of Malemba
and one of his Wives
John Sawyer is employed making a mat & lamenting the decline of the Slave Trade 25th Jan 1855 H.H.

Cat.342

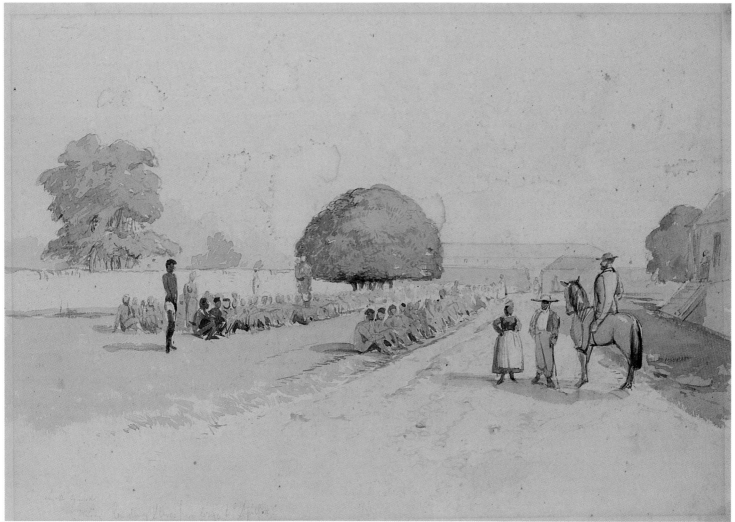

as a witness against an Englishman, to be tried for trafficking in slaves, this woman originally came from Lagos, and was purchased by the prisoner, at Little Popoe'.

ZBA2533

341
Watercolours of HMS *Linnet* on the suppression of slavery on the west coast of Africa
Henry Need, 1852–6
Watercolour, various sizes

Volume of 143 watercolours showing the commission of the sloop *Linnet* to suppress slavery. Need's sketches include many scenes of West African life as well as topographical views.

ART/10 / D9666

342
Kissy. Landing slaves from prize to Spitfire
L.A. Good, *c.*1860
Watercolour, 310 × 416 mm

Kissy was a few miles east of Freetown in the British colony of Sierra Leone. HMS *Spitfire* was a five-gun, wooden paddle steamer employed on anti-slavery patrol.

ZBA2731 / F0752

343
A person of rank in Congo carried by his slaves
Henry Wallis (*c.*1806–90) after William Marshall Craig (*d.*1827), 19th century
Engraving, 121 × 171 mm (image)

ZBA2785 / F5765

Cat.343

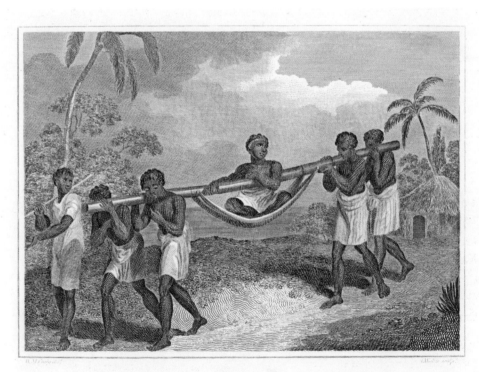

A PERSON of RANK in CONGO carried by his SLAVES.

344
Veroveringe van St Paulo in Angola ende St Thome Anno 1641
*c.*1641
Etching, 279 × 374 mm (image)

Print depicting coastal views of the settlements of St Thome and St Paulo.

PAF4478–79

345
The prospect of the English castle at Anamabou
Jan (Johannes) Kip (1653–1722), *c.*1700
Engraving, 264 × 349 mm

The English castle dominates the scene, overshadowing the other buildings of Anomabu. The castle and its oversized flag help to suggest the security and authority of this British outpost. Africa is portrayed as less inviting, the beach surrounded by dangerous reefs while beyond the castle an impenetrable forest extends to the horizon.

PAD1940

346
The prospect of the Negroes' town of Rufiscò
Jan Kip, *c.*1700
Engraving, 257 × 350 mm

This print shows Rufiscò, now Rufisque in Senegal, from the sea. Below are four smaller images showing views of other parts of the African coastline.

PAD2000

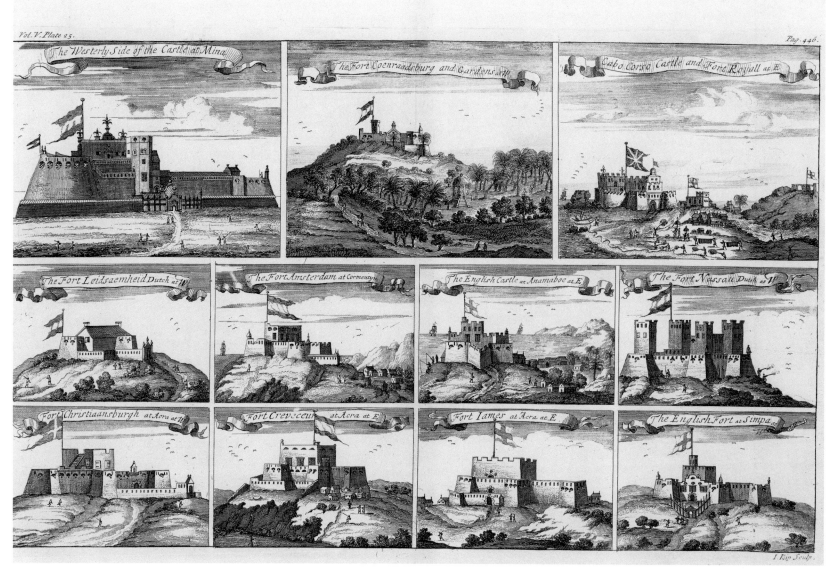

Cat.347

347
Views of forts and castles along the Gold Coast, West Africa
Jan Kip, *c.*1700
Engraving, 275 × 440 mm

Print of 11 European forts along the West African coast.

PAH2826 / PY2826

348
Het Kasteel Del Mina, gelegen in Guinea, niet verre van den withoek, Kab de Tres puntas
C.P. Amsteld after Pieter Schenk (1660–1718/19), 1702
Engraving, 213 × 265 mm

View of the castle of Elmina (in modern Ghana) from the sea.

PAD1931

349
South prospect of Dickscove Fort
after William Smith, *c.*1744
Engraving, 108 × 325 mm (image)

See Fig.41 (p.123).

ZBA2677 / E9954

350
S.W. prospect of the English and Dutch forts at Sakkundi
after William Smith, *c.*1744
Engraving, 108 × 325 mm (image)

ZBA2678

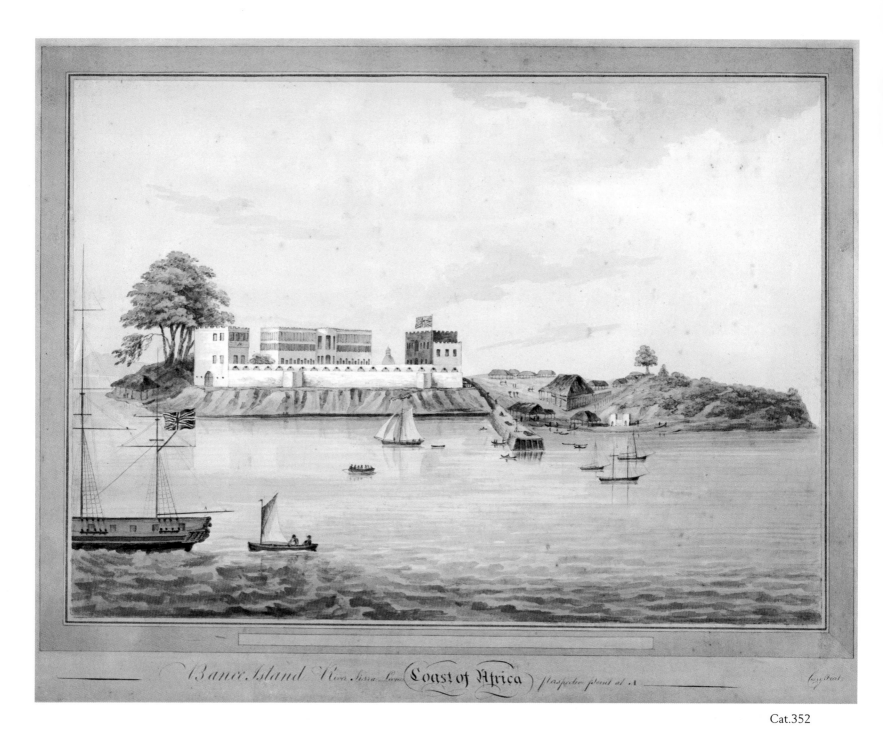

Bance Island River Sierra Leone (Coast of Africa) flagspecter point at A

Cat.352

351

Esclave Favori du Roi de Congo

J. Laroque after Jacques Grasset de Saint-Sauveur (1757–1810), *c.*1795

Hand-coloured engraving, 211 × 147 mm

ZBA2700

352

Bance Island, River Sierra Leone, coast of Africa

Joseph Corry, *c.*1805

Watercolour, 465 × 614 mm

The original watercolour for the coloured aquatint published in Corry's *Observations upon the windward coast of Africa* (G. & W.

Nichol and James Asperne, London, 1807). Bance Island, lying 15 miles upstream of the mouth of the Sierra Leone River, was once the property of the Royal African Company. In 1749 it was acquired by the London merchants Grant, Oswald & Co. They spent heavily on the rebuilding and extension of the fort, and built dwellings for local factors.

Eventually they constructed Africa's first golf course in the 1770s, making the island, so far as visiting merchants and captains were concerned, the most agreeable spot for slave trading on the coast. One visitor described the sportsmen dressed in whites, attended by African caddies in tartan loincloths. Thousands of Africans sailed for the Americas from Bance Island, and its owners were strongly opposed to abolition. By the 1790s, the island's then owners, John and Alexander Anderson, argued they had a right to trade, enshrined by an Act of Parliament. Forts like Bance Island were important points in the slave trade. Here Africans captured inland were taken and locked up while slave traders came to collect them for the voyage to the Americas.

ZBA2744 / F5773

353
Dixcove; a British settlement on the Gold Coast, Africa . . .
John Hill (1770–1850) after George Webster (active 1797–1832), published by J. Barrow, London, 26 October 1806
Hand-coloured aquatint, 389 × 557 mm

PAI2621 (original), PAI0268, PAI2623

354
St George d'Elmina, a Dutch settlement on the Gold Coast, Africa . . .
John Hill after George Webster, published by J. Barrow, London, 26 October 1806
Hand-coloured aquatint, 390 × 568 mm (image)

PAI0269, PAI0270–71 (originals)

355
Christiansborg, a Dutch settlement on the Gold Coast, Africa . . .
John Hill after George Webster, published by J. Barrow, London, 26 October 1806
Hand-coloured aquatint, 390 × 567 mm (image)

PAI0272–74

356
Cape Coast Castle, a British settlement on the Gold Coast, Africa . . .
John Hill after George Webster, published by J. Barrow, London, 26 October 1806
Hand-coloured aquatint, 389 × 555 mm

PAI2622, PAJ1745, PAJ2689

357
Island of Goree on the west coast of Africa
Thomas Medland (c.1765–1833) after Nicholas Pocock (1740–1821), published by Joyce Gold (active 1799–1823), London, 31 Mar 1806
Aquatint, 135 × 202 mm (image)

This is one of many similar prints (in terms of medium) which illustrate the *Naval Chronicle*, effectively the navy's newspaper, published by Joyce Gold, 1799–1816.

PAI3105, PAI9429

358
Island of Goree
Joseph Constantine Stadler (active 1780–1812) after R. Cocking based on sketch by Joseph Corry, c.1807
Hand-coloured aquatint, 170 × 350 mm (image)

This print shows the two slave forts on the island, Fort St Michel, and Fort Vermandois.

Goree, off the coast of West Africa, had a turbulent history. It was first occupied by the Portuguese in the fifteenth century, captured by the Dutch in 1617, recaptured by the Portuguese, then lost to the Dutch again, who fortified the island in 1647. England captured it during the Second Anglo-Dutch War (1665–7). The French then occupied Goree in 1677, except during the Seven Years War (1756–63), when it was held by Britain. After the war the island was returned to France. It was a very important slave-trading centre, and gave its name to one of the quays in Liverpool docks.

PAD1924

359
Gorée
Charles Randle, 15 November 1815
Ink and wash, 178 × 316 mm

Drawing of French trading post on Goree Island, off the coast of Senegal. Dated and monogrammed. Watermarked 1814.

ZBA2640

360
Cape Coast Castle – an English settlement on the coast of Africa 1828
C. Jones, 1828
Pen and ink, with watercolour, 225 × 295 mm

At first legitimate trade between Britain and Africa was conducted through fortresses or 'castles'. A number of these were established around the African coast. Here merchants and traders from the interior could make contact with the ships' masters and company officers arriving from Europe. British officials supervised these transactions.

PAD1934 / PU1934

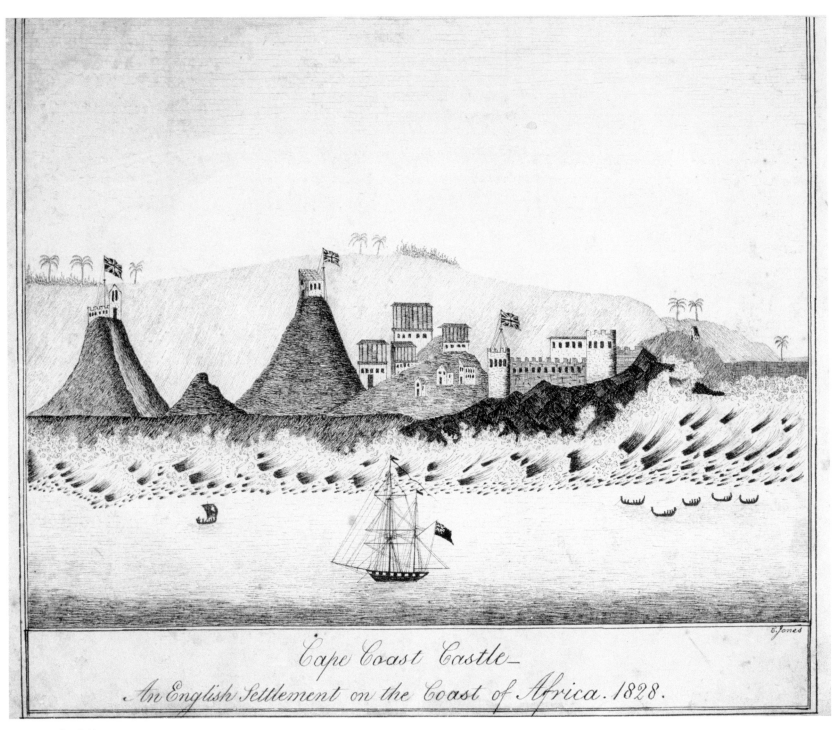

Cape Coast Castle
An English Settlement on the Coast of Africa. 1828.

Cat.360

361

Fernando Po – Africa

C. Jones, *c.*1828

Pen and ink, with watercolour, 220 × 297 mm

Fernando Po was a Spanish possession and one of three main islands off the west coast of Africa. In 1827, with Spanish consent, Britain took over the administration of the island and used it as a base for anti-slavery patrols. In 1841 the foreign secretary, Lord Palmerston (1784–1865), wanted to establish a British trading colony on the island and offered to purchase it for £50,000. Spain refused and reclaimed the island in 1844. The port continued to welcome Royal Navy vessels, but it also provided refuge for a number of Cuban and Brazilian slave ships.

PAD1916 / PU1916

362

Cape Coast Castle

C. Rosenberg after W. Bartels, published by William John Huggins, London, *c.*1830

Hand-coloured aquatint on card, 350 × 554 mm

PAI0267

Cat.361

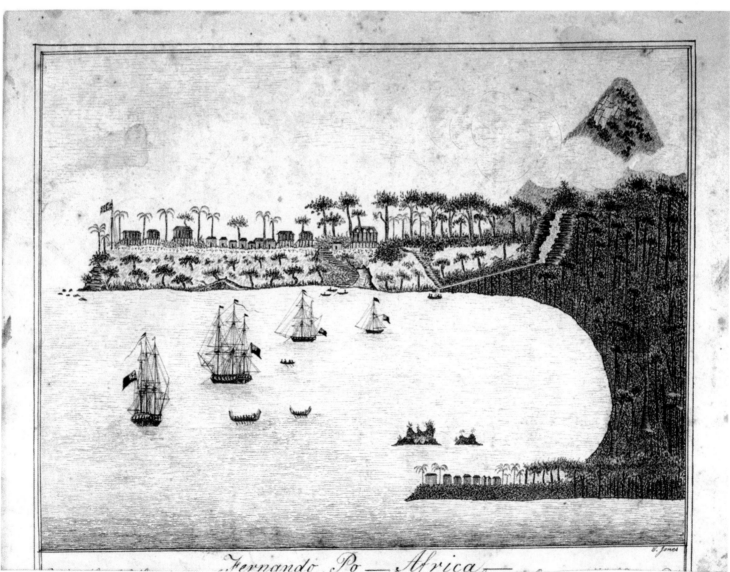

363

Sierra Leone. This plate is respectfully dedicated by permission to the Right Hon'ble Lord Gambier...
Edward Duncan (1803–82) after
Lt John McArthur, published by
William John Huggins, London, c.1830
Hand-coloured aquatint,
337 × 591 mm (image)

PAI0265

364

View of Clarence Cove, Island Fernando Po
C. Rosenberg after M. Tait, published by
William John Huggins, London, June 1833
Hand-coloured aquatint, 391 × 534 mm

Taken after a sketch by Commander M. Tait, with margins, title and a key to the buildings including slave court, governor's house etc.

ZBA2728

365

View, Sierra Leone June 25th 1849
C.G. Nelson, 1849
Watercolour, 135 × 220 mm

PAF8606

366

Ile de Gorée
Auguste Bry after Louis Le Breton
(1818–66), published by E. Savary et Cie,
Paris and Ernest Gambart & Co., London,
c.1850
Hand-coloured lithograph,
245 × 375 mm (image)

Le Breton was a surgeon in the French Navy, 1836–48, and made several very long voyages, including a circumnavigation in the *Astrolabe*, 1837–40. His various watercolours from this voyage were exhibited at the Salon de Paris in the 1840s.

PAH2824–25

367

The anchorage off the town of Bonny River sixteen miles from the entrance
P.M.G., mid-19th century
Watercolour and graphite, 200 × 370 mm

The Bonny River was a major collection point for West African slavers, located in present-day Nigeria. After 1808, a trade in palm oil was encouraged in an attempt to shift the economy of the region away from slavery. A number of former British slave dealers quickly switched their business from human to palm oil cargoes. The king of Bonny, however, continued to supply some 30,000 slaves a year to Portuguese dealers during the 1820s and 1830s.

PAD1929

REST OF AFRICA AND ATLANTIC ISLANDS

368

Slave girls, Cape of Good Hope
c.1830
Watercolour and graphite, 140 × 180 mm

ZBA2539 / E9930

369

Eunuch presenting slave girl
c.1840
Ink and wash, 409 × 311 mm

ZBA2732

Cat.368

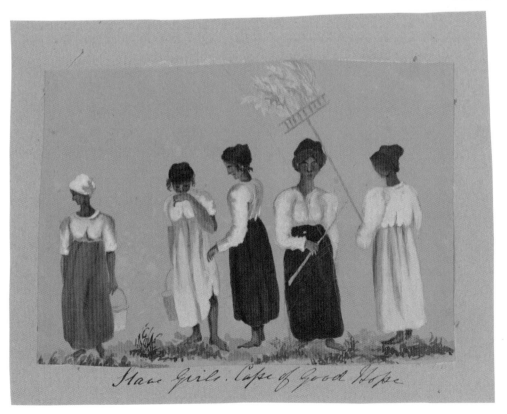

370

Slave market, Cairo

T.C. Bourne after Owen Browne Carter
(1805/6–59) and H. Warren, printed by
Charles Joseph Hullmandel (1789–1850),
*c.*1845

Lithograph, 263 × 372 mm (image)

Carter, an architect and draughtsman,
travelled to Egypt in 1829–30.

ZBA2647

371

*View of James Town and the harbour,
Saint Helena . . .*

Thomas Picken (1815–70) after
Lt F.R. Stack, published by Day & Son,
London, *c.*1846

Hand-coloured lithograph,
363 × 592 mm (image)

With the caption: 'Taken from the Harbour
Master's Office during the rollers of the
17th February 1846, on which day thirteen
vessels (mostly captured slavers) were
destroyed by the extraordinary phenomenon,
and public as well as private property to
the amount of £10,000 destroyed. It was
also remarkable that the agitation of the
water was confined to about 500 yards from
the shore, beyond which distance the sea was
perfectly calm, there being at the time
scarcely any wind'. A key names a number of
vessels including the slave ships *Descobrador*,
St Domingos, *Aquilla*, *Eufrazia*, *Esperanza* and
the *Quatre-de-Marco*, which was captured
with 540 slaves on board. The destructive
phenomenon was presumably a tsunami.

PAI0414, ZBA2762

Cat.371

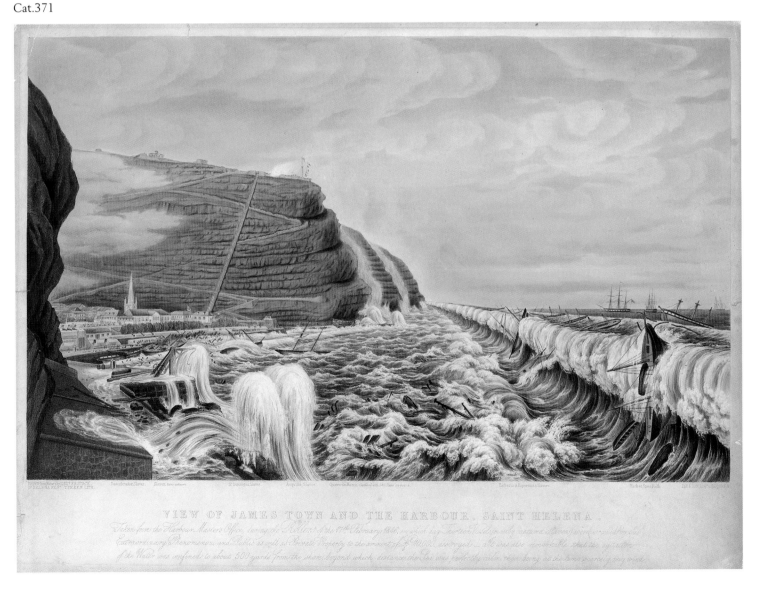

372

*Abyssinian slaves resting
at Korti – Nubia*

Louis Haghe (1806–85) after David Roberts
(1796–1864) in Roberts' *The Holy Land,
Idumea, Arabia, Egypt and Nubia* (1842–9),
published by Francis Graham Moon
(1796–1871), London, 1 May 1847
Lithograph, 260 × 357 mm (image)

ZBA2715

373

*Neger von Mozambique. Nègres de
Mozambique*

after Johann Moritz Rugendas (1802–58),
*c.*1850
Lithograph, 349 × 255 mm (image)

Between 1821 and 1846, Rugendas, a
German artist, travelled extensively in South
America. This lithograph, depicting tattoos on
the faces of four people from Mozambique, is
a later copy based upon a plate by Rugendas,
originally published in *Voyage pittoresque dans
le Brésil* (Engelmann & Cie, Paris, 1835).

ZBA2720

374

A slave caravan on the march

Anton Muttenthaler (1820–70)
after Johann-Martin Bernatz (1802–78),
*c.*1852
Hand-coloured lithograph, 235 × 340 mm

Bernatz was the official artist on a British
embassy to Sahela Selassie, king of Shoa, in
1842. He published *Scenes of Ethiopia* in
London and Munich in 1852.

ZBA2688

375

*The 'slave-market' church
at Mkunazini*

C.D.M.T., 29 September 1880
Graphite, 176 × 251 mm

Monogrammed 'C.D.M.T.' with the
inscription: 'The 'slave-market' church and
the mission infirmary at Mkunazini in the
town of Zanzibar. Taken from Ngambo,
a suburb the other side of the creek, at
low water'. Further inscription below:
'Christchurch Cathedral on the site of the
slave market, the high altar is on the spot
where the whipping post stood.'

ZBA2686

376

*Slave dhow destroyed after capture
in Port Zanzibar, 1885 and 1886*

British school, *c.*1886
Watercolour, 367 × 497 mm

ZBA2592

377

Boats of HMS Briton *capturing slave
dhows in the Mozambique Channel,
1885 and 1886*

British school, *c.*1886
Watercolour, 380 × 505 mm

In the mid-1880s, HMS *Briton* was
commanded by Captain Rodney Lloyd.
Between May 1884 and July 1887 the
Briton was responsible for capturing
ten slave dhows.

ZBA2593

378

Illustrations from *Heroes of
the Dark Continent*

United States, *c.*1890
Wood engraving, 178 × 150 mm (image)

James William Buel (1849–1920) published
his *Heroes of the Dark Continent, and how
Stanley found Emin Pasha* in various editions
across North America in 1889–90. The book,
which deals with European exploration of
Africa, has over 500 line illustrations, many
of them quite shockingly graphic depictions
of the appalling brutality of the East and
Central African slave trade.

ZBA2765, ZBA2768–77 / E9965-1

379

Slave caravan

Walter Stanley Paget (1863–1935), 1892
Grey wash with white heightening,
310 × 217 mm

Depicts Africans with guns guarding slaves.
There are two European men in the
background. Paget studied at the Royal
Academy Schools and accompanied the
Gordon Relief Expedition (1884) as war
artist for *The Illustrated London News*. He
exhibited at the Royal Academy from 1884
and also contributed to *The Sphere* and other
periodicals, as well as illustrating books such
as *King Solomon's mines* and *She*, both by
H. Rider Haggard (1856–1925).

ZBA2595 / F0720

380

Band of captives driven into slavery

Late 19th century
Chromolithograph, 218 × 144 mm (image)

ZBA2764

so that a rest was necessary and the expedition did not start for the interior until April 6th, moving along the Rovuma valley.

THE HORRORS OF SLAVERY.

The march was continued without serious interruption, so that in June the expedition reached the region of Lake Nyassa, which they discovered by seeing so many evidences of inhuman cruelties practised on the slave parties that were met. One entry in Livingstone's journal, June 19th, reads as follows: "We passed a woman tied by the neck to a tree, and dead. The people of the country explained that she had been unable to keep up with the other slaves in a gang, and her master had determined that she should not become the

ARABS MURDERING EXHAUSTED SLAVES.

property of any one else if she recovered after resting for a time. I may mention here that we saw others tied up in a similar manner, and one lying in a path shot or stabbed, for she was in a pool of blood. The explanation we got invariably was that the Arab who owned these victims was enraged at losing his money by the slaves becoming unable to march, and vented his spleen by murdering them. A poor little boy with *prolapsus ani* was carried yesterday by his mother many a weary mile, lying over her right shoulder—the only position he could find ease in; an infant at the breast occupied the left arm, and on her head were carried two baskets. The mother's love was seen in binding up the part when we halted, while the coarseness of low civilization was evinced in the laugh with which some black brutes looked at the sufferer."

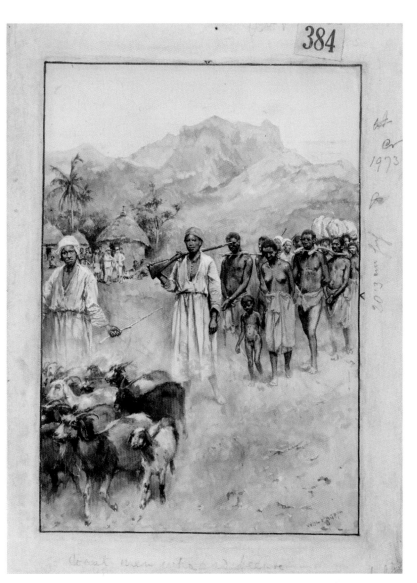

Cat.378 Cat.379

381
Slaves abandoned on the march
Late 19th century
Lithograph, 229 × 163 mm (image)

ZBA2778

382
Slaves abandoned
Whymper after J.B. Zovecker,
late 19th century
Wood engraving, 100 × 174 mm (image)

ZBA2766

383
Slavers revenging their losses
Late 19th century
Lithograph, 99 × 171 mm (image)

ZBA2767

PRINTS AND DRAWINGS: THE CARIBBEAN

PEOPLE AND PLANTATION LIFE

384
Shipping slaves off the Pitons, St Lucia
Attributed to Nicholas Pocock (1740–1821), c.1771
Watercolour, 324 × 614 mm

Richard Champion (1743–91), a successful Bristol merchant and a Quaker with strong anti-slavery beliefs, employed the marine artist Nicholas Pocock as a captain. During the years 1767–76, Pocock captained Champion's ships on no less than 12 voyages. Six of these were made to the West Indies between 1771 and 1776. St Lucia, one of the Windward Islands, is located in the Caribbean between Martinique to the north and the island of St Vincent to the south. The Pitons are in the south of the island near St Lucia's oldest town, Soufrière, which was established by the French in 1746. The twin peaks rise to over 2000 feet high and are St Lucia's most famous landmarks, visible to sailors from a great distance.

ZBA2743 / F5772

385
Les quatre piquets
Charles de Lyver, 2 June 1783
Ink and wash, 294 × 384 mm

Drawing of the *quatre piquets* punishment, where both hands and feet were bound before the victim was flogged. A caption is written on the mount: 'à la Grenade en 1783, Charles de Lyver offer. au Regt. de Champagne'.

ZBA2641

Cat.384

386
The Negroe at the place of execution
William Skelton (1763–1848) after Charles
Reuben Ryley (*c*.1752–98), published by
Thomas Hookham, London, 1 November
1787
Engraving, 120 × 72 mm (image)

ZBA2514

387
Separation of families
Late 18th century
Wood etching, 59 × 86 mm (image)

ZBA2515 / E9976

388
Sale of slaves by auction
Late 18th century
Wood etching, 58 × 80 mm (image)

ZBA2516

389
Slavery allegory
c.1800
Watercolour, 63 × 90 mm

ZBA2534

390
*The separation of a family of slaves
after being seized & sold on a warrant
of destraint for their master's debts*
c.1800
Engraving, green paper, 83 × 83 mm (image)

ZBA2582 / F0712

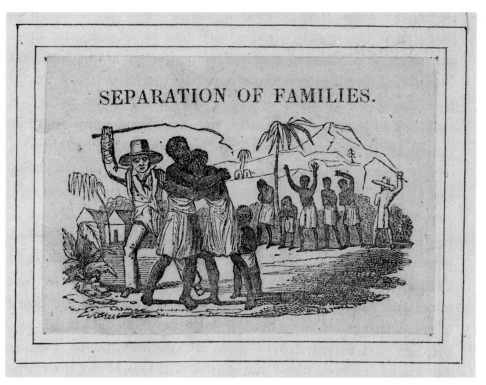

Cat.387

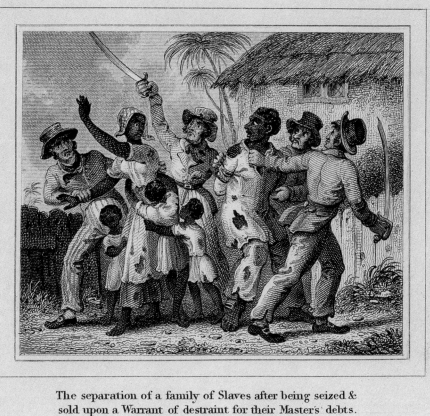

Cat.390

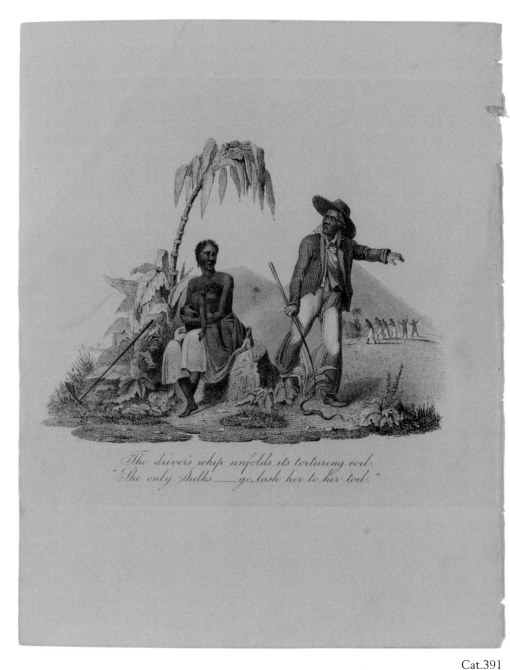

The driver's whip unfolds its torturing coil.
"She only Sulks____go lash her to her toil."

Cat.391

392

Pacification with the Maroon Negroes
after Agostino Brunias (1730–96), *c.*1801
Engraving, 226 × 170 mm (image)

Inscribed 'Drawn from the life by Agostino
Brunyas [sic]. From an original painting in the
possession of Sir William Young Bart F.R.S.'

Plate from Bryan Edwards, *The history, civil
and commercial, of the British colonies in the
West Indies* (3rd edition, London, 1801).

Bryan Edwards (1743–1800) was a Jamaican
planter and historian. His *History* was first
published in 1797. The third edition included
an additional section, which was an account
of a tour of the West Indies by Sir William
Young (see Cat.522). The image shows the
1773 peace treaty between the British crown
and the so-called Black Caribs of St Vincent.
This group was made up of the last remaining
Carib Indians and runaway slaves, who had
resisted British moves to take over land in
St Vincent from the 1760s. They drove back
British forces, and by 1772 so concerned
British authorities that they dispatched
William Young, lieutenant-governor of
Dominica (and father of Sir William Young)
to '[reduce] them to His Majesty's
Sovereignty'. Under the terms of the treaty,
land was reserved for the Caribs in return
for their allegiance. Their presence and their
enmity towards the British, however,
continued to scare the planters who
continually campaigned to have this 'internal
enemy' removed. Following a major
insurrection, in alliance with the French in
1795, the Caribs were brutally removed
from St Vincent.

ZBA2521 / E9981

391

*The driver's whip unfolds its torturing
coil. She only sulks – go lash her to her
toil.*
*c.*1800
Engraving, 126 × 174 mm

Pregnant women were expected to continue
their arduous work in the sugar fields until
just before they gave birth, and to return to
work very soon afterwards. In this print, the
exhausted woman is instructed to return to
work by a slave driver who carries his whip
and is clearly ready to use it. Strikingly, the
slave driver is a black man. The complex
hierarchies within enslaved society and
the corrupting influence of slavery as an
institution meant that it was not only white
men who abused the enslaved.

ZBA2588 / E9943

393

A Negro festival drawn from nature in the island of St Vincent

Philipp Audinet (1766–1837) after Agostino Brunias, *c*.1801

Engraving, 226 × 170 mm (image)

Inscribed 'from an original picture by Agostino Brunais [sic], in the possession of Sir William Young Bart F.R.S.'

Plate from Bryan Edwards, *The history, civil and commercial, of the British colonies in the West Indies* (3rd edition, London, 1801).

Brunias was a painter and draughtsman from Rome. In 1770 he accompanied Sir William Young (1749–1815), the first British governor of Dominica, to the West Indies. He concentrated on Caribbean subjects for wealthy planters. See Fig.44 (p.129).

ZBA2522 / E9982

394

Trelawney Town, the chief residence of the Maroons

c.1801

Engraving, 169 × 228 mm (image)

A plate from Bryan Edwards, *The history, civil and commercial, of the British colonies in the West Indies* (3rd edition, London, 1801).

The Maroons formed two distinct communities in the mountains of central Jamaica, known as 'cockpit country'. They were composed of runaway slaves and their descendents. They had a troubled relationship with British authorities. In 1730, in a treaty signed by the governor of Jamaica and Cudjoe, the Maroon leader, the Maroons' land was secured in exchange for their loyalty to Britain. In the peace that followed, the Maroons were true to their word, returning runaways and helping to put down slave insurrections. Despite this, the British were always wary of the Maroons, who remained outside their control. During the

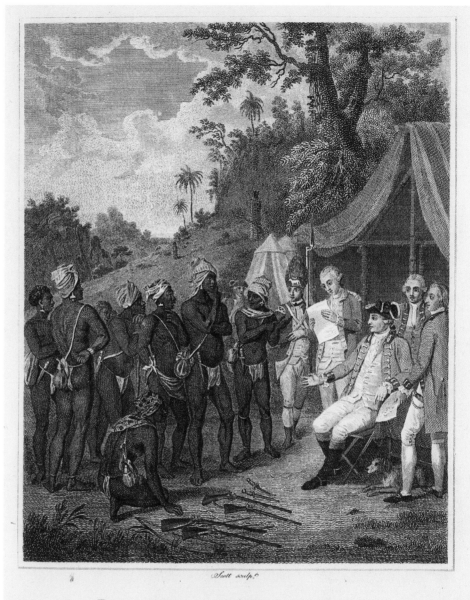

PACIFICATION *with the* MAROON NEGROES .

Drawn from the life by Agostino Brunyas . From an original painting in the possession of Sir W.m Young Bar.t F.R.S.

Cat.392

revolutionary crisis of the 1790s, this fear of the Maroons resulted in Britain turning a minor confrontation into an all-out war, and many Maroons were exiled. The communities survived, however, and their descendants live in Jamaica to this day.

ZBA2523

395

Elevation and plan of an improved sugar mill

Edward Wollery, *c*.1801

Engraving, 169 × 228 mm

A plate from Bryan Edwards, *The history, civil and commercial, of the British colonies in the West Indies* (3rd edition, London, 1801).

ZBA2524

396

Sketchbook of Edward Pelham Brenton

Edward Pelham Brenton (1774–1839),
*c.*1802–8

Watercolour, 125 × 206 mm

Edward Brenton was a naval officer, reaching the rank of captain. He was also naval historian and the younger brother of Vice-Admiral Sir Jahleel Brenton (see Cat.560). He served in the West Indies during the period of the French Revolutionary and Napoleonic Wars. His sketchbook contains a series of topographical views of Jamaica and Barbados. Importantly it also offers rare portraits of black women living in Barbados in the period of slavery. They are shown to be well dressed, which suggests that they were free, giving a sense of the complexity of Caribbean society. As well as the obvious division between the enslaver and the enslaved, there were other gradations of status, liberty, occupation, gender and wealth within black and white communities.

PAF8420 / PW8420, PAF8420 / PW8420

Cat.396a

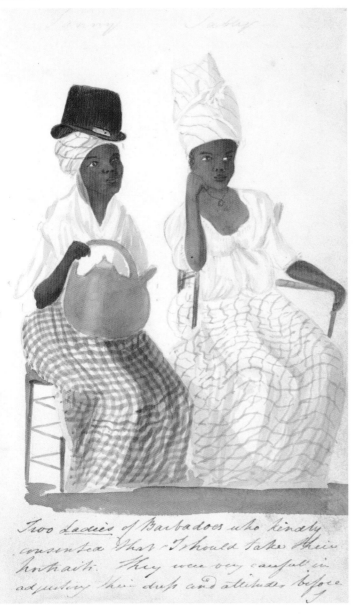

Cat.396b

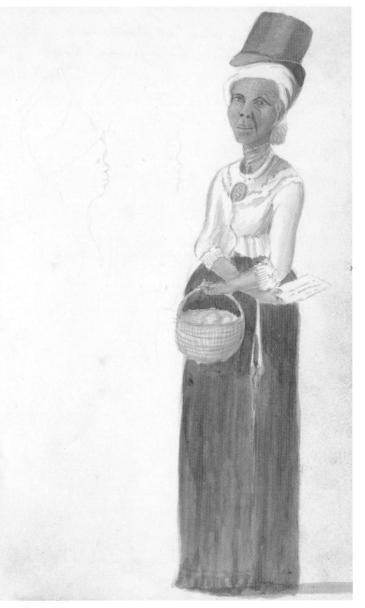

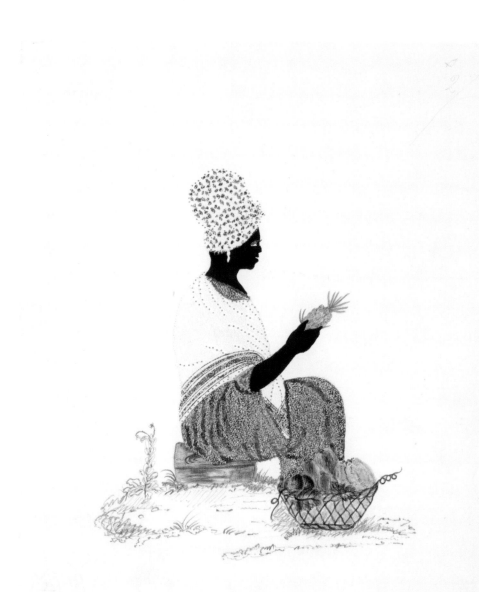

Cat.399

397
Negroes Sunday-market at Antigua
Cordon after W. E. Beastall, published by
Gaetano Testolini (active 1760–1818),
London, 1806
Hand-coloured aquatint,
329 × 428 mm (image)

Markets, like this one in Antigua, were an
important part of the local economies of the
Caribbean islands and were visited by whites
as well as blacks. Under slavery, planters were

obliged to provide food for their slaves.
To limit their costs, they allowed the slave
to grow their own crops on scraps of land
unsuitable for sugar production. These
provision grounds produced the commodities
that were sold at market. In some islands, the
revenue generated by the markets made up
to 20 per cent of the economy. The money
raised was sometimes used by the enslaved
to buy their freedom. See Fig.15 (p.57).

ZBA2594 / F0867

398
Slaves in Barbadoes
R. Stennett, published by Neele & Son,
London, c.1818
Etching, with aquatint and roulette work,
118 x 177 mm (image)

ZBA2550

399
Fruit seller
British school, c.1820
Watercolour with prickwork, 356 x 305 mm

ZBA2532 / F5764

Ten views in the island of Antigua by William Clark

*These two images (Cats 400–1) are taken from
William Clark's* Ten views in the island of
Antigua, in which are represented the process
of sugar making, and the employment of the
Negroes *(Thomas Clay, London, 1823).
Together they show the production of sugar, from
planting to harvest, from processing to shipping.
The two aquatints in the Museum collection
show a group of well-dressed slaves planting
sugar cane. After the cane was harvested and
processed into raw sugar, it was loaded into
barrels, known as hogsheads, and shipped to
Britain for refining and sale. Although the slave
trade had been abolished by the time of Clark's
visit, slavery itself still existed. Yet his images,
intended for publication in Britain, showed
nothing of the suffering of the enslaved and,
if taken at face value, would have given quite
the wrong impression of slave conditions to
the British public.*

400
Planting the sugar-cane
William Clark, published by The Infant
School Society Depository, London, 1823
Hand-coloured aquatint, 237 × 340 mm
(image)

ZBA2505 / F5885

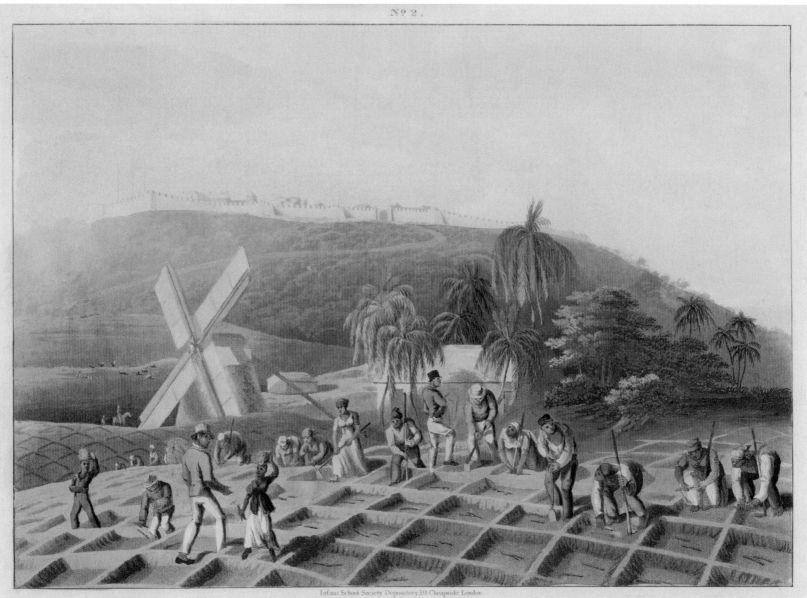

No. 2.

Infant School Society Depository, 19, Cheapside, London.

PLANTING THE SUGAR-CANE,

Cat.400

401
Shipping sugar
William Clark, published by The Infant School Society Depository, London, 1823
Hand-coloured aquatint,
235 × 348 mm (image)

See Fig.14 (p.54).

PAH3019 / PY3019

402
Dancers
*c.*1825
Watercolour and pencil with prickwork,
333 × 279 mm

The two dancing women in this drawing are taken from Agostino Brunias' engraving *Negroes dance in the island of Dominica* (London, 1779).

ZBA2561

403
Slave carrying a child on her back
*c.*1827
Watercolour and prickwork, 230 × 177 mm

ZBA2747

404

The captive slave

Edward Francis Finden (1791–1857) after
Philip Simpson (active 1825–36), published
by Smith, Elder & Co., London, *c*.1830

Engraving, 84 × 67 mm (image)

ZBA2779

405

*Destruction of the Boyne Estates by
the rebel slaves in 1831. Boats of
HMS* Blanche *engaging. Seventy-two
killed, 240 prisoners, Jamaica*

Captain James Fuller Boxer, RN, *c*.1831

Watercolour, 150 × 195 mm

This watercolour shows the navy being used
to put down a violent rising by slaves in
Jamaica. Sam Sharpe (*d*.1832) was a Baptist
preacher who called for the enslaved to stop
working from Christmas Day 1831, as part
of a peaceful protest at the continuation of
slavery. Violence quickly ensued after the
Kensington Estate in St James in the west
of the island was set ablaze, and the rising
spread rapidly to other plantations, including
the Boyne Estate. The authorities reacted
swiftly and brutally to suppress the rebellion.
In total over 500 slaves were killed. Sam
Sharpe, despite advocating non-violence,
was apprehended and hanged. The Christmas
Rising played an important role in hastening
the end of slavery. In 1975, Sharpe was
declared a hero of independent Jamaica.
See Fig.21 (p.72).

ZBA1585 / E7221

406

*Attack and Capture of the rebels
positions near Montego Bay by boats
from HMS* Blanche *1831, Jamaica*

Captain James Fuller Boxer, RN, *c*.1831

Watercolour, 200 × 287 mm

ZBA1586

407

*A Maroon encampment in the
mountains of Jamaica during
the rebellion, 1832, Jamaica*

Captain James Fuller Boxer, RN, *c*.1832

Watercolour, 150 × 200 mm

ZBA1603

408

Negro cottages in Trinidad, West Indies

Captain James Fuller Boxer, RN, *c*.1832

Watercolour, 285 x 350 mm

ZBA1604

409

*An interior view of a Jamaica
house of correction*

c.1834

Engraving, 109 × 138 mm (image)

Text below image reads: 'The whipping of
females, you were informed by me, officially,
was in practice, and I called upon you to
make enactments to put an end to conduct
so repugnant to humanity, and so contrary to
law. So far from passing an act to prevent the
recurrence of such cruelty, you have in no
way expressed your disapprobation of it.
I communicated to you my opinion, and that
of the Secretary of State of the injustice of
cutting off the hair of females in the house
of correction, previous to trial. You have
paid no attention to [illegible]'. On the
reverse is the written inscription: 'Speech
of the Marquis of Sligo to the Jamaican
House of Assembly in Feby 18-- [illegible]'.
Punishment and indignity were crucial means
by which the planters attempted to keep the
enslaved subservient. Many different forms
of punishment were employed, from the
use of masks and gags to the whip and
the treadmill. This print dates from the point
at which slavery had just been abolished.
However, abolition in 1834 did not
immediately free those who were already

enslaved – they had to endure a further
four years known as the 'apprenticeship'
before emancipation. Punishments were still
widely used, despite pressure on the colonial
assembly to legislate against such acts.
The treadmill was particularly exhausting
and made even more demeaning for the fact
that it produced nothing. See Fig.3 (p.22).

ZBA2544–46 / E9932

410

West Indian domestic scene

c.1835

Ink and watercolour, 273 × 349 mm

This scene depicts a man sitting with an
African woman standing. There are also a
couple of monkeys, a dog and a bird in a cage.

ZBA2755

411

*Esclaves de la Guadiloupe
charroyant du fumier*

Edward May, published by Rigo Frères et Cie,
Paris, *c*.1835

Lithograph, 124 × 212 mm (image)

Depicts nine slaves with baskets of dung on
their heads walking in a line from the fields.
Some wear collars or anklets and some are
chained together.

ZBA2547

412

*Trois piquets infligé à une esclave, sur
la place Bertin, à St Pierre Martinique*

Edward May, published by Rigo Frères et Cie,
Paris, *c*.1835

Lithograph, 125 x 212 mm (image)

From *Revue des Colonies* showing the *trois
piquets* punishment.

ZBA2548

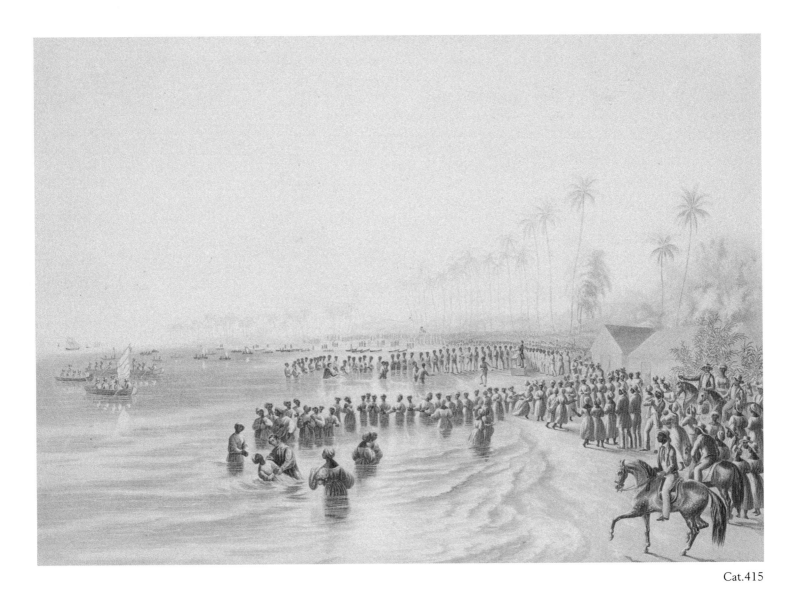

413
Marchand d'Esclaves
Eugène-Pontus Jazet (1815–56)
after Horace Vernet (1789–1863), *c.*1835
Mezzotint, 660 × 553 mm (image)

ZBA2742

414
Lady with parasol and pineapple
*c.*1840
Watercolour, 320 × 223 mm

ZBA2733

415
The ordinance of baptism in Jamaica
George Baxter (1804–67), 1842
Sepia-printed aquatint,
288 × 398 mm (image)

Baptist preachers campaigned strenuously
for the abolition of slavery, and their churches
provided places in which the enslaved
could plan and campaign as well as pray.
Importantly, too, Baptist worship was more
attuned to African religious practice. The
immersion in the ocean, for example, could
enable some Africans to connect baptism
with Yemaya, the Yoruba goddess of the

ocean, and the mother of all life. This
interweaving of African cultural and religious
practices with those of Europe was a key
element in the emergence of new religious
forms in the Americas. For the enslaved, the
Baptists also had the advantage of not being
one of the established churches, like the
Church of England, which had displayed
little desire to advocate abolition, and had,
in places, profited from slavery. Baxter, a
technically accomplished colour printer,
worked for the London Missionary Society
from 1837 to 1843.

ZBA2699 / F0744

416

Exterior Negro squatters' house, Grenada

Percy William Justyne (1812–83), *c.*1845
Watercolour with graphite and ink,
128 × 178 mm

Justyne was a painter and book illustrator. From 1841 to 1845 he was private secretary to Major-General Charles Joseph Doyle, governor of Grenada, following which he was acting stipendiary magistrate. He returned to Britain in 1848 upon Doyle's death.

PAD8967

417

Gÿ zult de arme Vrouw niet slaan. Blz 108

Early 19th century
Coloured lithograph, 130 × 84 mm (image)

Shows a slave being flogged.

PAH7368 / PY7368

Cat.417

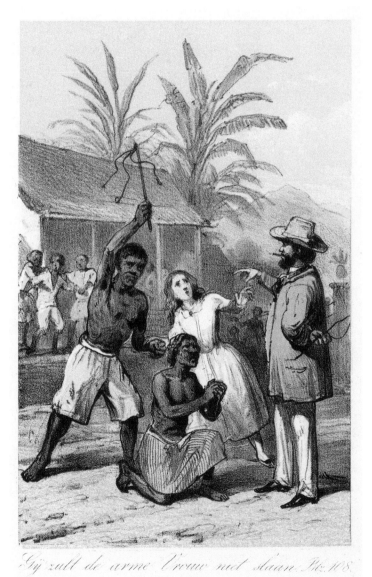

418

A view of the island of St Eustatia a Dutch settlement in the West Indies bearing NW & W dist. 2 miles. Taken from on board his Maj. Ship the Ludlow Castle *May 1764, by Gordon Shelly*

Gordon Shelly, May 1764
Grey wash, 264 × 360 mm

PAF7934

419

A view of Dry Harbour in the Parish of St Ann's Jamaica, taken from the west end of the tavern, with the fort and barracks now in ruins. To Rose Fuller Esq. this plate is humbly inscribed

June 1769
Engraving, 361 × 535 mm (image)

Rose Fuller (1708–77) was an MP and landowner. He was sent to Jamaica in 1733 to supervise the family sugar plantations. On his return to Britain in 1755, he was elected to Parliament and spoke on Jamaican affairs.

PAH2985

420

A prospect of Rio Bona Harbour in the Parish of St Ann's, and the tavern, wharf and stores in the Parish of St James, the north side Jamaica. To Edward Morant Esq. this plate is humbly inscribed

June 1769
Engraving, 365 × 534 mm (image)

The Morant family were also long-established estate owners in Jamaica. Edward Morant (*d.*1791) left the island in 1759 and settled in Hampshire, where he invested the profits from his sugar plantations in a country estate.

PAH2986

421

A prospect of Port Antonio, and town of Titchfield, in the Parish of Portland, on the north side Jamaica, taken from Navy Island. To Henry Dawkins Esq. this plate is humbly inscribed
26 January 1770
Engraving, 418 × 550 mm

Dawkins was a prominent Jamaican plantation owner.

PAH2981

422

A prospect of Ora Cabeca in the Parish of St Maries the north side Jamaica taken from the road leading to St Ann's 1766
26 January 1770
Engraving, 369 × 534 mm (image)

PAH2982

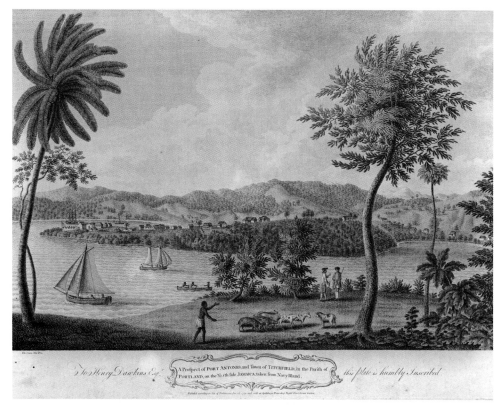

Cat.421

423

A view looking south of the town and harbour of Lucea in the Parish of Hanover in the north side of Jamaica. To John Ellis Esq. this plate is with all due respect inscribed
26 January 1770
Engraving, 368 × 536 mm (image)

The Ellis family were leading Jamaican planters with several estates. They settled in the island in the seventeenth century. John Ellis was lost at sea in 1782.

PAH2983

424

A view of the town and harbour of Montego Bay, in the Parish of St James, Jamaica, taken from the road leading to St Ann's
26 January 1770
Engraving, 422 × 555 mm

PAH2984

425

Perspective view of Roseau in the island of Dominica in the West Indies
J. Cooke, London, c.1777
Engraving and etching, 187 × 290 mm

A plate from Charles Theodore Middleton, *A new and complete system of geography: containing a full, accurate, authentic and interesting account and description of Europe, Asia, Africa, and Amercia . . .*, 2 vols (J. Cooke, London, 1777–8).

PAI6514

426

View of Port Royal and Kingston Harbour in the island of Jamaica
F. Cary, published by John Sewell, John Fielding and John Debrett (d.1822), London, 1 November 1782
Engraving, 145 × 212 mm (image)

PAI8482

427

t'Eyland Curacao anno 1786
c.1786
Watercolour, 470 × 700 mm

A watercolour of the island Curacao off the coast of Venezuela, with a key to the main buildings and vessels.

PAI0334

428

View of Port Antonia in the Parish of Portland, Jamaica
J. Merigot after Louis Bélanger (1736–1816), published by Sala Colnaghi & Co., London, 20 April 1800
Hand-coloured aquatint on card, 479 × 690 mm (image)

PAI7240

429

View of English Harbour, Antigua Bay
William Ellis (1747–1810) after Nicholas
Pocock (1740–1821), published by Bunney &
Gold, *Naval Chronicle*, London, 1 July 1800
Hand-coloured aquatint,
149 × 244 mm (image)

PAD0940

430

Port Royal Jamaica
Rickards after Nicholas Pocock (1740–1821),
published by Joyce Gold (active 1799–1823),
Naval Chronicle, London, 31 July 1806
Aquatint, 147 × 237 mm (image)

PAI3462

431

*The islands Redonda and Nevis
in the West Indies*
Hall after G.T., published by Joyce Gold,
Naval Chronicle, London, 30 April 1808
Hand-coloured aquatint,
151 x 249 mm (image)

PAD0939, PAI9628

432

*Needham's Point, Carlisle Bay,
Barbados*
Bailey after Lt J.E., published by Joyce Gold,
London, 30 November 1817
Aquatint, 140 × 230 mm (image)

PAD0944

433

*A view of the town of St George
on the island of Grenada taken from
the pasture of Belmont Estate by
Lieut. Col. J. Wilson & dedicated to
his Excellency Major General Phineas
Riall, Governor & Commander in
Chief &c &c &c*
William Daniell (1769–1837) and William
H. Timms after Lt-Col. John Morillyon
Wilson (1783–1868), published in London,
1 November 1819
Hand-coloured aquatint,
356 × 553 mm (image)

PAI0407–08

434

*View of the town of St Thomas, in the
West Indies taken from the residence of
P. van Vlierden Esq.*
W.L. Walton after a sketch by Lt Walford
Thomas Bellairs, RN, published by Charles
Joseph Hullmandel, London, *c.*1820
Hand-coloured lithograph,
310 × 520 mm (image)

Bellairs was stationed in the West Indies
towards the end of the Napoleonic War.

PAI0392

435

*View of the town of St Thomas, in the
West Indies taken from the Cola Depot
of Messrs Balinson & Co.*
W.L. Walton after a sketch by Lt Walford
Thomas Bellairs, published by Charles Joseph
Hullmandel, London, *c.*1820
Hand-coloured lithograph,
310 × 520 mm (image)

PAI0393

James Hakewill, A picturesque tour
in the island of Jamaica *(1825)*
*James Hakewill (1778–1843) is best known
for his pastoral scenes and architectural studies.
After publishing his* Picturesque tour of Italy
*(1818–20), he travelled to Jamaica in the early
1820s.* A picturesque tour in the island of
Jamaica *followed in 1825. His work shows
Jamaica as a strikingly beautiful island, full
of well-ordered plantations and supporting a
thriving agricultural industry. Yet he visited
before slavery had been abolished. On the
squalor and brutality of slavery, Hakewill is
noticeably silent.*

436

Cardiff Hall, St Ann's
Thomas Sutherland (1785–1838) after James
Hakewill, 1 July 1824
Hand-coloured aquatint,
134 × 209 mm (image)

PAD0931 / PU0931

437

*Kingston, and Port Royal.
From Windsor Farm*
Thomas Sutherland after James Hakewill,
1824
Hand-coloured aquatint,
143 × 206 mm (image)

PAD0932

438

Montego Bay from Reading Hill
Thomas Sutherland after James Hakewill,
1 March 1824
Hand-coloured aquatint,
136 × 217 mm (image)

PAD0933

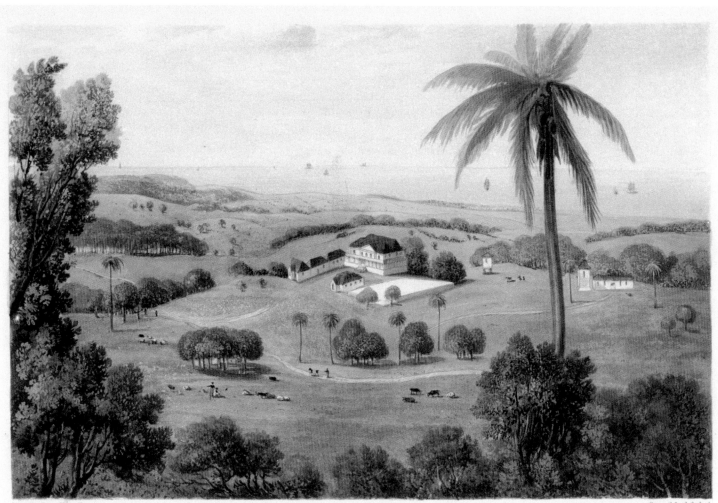

Drawn by James Hakewill.

Engraved by Sutherland.

Cardiff Hall,

St Anns.

Publishd July 1 1824, by Hurst, Robinson, & Co 90 Cheapside & E Lloyd Harley Str

Cat.436

439
Spring Garden Estate, St George's. The property of I.R. Grosett Esquire MP
Thomas Sutherland after James Hakewill,
1 April 1824
Hand-coloured aquatint,
133 × 204 mm (image)

PAD0934

440
View of St John's Harbour, Antigua
after J. Johnson, published by T. & G.
Underwood, London, 1 February 1827
Hand-coloured aquatint and etching,
350 × 515 mm

PAI0397

441
St John's Harbour, Antigua from the southward and eastward
L. Bentley after J. Johnson, published by
Smith, Elder & Co., London, 1 July 1829
Hand-coloured aquatint and etching,
353 × 495 mm

PAI0398

442

Two topographical drawings one of Jamaica, the other the Island of Haiti
Cmdr William Sidney Smith, *c.*1832
Ink and grey wash, 128 × 160 mm

Commander Smith, the nephew of Admiral Sir William Sidney Smith (1764–1840), was stationed in the Caribbean in the late 1820s and early 1830s in HMS *Victor* and HMS *Larne*.

PAF0198

443

Topographical drawings of Alto Vela, and Jamaica Morant Point
Cmdr William Sidney Smith,
17 September 1833
Ink and grey wash, 128 × 160 mm

PAF0205

444

Scarbro' Bay, island of Tobago
C. Rosenberg after D. McArthur, published by William John Huggins, London,
25 October 1834
Hand-coloured aquatint,
282 × 441 mm (image)

PAH3029

445

Two topographical drawings of Jamaica, North side
Cmdr William Sidney Smith, March – May 1835
Graphite, and pen and ink, 128 × 160 mm

PAF0212

446

Belle Estate, Barbados
British school, 1 September 1838
Ink, 217 × 293 mm (image)

The Belle Estate in Barbados was first owned in 1641 by Philip Bell, then governor of the island. It was quickly established as a sugar plantation. It was owned by a number of planters before being purchased for £23,000 in 1780 by Daniel Lascelles (whose family became the Earls of Harewood) in part payment of a debt owed by the estate's previous owner. Lascelles set about improving production on the estate, and continued to expand the enslaved population, which reached 299 in 1832. By the time of the end of slavery there were still 291 slaves at Belle, all of whom were emancipated in 1838, around the date of this sketch. The activities of the planters seem remarkably similar to the 1807 caricature of planter society by James Sayers (Cat.524). Although the sketch suggests a lack of activity on the estate, it continued to be productive, and was owned by the Lascelles family until 1970, four years after Barbados gained its independence. See Fig.13 (p.53).

ZBA2735 / F5886

447

View of the town and harbour of Port Royal in Jamaica (showing the Cumberland, Highflyer, *etc.)*
Adolphe Duperley (1801–64), published by G. Arnaboldi, 1844
Lithograph, 370 × 613 mm (image)

The Frenchman Adolphe Duperley (or Duperly) settled in Jamaica at the age of 21. He pioneered the development of photography on the island, establishing a photographic company in the early 1840s. He then published a set of lithographs based on his photographs of Jamaican scenes,

Daguerian excursions in Jamaica, being a collection of views…taken on the spot with the Daguerreotype (Kingston, Jamaica, 1844). The lithographs were produced in Paris.

PAH9245

448

Mama Gally. Country house of Honorable E. Thompson, Jamaica Mountains
Captain James Fuller Boxer, RN, 1845
Watercolour, 285 × 350 mm

ZBA1592

449

Port Royal, Martinique
Ambroise-Louis Garneray (1783–1857), 19th century
Hand-coloured aquatint and etching,
321 × 454 mm (image)

PAI0402

450

Port of Spain – Trinidad
Thomas Goldsworth Dutton (*c.*1819–91) after W.S. Andrews, published by Day & Co., London, 19th century
Hand-coloured lithograph,
176 × 303 mm (image)

PAD0949

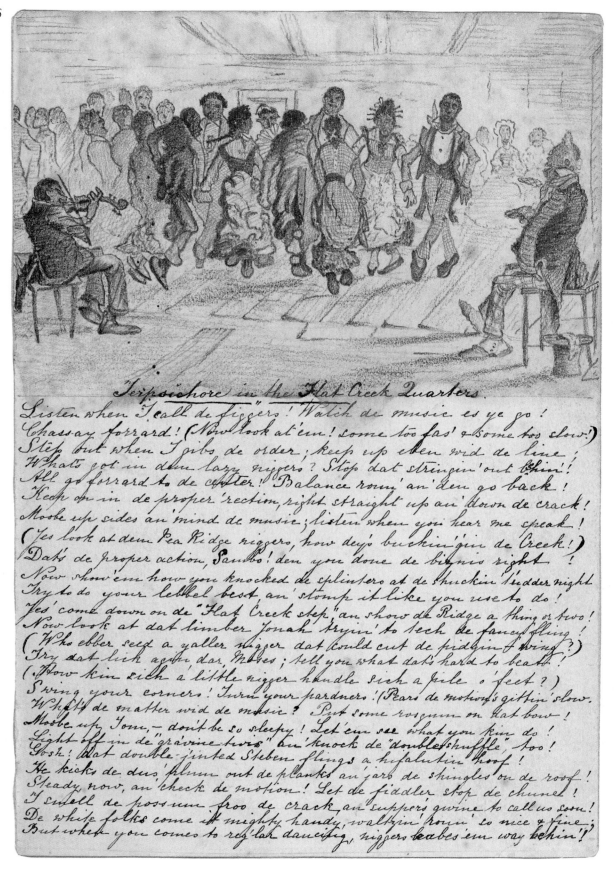

Terpsichore in the Flat Creek Quarters.

Listen when I call de figgers! Watch de music es ye go!
Chassay forrard! (Now look at 'em! some too fas' & some too slow!)
Step out when I gibs de order; keep up eben wid de line!
Whats got in dem lazy niggers? Stop dat stringin' out behin'!
All go forrard to de center! Balance roun' an' den go back!
Keep on in de proper 'rection, right straight up an' down de crack!
Moobe up sides an' mind de music; listen when you hear me speak!
(Jes look at dem Pea Ridge niggers, how dey's buckin' gin de Creek!)
Dat's de proper action, Sambo! den you done de bizness right!
Now show 'em how you knocked de splinters at de shuckin' t'udder night!
Try to do your lebbel best an' stomp it like you use to do!
Jes' come down on de "Flat Creek step," an show de Ridge a thing or two!
Now look at dat limber Jonah tryin' to tech de fancy fling!
(Who ebber seed a yaller nigger dat could cut de pidgin' wing?)
Try dat lick agin dar, Moses; tell you what dat's hard to beat!
(How kin sich a little nigger handle sich a pile o' feet?)
Swing your corners! Turn your pardners! (Pears de motion's gittin' slow.
Whats de matter wid de music? Put some rosgum on dat bow!
Moobe up, Tom, — don't be so sleepy! Let 'em see what you kin do!
Light off in de "grávine twis" an' knock de "double shuffle," too!
Gosh! dat double-jinted Steben flings a hifalutin hoof!
He kicks de dus' plum out de planks an' jars de shingles on de roof!
Steady, now, an' check de motion! Let de fiddler stop de chune!
I smell de possum froo de crack, an' supper's gwine to call us soon!
De white folks come it mighty handy, waltzin' roun' so nice & fine;
But when you comes to reg'lah dancing, niggers leabes 'em way behin'!

PRINTS AND DRAWINGS: NORTH AND SOUTH AMERICA

NORTH AMERICA

451

Mount Vernon, the seat of the late President Washington

M. Merigot, published by James Cundee (active 1799–1833), London, 1 March 1807

Hand-coloured etching, 135 × 194 mm (image)

PAD0893

452

A runaway slave finds a kind heart in a Quaker

*c.*1850

Coloured lithograph, 110 × 138 mm (image)

Depicts a runaway slave at the door of a Quaker's house.

ZBA2540

453

A distressing parting between parent and child

*c.*1850

Coloured lithograph, 110 × 138 mm (image)

Depicts a mother and child being separated after a slave auction.

ZBA2542

454

Poor Negro boys being instructed by the sons of missionaries

*c.*1850

Coloured lithograph, 110 × 139 mm (image)

ZBA2543

455

Negroes at school

*c.*1850

Coloured lithograph, 109 × 138 mm (image)

ZBA2544

456

Terpsichore in the Flat Creek quarters, Pea Ridge

*c.*1860

Graphite with ink inscription, 319 × 255 mm

Drawing showing a dance with musicians with the following manuscript poem below: 'Listen when I call de figgers! Watch de music es ye go!/ Chassay forrard! (Now look at 'em! some too fas' & some too slow!)/ Step but when I gibs de order; keep up eben wid de line;/ Whats got in dem lazy niggers? Stop dat stringin' out behin'!.../...Steady now, an' check de motion! Let de fiddler stop de chune!/ I smell de possum froo de crack an supper's givine to call us soon!/ De white folks come in mighty handy, waltzin roun' so nice & fine;/ But when you comes to reg'lah dancing, niggers leabes 'em way behin'!'

In March 1862, Pea Ridge in Arkansas was the site of a battle during the American Civil War.

ZBA2538 / F3065

457

Emancipation

American school, *c.*1860

Ink and watercolour, 237 × 309 mm

ZBA2560

SOUTH AMERICA

458

Hispani Indos oneribus succumbentis crudeliter tractant. [Spaniards cruelly using Indians as slaves]

Johannus Theodorus de Bry, 1617

Engraving, 157 × 192 mm (image)

PAG7626

459

S: Francisco de campesche, een wel betimmer stedeken in het Lantschap Jukatan, Vruchtbaer van campeschi hout en Indigo

C.P. Amsteld after Pieter Schenk (1660–1718/19), *c.*1702

Etching, 215 × 268 mm

PAD0908

Plates from John Gabriel Stedman's Narrative of a five years' expedition against the revolted Negroes of Surinam *(Cats 460–6)*

John Gabriel Stedman (1744–97) was born in the Netherlands. His Scottish father was in Dutch service in the Scots Brigade, which Stedman also joined. In 1771 he volunteered to serve in the Dutch colony of Surinam to put down a slave rebellion. Shortly after his arrival in 1773, he married a mixed-race woman called Joanna and they had a son, who died in 1792 as a midshipman in the Royal Navy. Stedman left Surinam in 1777, leaving Joanna, who was still enslaved, behind. She died in 1782, by which time Stedman had already remarried a Dutch woman. His extensive memoir of his time in Surinam, published in 1793 with a second edition in 1806, is one of the most detailed contemporary accounts of life in a slave society. Stedman was an enthusiastic artist, and produced over 100 images to illustrate his narrative, to which were added a number commissioned by the publisher, including 16 by William Blake.

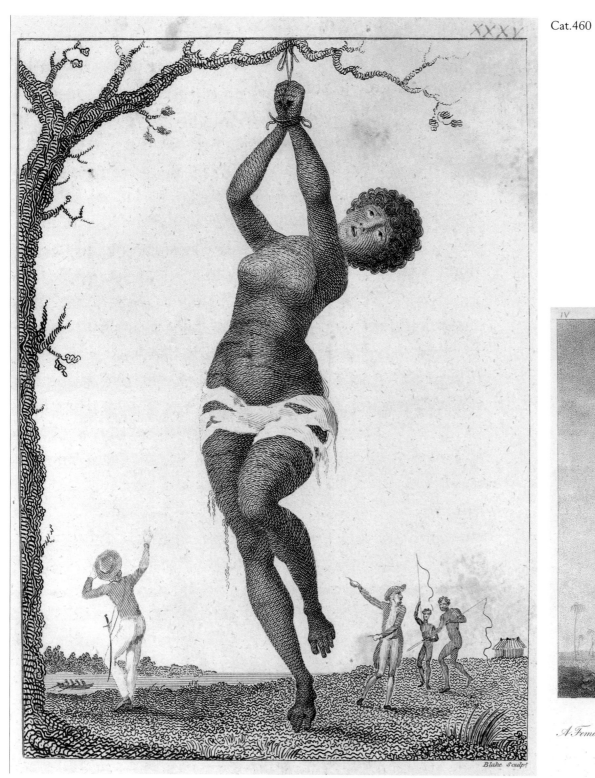

Cat.460

A Female Negro Slave, with a Weight chained to her Ancle.

London, Published Dec.ʳ 1ˢᵗ 1793, by J. Johnson, S.ᵗ Paul's Church Yard.

Cat.462

460

Flagellation of a female Samboe slave
William Blake (1757–1827) after John
Gabriel Stedman, published by Joseph
Johnson, London, 2 December 1793
Etching, with line, 183 × 134 mm (image)

ZBA2580 / E9919

461

*Group of Negros, as imported to be
sold for slaves*
William Blake after John Gabriel Stedman,
published by Joseph Johnson, London,
2 December 1793
Etching, with line, 182 × 132 mm (image)

ZBA2581

462

*A female Negro slave, with a weight
chained to her ankle*
Francesco Bartolozzi (1728–1815) after John
Gabriel Stedman, published by Joseph
Johnson, London, 1 December 1795
Etching, with line, 240 × 164 mm

ZBA2579 / E9909

463

*A Coromantyn free Negro,
or ranger, armed*
William Blake (1757–1827) after John
Gabriel Stedman, published and sold by
Joseph Johnson and Thomas Payne, London,
1806
Hand-coloured etching with engraving,
202 × 136 mm (image)

ZBA2563

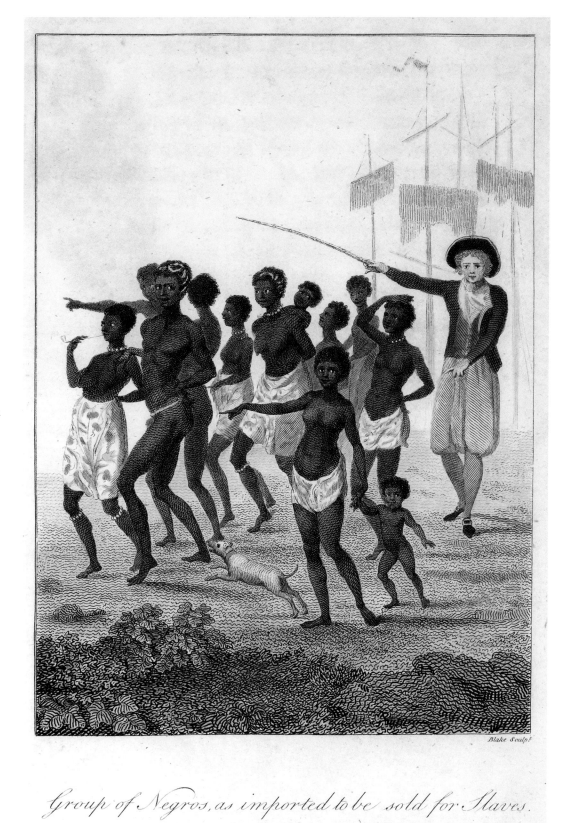

Group of Negros, as imported to be sold for Slaves.

Cat.465

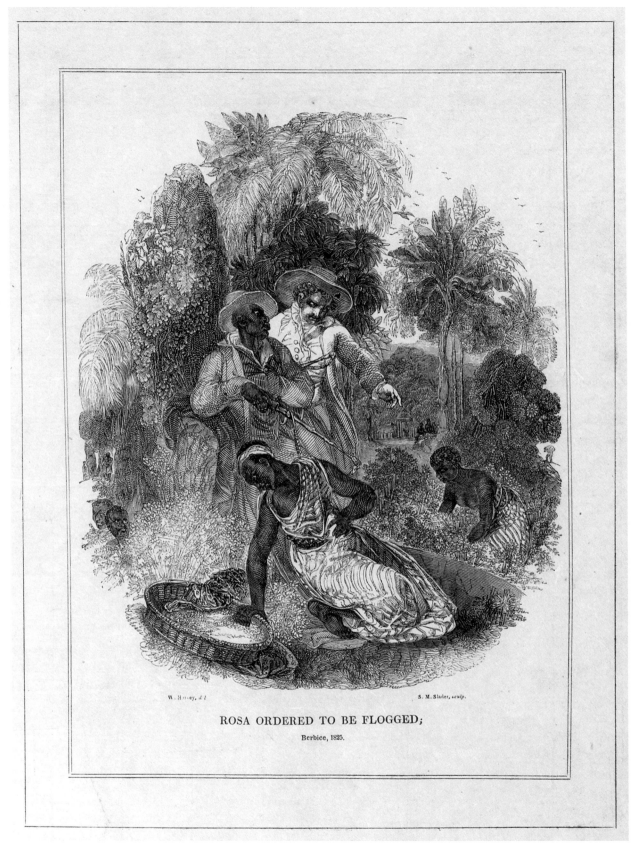

W. Huvey, d⋅l S. M. Slader, sculp.

ROSA ORDERED TO BE FLOGGED;

Berbice, 1825.

Cat.470

464

Female quadroon slave of Surinam
Perry after John Gabriel Stedman, published and sold by Joseph Johnson and Thomas Payne, London, 1806
Hand-coloured etching with engraving, 207 × 134 mm (image)

This plate shows a woman of mixed race. A quadroon was one-quarter black (i.e. having one black and three white grandparents) but, despite this, she was still enslaved. She is well dressed, but is conspicuously ignored by the two white women in the background.

ZBA2564

465

Group of Negros, as imported to be sold for slaves
William Blake after John Gabriel Stedman, published and sold by Joseph Johnson and Thomas Payne, London, 1806
Hand-coloured etching with engraving, 204 x× 134 mm (image)

Blake was one of the most prominent illustrators of his generation. Here he portrays a group of Africans, mainly women, who have survived the Middle Passage, and are bound for a plantation. It is not an accurate representation – the enslaved are not manacled and they all appear to be healthy. Blake's image tends to emphasise the perceived eroticism of black women rather than their suffering.

ZBA2565 / E9906

466

A private marine of Col. Fourgeoud's Corps
William Blake after John Gabriel Stedman, published and sold Joseph Johnson and Thomas Payne, London, 1806
Hand-coloured engraving, 185 × 167 mm (image)

In all the colonies in the Americas, European troops were essential parts of the white communities. In many cases, they made up a large proportion of white society. Their role was twofold: to protect the colonies from external attack by rival powers; and to protect the planter class from the vastly larger, and potentially hostile, enslaved population.

PAF0378

467

Paramaribo à la Rivière de Surinam Dédié avec Approbation, à Sa Majesté le Roi des Paijs-Bas, Grand Duc de Luxembourg
F. Dieterich after Pierre Béranger, published by E. Masskamp, Paris (?), 15 February 1817
Hand-coloured aquatint, 375 × 563 mm (image)

PAI0420

468

View of Georgetown
Edward Goodall (1795–1870) after William Parrot (1813–c.1869), published by Charles Joseph Hullmandel, London, c.1820
Hand-coloured lithograph, 275 × 423 mm (image)

Depicts Georgetown harbour in British Guiana (Guyana) and life in the town, including troops marching through the streets.

PAH3046–47

469

Pretos de Ganho
John Clarke after Lt Chamberlain, Royal Artillery, published by Thomas McLean, London, 1822
Hand-coloured aquatint, 198 × 279 mm (image)

Depicts two groups of men moving large barrels.

ZBA2751

470

Rosa ordered to be flogged
Samuel M. Slader (*d.* after 1861) after William Harvey (1796–1866), published by S.M. Slader, London, 1828
Wood engraving, 203 × 150 mm (image)

This wood engraving depicts an actual incident of brutality. In 1825, Rosa was a heavily pregnant slave on a coffee plantation in Berbice, Guyana. She found it increasingly difficult to pick coffee and complained, asking for lighter duties, but this was denied. The plantation manager thought the women were not working hard enough and ordered them all, including Rosa, to be whipped by a black overseer and sent back to work. Following this ordeal, Rosa returned to the fields and went into premature labour, giving birth to a stillborn child that had been bruised by the beating. This terrible event, which horrified the plantation slaves, was recorded and presented to Parliament as evidence in favour of the campaign for the abolition of slavery. The campaign also used Rosa's plight to advance the cause. The print is accompanied by a pamphlet entitled *The miseries of slavery*.

ZBA2555 / E9996

471

A view of the city of Bahia, in the Brazils, South America
W. Walton after Edmund Patten, published by Charles Joseph Hullmandel, London, June 1833
Hand-coloured lithograph, 266 × 424 mm (image)

PAH3064

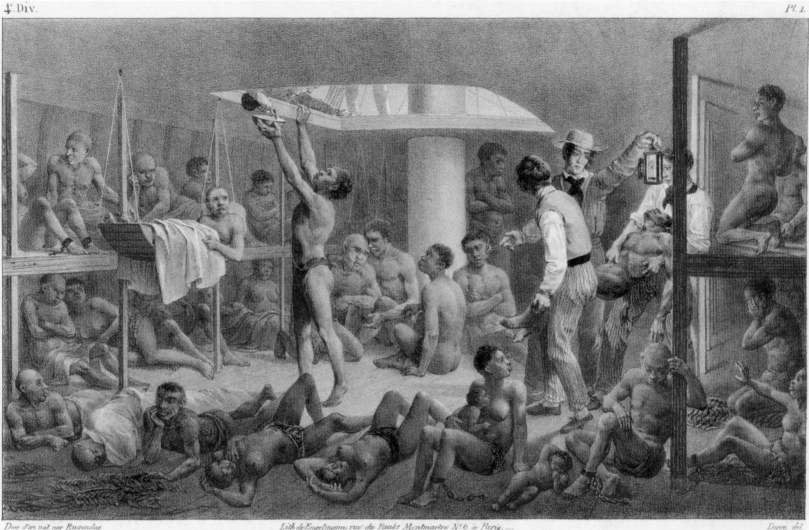

Dess. d'ap. nat. par Rugendas. Lith. de Engelmann, rue du Faub⁹ Montmartre N°6, à Paris.— Deroi del.

NÈGRES A FOND DE CALLE.

Cat.474

Johann Moritz Rugendas,
Voyage pittoresque dans le Brésil
(Paris, 1835) (Cats 472–5)
Johann Moritz Rugendas (1802–58) came
of a noted family of German artists. He spent
the early 1820s in Brazil making a series of
topographical, social and ethnographic studies
of the country. These were the basis for his
monumental Voyage pittoresque dans le
Brésil, *which contained more than 100 plates.*

It is a hugely important pictorial record of early
nineteenth-century Brazil and shows the
significant role of slavery in Brazilian society.
Rugendas toured the rest of South America
in the 1830s and early 1840s before returning
to Europe in 1846.

472
Porteurs d'eau
Deroi after Johann Moritz Rugendas,
published by Engelmann & Cie, Paris, 1835
Hand-coloured lithograph,
193 × 274 mm (image)

Depicts queues of people waiting to collect
water from a well.

ZBA2750

473
Transport d'un Convoi de Nègres
Deroi after Johann Moritz Rugendas,
published by Engelmann & Cie, Paris, 1835
Hand-coloured lithograph,
164 × 271 mm (image)

ZBA2683

474
Nègres a fond de Calle
Deroi after Johann Moritz Rugendas,
published by Engelmann & Cie, Paris, 1835
Hand-coloured lithograph,
154 × 255 mm (image)

ZBA2763 / F5767

475
Marché aux Nègres
Deroi after Johann Moritz Rugendas,
published by Engelmann & Cie, Paris, 1835
Hand-coloured lithograph,
193 × 286 mm (image)

ZBA2684

476
*Les Rafraichissemens de l'après dîner
sur la place du palais. Une visite a
la campagne*
Charles Motte (1875–1836) after Jean-
Baptiste Debret (1768–1848), *c.*1835
Hand-coloured lithograph,
375 × 240 mm (image)

ZBA2705

477
Un Marché D'Esclaves a Surinam
Jean-Baptiste Madou (1796–1877) and
Paulus Lauters (1806–75) after Pierre Jacques
Benoit (1782–1854), Brussels, 1839
Tinted lithograph, 182 × 248 mm (image)

Produced for Benoit's *Voyage à Surinam,
description des possessions néerlandaises dans
la Guyane* (Brussels, 1839).

ZBA2681

478
Slave auction in the Brazils
*c.*1850
Coloured lithograph, 108 × 138 mm (image)

Depicts a mother and child being auctioned.

ZBA2541

479
*Les Esclaves au Brésil – Supplice
Épouvantable d'un Esclave*
*c.*1865
Wood engraving and letterpress,
393 × 255 mm (image)

ZBA2708

480
Suriname. Een Plantaadge Slavenkamp
Jhr. J.E. van Heemskerck van Beest
after G.W. Voorduin, published by
F. Buffa & Zonen, Amsterdam, 1870
Hand-coloured lithograph,
272 × 430 mm (image)

ZBA2724

Prints and Drawings: Abolition Campaigns

Abolition of the Slave Trade

The slave ship Brooks *(Cats 481–2)*
This striking, iconic print – first published as
Plan and sections of a slave ship *– is perhaps
the most important image to emerge from the
British abolition campaign. At its most basic
level, the print consists of a sectional diagram
of the Liverpool slave ship* Brooks *(sometimes*
Brookes*), delineating how Africans would be
transported across the Atlantic under the terms
of the 1788 Dolben Act. This legislation, a
response to growing unease over the slave trade,
sought to restrict the number of Africans a ship
could carry in an effort to improve conditions on
board. The London committee of the recently
established Society for Effecting the Abolition
of the Slave Trade authorised the printing of
the* Brooks *diagram in 1789 as part of its
campaign. The ship is shown carrying 454
Africans, its new legal limit. The accompanying
text, which was adapted in later versions,
explains that the* Brooks *carried as many as
609 Africans before the regulation of the trade,
a figure rendered incomprehensible by the
diagram. The terrifying simplicity of the deck
plan, with its tightly packed and geometrically
arranged African figures, thus creates an
astonishingly powerful image that has an
immediate and lasting impact. Indeed, despite
the seemingly impersonal graphic approach
employed to depict the individual Africans, the
order and unrelenting nature of the print creates
an atmosphere of empathy between viewer and
victim. Taken together, the text and image
serve to bring home the suffocating horror of
the Middle Passage. James Phillips (1745–99)
was a Quaker bookseller and publisher and
a founder member of the abolition campaign.
He printed and distributed a great deal of
important abolitionist material, including the
images of the slave ship* Brooks.

481
Plan and sections of a slave ship
James Phillips, London, 1789
Engraving and letterpress,
710 × 465 mm (image)

ZBA2745 / F0886

482
The slave ship Brooks
From *The Traveller* (newspaper), 5 July 1814
Wood engraving,
297 × 444 mm (image)

ZBA2721

483
The abolition of the slave trade
Isaac Cruikshank (1756–1811), published by
Samuel William Fores (*c.*1761–1838),
London, 10 April 1792
Hand-coloured etching, 256 × 364 mm

Cruikshank's print relates to the notorious
case of Captain John Kimber of the merchant
ship *Recovery*. In the House of Commons on
2 April 1792, William Wilberforce accused
Kimber of brutally assaulting and murdering
a teenage slave girl, who refused to dance
on deck. The incident took place on
22 September 1791, when the ship was
bound for Grenada. The girl died following
convulsions on the 27th. The Admiralty
Court tried Kimber in June 1792. While
Wilberforce persisted in his belief that
Kimber was essentially guilty, the case was
poorly handled and he was honourably
acquitted. Once released, Kimber demanded
compensation and a public apology.
Cruikshank produced this print only eight
days after Wilberforce's statement in
Parliament. The original caption read:
'The abolition of the slave trade. Or the
inhumanity of dealers in human flesh
exemplified in Capt'n Kimber's treatment
of a young Negro girl of 15 for her virgin
modesty.' The two prints in the Museum
collection have an amended sub-title with
Kimber's name erased and substituted by
hand to read 'exemplified in the cruel
treatment'. This was presumably undertaken
after the trial to prevent any legal action by
Kimber – particularly as Cruikshank's overtly
sexualised version of events was at odds
with the official evidence – and thus to allow
the remaining stock of prints to be sold.
See Fig.11 (p.44).

PAF3932 / PW3932; ZBA2503

484
Slave traffic
Samuel Hutchinson (active 1770–1802),
1793
Ink and watercolour, 462 × 574 mm

This painting refers to the story of Inkle and
Yarico, first published in 1711. In the story,
the 'native' woman, Yarico, rescues an
Englishman Mr Inkle after a shipwreck.
They fall in love and live together in the
woods, before a passing ship brings them to
Barbados. The picture shows Inkle at the
moment that he sells Yarico into slavery.
She has just told him that she is pregnant
with his child, in the hope that this will
make him change his mind. Inkle asks the
trader for more money instead. Sentimental
stories like this often exposed the cruelties
of slavery, and they were used in the growing
art and literature of the abolition movement.
Signed by the artist and dated.

PAG9696 / PX9696

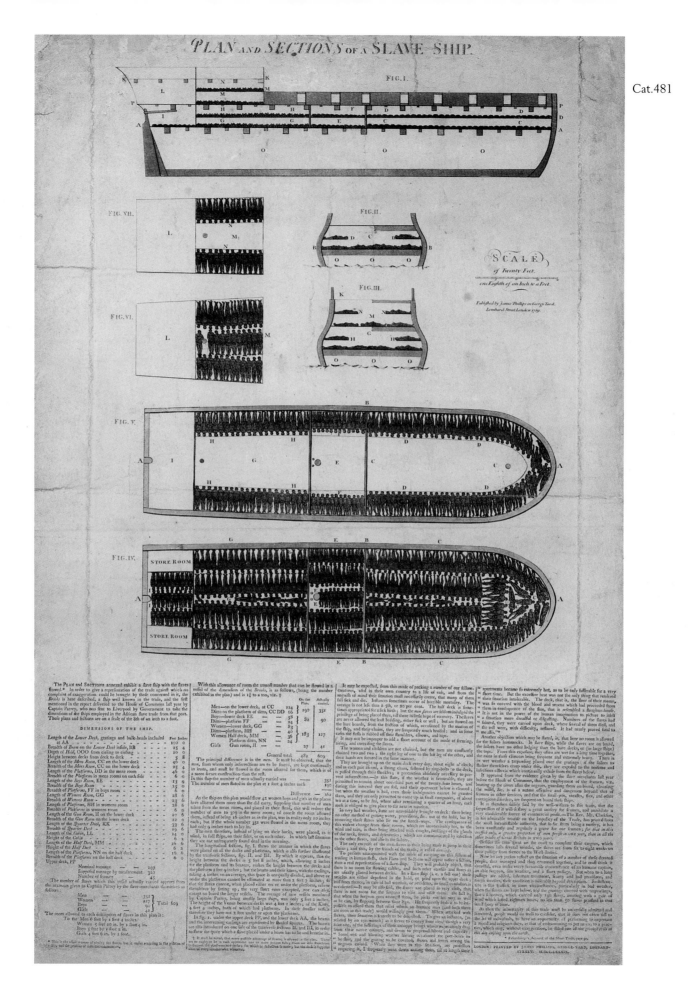

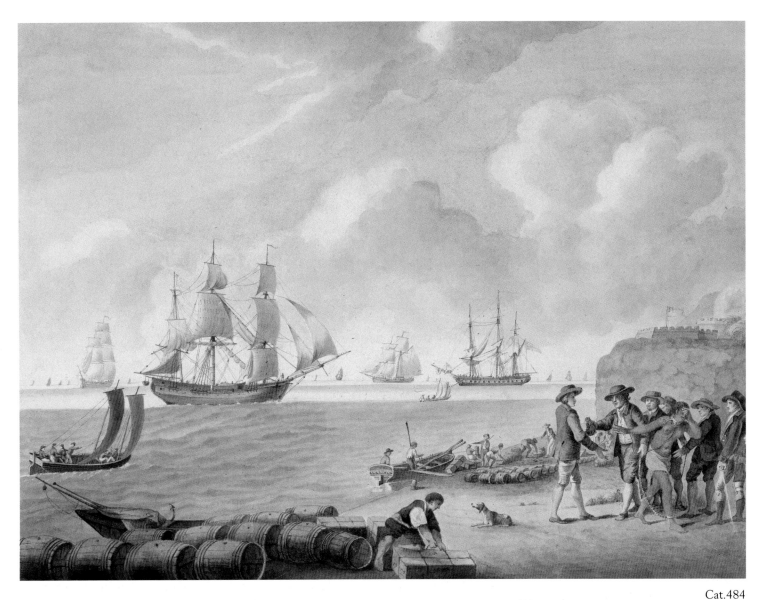

Cat.484

485

*Negro woman, who sittist pining
in captivity…*

*c.*1800

Engraving, 125 × 135 mm (image)

An image of a woman seated under a palm tree, holding a small child. On the reverse the following poem is printed: 'Negro woman, who sittist pining in captivity and weepest over thy sick child though no one seeth thee. God pitieth thee; raise thy voice forlorn and abandoned one; call upon him from amidst thy bonds for assuredly He will hear thee.'

ZBA2583

486

Two slaves kneeling in chains

*c.*1800

Engraving, 189 × 123 mm

Two slaves are show kneeling in chains. A European slave-driver has dropped his whip and in the background is a woman in classical dress. The caption reads 'But soon as approaching the land,/ That Goddess-like Woman he view'd;/ The scourge he let fall from his hand,/ with the blood of his subjects imbrued.'

ZBA2584

487

*O my great massa in heaven, pity me,
and bless my children.*

*c.*1800

Engraving, 206 × 144 mm

An African woman is shown with hands clasped and raised in prayer. In the background a slave-driver pulls a child towards a waiting sailing vessel.

ZBA2585

488

I would not have a slave to till my ground…

*c.*1800

Engraving, 124 × 156 mm

Inscribed 'I would not have a slave to till my ground/ To carry me, to fan me while I sleep, And tremble when I wake, for all the wealth/ That sinews bought and sold, have ever earn'd./ We have no slaves at home – why then abroad?'

ZBA2586

489

Slave on deck

George Cooke (1781–1834), 1801

Pen and wash, 158 × 96 mm (image)

In this image an enslaved African in chains stands on the deck of a ship holding a dagger in his hand. It is initialled and dated 'Sept. 1801' on the reverse but the image is rather mysterious and it may be an abolitionist one. Although the man is in chains, these are not attached to anything. This is a strikingly unusual representation of an African for this period. In many depictions during the abolitionist era, Africans were shown as kneeling, pleading or praying. Alternatively, they were caricatured in often grotesque ways. Here, however, the African is portrayed in a defiant pose, presumably contemplating suicide rather than captivity. The unconcern of the crew behind him, the other cargo, inkpot and bill of lading (perhaps) all suggest his status as another 'trade' commodity. Moreover, the broad arrow on the crate, lower left, and the guns suggest the vessel has some British government connection. See Fig.12 (p.45).

ZBA2660 / E9897

490

A Negro woman's lamentation

*c.*1805

Engraving and letterpress, 129 x 88 mm (image)

The engraving depicts an African woman kneeling beneath a palm tree with broken chains before on the ground; she holds a Bible to her breast. The caption reads: 'This book tell man not to be cruel; oh that massa would read this book'. The conflict between Christian belief and the slave trade is further developed in the 12 verses of *The Negro woman's lamentation* that flank the engraving. The verses deal with the woman's journey from blissful freedom in Africa, through capture at the hands of 'the fierce man-stealing crew', separation from her husband and the death of her child during the Middle Passage, to her cruel enslavement by 'massa hard'. It ends with an appeal: 'Cease, ye British sons of murder!/ Cease from forging Afric's chain;/ Mock your Saviour's name no further;/ Cease your savage lust of gain'. See Fig.51 (p.144).

ZBA2552 / E9995

491

Negroes just landed from a slave ship

Published by Richard Phillips (1767–1840), London, 1806

Engraving, 75 × 125 mm (image)

PAI9264

492

Slave trade abolished 1806

1806

Transfer print on glass with translucent oil colours, 229 × 160 mm (image)

The transfer print depicts an African warrior or chief in robes, carrying a spear and wearing a feathered headdress. He is standing outside a thatched hut with a stylised African landscape of hills and lakes beyond, which includes a large crocodile. In his right hand he holds a paper inscribed 'slave trade abolish'd 1806'. This may refer to Parliament's passing of the Foreign Slave Trade Bill in 1806, which restricted the British slave trade prior to its outright abolition the following year.

ZBA2752

493

Poems on the abolition of the slave trade

*c.*1807

Engraving, 168 × 130 mm (image)

The frontispiece of a book or pamphlet. The illustration below the title features an allegory in a roundel.

ZBA2780

494

Plate to commemorate the abolition of the slave trade

Joseph Collyer (1748–1827) after Henry Moses (1782–1870), published in London, 4 June 1808

Hand-coloured engraving, 267 × 223 mm (image)

On the occasion of Parliament abolishing the slave trade in March 1807, this engraving was designed and dedicated to Prince William, Duke of Gloucester and is captioned 'Britannia trampling on the emblems of slavery, holding a banner declaring the abolition and attending to the voice of justice and religion'. On the left, the trade is represented by a ship freighted with slaves, and the standard (with a skull) on which are inscribed the sufferings of the Negroes, and on the right is a bust of William Wilberforce, with a scroll containing the names of the speakers in favour of the abolition in both Houses of Parliament. See Fig.48 (p.139).

PAH7367 / PY7367, ZBA2644

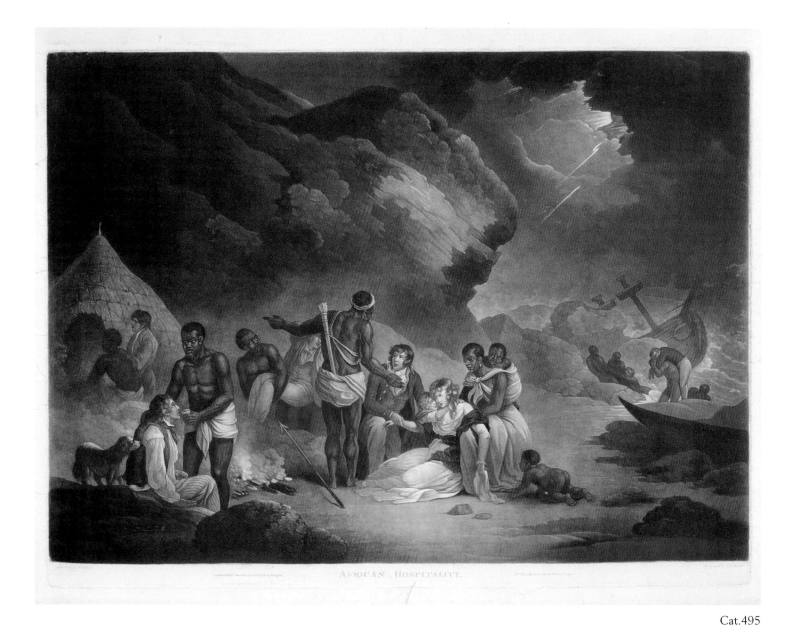

495
African hospitality
John Raphael Smith (1752–1812) after
George Morland (1763–1804), published by
S. Morgan, London, 1814
Hand-coloured mezzotint,
456 × 649 mm (image)

Morland's original oil painting, *European ship
wrecked on the coast of Africa*, the companion
to this print, was exhibited at the Society of
Artists of Great Britain in 1790.

ZBA2506 / E9126

496
Slave trade
John Raphael Smith after George Morland,
published by S. Morgan, London, 1814
Hand-coloured mezzotint,
456 × 649 mm (image)

Morland exhibited the original oil painting,
*Execrable human traffick, or the affectionate
slaves*, at the Royal Academy in 1788.
See Fig.43 (p.127).

ZBA2507 / E9125

497
Marchand d'Esclaves
Horace Vernet (1789–1863), printed by
François-Seraphin Delpech (1778–1825),
Paris, *c.*1820
Lithograph, 114 × 146 mm (image)

ZBA2597

498

The slave ship Vigilante
John Hawksworth (active 1819–48)
after S. Croad, 1823
Engraving, 557 × 445 mm (image)

The print shows plan and sections of the *Vigilante*, indicating how slaves were transported. The caption reads: 'The representation of the brig *Vigilante* from Nantes, a vessel employed in the slave trade, which was captured by Lieutenant Mildmay, in the River Bonny, on the coast of Africa, on the 15th of April 1822. She was 240 tons burden & had on board, at the time she was taken 345 slaves. The slaves were found lying on their backs on the lower deck, as represented below, those in the centre were sitting some in the posture in which they are shown & others with their legs bent under them, resting upon the soles of their feet'. The Royal Navy squadron that captured the *Vigilante* also seized a further six French and Spanish slave ships in a very successful action. Nantes was the main French slave-trading port. Anti-slavery campaigners used this print – similar in concept to the famous *Brooks* image (Cat.481) – to remind the public of how extraordinarily cramped conditions were on slave ships. The image also shows how men and women were segregated on board. The men are shown restrained in pairs with handcuffs and leg-irons. See Fig.54 (p.149).

PAH7370 / PY7370, ZBA2740

499

Album of watercolours
Lt Francis Meynell, RN, *c*.1846

This sketchbook of watercolours depicts places visited by Francis Meynell while on a Royal Navy anti-slavery patrol off the west coast of Africa and includes several ship portraits. The two watercolours here show slaves above and below deck. They were painted on board the *Albanoz*, a captured Spanish slave ship in 1846. They provide a rare eyewitness view of conditions in the hold of a slave ship. The enslaved are not chained, but rather imprisoned in a confined space. During the Middle Passage, the enslaved were usually not kept constantly below deck, unless the weather was particularly bad or there was a serious threat of revolt on board. In order that as many Africans should reach the Americas with some of their health intact, they were allowed out of the fetid holds and to exercise on deck. See Fig.33 (p.108).

MEY/2 / D9316, D9317

500

Le Nègrophile. Faire la traite des negros!…La Caricature Journal (Negro slave trade)
Bauger after Clément Pruche (active 1834–70), published by Aubert & Cie, Paris, mid-19th century
Hand-coloured lithograph, 210 × 269 mm (image)

PAH7369

Cat.499

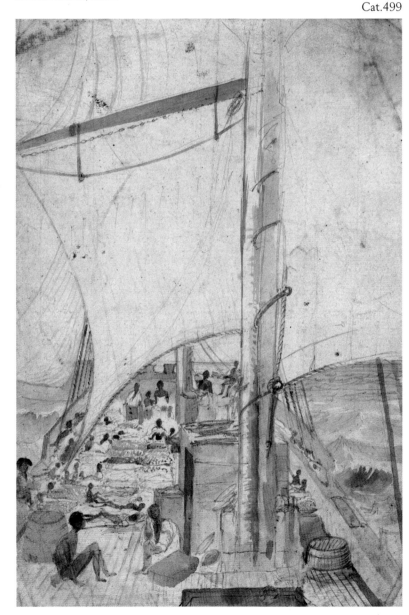

501

Am I not a man and a brother?

*c.*1820

Watercolour and prickwork, 220 × 179 mm

Depiction of the beseeching enslaved African.

ZBA2537

502

Slaves in chains: 'O Britain to thee we appeal'

*c.*1820

Watercolour on ivory, wax and metal wire, 55 × 55 mm (image)

Glazed ivory panel surrounded by gilt quillwork and set in a white marble frame. The background of the panel is painted with a landscape scene. On it are two wax figures of slaves in wire chains.

ZBA2787

503

Slave in chains

*c.*1825

Wood engraving, 114 × 81 mm (image)

Image of a slave in chains above a story about a woman and her two children, who claim to be free but have been put in gaol without any evidence that they are escaped slaves. The article quotes an advertisement from a Jamaican newspaper saying if they are not claimed they will be put up for sale. The author uses this as an example of the injustice of slavery. On the reverse is a letter to the editor of the *Devizes Gazette* with the headline 'Slavery in the British West Indies', 10 September 1825.

ZBA2587

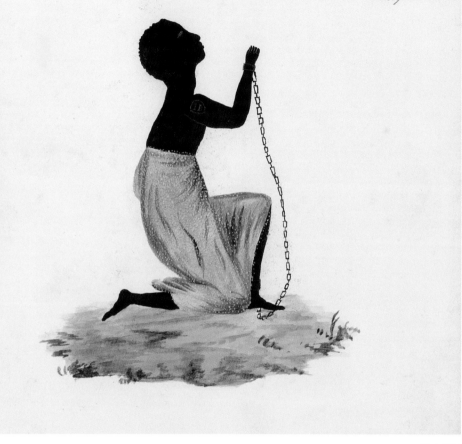

Cat.504

504

Thus man devotes his brother…

*c.*1827

Watercolour with prickwork, 195 × 157 mm

The inscription is a verse by the influential abolitionist poet William Cowper (1731–1800): 'Thus man devotes his brother and destroys;/ And worse than all, and most to be deplored/ As human nature's broadest, foulest blot/ Chains him, and tasks him and exacts his sweat/ With stripes, that Mercy with a bleeding heart/ Weeps when she sees inflicted on a beast.' Watermarked 1827.

ZBA2510 / E9123

505

Pity the poor Negro!

*c.*1827

Watercolour on card, 220 × 179 mm

In the centre of the panel, surrounded by an elaborate border, is a watercolour of a black woman sitting on a basket with a pear in her hand. Her clothes and headscarf have been done in watercolour and prickwork. Under the figure is the handwritten inscription: 'Pity the poor Negro!'

ZBA2536

506

Slavery/Freedom

Robert Seymour (1798–1836), published by Thomas McLean, London, *c.*1832

Hand-coloured lithograph, 242 × 364 mm (image)

The campaign for the abolition of colonial slavery coincided with widespread upheaval in Britain with calls for parliamentary reform and legislation to address the social problems associated with rapid industrialisation and urbanisation. This print brings the perceived irony of the anti-slavery campaign into sharp focus. In 'freedom', to the right, a well-fed and contented family in the Caribbean seem happy with their lot, despite their enslavement; happy slaves dance in the distance while tropical plenty, in the form of an abundance of fruit and vegetables, occupies the foreground. In 'slavery', a destitute British family, burdened with taxation, bemoans its situation. In the centre, a man standing in a barrel invites the viewer to consider the apparent paradox. 'Think of the poor suffering Affican [sic] called a Slave unpossess'd of any of the rights & privileges that you enjoy, while you sit under the vine of your Reform Bill and the fig-tree of your Magna Chart [sic]. He knows nothing of such blessings.'

ZBA2500 / F5770; ZBA2680
(without publisher's colour)

Cat.506

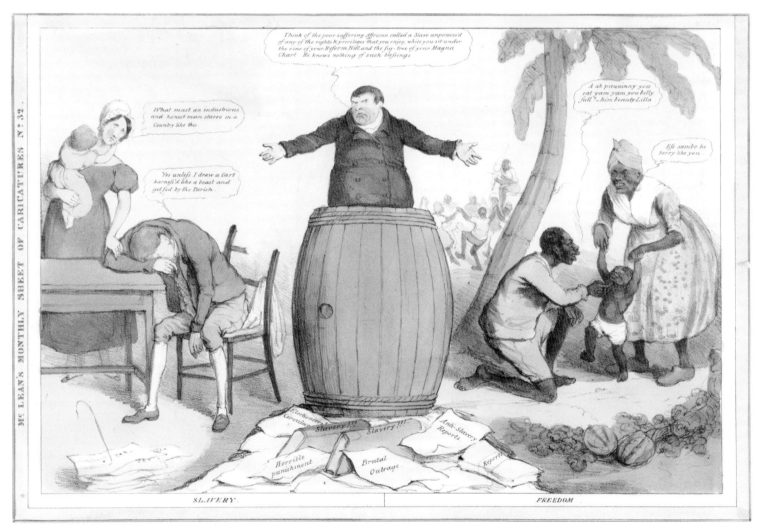

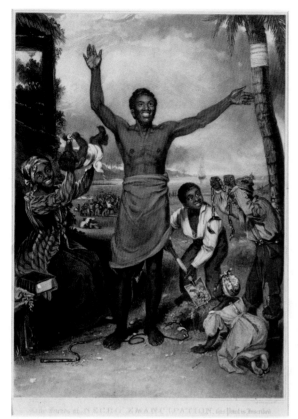

Cat.509

507

Cocker's solution of the slave question
J. J., 1831
Hand-coloured lithograph,
195 × 315 mm (image)

Divided into four scenes of contrasting
pairs. The first is inscribed: 'As the soldier
is to the starving operative'; the second is
inscribed: 'So is the slave to the free Negro'.
See Fig.53 (p.147).

ZBA2704 / E9916

508

The year of release is at hand
Timothy Stansfeld Engleheart (1803–79)
after Henry Corbould (1787–1844), c.1833
Engraving, 75 × 72 mm (image)

Print of slave family kneeling in front of the
name 'Wilberforce' carved on a rock face.
Next to them lie broken chains, and a scroll
on which is written 'Emancipation' and the

names of Clarkson, Suffield and Buxton.
Edward Harbord, the 3rd Baron Suffield
(1781–1835), sat in the House of Lords,
where, from 1822, he persistently and
almost single-handedly advocated the
abolition of slavery.

ZBA2786

509

To the friends of Negro emancipation
David Lucas (1802–81) after Alexander
Rippingille, published by Francis Graham
Moon (1796–1871), London, 1836
Aquatint, 308 × 224 mm (image)

PAH7366 / PY7366

510

The 1st of August 1833
after Alexander Rippingille, c.1836
Engraving, 136 × 102 mm (image)

A version of Cat.509.

ZBA2783

511

*Celebration of the 1st of August 1838
at Dawkins Caymanas, near Spanish
Town, Jamaica*
R. A. Leighton after William Ramsay,
published by R. Cartwright, London, 1838
Lithograph, 226 × 335 mm (image)

After the abolition of slavery came into
force in the British colonies in 1834, freed
slaves were still bound to their former
masters under the apprentice system. This
scene shows the celebrations in Jamaica for
the end of the apprentice system in 1838.
Print comes with a double-sided sheet
containing printed details of the occasion,
naming the guests and describing the
banquet. See Fig.52 (p.146).

ZBA2501 / E9111 and ZBA2501.1

512

Abolition of slavery in Jamaica
Thomas Picken (1815–70), published by
R. Cartwright, London, 1838
Lithograph, 211 × 347 mm (image)

Below the image is the following caption:
'Procession of the Baptist church and
congregation in Spanish Town under the
pastoral care of the Revd. J. M. Phillipo, with
about 2000 children of their schools and their
teachers, to the Government House on the
1st August 1838 – when they were received
by His Excellency the Governor Sir Lionel
Smith who after addressing them, read to
them the proclamation of freedom, amidst
the hearty rejoicing of not less then 8000
persons, the majority of whom had previously
attended divine worship, and who
subsequently retired to their respective
homes peaceful and happy. – The Governor –
The Revd. J.M. Phillipo and the Bishop are
seen standing in front of the portico thus
representing the happy union of civil &
religious feeling on this joyful occasion'.

The Governor of Jamaica, Sir Lionel Smith
(1778–1842), is shown on the steps of
Government House in Spanish Town reading
the proclamation of freedom that marked the
emancipation of slaves in Jamaica. The event
is presented as a joyous occasion, attended by
deeply religious people. The Baptist church
was particularly important. It provided for a
in which abolition could be advanced, and
white Baptist ministers, like J.M. Phillipo,
advocated abolition and emancipation to the
planter class on behalf of their black
congregations. After the celebration of
emancipation, however, it soon became clear
to the now ex-slaves that freedom did mean
equality, and resentment quickly returned.

ZBA2725 / F5884

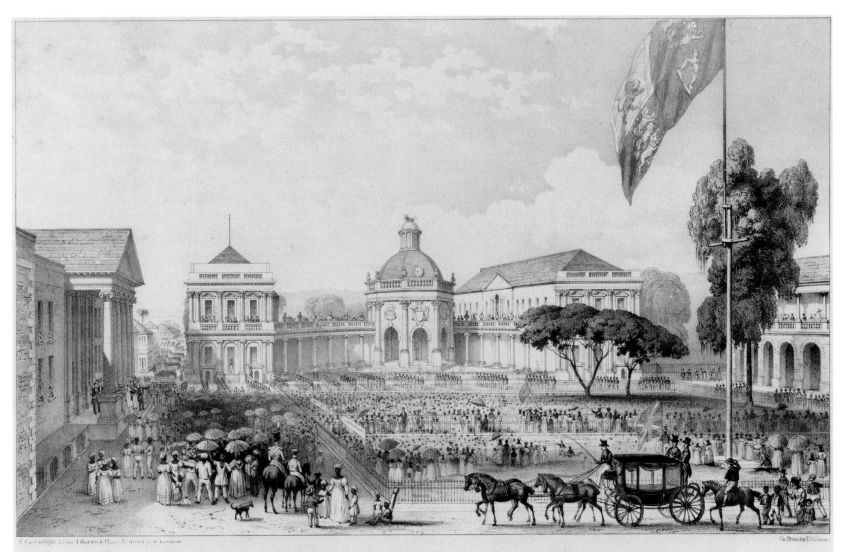

ABOLITION OF SLAVERY IN JAMAICA.

PROCESSION of the BAPTIST CHURCH and CONGREGATION in SPANISH-TOWN under the Pastoral care of THE REV.ᴰ J.M. PHILLIPPO, with about 2000 Children of their Schools and their Teachers, to the Government House on the 1ˢᵗ August 1838 _ when they were received by His Excellency the Governor SIR LIONEL SMITH who after addressing them, read to them the PROCLAMATION of FREEDOM, amidst the hearty rejoicing of not less than 8000 persons, the majority of whom had previously attended Divine Worship, and who subsequently retired to their respective homes peaceful and happy _____ The Governor _ The Rev.ᵈ J M Phillippo and the Bishop are seen standing in front of the Portico thus representing the happy Union of Civil & Religious feeling on this joyful occasion.

Cat.512

513

Chart of the World

J. Cross, London, 1839

Hand-coloured engraving, 178 × 243 mm

Map of the world coloured to show the status of the sugar-growing countries, and with narration arguing that the retention of colonial slavery increases the price of sugar in Britain. With a caption: 'Chart of the World, on Mercator's projection. Illustrative of the impolicy of slavery'. A plate from Thomas Clarkson, *The history of the rise, progress and accomplishment of the abolition of the African slave-trade by the British Parliament* (J.W. Parker, London, 1839).

ZBA2639

Prints and Drawings: Caricatures and Social Satires

514
Taste in high life
William Hogarth (1697–1764), 1746
Etching, with line, 215 × 282 mm (image)

Caption is printed below: 'Sold by Mr Jarvis in Bedford Court Covent Garden. Price 6d. Published May 24th, according to Act of Parliament'.

William Hogarth was one of the most important artists and caricaturists of the eighteenth century. In *Taste in high life* Hogarth included, amid the exaggerated opulence of a fashionable house, a young African boy attired somewhat incongruously in eastern dress. The pretensions of British society and its fascination with passing fads and trends are the target of Hogarth's satire. The African servant boy was a symbol of this obsession with status and its trappings. African servants, or slaves, were depicted in eighteenth-century society portraits. Who the African boy was is unclear. It has been suggested, but not proved, that Hogarth modelled him on Ignatius Sancho who, although 16 or 17 when this print was published, had been kept by three sisters in Greenwich as a child. See Fig.26 (p.97).

ZBA2598 / F5769

515
Allegory of nature
Charles-Etienne Gaucher (1741–1804) after Charles Dominique Eisen (1720–78), published in London, 1773
Engraving, 160 × 101 mm (image)

ZBA2577

516
Slave and his mistress
British school, *c.*1780
Watercolour, 84 × 103 mm

Framed and glazed oval watercolour of a slave and his mistress.

ZBA2823

517
Every man has his hobby horse
Thomas Rowlandson (1757–1827), published by William Humphrey (*c.*1742– *c.*1814), London, 1 May 1784
Etching, 245 × 337 335 mm (image)

Signed under the pseudonym 'J. Pether'.

ZBA2717

518
The rabbits
Published by Robert Sayer (1724/25–94), London, 8 October 1792
Engraving, 251 × 201 mm

A black street vendor is selling rabbits to a fashionably dressed white woman. She picks up one of the dead rabbits by the leg and says 'O la, how it smells – sure it's not fresh'. The kneeling vendor replies, 'Be Gar miss, dat no fair, – If Black Man take you by Leg so – you smell too'. This print is highly charged with sexual innuendo and challenges late eighteenth-century taboos regarding inter-racial relationships.

ZBA2559

519
The weather cock of St Stephen's
James Sayers (1748–1823), published by Hannah Humphrey (*c.*1745–1822), London, 14 April 1795
Etching, 300 × 239 mm (image)

Satirical engraving of William Wilberforce. Below the title of the print is the caption: 'Vide Bewilderforce's rhapsodies on peace etc.'

ZBA2642

520
Johnny New-come in the island of Jamaica
J.S. [James Sayers], published by William Holland, London, 1 October 1800
Hand-coloured etching, 322 × 476 mm (image)

Twenty-one frames depicting a tale of 'Johnny New-come in the island of Jamaica'. The captions read as follows (from top left): (1) 'Johnny Newcome.' (2) 'Damns all musquetoes, and calls for sangaree.' (3) 'Feels his pulse and trembles.' (4) 'Disembogues the first fruits of the torrid zone.' (5) 'Blasts such a country and regrets he came out.' (6) 'The billiary ducts of Johnny's stomach laid open.' (7) 'Johnny recovers apace and domesticates.' (8) 'Johnny convalesces and believes himself Seasoned.' (9) 'Johnny assumes the planter's castor(?) & dashes at game.' (10) 'Johnny creolizes, and puffs sickness away.' (11) 'John gets wet & plays the Devil with Quashie.' (12) 'Johnny capers a la Samboese to the tune of Morgan Rattleher.' (13) 'Dr Calomel feels the pulse of Mr Newcome and shakes his head.' (14) 'The yellow claw of Febris gives Johnny a mortal nip.' (15) 'John sends for Mr Codicil & bequeaths his kit.' (16) 'John writes by the packet a state of his case.' (17) 'John thinks himself better, even on his last legs.' (18) 'The delirium of Johnny astonishes Quashie.' (19) 'The soul & body of

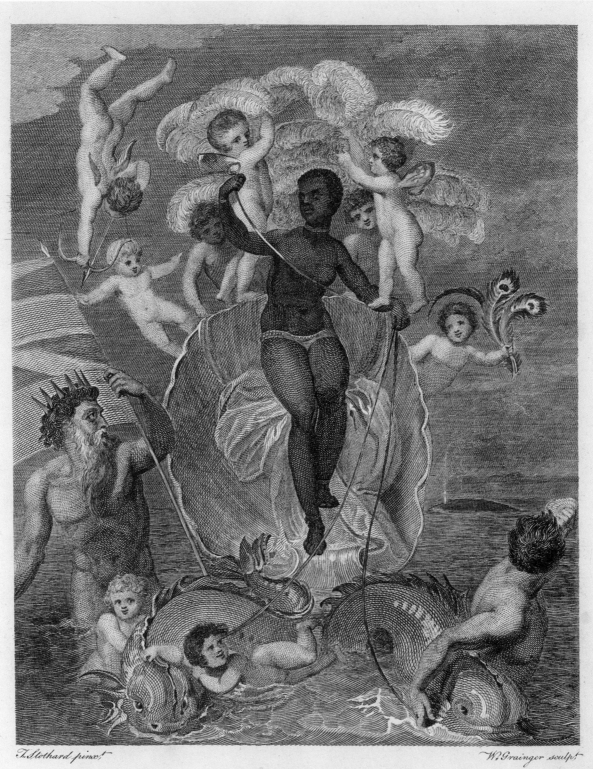

T. Stothard pinxt. *W. Grainger sculpt.*

The VOYAGE of the SABLE VENUS, from ANGOLA to the WEST INDIES.

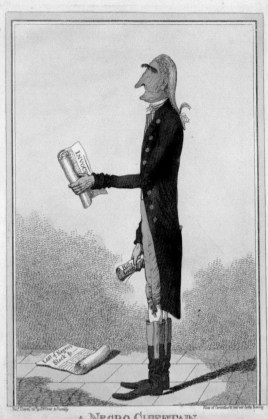

A NEGRO CHIEFTAIN.

Cat.522

John are consigned to the priest.' (20) 'The body of John is pack'd up for the penn.' (21) 'Hic Jacet: Johannes New-come.' See Fig.47 (p.132).

ZBA2722 / F0873

521

The voyage of the Sable Venus from Angola to the West Indies
W. Grainger (active 1784–93) after Thomas Stothard (1755–1834), *c.*1801
Engraving, 203 × 164 mm (image)

This etching is a plate from the third edition of Bryan Edwards' *The history, civil and commercial, of the British colonies in the West Indies* (1801). Thomas Stothard was a highly prolific artist and book illustrator. Inspired by Sandro Botticelli's fifteenth-century

masterpiece *The birth of Venus*, Stothard presents an African woman (the 'Sable Venus') standing on a half-shell, attended by cherubs, being towed by dolphins to the Americas. To the left, Triton, carrying the British flag and guiding the procession across the ocean, looks upon her exotic and eroticised form with palpable sexual desire. In this extraordinary depiction of the Middle Passage there is no reference to the horrors endured by those transported across the Atlantic on slave ships. The enslavement of African women left them vulnerable to rape and abuse.

ZBA2520 / E9980

522

A Negro chieftain
Published by Samuel William Fores, London, *c.*1802
Hand-coloured etching 353 × 250 mm

Sir William Young of Delaford, 2nd Baronet (1749–1815) is the subject of this caricature. He was the MP for St Mawes in Cornwall between 1796 and 1804, and a leading opponent of Wilberforce's motion against the slave trade. He was agent for the island of St Vincent from 1795 to 1802, secretary to the Association for Promoting Discovery of Interior Parts of Africa, and governor of Tobago from 1807 until his death in 1815. He had sizeable estates in the West Indies and was the owner of 1300 chattel slaves. His family's wealth was based on the profits made by these slaves. His father, Sir William Young, 1st Baronet, had begun his career in Antigua, and had moved to the Windward Islands in the 1760s, where he founded estates on Dominica, St Vincent and Tobago. He was also governor of Dominica, and led the expedition against the Carib population of St Vincent in 1773.

ZBA2638 / F0730

523

Jack of Guinea
Isaac Cruikshank (1756–1811),
published by Robert Laurie (1755–1836) and James Whittle (*c.*1757–1818), London, 20 May 1805
Hand-coloured etching, 197 × 247 mm

With a poem by Thomas John Dibdin (1771–1841).

ZBA2676

524

A West India sportsman. Make haste with the sangaree, Quashaie, and tell Quaco to drive the birds up to me – I'm ready
J.S. [James Sayers], published by William Holland, London, 1 November 1807
Hand-coloured etching,
257 × 349 mm (image)

In 1807 when the bill banning the slave trade in British dominions was finally passed, William Holland published a series of prints aimed as an attack on colonial exploitation. It mocks the idleness, luxury and pretension of the planter class. Here the planters want to hunt, but can do so only by having their prey driven to where they are sitting, while their black servants struggle to carry unfeasibly large glasses of *sangaree* to them.

ZBA2432 / E9114

525

On a visit in style – taking a ride – West India fashionables
J.S. [James Sayers], published by William Holland, London, 1 November 1807
Etching, engraving and aquatint with publisher's colouring, 196 × 303 mm (image)

Two vignettes on one plate.

ZBA2513

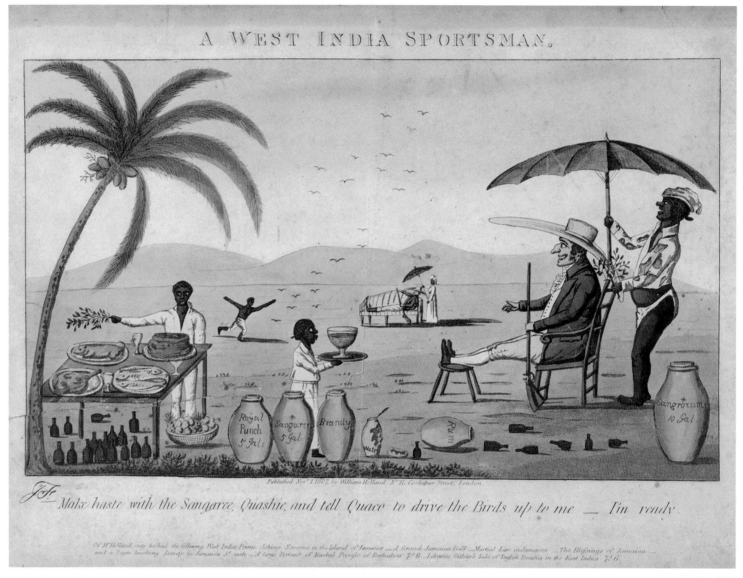

A WEST INDIA SPORTSMAN.

Published Nov.ʳ 1 1807, by William Holland, N.ᵒ 11, Cockspur Street, London.

— Make haste with the Sangaree, Quashie, and tell Quaco to drive the Birds up to me — I'm ready.

Cat.524

Saartjie Baartman, the 'Hottentot Venus' (c.1788–1815/16)

Saartjie (Sara) Baartman was a Quena, or Hottentot, woman brought to Europe from South Africa in 1810 by a ship's surgeon. She was publicly displayed in Britain and later France. Audiences reacted with both curiosity and mocking incredulity at her physical appearance, which – with prominent genitalia and pronounced buttocks (steatopygia) – was in striking contrast to that of European women. Baartman embodied the 'other', representing the exoticism and eroticism of 'primitive' Africa. She was exhibited naked in a cage in Piccadilly, and in Paris she posed as a model and became the focus of wanton sexual attention. She died of an infection on, or shortly before, 1 January 1816. The French anatomist Georges Cuvier (1769–1832) made a cast of her body, and her brain and genitals were pickled for public exhibition. They remained on display in Paris until 1985 and were finally returned to South Africa for a traditional burial in 2002.

526

Love and beauty – Sartjee the Hottentot Venus

Christopher Crupper Rumford, October 1810
Hand-coloured engraving,
288 × 228 mm (image)

With inscription: 'Tho' Venus of old/ By records we're told/ Excited the praise of mankind/ Our Hottentot still/ Let her die when she will/ Will not leave her equal behind'.

ZBA2695

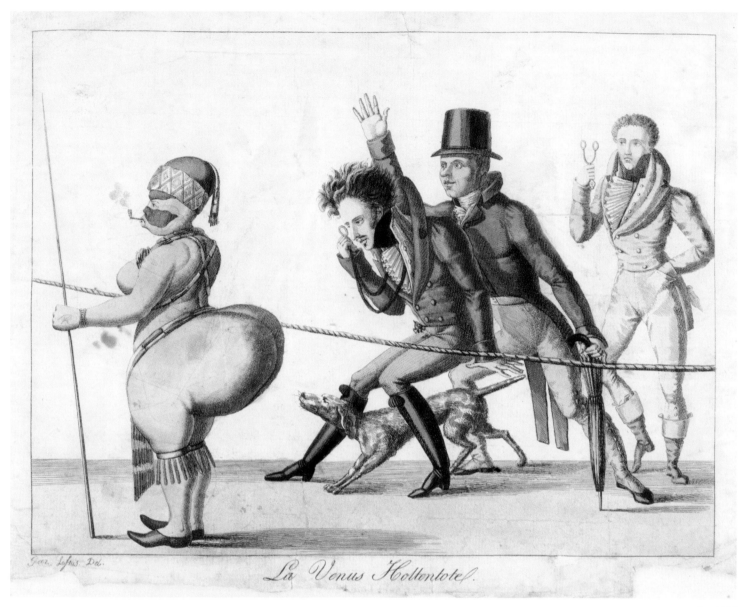

La Venus Hottentote.

Cat.527

527
La Venus Hottentote
George Luftus, *c.*1814
Hand-coloured etching,
250 × 172 mm (image)

ZBA2687 / F5768

528
Les Curieux en extase ou les Cordons de souliers
*c.*1814
Hand-coloured engraving,
211 × 288 mm (image)

Depicts 'La Belle Hottentote' on display in Paris.

ZBA2558

William Elmes, Adventures of Johnny Newcome *(Cats 529–33)*
William Elmes (active 1797–1815) produced these satirical vignettes of Johnny Newcome, who had earlier appeared in prints by James Sayers (see Cat.520). Newcome represented the naïve and pleasure-seeking planter intent on enjoying colonial life in the West Indies. The prints were published by Thomas Tegg (1776–1846) in 1812 at a time when there

was political pressure to ensure the enforcement of the 1807 Act. For more on Johnny Newcome, see Chapter 9 pp 130–33.

529
Adventures of Johnny Newcome,
Plate 1
William Elmes, published by Thomas Tegg, London, 1812
Hand-coloured etching, 245 × 346 mm

See Fig.45 (p.130).

PAF3747 / PW3747

530
Adventures of Johnny Newcome,
Plate 2
William Elmes, published by Thomas Tegg, London, 1812
Hand-coloured etching, 245 × 346 mm

See Fig.46 (p.131).

PAF3748 / PW3748

531
Johnny and his fair bride reveling in jollity and festive mirth
William Elmes, published by Thomas Tegg, London, 1812
Hand-coloured etching,
115 × 113 mm (image)

Below the image is the caption: 'Price one shilling coloured'.

ZBA2575

532
Adventures of Johnny Newcome
William Elmes, published by Thomas Tegg, London, 1812
Hand-coloured etching,
245 × 351 mm (image)

Set of six images detailing the 'Adventures of Johnny Newcome'. The captions are as follows (starting top left): (1) 'Johnny's reception by merry Jonkanes at Negro Ball.' (2) 'Johnny dancing with Rosa – the planter's beautiful daughter.' (3) 'Johnny's courtship and professions of love to Rosa.' (4) 'Johnny and the fair Rosa tripping to the altar of Hymen.' (5) 'Nuptial ceremony of Johnny and the charming Rosa.' (6) 'Johnny and his fair bride reveling [sic] in jollity and festive mirth.'

ZBA2718

533
Adventures of Johnny Newcome: Johnny situated as clerk of stores
William Elmes, published by Thomas Tegg, London, 1812
Hand-coloured etching, vignettes,
116 × 105 mm (image)

Set of four vignettes, mounted and framed together. The captions below the images read: 'Johnny situated as clerk of stores'; 'Johnny enamoured with nymphs bathing'; 'Johnny enjoying the sports of the field'; and 'Johnny preachee and floggee poor Mungo'.

ZBA2757–60

534
Her mistress's clothes
c.1815
Watercolour on ivory, 91 × 78 mm (image)
In original gilt bronze frame and case.

This complex and disturbing watercolour depicts a mistress with her servant or slave. The young European woman is simply attired in the Regency style, while the black girl has been elaborately dressed in her mistress's fine, white, empire-line gown and red coral jewellery. The mistress holds her servant in place, manipulating her face into a distorted smile as if she were a living doll. The mistress looks out at the viewer; the servant observes her reflection in the mirror held in her right hand. The overall effect, heightened by the stark contrast between the black and white skin tones, is one of glaring racial and social distinction and disparity, with the mistress exerting complete control over the servant's appearance and posture. The American artist Harriet Cany Peale (1800–69) painted the most famous version of this image – also titled *Her mistress's clothes* – in 1845. It is certain that Peale's small oil painting on tin is not the original but rather an updated reworking of an earlier composition. Based on the differences in the styling of the mistress's hair and the cut of her dress, it seems most likely that this watercolour, possibly of the French school, is earlier and therefore closer in date or realisation to the unknown original.

ZBA2436 / E9104

535
Puzzled which to Choose!! or, The King of Tombuctoo offering one of his daughters in marriage to Capt--- (anticipated result of ye African mission)
George Cruikshank (1792–1878), published by George Humphrey (active 1783–1831), London, 10 October 1818
Hand-coloured etching,
224 × 334 mm (image)

The mission anticipated in Cruikshank's caricature was the African Association's trans-Sahara expedition of 1818–20, which sought, unsuccessfully, to reach central Africa from the north. The naval captain is Frederick Marryat (1792–1848), who was meant to accompany the expedition leader, Joseph Ritchie (*c*.1788–1819). Marryat, a friend of Cruikshank's with whom he collaborated, was indisposed and Captain George Francis Lyon (1795–1832) volunteered for the position in Malta, where he met Ritchie by chance. The expedition started at Tripoli in November 1818 but was greatly delayed and very poorly organised. Ritchie died in November 1819 as a result of illness and the effects of heat; Lyon took command and

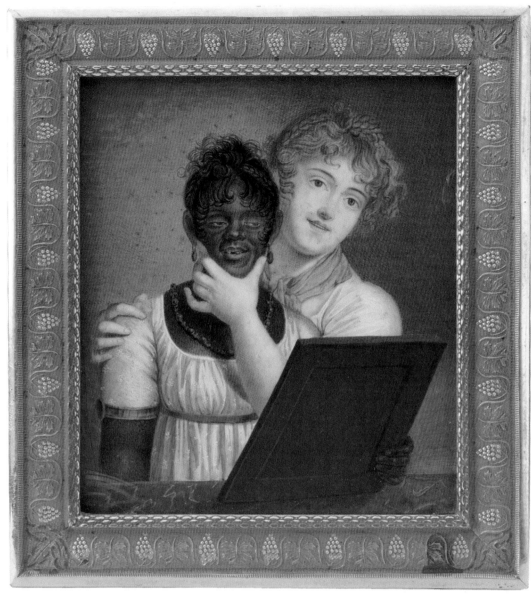

Cat.534

returned to Tripoli in March 1820. He later described and illustrated the mission in his *A narrative of travels in Northern Africa* (1821). Cruikshank's image is full of racial stereotypes and heightened cultural differences. Resplendent in his blue naval uniform, Marryat stands as an exemplar of propriety and European civilisation. He bows before the squatting king, who has a large ring through his nose and, ludicrously, sports a large sword through his ear. The king's daughters, depicted as versions of the Hottentot Venus with grotesquely exaggerated features, adopt the pose of the three graces with mock coyness.

In the background, uniformed British officers and sailors, their sensibilities both shocked and amused, view the scene watched by a crowd of African men, again with absurdly distorted faces. Cruikshank completes this uncomfortable satirical *tour de force* by implying cannibalism with human skulls on the spears of the king's bodyguards. The basic format was repeated in his *Probable effects of over female emigration…* (Cat.558), which shows a bemused crowd of British men confronted by a group of leering black women.

PAG8631 / PX8631, ZBA2511

536

Every dog has his day – or black devils amusing themselves with a white Negro driver
George Cruikshank, 1818
Hand-coloured lithograph,
278 × 231 mm (image)

See Fig.55 (p.150).

ZBA2502 / E9120

537

The New Union Club, being a representation of what took place at a celebrated dinner, given by a celebrated – society
George Cruikshank, published by George Humphrey, London, 19 July 1819
Hand-coloured etching,
312 × 482 mm (image)

This is one of the most racist and most complex prints of the nineteenth century. It purports to show a dinner held at the African Institution that became increasingly drunken and debauched as the evening progressed. Cruikshank employed many common nineteenth-century racist stereotypes of black people – drunkenness, aggressiveness and sexual promiscuity – and lampooned the idea that black people could aspire to behave like Europeans. In the print, the white abolitionists are portrayed as unsuspecting and bewildered innocents who find themselves entirely out of their depth. Cruikshank seemed to suggest that their association with black people corrupted them – that they were being 'uncivilised' rather than black people becoming 'civilised'. Meanwhile, the idea of relationships between races is ridiculed. Many familiar and important figures are represented. Abolitionists such as William Wilberforce, James Stephen (1758–1832) and Zachary Macaulay (1768–1838) appear next to the street entertainer Billy Waters and the

Cat.535

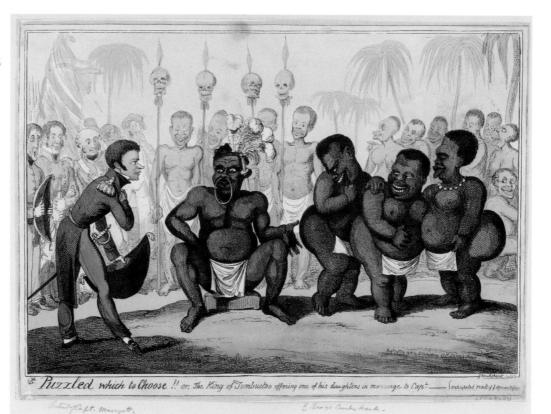

Puzzled which to Choose !! or, The King of Tombuctoo offering one of his daughters in marriage to Cap.t ——— {anticipated result of ♀ African Mission}

Portrait of Capt. Marryott. By George Cruikshank.

Cat.537

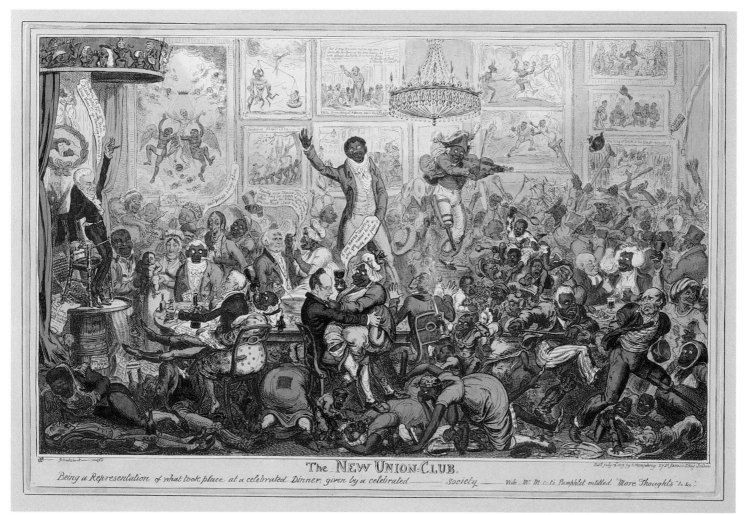

The NEW UNION-CLUB.

Being a Representation of what took place at a celebrated Dinner, given by a celebrated ——— Society. ——— Vide Mr M——'s Pamphlet entitled "More Thoughts &c.&c."

radical Robert Wedderburn (1762–1835/6).
Around them, mayhem prevails. Cruikshank
provided a challenge to the abolitionist cause
and was influenced by Joseph Marryat MP, the
agent for the island of Grenada. Cruikshank
also took inspiration from a print by James
Gillray (1756–1815) – *The Union Club* (1801)
– which showed a drunken dinner celebrating
the Anglo-Irish Union of 1801. In Gillray's
print, the objects of ridicule were the Irish
and their supporters. For Cruikshank, the
targets of racist caricature and abuse were
black people and the abolitionists. While
there are clear political and social comments
in this satirical print, it was also intended to
be entertaining. For all its racial prejudices, it
was meant to be funny, and thus tells us
something about wider public attitudes to
black people and racial difference. This print,
and others like it, suggests the depth of racial
prejudice in nineteenth-century Britain.

ZBA2498 / E9118

538
*Strike while the iron's hot
(or, The consequence of not
answering a bell)*
Richard Dighton (1795/6–1880), London,
10 January 1822
Hand-coloured etching, 273 × 198 mm

Caricature of an African servant being
threatened with a hot poker after failing to
bring his master's tea on time.

ZBA2433

539
*Ebony and ivory; or Chacun
a son gout*
S. & J. Fuller, 1 May 1824
Hand-coloured etching,
168 × 144 mm (image)

A caricature of a tall thin African with a
short, fat European woman on his arm; both
are attired in fashionable dress. Below is the

A DISAPPOINTMENT
— D—nme she's a Black one

Cat.542

inscription: 'Each gives to each a double
charm/ Like pearls upon Ethiop's Arm/
London Pub. May 1 1824 by S. & J. Fuller,
Temple of Fancy 34 Rathbone Place'.

ZBA2528

540
Everyone to his liking
c.1825
Hand-coloured etching, 82 × 73 mm (image)

Caricature showing a European man with a very large African woman on his lap. Both are in fashionable dress.

ZBA2529

541
Hybrida – Venus's looking glass
c.1825
Hand-coloured etching,
88 × 103 mm (image)

Caricature showing a very large African woman seated before a fashionable toilet table and mirror in a very low-cut dress.

ZBA2530

542
A disappointment
Published by Thomas McLean, London,
c.1828
Hand-coloured etching,
360 × 247 mm (image size)

A European dandy, by implication a rake, lifts a handkerchief from the face of a sleeping woman dressed in European clothing, and discovers she is an African. His expression is one of disgust, contempt and, as the title of the print makes clear, disappointment. The caption below reads: 'D-nme she's a Black one.'

ZBA2679 / F0725

543
Sketches of character, footman.
'It a pity you noting to do, but look at me, did you never see a lady's gentleman a fore eh?'
William Heath (1794/5–1840), published by Thomas McLean, London, April 1829
Hand-coloured etching,
348 × 239 mm (image)

Caricature of a black servant in exaggerated footman's livery. The satire is as much, if not more, aimed at the pretensions of his employers as at the man himself – a late example of a much earlier fashion for black servants.

ZBA2706

544
Drunken sailor
John Locker, 1829
Watercolour, 252 × 282 mm

ZBA2671 / E9958

545
Barbados
British school, c.1830
Watercolour, 366 × 533 mm

This image shows a man on horseback with a slave running behind holding a parasol.

ZBA2734

546
The inspection
c.1830
Watercolour, 310 × 416 mm

ZBA2531

Cat.544

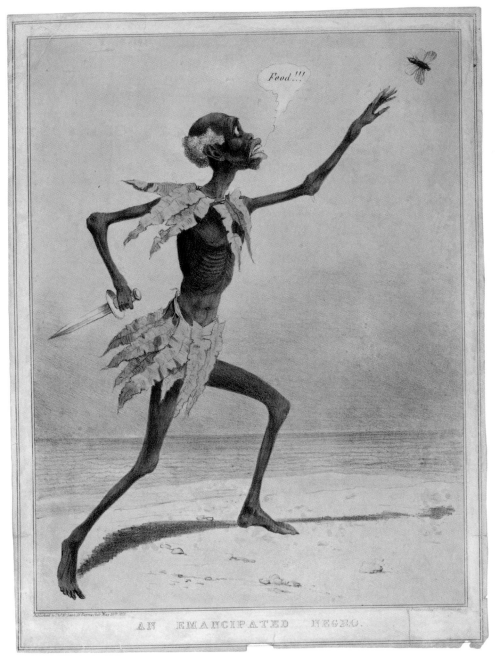

AN EMANCIPATED NEGRO.

Cat.547

Tregear's flights of humour no. 27
Robert Seymour (1798–1836), published by
Gabriel Shire Tregear, London, August 1833
Hand-coloured lithograph,
331 × 241 mm (image)

A white woman, holding a black baby, greets
her sailor lover, returned from sea, at the
quayside in Wapping. The print has the
following inscription: 'Your Molly has never
been false, she declares, since the last time we
parted at Wapping Old Stairs. Then how is it
you have got that young nigger, Why Jack
that wasn't the last time you know.'

PAD4778

Tregear's black jokes, being a series of laughable caricatures on the march of manners amongst blacks *(1834)* *(Cats 549–53)*

*Treager's black jokes were a series of prints
issued by the London engraver and print
dealer Gabriel Shire Tregear. In their style
and subject matter, they are an adaptation of
Edward W. Clay's earlier lithographic series*
Life in Philadelphia *(1828–30), which sought
to lampoon and ridicule the social pretensions
of black Philadelphians through a number of
exaggerated situations and compositions.
Tregear followed this format, producing vivid
hand-coloured aquatints from Hunt's
engravings of W. Summers' original caricatures
that far exceed Clay's in their technical
accomplishment. The set relies heavily on its
humour being drawn from the incongruity
of placing Africans in overtly European social
contexts. The 'joke' is continued with the
extensive use of patois, deepening the sense
of social and racial disparity.*

547

An emancipated Negro
A. Ducote, published by Thomas McLean,
London, 20 May 1833
Hand-coloured lithograph,
322 × 252 mm (image)

This is a caricature on the issue of
emancipation. It shows an elderly emaciated
ex-slave, clad in leaves, shouting 'Food!!!'
while chasing an insect. It supports the notion
that emancipation would lead to economic
collapse in the Caribbean, resulting in
starvation among the former slave population.

ZBA2713 / F3070; ZBA2643 (without colour)

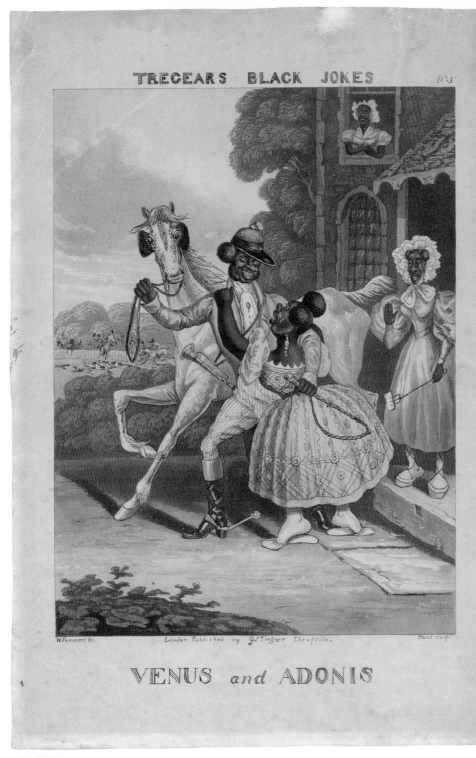

Cat.550

549

The card party

Hunt after W. Summers, published by
Gabriel Shire Tregear, London, *c.*1834
Hand-coloured aquatint,
196 × 282 mm (image)

ZBA2672

550

Venus & Adonis

Hunt after W. Summers, published by
Gabriel Shire Tregear, London, *c.*1834
Hand-coloured aquatint,
195 × 260 mm (image)

ZBA2673 / F3067

551

The route

Hunt after W. Summers, published by
Gabriel Shire Tregear, London, *c.*1834
Hand-coloured aquatint,
197 × 324 mm (image)

ZBA2674

552

The breaking up

Hunt after W. Summers, published by
Gabriel Shire Tregear, London, *c.*1834
Hand-coloured aquatint,
196 × 285 mm (image)

ZBA2675

553

Othello, Desdemona asleep

Hunt after W. Summers, published by
Gabriel Shire Tregear, London, *c.*1834
Hand-coloured aquatint,
195 × 283 mm (image)

With caption: 'Yet I'll not shed her blood;/
Nor scar dat whiter skin ob hers dan snow,/
And smoove as monumental alabaster./ Yet
she must die, else, she'll betray more Niggers.'

ZBA2690

HARMONY and DISCORD.

"Oh! how sweet is the pleasure, how great the delight,"
"When soft love and harmony together unite!"
But how sad is the contrast where envy and strife,
Make two once-loving souls lead a cat-and-dog life!

Cat.556

a worker on a sugar cane plantation startled by his master. He explains his indolence by remarking that as long as the French eat sugar beet he does not need to work and can get as fat as he pleases on the sugar cane. The caption reads 'Maître…moi pouvoir plus travailler li canne!…pendant que ti français, manger li sucre de li Betterave, moi avoir engraissi, moi pouvoir plus bougis de tout.' This refers to the controversy at the time when the colonial planters persuaded the French government to support the production of sugar cane by placing a high duty on imported refined sugar.

ZBA2596

558
Probable effects of over female emigration, or importing the fair sex from the savage islands in consequence of exporting all our own to Australia!!!!
George Cruikshank, published by David Bogue (1807/08–56), London, 1844
Hand-coloured etching,
149 × 394 mm (image)

ZBA2723

554
Black Thorn
Published by Gabriel Shire Tregear, London, 1836
Hand-coloured lithograph,
256 × 191 mm (image)

A large European man is depicted walking along carrying a whip. Unseen around the corner an African man stands holding a club.

ZBA2693

555
Virginia stock
Ingrey, published by Gabriel Shire Tregear, London, 1836
Hand-coloured lithograph with publisher's watercolour, 214 × 269 mm (image)

Depicts six slaves chained together standing in a row, with palm trees in the background.

ZBA2691

556
Harmony and discord
W.P., 1837
Hand-coloured etching, 137 × 184 mm

With an added manuscript caption: 'Oh! how sweet is the pleasure, how great the delight, / When soft love and harmony together unite! / But how sad is the contrast where envy and strife, / Make two once loving souls lead a cat-and-dog life!'

ZBA2692 / E9950

557
Actualités
D'Aubert after Honoré Daumier (1808–79), published by Chez Bauger, Paris, 1839
Hand-coloured lithograph,
261 × 225 mm (image)

One of a series of five images produced for the French journal *Charivari*. It shows

PRINTS AND DRAWINGS: PORTRAITS

559
Captain John Andrews
British school, c.1815
Watercolour on ivory, 77 × 60 mm (image)

Miniature of Captain John Andrews on ivory and mounted on pink paper. An inscription has been written below the miniature: 'Captain John Andrews (my mother's brother) perished in that abominably horrid traffic The Slave Trade, his adventures, which were too revolting to be repeated, exhibit[ed the] trade in colours truly infernal. He & his father were gallant officers in the royal navy – my grandfather fell while fighting his country's battle – commander of the Asia of 74 guns....[signed] George Offor 1835'. Six small ivory panels painted with various tropical birds (by Edward Offor in December 1858) have been glued onto the reverse of this paper.

ZBA2535

560
Hermes Barry
British school, 1826
Watercolour, 256 × 202 mm

Profile of Hermes Barry with inscription: 'Hermes Barry, a little Bush boy brought from the Cape of Good Hope by Sir Jahleel Brenton, remarkable for his docility, good humour, gratitude, a love of learning and great progress in knowledge of the Scriptures. About 14 years of age. Dec. 1826.' Hermes Barry was named after Dr James Barry (1775–1865), a British army medical officer serving at the Cape between 1816

Cat.560

and 1828. Details of Hermes Barry's life are contained in the memoirs of Vice-Admiral Sir Jahleel Brenton (1770–1844), who was appointed commissioner of the Dockland at the Cape in 1813. Dr Barry, who attended Mrs Brenton during her final illness, 'had rescued this boy, when a mere child, from the tyranny of a Dutch woman, his mistress, who abusing the power which the law gave her over a slave, was about to commit him to

prison on account of some trifling theft, which he had been guilty of. Dr Barry, touched with the compassion of the boy's appearance, ransomed him from slavery, and was then glad to consign his purchase to the care of his benevolent patron. The boy thus admitted into Sir Jahleel's family, gave remarkable evidences of intelligence and quickness'. Hermes accompanied Brenton when he returned home in 1821. 'With

Sir Jahleel this boy came to England, where the peculiarity of his appearance (for of all the sections of the human race, the Bushman most nearly resembles the monkey) attracted general observation; and in his family he remained discharging with correctness the several duties of a domestic servant; subject to no other interruption than that which his vivacity and quickness of temper contrived to draw from the common occurrences of the day.' 'After having remained in England, after having acquired and adopted all the usages of civilized life, and apparently overcome his earlier propensities; the irritability of his temper rendered it inconvenient to retain him in the family; and as his health was suffering from the climate of England, it was thought expedient to send him back to the Cape, and to place him in such a situation there, as might maintain the influence of his new habits, and prepare him for future usefulness in the country'. It was rumoured that, upon his return, Hermes 'had disappeared from the Colony [and] plunged again into the bush'. But Henry Raikes (1782–1854), the editor of Brenton's memoirs, reported that Hermes was settled 'in a respectable position'. (Rev. Henry Raikes (ed.), *A memoir of the life and services of Vice-Admiral Sir Jahleel Brenton* (Hatchard & Son, London, 1846), pp 602–4)

ZBA2512 / E9122

Thomas Clarkson (1760–1846)

Clarkson was one of the leading figures in the abolition campaigns. In 1786, his prize-winning Cambridge University MA thesis on slavery was published and it made an immediate impact. It brought him to the attention of other campaigners, and he was one of the founder members of the Society for Effecting the Abolition of the Slave Trade in May 1787. Clarkson worked full-time for

the society. He spent two years gathering information and evidence against the slave trade, often at personal risk, which was used by Wilberforce in his parliamentary campaign. Clarkson fought for the cause with such energy that he suffered a breakdown in 1794, and largely withdrew from the campaign until the early 1800s. Some years after the abolition of the slave trade, Clarkson turned to the abolition of slavery itself, and was vice-president of the Anti-Slavery Society by 1825.

561

Thomas Clarkson Esqr., 1822
William Home Lizars (1788–1859) after R.S.M., *c.*1822
Etching, 275 × 211 mm

PAH6075

562

Thomas Clarkson
Charles Turner (1774–1857) after Alfred Edward Chalon (1780–1860), *c.*1825
Mezzotint, 440 × 354 mm (image)

Caption reads: 'To His Royal Highness William Frederick Duke of Gloucester, this portrait of Thomas Clarkson, Esq. M.A.'

ZBA2648

563

Thomas Clarkson
G. Lobel after Henry Room (1803–50), *c.*1840
Mezzotint, proof before letters on India paper, revision of highlight, 440 × 354 mm (image)

Portrait of Thomas Clarkson holding a scroll, which reads 'Slavery abolished, Jamaica August 1st 1838'. See Fig.18 (p.66).

ZBA2504 / E9112

Cat.564

564

Archibald Dalzel Esqr. Governor of Cape Coast Castle & its dependencies, on the coast of Africa
James Heath (1757–1834) after Johann Eckstein (1736–1817), published by Robert Laurie (1755–1836) and James Whittle (*c.*1757–1818), London, 12 Aug 1799
Stipple engraving, 74 × 54 mm

Archibald Dalzel (1740–*c.*1811) was born in Kirkliston in Scotland. He studied medicine at Edinburgh University and served in the Royal Navy as a surgeon during the Seven Years War (1756–63). When he was discharged in 1763, he accepted a position as a surgeon in the Company of Merchants Trading to Africa, and was stationed at Anomabu on the Gold Coast. While in West Africa he began slave trading. He was director of the British fort at Ouidah from 1767 to 1770, and then concentrated on slave trading

until he was declared bankrupt in 1778. Dalzel was active in the campaign opposing abolition. In 1791 he became governor of Cape Coast Castle, and soon afterwards published his *History of Dahomy* (London, 1793). The book, which was used by anti-abolitionists, argued that the slave trade benefited Africans and defended Europeans from the charge that they incited wars in Africa. His brother, the classical scholar Andrew Dalzel (1742–1806), was a prominent opponent of slavery.

PAD3039 / PU3039

565
Olaudah Equiano, or Gustavus Vassa, the African
Daniel Orme (1766–1837) after William Denton; published by Gustavus Vassa (*c.*1745–97), London, 1789
Stipple engraving, 155 × 96 mm

Frontispiece from Olaudah Equiano's self-published book *The interesting narrative of the life of Olaudah Equiano, or Gustavus Vassa, the African* (London, 1789).

Equiano's *Interesting narrative* went through eight editions prior to his death in 1797. It describes his capture in Africa, the horrors of the Middle Passage, and his life as a slave and then as a free man. It was one the most important books in the abolition campaign. Equiano (who called himself Gustavus Vassa for most of his life) claimed to have been born in present-day Nigeria in about 1745, although his African birth is now questioned. He was purchased by a sailor, and served aboard merchant ships, before eventually purchasing his freedom in 1766. As a free man he gained employment in a wide range of occupations, including serving on the Arctic expedition of Constantine Phipps (1744–92) in 1772. In the 1780s he became acutely interested in the plight of poor black people in London, and in the emerging

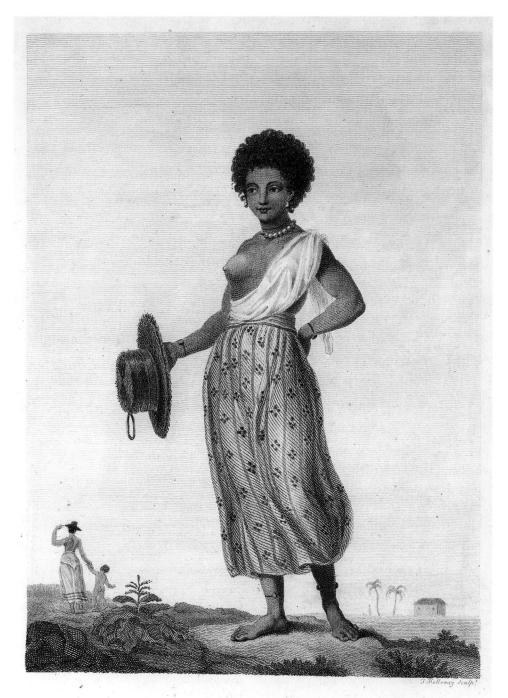

Joanna.

Cat.566

abolition campaigns. Equiano actively promoted abolitionism (and his book) in a series of public lectures around Britain. His presence as a well-dressed, educated, articulate and Christian black man helped reinforce the inhumanity of the institution of slavery. Equiano's book remains a powerful and moving account of the brutality and indignity of slavery. See Fig.10 (p.43).

ZBA2657 / F2255

566

Joanna

Thomas Holloway (1748–1827) after John Gabriel Stedman, published and sold by Joseph Johnson (1738–1809) and Thomas Payne (1752–1831), London, 1806 Hand-coloured etching, 219 × 134 mm (image)

A plate from the second edition of Stedman's *Narrative of a five years' expedition against the revolted Negroes of Surinam.* Joanna (*d.*1782) was 15 when she married Stedman, who drew the picture on which this etching was based. Joanna was of mixed race,

but was still a slave. Stedman was unable to free his wife, and had to purchase his own son's freedom when he was born.

ZBA2562 / E9900

567

Job, son of Solliman Dgiallo, High Priest of Bonda in the country of Foota, Africa and William Ansah Sessarakoo, son of Iohn Bannishee Corrantee Ohinnee, of Anamaboe after William Hoare (1707/08–92), 1750 Engraving, 104 × 195 mm (image)

Double portrait after William Hoare of Bath, published in *The Gentleman's Magazine.* William Ansah Sessarakoo (right) was the son of the king of Akwamu, one of the powerful slave-brokers on the Gold Coast. In 1744 Ansah set out on a trading mission to Britain but was kidnapped by the captain of the ship and sold into slavery. Four years later he was freed and became the toast of London society. His experiences as a slave made him an early black champion of abolition.

ZBA2557 / E9997

568

Job, son of Solliman Dgiallo, High Priest of Bonda in the Country of Foota, Africa after William Hoare, *c.*1750 Copper engraving, 244 × 169 mm

ZBA2711

Toussaint L'Ouverture (c.1743–1803) Born of African slave parents, Toussaint L'Ouverture became the great black general and liberator who freed his native Saint-Domingue from French control. Toussaint was the steward of the livestock on his master's estate in Saint-Domingue until the French Revolution of 1789 sparked turmoil in the colonies. After 1791, a dispute between wealthy and poor whites on the island grew into a slave revolution, with Toussaint at the head of a powerful army of ex-slaves. In 1794, after France abolished slavery, Toussaint's forces joined the French army to attack the Spanish (who controlled the colony of Santo Domingo). Toussaint emerged as commander-in-chief in 1797. When Napoleon came to power, however, he reinstated slavery. Toussaint was captured and exiled to France in 1802, and died a year later. He did not live to see the final triumph of black forces when, in 1804, Saint-Domingue became Haiti, the first independent black republic outside Africa.

569

Toussaint Louverture, chief of the French rebels in St Domingo William Holl (1771–1838) after François Bonneville (active 1787), published by Henry Delahoy Symonds, London, 1802 Stipple engraving, 90 × 70 mm (image)

ZBA2710 / E9974

Cat.567

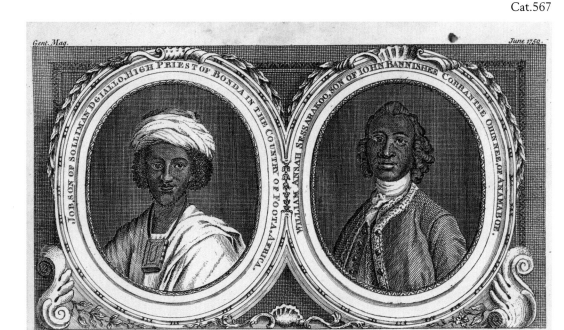

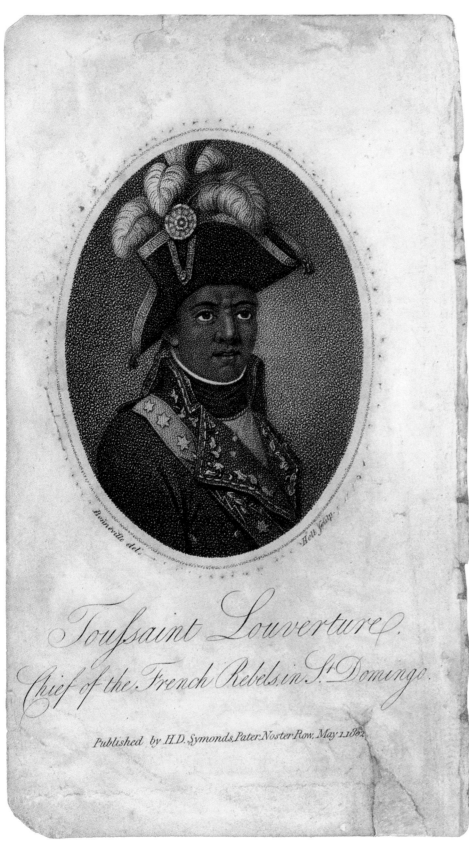

Toussaint Louverture.

Chief of the French Rebels in St Domingo.

Published by H.D. Symonds, Pater. Noster Row. May 1.1802.

Bonneville del.

Holl Sculp.

Cat.569

570

Tout Saint en Général, ne fais pas miracle; se vend au cap
1802
Stipple engraving, 248 × 194 mm

ZBA2689

571

Le Gal Toussaint Louverture à qui le Fal Leclerc avait envoyé ses enfants, pour tâcher par là de l'engraver à déserter la cause des noirs, les renvoie après les avoir embrassés
[The … [gallant or General]… Toussaint Louverture, to whom the [General?] Leclerc had sent his children to try to persuade him to desert the black cause, sends them away after embracing them]
De Villain, 1822
Lithograph, 309 × 240 mm (image)

Under the image is the caption: 'Les sollicitations de sa femme et de ses enfants ne peuvent le faire changer de résolution, et il s'éloigne d'eux en disant au Gouverneur de ses enfants qui les lui avait amenés: Reprenez mes enfants puisqu'il le faut. Je veux être fidèle à mes frères et à mon Dieu' (The supplications of his wife and children cannot make him change his resolution, and he leaves them, saying to his children's tutor, who had brought them to him: Take my children away, since this must be so. I wish to remain faithful to my brothers and to my God.) Napoleon had sent Toussaint's children and their tutor to Haiti with a letter asking him to meet with General Leclerc, who was brutally leading the campaign to recapture the island. Toussaint at first refused but when he later went to do so he was treacherously seized and taken to France, where he died in captivity.

ZBA2719

572
Janus Majeval
1845
Pencil, 214 × 175 mm

Drawing of a bearded man in profile with inscription below in ink: 'Majeval. Slaver pirate who run the knife into Mr Palmer Midshipman HMS *Wasp* – Tried and convicted 184[5] Exeter.'

Midshipman Thomas Palmer and nine British sailors of HMS *Wasp* took part in the Royal Navy's anti-slavery operations during the mid-1840s. On 27 February 1845, the *Wasp* sighted the Brazilian slave schooner *Felicidade* with a crew of 28 men. On 1 March, during an uprising, the schooner's crew murdered Palmer and the men who were left in the *Felicidade*. The trial of the members of the crew of the *Felicidade* took place at Exeter, 25–27 July 1845. The accused included: Janus Majeval, 22; Francisco Feriera De Santo, 38; Manuel Josi Alves, 23; Florenco Ribiero Joaquin, 25; Sebastian De Santos, 26; Manual Antonio, 22; and Joye Antonio, 18.

ZBA2553

573
Witness against the 10 slaver pirates tried at Exeter, July 1845
1845
Pencil, 263 × 235 mm

Drawing of a black man in a greatcoat with an inscription in ink below: 'one of the witnesses against the 10 slaver pirates tried at Exeter Trewman for the murder of Mr. Palmer Midshipman & 9 English sailors in coast of Africa – Judgement convicted arrested.'

ZBA2554

Painted by J. Rufsell R.A Engraved on Steel by T. Ranson.

REV. JOHN NEWTON.

Cat.574

574

Rev. John Newton

Thomas Fryer Ranson (1784–1828), after
John Russell (1745–1806), c.1809
Steel engraving, 74 × 54 mm (image)

John Newton (1725–1807) is renowned
as a slave ship captain and a prominent
abolitionist, as well as the composer of
'Amazing Grace'. He was born in Wapping,
East London. In late 1744, Newton joined a
slave ship going to Africa. He traded there for
six months and then lived in Africa for two
years, trying to establish himself as a trader on
the Guinea coast. He was unsuccessful and
set sail for Britain in 1748. On his homeward
voyage, the ship encountered a storm so
fierce that it caused him to turn to religion,
and thereafter to read the Bible. His new-
found religion did not immediately turn him
against the slave trade, and in the early 1750s
he made three voyages on two slave ships,
the *Duke of Argyll* and the *African* (Cat.113).
Newton's religious beliefs developed and
deepened after ill health forced him to retire
from the sea. He devoted himself to private
religious study, and was active in the
evangelical movement, becoming curate
at Olney in Buckinghamshire. In 1780 he
moved to London, where he published his
Thoughts on the African slave trade during
the political campaigns of the 1780s.
He drew particular attention to the harmful
effects involvement in the slave trade had
on the physical and emotional health of the
seamen. By the time of his death, he was
regarded as a key figure in the evangelical
and abolitionist movements. He lived just
long enough to see the slave trade abolished.

PAD3099 / PU3099

575

Mungo Park

after Henry Edridge (1769–1821), c.1815
Stipple engraving, 115 × 100 mm (image)

Mungo Park (1771–1806) was one of the first
Europeans to travel into the African interior.
In 1795 he was sent by the London-based
African Association to discover the course of
the Niger River. Like many explorers of
Africa his primary concern was the geography
of the continent and especially its rivers. His
investigations came to an abrupt end in 1805
when he was drowned at the Bussa rapids.

PAD3097

576

The Right Honorable William Pitt, Chancellor of the Exchequer 1789

John Jones (c.1755–96) after George Romney
(1734–1802), published by J. Jones, London,
20 May 1789
Mezzotint, 504 × 351 mm

William Pitt the Younger (1759–1806) is
shown here as Chancellor, before he became
Prime Minister. Between 1787 and 1792, Pitt
encouraged Wilberforce to begin and advance
the parliamentary campaign for the abolition
of the slave trade. Pitt's government, which
received its support from George III
and from business interests with connections
to slavery, was under great political pressure
not to adopt radical measures. Although he
agreed with Wilberforce, Pitt did not force
his government to back abolition. After 1793
his attention was focused on the war with
revolutionary France, effectively undermining
the abolition campaign.

PAH5460

577

Ignatius Sancho

Francesco Bartolozzi (1728–1815) after
Thomas Gainsborough (1727–88), published
by J. Nichols, London, 1781
Stipple engraving, 72 × 92 mm (image)

The frontispiece to *Letters of the late Ignatius
Sancho: an African, to which are prefixed,
memoirs of his life*, ed. Joseph Jekyll
(1754–1837) (2 vols, J. Nichols, London,
1782).

Ignatius Sancho (1729–80) was born on a
slave ship in the Atlantic. Orphaned at the
age of two, he was taken to Britain where
he was given to three sisters in Greenwich.
A chance meeting with the Duke of Montagu
(1690–1749) changed the young Sancho's
life. Montagu was taken by the child's
intelligence, and encouraged his education.
After Montagu's death in 1749, Sancho
persuaded his widow to take him away from
his mistresses, and she hired him as a butler.
With the support of the Montagu family,
Sancho established a grocery in Westminster
(ironically selling slave-produced
commodities). His wealth and property
secured him the vote. Sancho moved in, and
corresponded with, a wide and influential
social circle of nobles, actors, writers, artists
and politicians. He was a supporter and
patron of the arts, as well as being a composer
in his own right. Sancho died in December
1780, and was the first African in Britain to
receive an obituary. See Fig.27 (p.98).

ZBA2573 / E9975

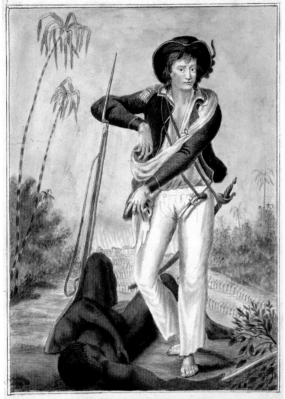

Cat.578

578
Captain John Gabriel Stedman
English school, *c*.1800
Pencil and wash, 203 × 149 mm

This drawing is after the frontispiece of Stedman's *Narrative of a five years' expedition against the revolted Negroes of Surinam* (J. Johnson and J. Edwards, London, 1796). It shows Stedman standing over the body of a slave he had captured. The inscription on the reverse of this portrait may refer to the loss of his son in 1792. 'From different parents, different climes we came, at different periods; Fate still rules the same. Unhappy youth while bleeding on the ground, 'Twas yours to fall – but mine to feel the wound.'

ZBA2556 / E9998

579
Sketch of Tom, the Negro servant of Sir Robert Lawrie
Early 19th century
Watercolour, 92 × 119 mm

It was not uncommon for naval officers (nor for other British people in the eighteenth century) to have black servants. Admiral Sir Robert Lawrie (or Laurie) (1764–1848) had a servant called Tom. His dress suggests the wealth of his employer. It is less clear, however, to whom the remarks in the speech bubble are directed. Tom is complaining to someone, 'Damn you Chip [Ship] and you Conboy [Convoy] too you Chip no Sail, & you Conboy no sail, I really tink [think] we shall neber [never] get home'. Tom's speech is not reported in plain English, but is made to represent his African accent and dialect.

PAH4939 / PY4939

580
Billy Waters
Thomas Lord Busby (active 1804–37), published by Baldwin & Co., London, 1 November 1819
Hand-coloured etching, 227 × 192 mm (image)

Billy Waters was born in America and lost his leg when a seaman in the *Ganymede*, sloop, under (later Sir) J. Purves, as a result of falling from her topsail yard.

ZBA2696, ZBA2698 (re-engraving with publisher's watercolour, 155 × 107 mm)

Cat.579

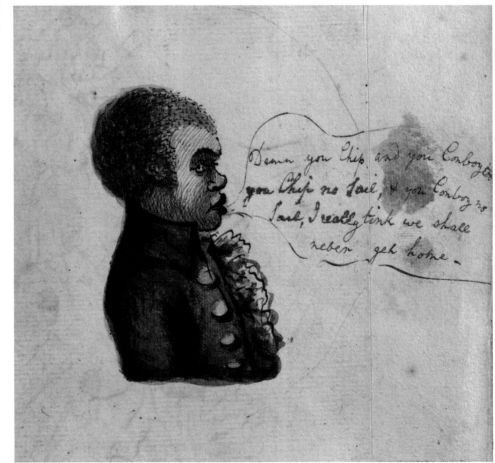

581

Richard Waters Esq.

Thomas Lord Busby, *c.*1815

Ink, 153 × 136 mm

A sketch of Billy Waters, wrongly named Richard.

ZBA2697

582

The notorious Black Billy 'at home' to a London street party

Sutherland after S. Alken, published by Thomas Kelly, London, March 1823

Hand-coloured etching with aquatint, 137 × 226 mm

Billy Waters entertains a crowd near the equestrian statue of Charles I at Charing Cross. It includes fashionable people, porters and street traders, a pickpocket and a man with a placard advertising the lottery run by Thomas Bish, later proprietor and manager of the Theatre Royal Drury Lane.

ZBA2754

William Wilberforce (1759–1833) (Cats 583–6)

William Wilberforce was born into a merchant family in Hull in 1759. He studied at Cambridge University, and was elected MP for Hull in 1780 and for Yorkshire in 1784. Wilberforce converted to evangelical Christianity in 1785. By 1787 he was associated with the campaign to abolish the slave trade and, encouraged by his friend William Pitt the Younger, he became its leading parliamentary spokesman. Wilberforce argued consistently for abolition throughout the political storms of the 1790s. By the early 1800s, Parliament was more amenable and the bill abolishing the trade in slaves in British dominions was passed in 1807. His role in Parliament was of great importance, but it was made possible by the crucial work of many other abolitionists, both

white and black. Wilberforce lived to hear the news that the legislation abolishing slavery had passed its final hearing in the House of Commons, dying three days later on 29 July 1833.

583

William Wilberforce. Drawn from life

J. Davies and I. Read, 28 April 1792

Etching with engraving and aquatint, 190 × 136 mm (image)

Inscription below image reads: 'Nature imprints upon what e'er we see,/ That has a heart and life in it – Be free./ London pub April 28, 1792 by I. Read Coventry Ct. Coventry St.'

ZBA2526

584

William Wilberforce Esqr. Member of Parliament for the County of York

James Heath (1757–1834) after John Russell (1745–1806), published by William Faden (1750–1836), London, 1807

Engraving, 294 × 254 mm (image)

See Fig.19 (p.67).

ZBA2499 / E9117

585

William Wilberforce, 1759–1833

Charles Edward Wagstaff (1808–50) and James Stewart (1791–1863) after George Richmond, *c.*1833

Engraving, 229 × 185 mm (image)

George Richmond's original watercolour depicts Wilberforce at the age of 74, seated in an armchair and holding his spectacles. The work was exhibited in the Royal Academy in 1833 and is now in the National Portrait Gallery. Another version is in the collection of the House of Commons. The portrait was painted by Richmond at Battersea Rise

House, the home of Sir Robert Inglis, MP and where Wilberforce himself had lived before his marriage.

ZBA2527

586

William Wilberforce, 1759–1833

Joseph John Jenkins (*c.*1812–85) after George Richmond (1809–96), *c.*1835

Engraving, 230 × 147 mm

ZBA2525

587

His Royal Highness Prince William Henry, serving as midshipman on board His Majesty's Ship Prince George

Francesco Bartolozzi (1728–1815) and Paul Sandby (*c.*1730–1809) after Benjamin West (1738–1820), published by Antonio de Poggi, London, 15 January 1782

Etching (Bartolozzi) and aquatint (Sandby), 527 × 428mm (image)

Prince William Henry, later William IV, was the third son of George III. He entered the Royal Navy during the American War of Independence (1775–83). He became a competent officer but lacked tact and judgement. As captain of the frigate *Pegasus* he later served under Horatio Nelson in the West Indies in 1784–5. While he was in the West Indies, the future king, like many white men in the Caribbean, had a black mistress. During the anti-slave trade debates of the 1790s he sided with the slavers and West Indies merchants and planters. Probably encouraged by George III, he stated in the House of Lords that British slaves were well treated and were generally happy with their lives.

PAH5531

588

The Hon'ble Dudley Woodbridge Esq.
Director Genll of ye Royal Assiento
Company of England in Barbados
John Smith (1652–1743), after
Sir Godfrey Kneller (1646–1723), 1718
Mezzotint, 305 × 250 mm (image)

Dudley Woodbridge became director-general of the Royal Asiento Company, which, after 1713, had the right to trade from Barbados to the Spanish colonies in the Americas. Legitimate trade often acted as a cover for smuggling between the colonies of Britain and Spain, particularly if leading figures in the company were on good terms with the

planter class. Woodbridge's daughter married into the wealthy and influential West Indian family, the Alleynes, in 1719, a year before Woodbridge's death in 1720.

PAF3319 / PW3319

Cat.588

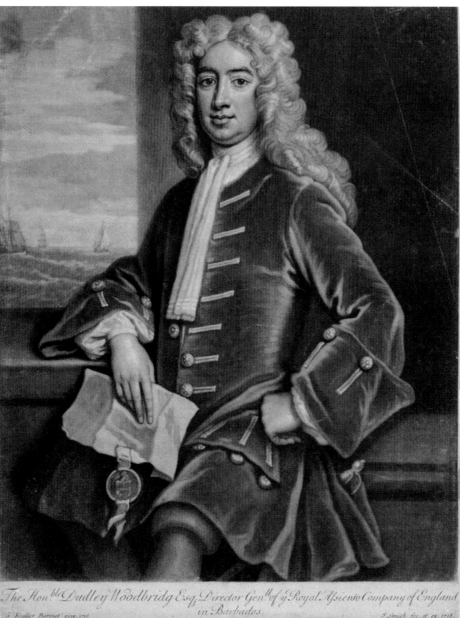

The Hon.ble Dudley Woodbridg Esq, Director Gen.ll of ye Royal Assiento Company of England in Barbados.
G. Kneller Baronet pinx. 1716. J. Smith fec. et ex. 1718.

Portraits of servants
These two portraits are from a sketchbook from the family of William Beckford. It is unclear from the provenance whether this was William Thomas Beckford (1760–1844), who was the only legitimate son of William Beckford (1709–70), the sugar planter, politician and sometime Lord Mayor of London. William Thomas was a writer and collector who inherited a huge fortune of £1 million and an income of £100,000 a year from his father, much of which he spent on his estate at Fonthill, Wiltshire. His cousin, also William Beckford (1744–99) was the son of Richard Beckford, another member of the Beckford dynasty whose prodigious wealth came from their Jamaican possessions. This William Beckford spent 13 years in Jamaica, and was a prominent member of the anti-abolition campaign. Although the Beckfords had very strong links with the Caribbean, and owned many thousands of slaves, they were far from unique in British society in having black servants.

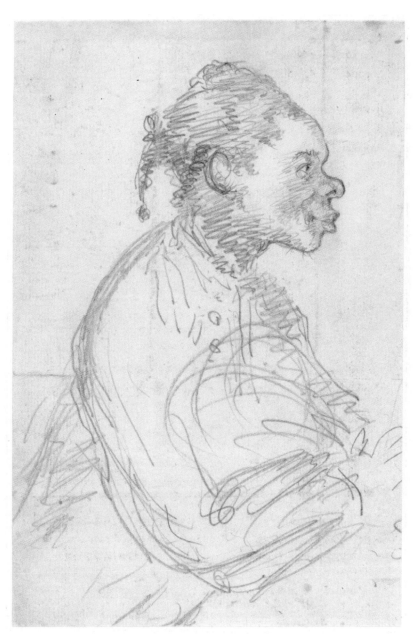

Cat.589

Cat.590

589
Portrait of a female servant
J.W. Hay, *c.*1790
Pencil, 253 × 188 mm

ZBA2748 / E9901

590
Portrait of a male servant
J.W. Hay, *c.*1790
Pencil, 245 × 185 mm

ZBA2749 / E9903

Prints and Drawings: Ships and Naval Engagements

Royal Navy and naval actions

591

Sketch of HMS Ontario *cruizing off Jamaica 1820*

c.1820

Pen and black ink, 163 × 218 mm (image)

PAH5195

592

H.M. Ship Doris *on passage to Brazil 1825*

Thomas Lyde Hornbrook (1780–1850), c.1825

Watercolour, 283 × 402 mm (image)

PAG9773

593

To Commodore Francis Augustus Collier…H.M. Brig Black Joke… *(tender to HMS* Sybille*) engaging the Spanish slave brig* El Almirante *in the Bight of Benin, Feby 1st 1829 which she captured…(with key)*

Edward Duncan after William John Huggins, published in London, 1 June 1830

Hand-coloured aquatint and etching, 370 × 560 mm (image)

See Fig.22 (p.83).

PAH8175 / PY8175

594

Capture of the two top sail slave schooner Bolodora *by H.M. Schooner* Pickle *on the 6th of June 1829*

Edward Duncan after William John Huggins, published in London, 10 June 1831

Hand-coloured aquatint, 323 × 460 mm (image)

PAG9091–92

595

Capture of the Spanish slave brig Midas *by H.M. Schooner* Monkey *on the Great Bahama Bank June 27th 1829*

Edward Duncan after William John Huggins, published in London, 1 July 1831

Hand-coloured aquatint, 314 × 450 mm (image)

PAG7141, PAG9093

596

To Vice Admiral…Sir George Cockburn…This plate representing an action with the Spanish slave frigate Velos Passahera *captured by boarding by H.M. Ship* Primrose…*off Whydah, Bight of Benin the 6th September 1830*

Edward Duncan after William John Huggins, published in London, 1 September 1831

Hand-coloured aquatint, 311 × 453 mm (image)

PAG9095, PAH8176

597

Teresa, *slaver taken by HMS* Pelorus *on the coast of Africa*

British school, 1832

Watercolour, 240 × 292 mm

ZBA2519

598

The capture of the Spanish slave brig Marinereita, *by H. Majesty's brig* Black Joke *April 26th 1831*

R.A. Graham, 1834

Watercolour, 188 × 269 mm

PAD8684

599

H.M. Brig Black Joke *Lieut Wm Ramsay, tender to HMS* Dryad *engaging the Spanish slave brig* Maranerito *in the Bight of Biafra, April 26th 1834*

George Philip Reinagle (d.1835), printed by Charles Joseph Hullmandel, c.1834

Hand-coloured aquatint, 323 × 460 mm (image)

PAG9099

600

To Lieut Millward…of…His Majesty's Brigantine Buzzard *Lieut Millward capturing the Spanish slave brig* Formidable, *on the coast of Africa December 17th 1834…(with key)*

Edward Duncan after William John Huggins, published by F. S. Crawley, London (?), c.1834

Hand-coloured aquatint, 482 × 650 mm

PAH8184

601

Paquito de Cabo Verde *Portuguese slave brig captured by the boats of* HMS Scout *on the 11th Jany 1837 in the Bonny River. She had mounted 2 18 Prs with crew of 35 men and 576 slaves on board*

Lt Thomas Frederick Birch, RN,
10 January 1837
Etching, 105 × 197 mm (image)

Birch served off the west coast of Africa in the late 1830s and early 1840s. He was involved in the capture of a number of slave ships.

PAD5861

602

Carolina *slaver (afterwards HMS* Fawn*) captured by* Electra *with 350 slaves on board*

British school, 1838
Watercolour, 306 × 420 mm

ZBA2716

603

H.M. Brig Acorn *16 guns in chase of the piratical slaver* Gabriel

Thomas Goldsworth Dutton (*c*.1819–91) and Day & Haghe after Nicholas Matthew Condy the Younger (1818–51), published by Ackermann & Co. and Edmund Fry, London, 1841
Hand-coloured lithograph,
300 × 400 mm (image)

PAG9194–95

604

Capture of the slave brig Borboleta… *by the boats of H.M.B.* Pantaloon… *under the command of Lieut Lewis de Teissier Prevost off Lagos, W coast of Africa, May 26th 1845*

Thomas Goldsworth Dutton and Day & Haghe after John H. Vernon, published by Ackermann & Co. and A. Hinton, London, *c*.1845
Tinted lithograph, 225 × 302mm (image)

PAI6751

605

Group out of 311 slaves on board HMS Vesuvius

Commodore Charles Wise, *c*.1850
Pencil and ink, 145 × 209 mm

Rough sketch showing some of the slaves on the deck of the ship gathered round a large bowl of food. Inscribed 'Commodore Charles Wise, second in command, West Coast of Africa Station'.

ZBA2670 / E9959

606

HMS Skipjack *running through the Mona Island Passage in chase of a slaver*

G.J. Briggs, mid-19th century
Watercolour, 138 × 185 mm

PAD6138

607

Slaver 500 slaves after a long chase by HMS Rifleman *ran on shore near Cape Frio Brazils*

Artist unknown, mid-19th century
Black crayon on prepared green paper with scraped highlights, 140 × 222 mm

The inscription continues: 'Next morning the decks were covered with dead bodies 40 slaves were found alive, many doubtless got on shore but most were drowned.'

PAD8892

Cat.605

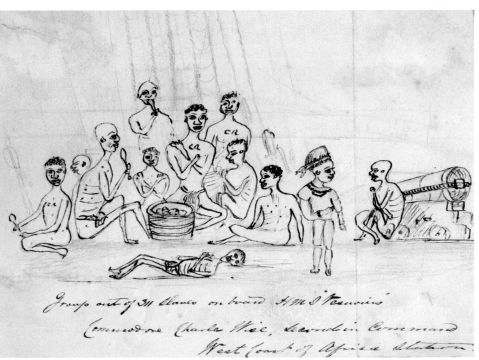

Cat.607

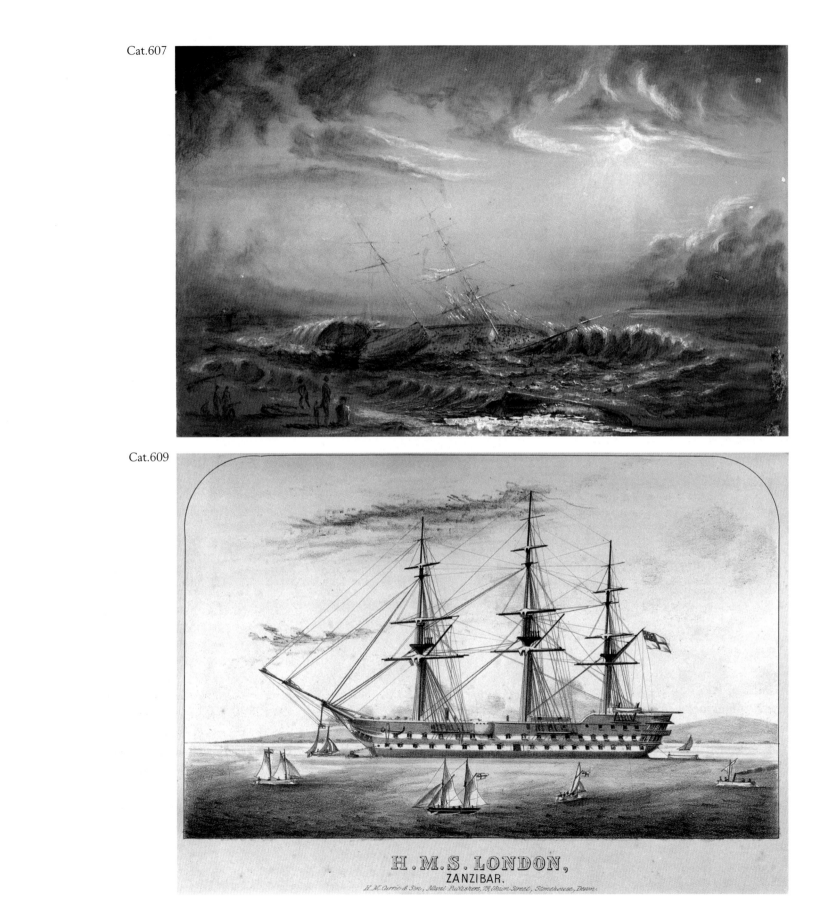

Cat.609

H.M.S. LONDON,
ZANZIBAR.
H.M. Currie & Son, Naval Publishers, 79 Union Street, Stonehouse, Devon.

608

Le Célèbre Brick Africain 'Gabriel',
Cap: Gabriel Giraud. Forçant a La
retraile le Brick de Guerre Anglais Le
Termagant

J. Aresti, mid-19th century

Tinted lithograph, 282 × 380 mm (image)

PAF7723

609

HMS London, *Zanzibar*

Published by H.M. Currie & Son, London (?),
*c.*1875

Hand-coloured lithograph,
215 × 345 mm (image)

HMS *London* (1840), a two-deck wooden
ship of the line, saw action during the
Crimean War and was converted to steam
in 1858. From 1873, *London* was the depot
ship at Zanzibar, essentially a floating
headquarters, hospital, repair shop and store
for the Royal Navy's anti-slavery patrols off
the East African coast. Small boats and steam
launches were used to intercept Arab dhows
suspected of illegal slave trading. These were
kept in a state of readiness, loaded with
supplies, and were often away from
HMS *London* for some days, or even weeks,
patrolling the many inlets and lagoons
favoured by Arab traders.

PAF8085 / PW8085

610

Pinnace of HMS London *chasing a*
slaving dhow near Zanzibar

Rev. Robert O'Donelan Ross-Lewin, 1876–7

Watercolour, 318 × 470 mm (image)

Robert O'Donelan Ross-Lewin was the
Royal Navy chaplain aboard HMS *London* in
1876–7. *London* was an important instrument
in the Royal Navy's anti-slavery campaign
along the East Coast of Africa. The ship sailed
to Zanzibar to take up her position as a
stationary depot vessel to counter the slave

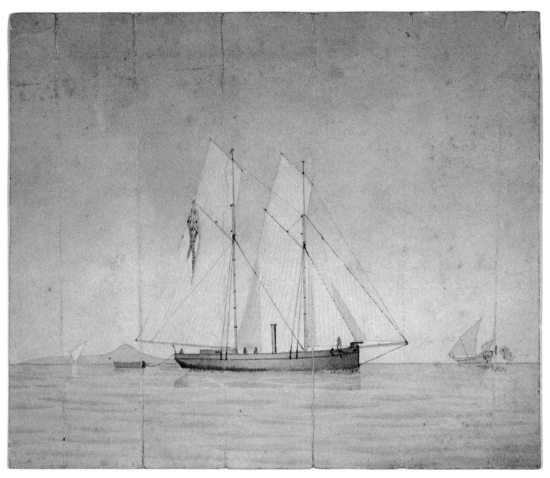

Cat.611

trade and maintain a presence against
European rivals in the region. See Fig.24
(p.89).

ZBA2738 / F0877

611

Pinnace for chasing slaves. Probably
attached to HMS London…

Lt E.F. Inglefield, *c.*1880

Watercolour and graphite, 203 × 240 mm

PAF5717 / PW5717

612

Slave-ship captured by HMS Osprey

*c.*1885

Watercolour and pencil, 290 × 519 mm

ZBA2714

613

Sailing vessel HMS Fair Rosamond
(ex-slaver Dos Amigos*)*

Alfred Basil Lubbock (1876–1944), 1936

Ink, 317 × 258 mm

The *Fair Rosamond* had been a Brazilian slave
ship, the *Dos Amigos*, which carried Africans
between West Africa and Brazil until about
1827. It was captured by the Royal Navy, and
converted to the *Fair Rosamond*. Ex-slave
ships, often speedy and with a shallow
draught, made extremely effective anti-
slavery vessels. Lubbock wrote many books
on sailing ships, including *Cruisers, corsairs*
and slavers, published posthumously in 1993.

PAH5778 / PY5778

614

*Bahama Banks 1767. Thus God
speaketh once, yea, twice, yet Man
perceiveth it not. In a dream in a
Vision of the Night, when deep sleep
falleth upon Men in slumbrings upon
the Bed; Then he openeth the Ears of
Men, & sealeth their instruction. Job
Ch.33.Ver 14.15.16. & 29 & 30*
Samuel Atkins, published by Barnes and Co.,
London, late 18th century
Etching, 110 × 164 mm (image size)

Print depicting the wreck of the slave ship
Nancy on the Bahama Banks in 1767. The
Caribbean waters were dangerous to sail in,
and many slave ships were wrecked on
sunken reefs and in sudden squalls. Mostly,
the slaves on board, who were shackled
together, would have drowned. Sometimes,
however, they survived. On St Vincent
shipwrecked Africans intermarried with the
islanders, and fought against French and
British colonisation until the end of the
18th century.

PAD6489 / PU6489

615

*An elevated view of the new docks &
warehouses now constructing on the
Isle of Dogs near Limehouse for the
reception & accommodation of shipping
in the West India trade*
William Daniell (1769–1837), *c.*1804
Coloured aquatint and etching,
400 × 776 mm (image)

During the eighteenth century, the viability
of London as Britain's greatest port was
threatened by the appalling congestion on the
River Thames. The loading and discharging of
cargoes could take weeks and theft was rife
from ships, barges and wharves. Authorised

Cat.614

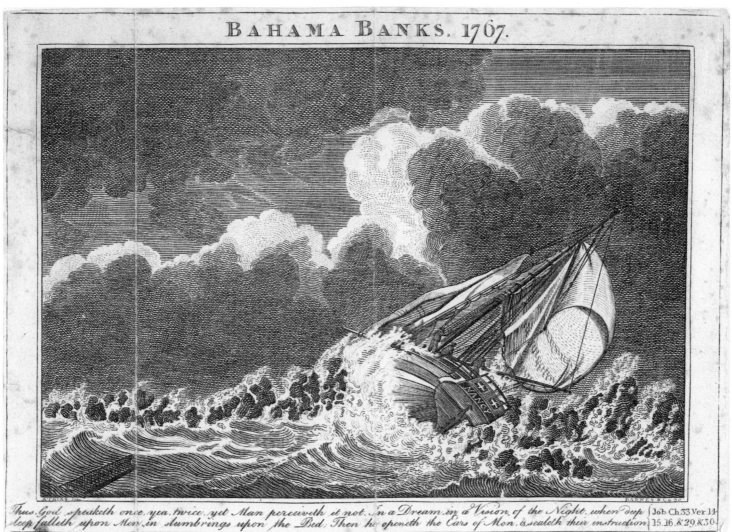

BAHAMA BANKS. 1767.

*Thus God speaketh once, yea, twice, yet Man perceiveth it not. In a Dream in a Vision of the Night, when deep
sleep falleth upon Men in slumbrings upon the Bed; Then he openeth the Ears of Men, & sealeth their instruction.* Job Ch 33 Ver 14 15.16. & 29.&30.

An Elevated View of the New Docks & Warehouses now constructing on the Isle of Dogs near Limehouse for the reception & accommodation of Shipping in the West India Trade.

Cat.615

by an Act of Parliament in 1800 and financed by wealthy merchants, the West India Docks on the Isle of Dogs were built by William Jessop and John Rennie between 1800 and 1805. They were the first of London's new enclosed docks, offering greater efficiency and the capacity to berth up to 600 sailing ships. The extensive complex of bonded warehouses, designed by George Gwilt and built by William Adam, was completed in 1806, providing secure storage for imported goods such as sugar, molasses and rum.

PAI7124 / PZ7124

616
The slaver Campeadore
Captain James Burney, *c.*1815
Watercolour, 305 × 364 mm

Inscribed: 'The Spanish brig *Campeadore* of 12 guns and 50 men laden slaves from Old Calabar bound to the Savannah, taken by HMS *L'Aigle* in the Gulf of Florida, after a smart chase'. Captain James Burney was appointed to the HMS *L'Aigle*, 17 November 1814, under Captain Sir John Louis on the West Indies station.

ZBA2571

617
Two sketches of a slaver
Lt Robert Strickland Thomas (1787–1853), RN, *c.*1815
Graphite and brown ink, 140 × 231 mm

Thomas served in HMS *Creole* off the west coast of Africa in 1814–15.

PAH4404

618
Ship plans: *Fair Rosamond*
1832–7
Lines and profile, upper deck and ship plans of *Fair Rosamond* (see Cat.613).

ZAZ6180–82

Cat.622

619
Ship plans: *Diligence* taken
by HMS *Pearl*
1839
Lines and sail plan of *Diligence* taken by
HMS *Pearl*.

ZAZ5173–74

620
The celebrated piratical slaver
L'Antonio *with others of the black
craft lying in the Bonny River*
Thomas Goldsworth Dutton and Day &
Haghe after Nicholas Matthew Condy the
Younger, published by Edward Ramsden
and Edmund Fry, London, 1845
Coloured lithograph, 225 × 305 mm (image)

PAF7728, PAI8896, ZBA2756

621
Slaver Esmeralda *captured November
1 1849 off Loango, west coast of
Africa, by HMS* Rattler *and taken to
St Helena to prize court by C.G.
Nelson midshipman in command*
C.G. Nelson, *c*.1849
Watercolour, 250 × 350 mm

Monogrammed.

ZBA2737

622
Shipping slaves, W. coast of Africa
John Robert Mather (1834–79), 1860
Watercolour, 308 × 570 mm (sheet size)

Signed, inscribed and dated by the artist.
The ship depicted is almost certainly
L'Antonio (see Cat.620), 'the celebrated
piratical slaver' painted in oils by the
Plymouth marine artist Nicholas Matthew
Condy the Younger and issued as an
engraving in 1845.

ZBA2741 / F0883

INDEX